WEB DESIGN INDEX BY CONTENT

THE PEPIN PRESS | AGILE·RABBIT EDITIONS

.03

D1067036

COMPILED BY GÜNTER BEER

Compilation & layout by Günter Beer & Sigurd Buchberger
CD Master by Sigurd Buchberger

Cover and book design by Pepin van Roojen

Cover image by Miguel Ripoll (www.miguelripoll.com)

The cover image is an adaptation of an illustration for
spanish-portuguese.berkeley.edu (see page 254).

Translations by Justyna Wrzodak (Polish),
Vladimir Nazarov (Russian), Michie Yamakawa (Japanese),
Franca Fritz (German), Web Translations (Korean),
Reese Lee (Chinese), LocTeam (Spanish, Italian, French and Portuguese).

With special thanks to Magda Garcia Masana.

ISBN 978 90 5768 111 0
The Pepin Press | Agile Rabbit Editions
Amsterdam & Singapore

The Pepin Press BV
P.O. Box 10349
1001 EH Amsterdam
The Netherlands

Tel +31 20 4202021
Fax +31 20 4201152
mail@pepinpress.com
www.pepinpress.com

10 9 8 7 6 5 4 3 2 1
2012 2011 2010 2009 2008 2007

Manufactured in Singapore

Web Design Index by Content.03 contains a selection of 500+ websites illustrating the latest trends in web design. Two views of each site have been chosen: an opening page and a page that is representative of the site. A section on blogs has been added to this edition to highlight how design trends are reaching new areas of the web. The enclosed CD-ROM contains all the images found in the book and direct links to the websites. Together, this book and CD set offer a comprehensive overview of web design today, organised by subject for easy reference.

The URL is indicated for each website. The names of those involved in the design and programming of the sites are listed as follows:

D design
C coding
P production
A agency
M designer's e-mail address

Submissions and recommendations
Each year, The Pepin Press publishes new editions of two leading reference books in web design: **Web Design Index** and **Web Design Index by Content**. If you would like to submit or recommend designs for consideration, please complete the submissions form at www.webdesignindex.org.

The Pepin Press / Agile Rabbit Editions
For more information on The Pepin Press or to order from our selection of publications on design, fashion, popular culture, visual reference and ready-to-use images, please visit www.pepinpress.com.

Web Design Index by Content.03 comprend une sélection de plus de 500 sites Internet, illustrant les dernières tendances en matière de conception Web. Pour chaque site, deux pages ont été choisies : une page d'ouverture et une page représentative du site. Une section consacrée aux blogs a été introduite dans cette édition pour démontrer comment les tendances de conception touchent de nouveaux espaces sur le Web. Le CD-ROM ci-joint comprend toutes les images présentées dans le livre ainsi que des liens directs vers les sites Web. Cet ensemble livre et CD, organisé par thème pour en faciliter la consultation, offre un panorama complet de la conception Web actuelle.

L'URL de chaque site est indiquée. Les noms des personnes ayant participé à la conception et à la programmation du site sont classés comme suit :
D conception
C codage
P production
A agence
M adresse e-mail du concepteur

Suggestions et recommandations
Chaque année, The Pepin Press publie de nouvelles éditions de ses deux ouvrages de référence en matière de conception virtuelle : **Web Design Index** et **Web Design Index by Content**. Si vous avez des designs à nous suggérer ou à nous recommander, veuillez remplir le formulaire de suggestion qui se trouve à l'adresse www.webdesignindex.org.

The Pepin Press / Agile Rabbit Editions
Pour en savoir plus sur The Pepin Press ou pour commander un ouvrage parmi notre sélection de publications consacrées au design, à la mode, à la culture pop, aux références visuelles et aux images prêtes à l'emploi, rendez-vous sur notre site Web www.pepinpress.com.

Web Design Index by Content.03 illustra le ultime tendenze del web design attraverso una rassegna di più di 500 pagine web. Vengono presentate due pagine per ogni sito: una pagina d'apertura e una pagina interna esemplificativa. La nuova sezione dedicata ai blog intende sottolineare come le nuove tendenze del web design stiano conquistando nuovi spazi in rete. Il CD-ROM accluso contiene tutte le immagini presenti nel libro e i link ai siti citati. Il libro e il CD insieme offrono una panoramica esaustiva dello stato attuale del settore, organizzata per argomenti e di facile consultazione.

Per ogni sito è indicato l'URL corrispondente. I nomi delle persone che hanno collaborato al design e alla programmazione dei siti sono riportati come segue:

D design
C codificazione
P produzione
A agenzia
M indirizzo e-mail del designer

Segnalazioni
Ogni anno The Pepin Press pubblica un'edizione aggiornata dei due punti di riferimento principali per il settore del web design: **Web Design Index** e **Web Design Index by Content**. Se desiderate inviare o segnalare un progetto grafico in particolare, compilate l'apposito modulo sul sito www.webdesignindex.org.

The Pepin Press / Agile Rabbit Editions
Per ulteriori informazioni su The Pepin Press o per ordinare le nostre pubblicazioni dedicate a design, moda, cultura popolare, banca immagini e consultazione grafica, visitate il sito www.pepinpress.com.

Web Design Index by Content.03 presenta una selección de más de 500 ejemplos reales que ilustran las últimas tendencias en el diseño de sitios web. De cada sitio se incluyen dos páginas: una página inicial y una representativa de la naturaleza del sitio. Los sitios web están clasificados por temas para facilitar su consulta. En esta nueva edición se ha incorporado un apartado de blogs con el fin de ilustrar cómo las últimas tendencias en diseño están llegando a nuevos sectores de Internet. Además, se adjunta un CD-ROM con todas las imágenes del libro y enlaces directos a las páginas web. Juntos, el libro y el CD ofrecen un panorama exhaustivo del diseño web actual.

Se indica la URL de cada sitio que aparece en el libro. El nombre de las personas que han participado en el diseño y la programación de dichos sitios se recoge del modo siguiente:

D diseño
C codificación
P producción
A agencia
M dirección de correo electrónico del diseñador

Propuestas y recomendaciones

Cada año, The Pepin Press publica nuevas ediciones de sus dos libros de referencia en materia de diseño de páginas web: **Web Design Index** y **Web Design Index by Content**. Si desea proponer o recomendar un diseño para que se tenga en cuenta en próximas ediciones, rellene el formulario que figura en: www.webdesignindex.org.

The Pepin Press / Agile Rabbit Editions

Para obtener más información acerca de las numerosas publicaciones de The Pepin Press sobre diseño, moda, cultura popular, referencia visual e imágenes listas para utilizar, visite: www.pepinpress.com.

Web Design Index By Content.O3 inclui uma selecção de mais de 500 sítios da Web ilustrando as mais recentes tendências do Web design. Foram seleccionadas duas páginas de cada sítio na Web: uma página de abertura e uma página representativa desse sítio. A esta edição acrescentou-se uma secção com blogues com vista a realçar como as tendências do design começam a penetrar em novas áreas da Web. O CD-ROM incluído contém todas as imagens que se encontram no livro e hiperligações directas para os sítios da Web. Em conjunto, este livro e CD oferecem uma perspectiva abrangente do Web design da actualidade, organizados por assunto, para mais fácil consulta.

É indicado o URL de cada sítio na Web presente no livro. Os nomes das pessoas envolvidas na concepção e programação dos sítios na Web são indicados da seguinte forma:

D design
C codificação
P produção
A agência
M endereço de correio electrónico do designer

Propostas e recomendações
Todos os anos, a The Pepin Press publica novas edições de dois livros de referência no âmbito do Web design: **Web Design Index** e **Web Design Index by Content**. Para propor ou recomendar designs à nossa avaliação, aceda ao formulário de propostas em www.webdesignindex.org

The Pepin Press / Agile Rabbit Editions
Para obter mais informações sobre a The Pepin Press ou para efectuar encomendas das nossas obras sobre design, moda, cultura popular, referências visuais e imagens prontas a usar, visite www.pepinpress.com

Web Design Index by Content.03 enthält eine Auswahl von über 500 Websites, die die aktuellsten Entwicklungen im Bereich Webdesign aufzeigen. Jede vorgestellte Website wird mit zwei Seiten präsentiert – der Startseite und einer für die jeweilige Website repräsentativen Seite. Zusätzlich wurde eine Kategorie zum Thema Blogs aufgenommen, die zeigt, wie innovative Designideen neue Bereiche des Internets erreichen. Die der Buchausgabe beiliegende CD-ROM enthält alle gezeigten Designs und Links zu den vorgestellten Websites. Auf diese Weise bieten Buch und CD-ROM – zum schnellen Nachschlagen nach Kategorien sortiert – einen umfassenden Überblick über die neuesten Trends im heutigen Webdesign.

Für jede Website wird die URL angegeben. Die Angaben zu den für Design und Programmierung Verantwortlichen sind nach folgenden Codes sortiert:

D Design
C Code
P Produktion
A Agentur
M Kontaktadresse

Vorschläge und Empfehlungen

Pepin Press bringt jedes Jahr eine neue Ausgabe seiner führenden Nachschlagwerke zum Thema Webdesign heraus: **Web Design Index** und **Web Design Index by Content**. Wenn Sie eine Website für unsere zukünftigen Publikationen vorschlagen oder empfehlen möchten, verwenden Sie bitte das entsprechende Formular auf www.webdesignindex.org

The Pepin Press / Agile Rabbit Editions

Weitere Informationen zu den zahlreichen Veröffentlichungen von Pepin Press – in den Bereichen Design, Mode und Popkultur, mit visuellem Referenzmaterial und sofort verwendbaren Bildern für Designer – finden Sie auf unserer Website www.pepinpress.com.

Книга **«Web Design Index by Content.03»** содержит выборку из 500 лучших веб-сайтов, иллюстрирующих последние тенденции веб-дизайна. Каждый сайт представлен двумя страницами: заглавной и содержательной. Секция по блогам добавлена, чтобы подчеркнуть, как передовые проектные идеи достигают даже тех областей, которые раньше ассоциировались только с текстовой информацией. В книгу включен CD-ROM, содержащий все изображения из книги и ссылки на представленные веб-сайты. Книга и компакт-диск вместе содержат полный обзор современного состояния веб-дизайна, сгруппированного по тематическим областям.

Для каждого сайта, приведенного в книге, указывается его адрес (URL). Фамилии людей, принимавших участие в проектировании и создании сайтов, отмечены следующим образом:

D дизайн
C программирование
P производство
A агентство
M адрес электронной почты дизайнера

Подача на рассмотрение заявок и рекомендации
Каждый год The Pepin Press публикует новые издания книг по веб-дизайну: **Web Design Index** и **Web Design Index by Content**. Если вы желаете подать на рассмотрение заявку или порекомендовать какой-либо дизайн, заполните, пожалуйста, бланк заявки на сайте www.webdesignindex.org.

Издательство **The Pepin Press** / **Agile Rabbit Editions**
За дополнительной информацией об основных публикациях издательства The Pepin Press по дизайну, моде, современной культуре, визуальным справочникам и библиотекам высококачественных изображений, готовых к непосредственному использованию, обращайтесь на сайт www.pepinpress.com.

Web Design Index By Content.03 zawiera wybór ponad 500 aktualnych, ułożonych tematycznie stron internetowych, przedstawiając tym samym najnowsze trendy w projektowaniu stron internetowych. Każda ze stron reprezentowana jest stroną startową oraz inną dla niej charakterystyczną stroną. Do obecnej edycji została dodana sekcja blogów, która pokazuje w jaki sposób innowacyjne pomysły w projektowaniu osiągają nowe dziedziny Internetu. Dołączony do książki CD-ROM zawiera wszystkie obrazy oraz bezpośrednie linki do przedstawionych stron internetowych. Razem, książka i CD-ROM, oferują wyczerpujące zestawienie najnowszych standardów projektowania stron internetowych.

Do każdej strony internetowej podawany jest adres URL. Nazwiska osób zaangażowanych w projektowanie i programowanie stron internetowych podawane są następująco:

D projektowanie
C kodowanie
P wykonanie
A agencja
M adres email projektanta

Propozycje i rekomendacje

Każdego roku wydawnictwo The Pepin Press publikuje nowe edycje dwóch książek z zakresu projektowania stron internetowych: **Web Design Index** oraz **Web Design Index by Content**. Jeśli chcieliby Państwo przedłożyć lub polecić nam projekt, proszę wypełnić odpowiedni formularz na stronie internetowej www.webdesignindex.org.

Wydawnictwo The Pepin Press / Agile Rabbit Editions

Więcej informacji o licznych publikacjach wydawnictwa The Pepin Press na temat projektowania, mody, kultury, referencji wizualnych oraz gotowych do bezpośredniego użycia obrazów znajdą Państwo na stronie internetowej www.pepinpress.com.

Web Design Index by Content.03（网页设计索引 - 主题篇.03）精心挑选了五百多个网页，展示网页设计的最新潮流。书中所介绍的每个网页，其中两个版面会被选出：首页、及对整个网站而言具有代表性的一页。这新订版亦增设了一个关于网志(博客)的单元，彰显设计潮流如何伸展到互联网上的新领域。随书的光碟载有书中所辑录的所有图像及网页连结。这书及光碟套装，展示了当今网页设计的总览，而且是按主题组织整编，以供轻松参考。

本书列出每个网页的统一资源定位符(URL)。网页的设计和编写程式的人员名单，分列如下：
D 设计
C 编码
P 制作
A 机构
M 设计师的电邮地址

投稿及推荐
Web Design Index（网页设计索引）及 **Web Design Index by Content**（网页设计索引 - 主题篇）这两部参考书籍，在网页设计业内带著领导的地位。The Pepin Press 每年均会为这两部书推出新订版。若阁下有意把设计投稿或作推荐，请到 www.webdesignindex.org 填写投稿表格。

The Pepin Press / Agile Rabbit Editions
若阁下需要更多关于 The Pepin Press 的资料，或想订购本社有关设计、时装、流行文化、视觉参考及现成图像的刊物，请到 www.pepinpress.com 查阅本社的网页。

「**Web Design Index By Content. 03**」には、500を越すウェブサイトが収録され、ウェブデザインの最新トレンドがわかります。各サイトについて、オープニング・ページと、そのサイトの特徴をよく表しているページを載せています。また、ウェブデザインが新しい時代に入ったことの証明として、新たにブログのセクションも付け加えました。附録のCD-ROMには、本書に掲載されているウェブサイトのイメージがすべて掲載され、各ウェブサイトに簡単にリンクできます。使いやすいように、本書もCDも、ウェブデザインはカテゴリー別に収録されています。

本書には、各サイトのURL、及びデザイナーとプログラマーの名前も載せています。表記方法は以下のとおりです。

D デザイン
C コーディング
P プロダクション
A エージェンシー
M デザイナーのEメール・アドレス

ウェブサイトの自薦・他薦
Pepin Pressは、ウェブデザイン業界の人気参考書、「**Web Design Index**」と「**Web Design Index by Content**」の改訂版を毎年出版しています。自分のウェブサイトを掲載ご希望の場合、また推薦なさりたいサイトがある場合には、www.webdesignindex.orgにアクセスしてお申し込みください。

The Pepin Press / Agile Rabbit Editions
Pepin Pressは、デザインやファッション、ポップ・カルチャーなどについて多様な出版物や、すぐにそのまま使えるイメージ素材などを出しています。当社の出版物やイメージ素材について、詳しい情報をお知りになりたい方、あるいは当社の商品をご注文なさりたい方は、www.pepinpress.comにアクセスしてください。

Web Design Index by Content.03 (내용별 웹 디자인.03)에는 웹 디자인에 대한 최신 경향을 설명해 주는 500여개의 웹사이트가 수록되어 있다. 각 사이트는 첫 페이지와 사이트의 특징을 잘 나타내는 기본 페이지 등 두 페이지로 구성되어 있다. 이번 에디션에서는 블로그 섹션을 추가하여 디자인 경향이 웹의 새로운 영역으로 어떻게 옮겨가고 있는지 집중적으로 다룬다. 동봉한 CD-ROM에는 책에 실린 모든 이미지와 웹사이트로 바로 가는 링크가 포함되어 있다. 또한 책과 CD에는 간편한 참조를 위해 최근의 웹 디자인에 대해 주제별로 정렬한 종합적인 개관이 알기 쉽게 설명되어 있다.

책에는 각 사이트의 URL이 표시되어 있다. 사이트의 디자인 및 프로그래밍 관련 명칭은 다음과 같이 표기되어 있다.

D 디자인
C 코딩
P 제작
A 에이전시
M 디자이너의 이메일 주소

제안 및 추천

해마다 Pepin Press는 웹 디자인의 두 가지 주요 참고 서적, **Web Design Index**(웹 디자인 인덱스) 및 **Web Design Index by Content**(내용별 웹 디자인)를 새로운 버전으로 출판합니다. 생각하고 있는 디자인을 제출하거나 추천하시려면 www.webdesignindex.org에서 제출 양식을 작성하시기 바랍니다.

The Pepin Press / Agile Rabbit Editions

디자인, 패션, 대중문화, 영상 자료 및 기성 이미지와 관련된 수많은 Pepin Press의 출판물 및 주문에 대한 자세한 내용은 www.pepinpress.com을 방문하시기 바랍니다.

○ ○ ○ 4–pli design –– Brooklyn, NY

4·pli

Architecture
Furniture
News
About Us
Contact

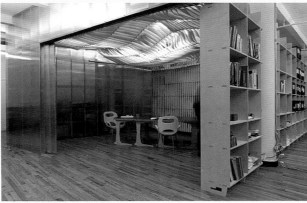

○ ○ ○ 4–pli design –– Brooklyn, NY

4·pli

Architecture
Furniture
News
About Us
Contact

4pli is a young architectural firm that strives to integrate itself fully into every stage of the design process -- from conceptualization to construction. It is our belief that through this commitment we can create work that is innovative, economical and especially functional.

Founded by graduates of the Columbia University (Jeffrey Taras, Kenneth Tracy, William Mowat and Amy Stringer), 4pli is located in a 4,000 square foot industrial space in North Williamsburg. We are all builders as well as architects, and our office doubles as a workshop where we (happily) get our hands dirty every day.

www.4-pli.com
D: 4-pli design C: jeffrey taras P: jeffrey taras
A: 4-pli design M: contact@4-pli.com

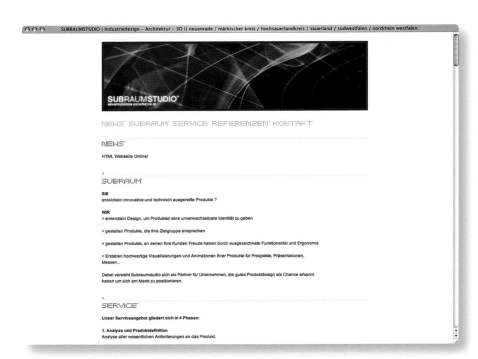

NEWS' SUBRAUM' SERVICE' REFERENZEN' KONTAKT'

NEWS'

HTML Webseite Online!

SUBRAUM'

SIE
entwickeln innovative und technisch ausgereifte Produkte ?

WIR
+ entwickeln Design, um Produkten eine unverwechselbare Identität zu geben

+ gestalten Produkte, die Ihre Zielgruppe ansprechen

+ gestalten Produkte, an denen Ihre Kunden Freude haben durch ausgezeichnete Funktionalität und Ergonomie

+ Erstellen hochwertige Visualisierungen und Animationen Ihrer Produkte für Prospekte, Präsentationen, Messen...

Dabei versteht Subraumstudio sich als Partner für Unternehmen, die gutes Produktdesign als Chance erkannt haben um sich am Markt zu positionieren.

SERVICE'

Unser Serviceangebot gliedert sich in 4 Phasen:

1. Analyse und Produktdefinition
Analyse aller wesentlichen Anforderungen an das Produkt.

3D Visualisierung.

3D Visualisierung.

KONTAKT'

// Anfahrt: SUBRAUMSTUDIO @ maps.google.de

SUBRAUMSTUDIO | Industriedesign - Architektur - 3D
Dipl.-Ing. (FH) Andreas Raphael
Im Duda 2
58809 Neuenrade

Fon: 02392 - 808 169
Fax: 02392 - 808 196
Mobil: 0177 - 935 11 96

Email: info@subraumstudio.com
Webseite: www.subraumstudio.com

www.subraumstudio.com/html/index.html
D: andre weier **C:** andre weier **P:** andre weier
A: nalindesign™ **M:** www.nalindesign.com

○ ○ ○ Richard Perry Architect | Projects | Peters Loft

1 2 3 4 5

PETERS LOFT
New York, NY completed 2002 2,000 sf

This complete interior loft renovation of a converted industrial building located just west of the historic Soho district includes a living room, dining room and kitchen in one large open space. The two bedrooms with floor to ceiling industrial steel and glass window walls share a balcony facing the rear light court. In the center of the loft is a rectangular island which houses the two bathrooms, closets, laundry and a study. Existing elements such as the maple flooring, exposed wood joists and exposed brick walls are balanced with new elements such as Homasote and Polygal wall panels edged with aluminum.

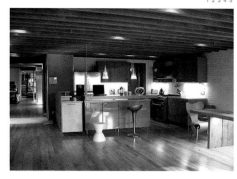

RICHARD PERRY ARCHITECT PROJECTS PROFILE CONTACT

○ ○ ○ Richard Perry Architect | Overview

OVERVIEW
Richard Perry Architect, located in New York, NY, was established in 2000 by Richard Perry. Cecelia Lee joined the firm as a partner in 2003. The combined experiences of both partners and their dedication to the art and craft of architecture define the firm's reputation. The progressive firm is known for innovative designs that are both sensitive and practical. Although the firm's primary focus is on residential projects, they also have extensive experience in commercial work as well including restaurant and retail projects. The firm offers complete architectural services including planning, design, construction documents, filing, bidding and negotiating and construction administration. The firm has also worked with notable decorators including Stephen Stempler, Jonathan Adler and Francois Catroux.

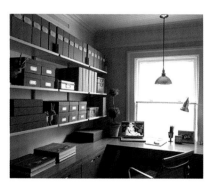

RICHARD PERRY ARCHITECT PROJECTS PROFILE CONTACT

www.rpany.com
D: jessica perilla C: jessica perilla P: jessica perilla
A: jessica perilla design M: jessica@jessicaperilla.com

jubu – arch

PROJECTS **URBAN** NEWS ME FAVOURITES

JULIAN BUSCH

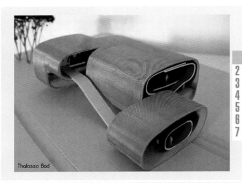

Thalasso Bad

2 3 4 5 6 7

➤➤ KLETTER ARENA ➤➤ LICHTMUSEUM
➤➤ THALASSO 1 ➤➤ VIDEOWERKE
➤➤ THALASSO 2

Entwurf für ein Thalassobad. Mediziner der griechischen Antike wandten die Thalasso-therapie (Meerwassertherapie)... ➤➤

jubu – arch

ME FAVOURITES **URBAN** NEWS PROJECTS

JULIAN BUSCH

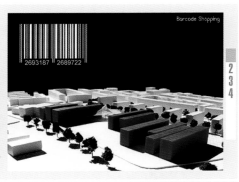

Barcode Shopping

2 3 4

➤➤ BARCODE SHOPPING

Grundgedanke des Barcode Shopping Centers ist es, eine sinnvolle und überschaubare Struktur aus... ➤➤

www.jubu.org
D: julian busch
A: phillennium.com **M:** mail@jubu.org

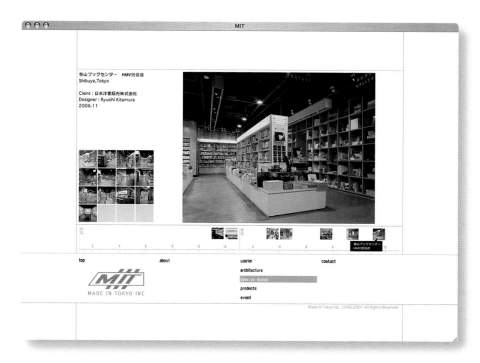

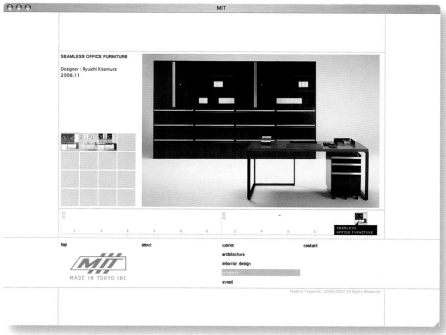

www.madeintokyo.org
D: haruma kikuchi
A: uniba inc. M: info@uniba.jp

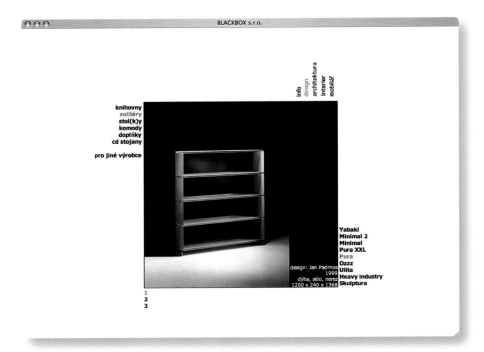

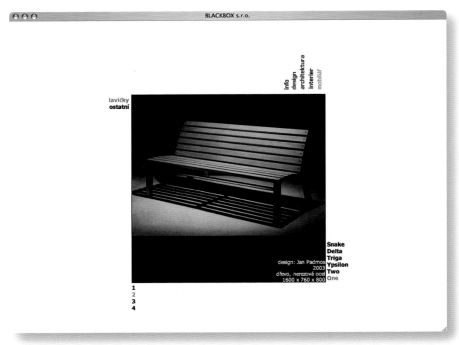

www.blackbox.cz

D: jan padrnos **C:** jan konas **P:** blackbox s.r.o.

A: blackbox s.r.o. **M:** info@blackbox.cz

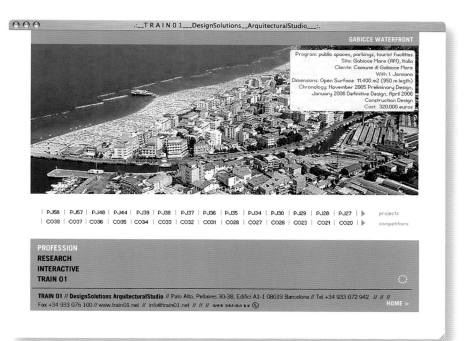

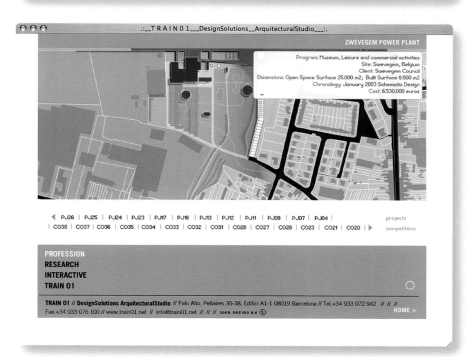

www.train01.net
D: tamara villoslada
A: tamarindous (tamara villoslada) M: www.tamarindous.com/web

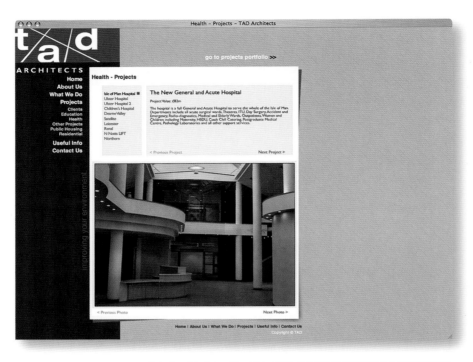

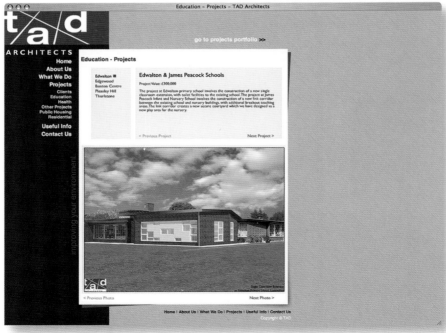

www.tadarchitects.co.uk
D: thrusites C: thrusites P: charles dalton-moore at thrusites
A: t.a.d. architects M: info@thrusites.com

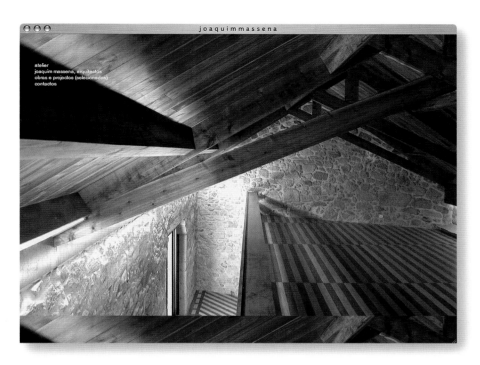

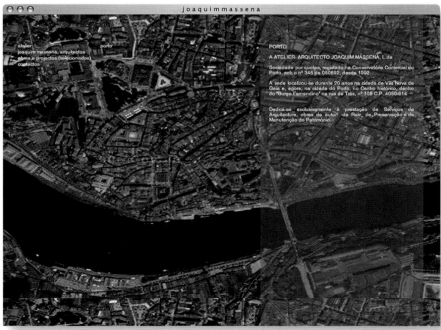

www.joaquimmassena.com
D: paula granja C: paula granja P: paula granja
A: pcw M: paulagranja@pcw.pt

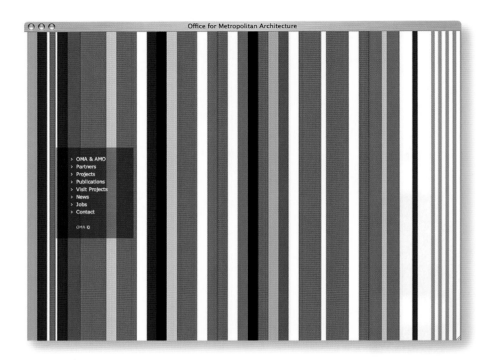

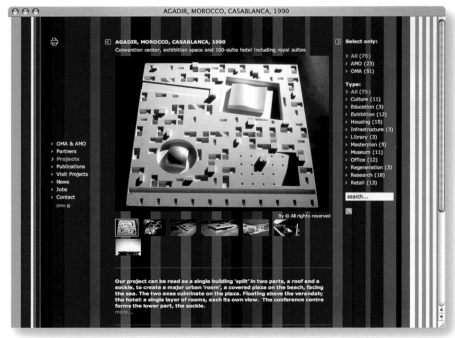

www.oma.eu

D: office for metropolitan architecture
A: office for metropolitan architecture **M:** office@oma.nl

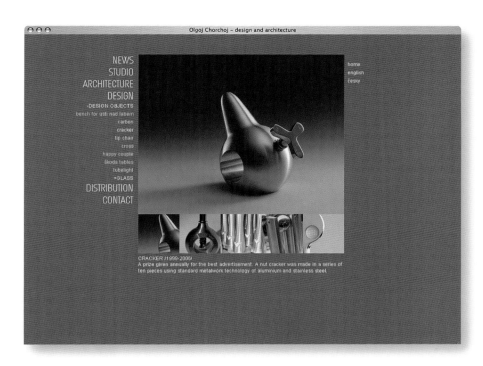

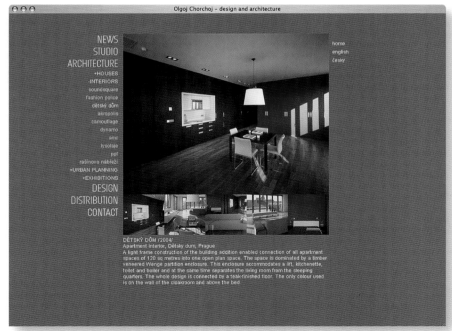

www.olgojchorchoj.cz

D: pavol mikulas C: pavol mikulas

M: mail@pavol-mikulas.com

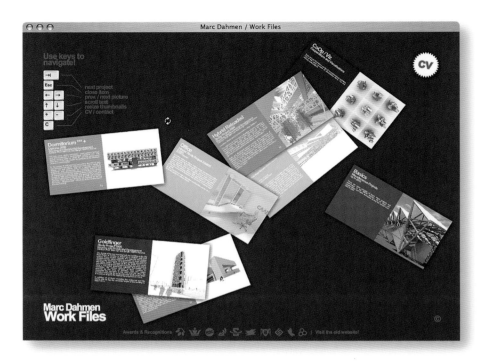

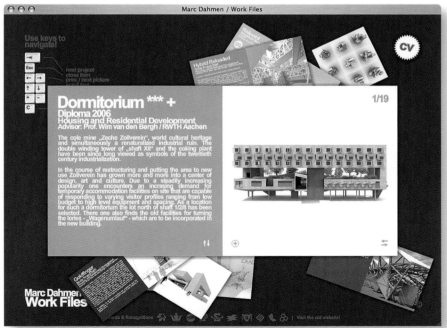

www.marcdahmen.de

D: marc anton dahmen **C:** marc anton dahmen **P:** marc anton dahmen
M: mail@marcdahmen.de

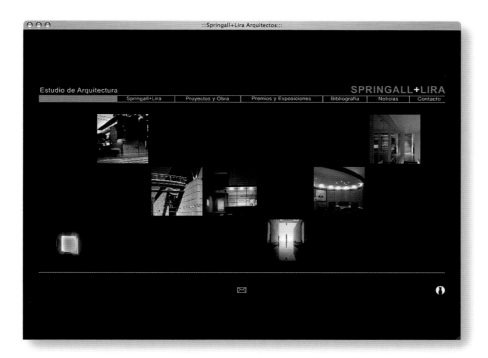

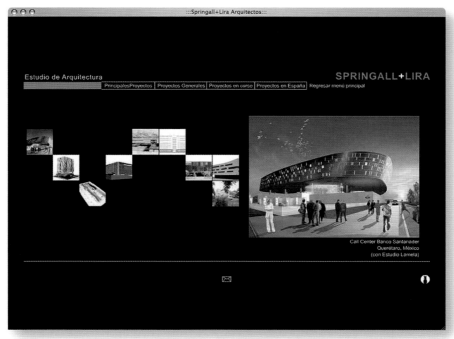

Call Center Banco Santanader
Querétaro, México
(con Estudio Lamela)

www.springall-lira.com
D: arturo viñas robles C: arturo viñas P: francisco martínez cajiga
A: p6 M: avr@pseis.com.mx

wir.ag

WIR GESAMTLISTE PRESSE IMPRESSUM

JULI F. AUS KARLSRUHE
MEHR STREET ART | ZURÜCK ZUR ÜBERSICHT

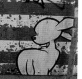

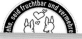

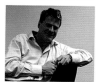

Nach dem Fernseh-Trubel der letzten zwei Tage sind wir den heutigen Tag eher ruhig angegangen. Heute um 18:45 Uhr kam der Fernsehbeitrag zur wir.ag, den wir trotz schlimmster Befürchtungen eigentlich ganz gelungen finden. Dass von unserer gestrigen Aktion mit einer Karlsruher Werbeagentur nur das "BING" übrig blieb, ist leider etwas schade.
Heute morgen um 9 Uhr standen wir bei Juli auf der Matte. Bei ihr in der WG tranken wir ganz gemütlich und ruhig Kaffee. Still und leise war und ist auch die heutige Aktion.

Das Anliegen:

Juli will mehr Street Art sehen. Zur Street Art gehören Grafitis, Stencils, Stick-Ups, Sticker und Sprühschablonen-Kunst. Tagging (d.h. seinen Namenschriftzug überall hin zu schreiben) gehört rein theoretisch auch dazu, hat aber eigentlich mehr die Funktion der "Reviersmarkierung" als die des künstlerischen Ausdrucks. Street Art-Kunstwerke sind meistens Unikate, in deren Produktion sehr viel Liebe und Zeit gesteckt wurde, und die nach der Vollendung ihrem Schicksal im Großstadtdschungel ausgesetzt werden und der Verwitterung preisgegeben werden. Woher kommen diese anonymen Kunstwerke? Warum macht sich jemand soviel Mühe? Juli weiß auch keine Antwort, jedoch sammelt und fotografiert sie seit ca. 2 Jahren mit viel Interesse jedes neue Kunstwerk, das sie findet. Von einem auf den anderen Tag sind sie da, wie von Zauberhand hingeklebt, manche sind politisch motiviert oder sozial kritisch, viele sind Fabelwesen, Tiere, Strichmännchen oder skurrile Objekte wie Pilze und Totenköpfe, die die Menschen, die sie entdecken zum Lächeln anregen oder zumindest zum Wundern bringen. Street Art schafft sich selbst Raum in Städten, wo jeder Zentimeter irgendeinen Besitzer hat. Eine reinere und selbstloser Form der Kunst gibt es nicht. Street Artists wie z.B. Banksy aus London werden heute schon von der Kunstszene anerkannt. Wer nur den Vandalismus und die Eigentumszerstörung sieht, sieht zu wenig.

Unsere Gedanken & Überlegungen:

wir.ag

WIR GESAMTLISTE PRESSE IMPRESSUM

WOCHE 1 | WOCHE 2 | WOCHE 3 | WOCHE 4 | WOCHE 5 | WOCHE 6 | WOCHE 7 |**WOCHE 8**
2. OKTOBER BIS 6. OKTOBER 2006

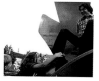

Weltverbesserer #36 >> Ergebnis anschauen
2. Oktober 2006

Ich möchte die Säkularisierung und die Etablierung von international verbindlichen Moralkriterien voranbringen. Das heißt, Vorstellungen aus verschiedenen Religionen, die zum Gefühl der Macht dieser Gruppen führen können, von deren Sockel zu stoßen, um statt dessen international verbindliche Moralvorstellungen zu etablieren und durch eine Exekutive durchzusetzen.

Weltverbesserer #37 >> Ergebnis anschauen
3. Oktober 2006, Tag der Deutschen Einheit

Ich will mehr Kunst im öffentlichen Raum sehen. Öffentliche Kunst wird leider „zu autoritär und zu kapitalistisch" behandelt. Der Bürger muss das anschauen, was er nicht versteht und nicht will. Mein Thema setzt den verkrusteten Strukturen „sozial-toter" öffentlicher Kunst „sozial-sinnliche" Realität entgegen.

www.wir.ag
D: evamaria judkins C: evamaria judkins P: evamaria judkins
A: www.thespecialmachine.com M: info@thespecialmachine.com

Paperheart
Jessica Williams

works

info

blog

Paperheart
Jessica Williams

works

I'm too sad
Five minutes
Drawings 1 2 3
Notes to self
Making connections
Little messages
Trust exercises 1 2 3
A View
Light hunting
Sketchbook 1 2
Some books I've made
Goodbye teenage years
Growing up is hard
Some self-portraits
Polaroids
Waiting

info

blog

I'm Too Sad To Tell You (after Bas Jan Ader)
March 2007

"I'm Too Sad To Tell You (after Bas Jan Ader)" was originally conceived as a project to create an archive of self-portraits taken while crying. The images were to be displayed online on a website and then later made into a book. An open call was posted on the photo sharing community Flickr.com asking people to submit their crying self-portraits over the period of one month.

The website went online containing over 100 self-portraits, a third of which were found on Flickr searching through "tags" people attached to their images. A majority of the people who independently submitted images had Flickr accounts as well. Thus, the project also deals with the phenomenon of Flickr and other like-minded communities using photographs as a form of communication. The "I'm Too Sad" website then becomes an attempt to give the images back some of their integrity as images by placing them in a clean non-communication based gallery format.

The project is still growing! It is not too late to submit an image, the call is still open. The book form of the project will tentatively be published in the fall and the website will be updated monthly with a final installment on September 1, 2007. For more information, see the site.

http://www.paperheart.org/imtoosad

www.paperheart.org
D: jessica williams C: jessica williams
M: dearjessica@gmail.com

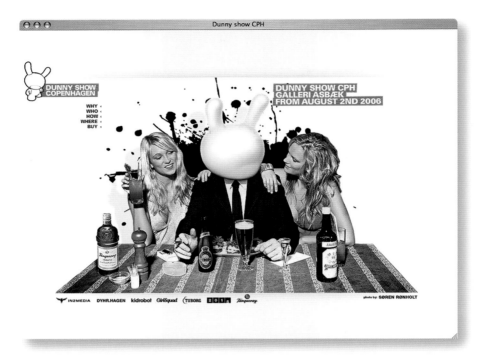

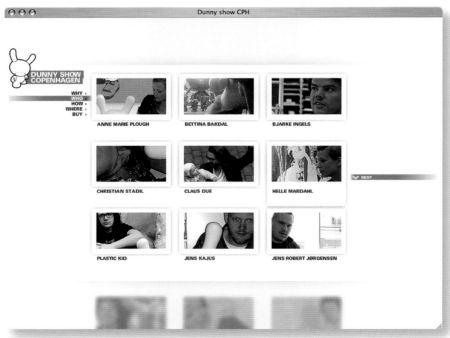

dunnyshowcph.dk
D: pelle martin, plastickid C: jake jensen, kim lynge, felix nielsen P: soren kjaer
A: in2media M: sk@lightbox.dk

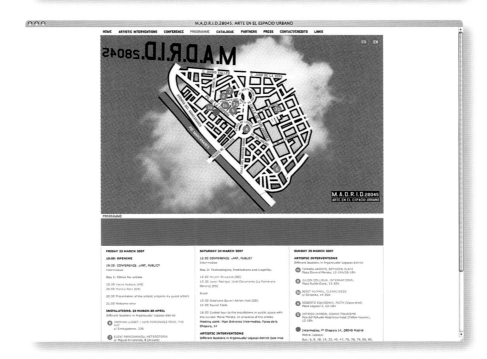

www.madrid45.net

D: flavia ruotolo **C:** lung- ruen jung **P:** área de las artes-ayuntamiento de madrid
A: flavia ruotolo **M:** flavia.ruotolo@fastwebnet.it

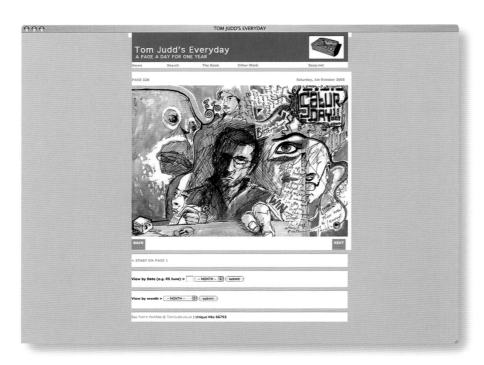

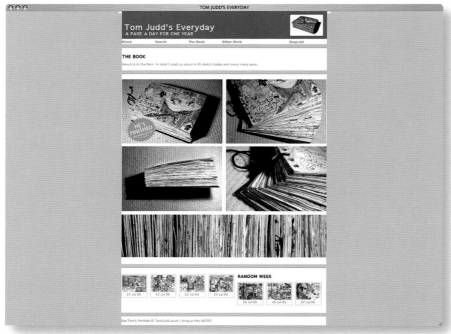

www.tomjuddeveryday.com

D: tom judd **C:** tom judd **P:** tom judd

A: tom judd / freelance illustration and design **M:** tom@5oup.com

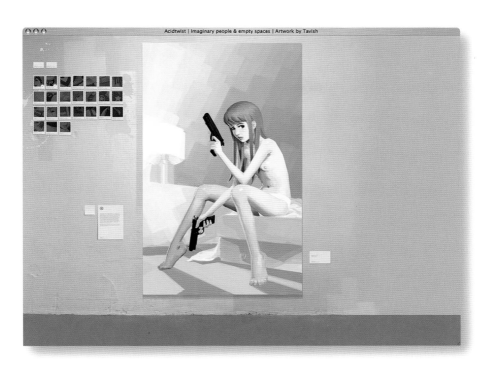

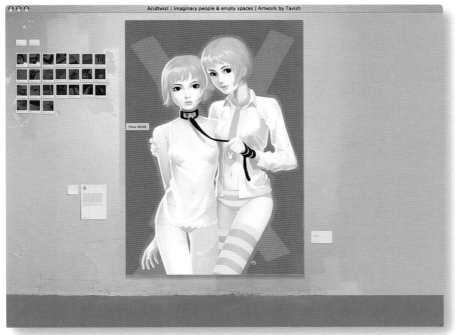

www.acidtwist.com

D: tavish **C:** tavish

A: notice bureau **M:** tavish@noticebureau.com

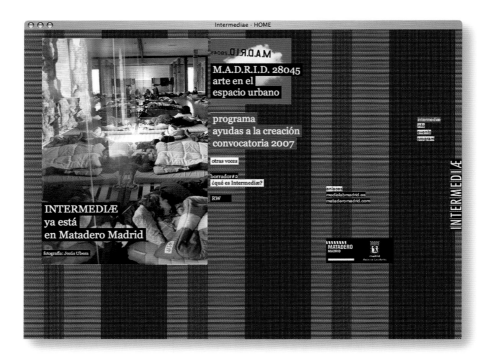

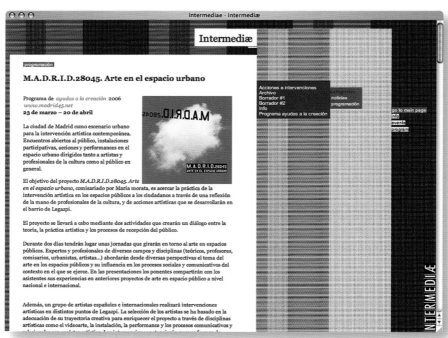

www.intermediae.es

D: gabriel martínez, cristina hernanz C: cristina hernanz, freekeylabs P: intermediae
A: lacucharanoexiste, lsdspace, freekeylabs M: chh@ya.com, gabriel@lsdspace.com

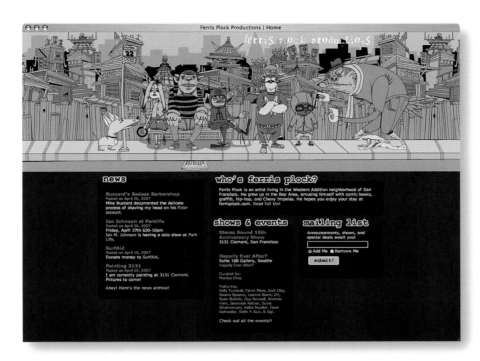

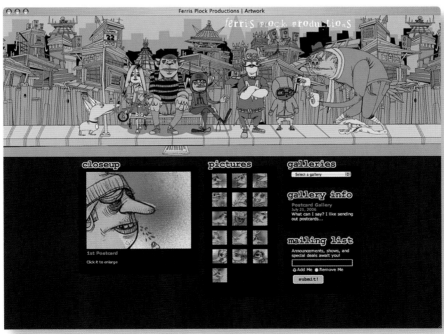

www.ferrisplock.com
D: arlo jamrog, ferris plock **C:** mike buzzard **P:** arlo jamrog
A: kni, cuban council **M:** ferris plock

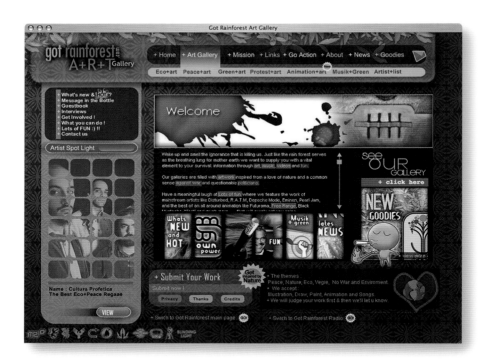

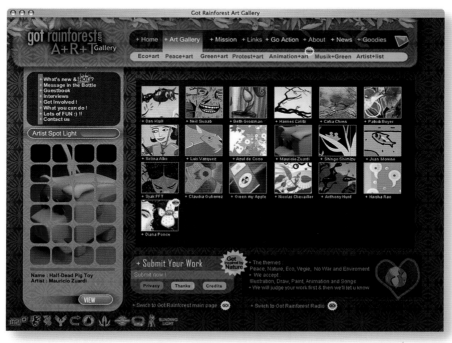

www.gotrainforestart.com

D: marcelo lozada C: marcelo lozada P: marcelo lozada

A: pixeloso M: info@pixeloso.com

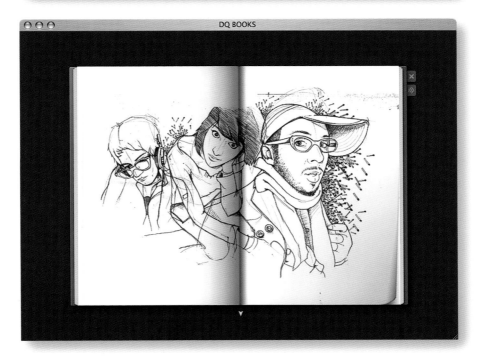

www.dqbooks.com

D: pierrick calvez **C:** pierrick calvez **P:** pierrick calvez

A: 1h05 **M:** dqbooks@1h05.com

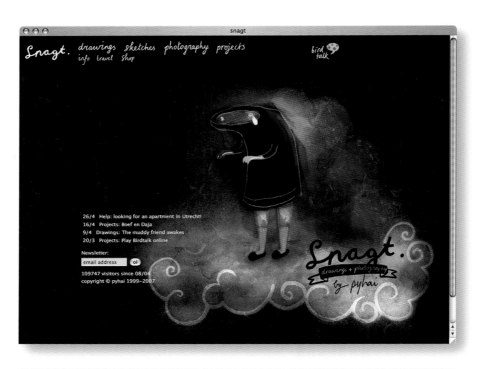

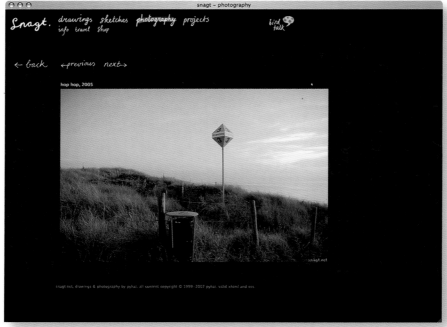

snagt.net

D: pyhai C: pyhai P: pyhai

A: snagt.net M: pyhai@snagt.net

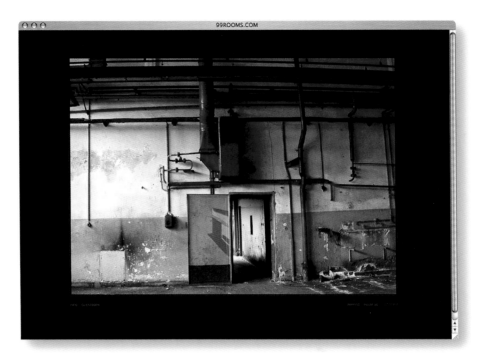

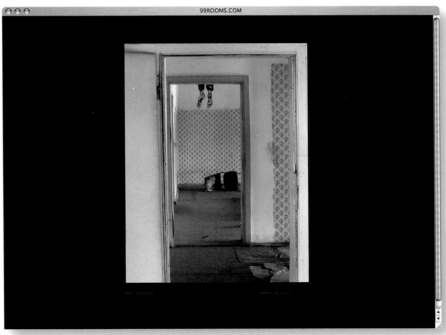

www.99rooms.com

D: kim köster, johannes bünemann **C:** stephan schulz **P:** richard schumann

A: rostlaub gbr **M:** wir@rostlaub.com

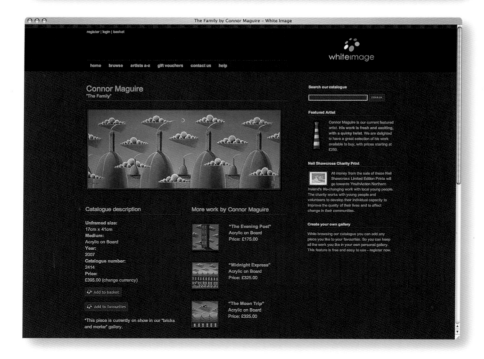

whiteimage.com

D: bill morrison C: bill morrison P: bill morrison

A: white image M: info@whiteimage.com

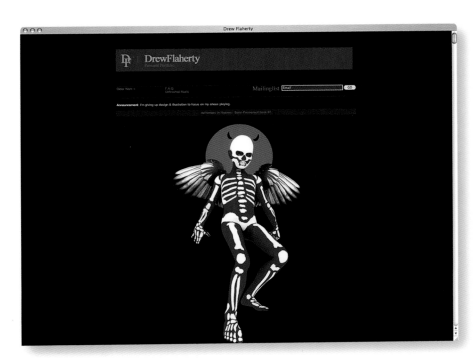

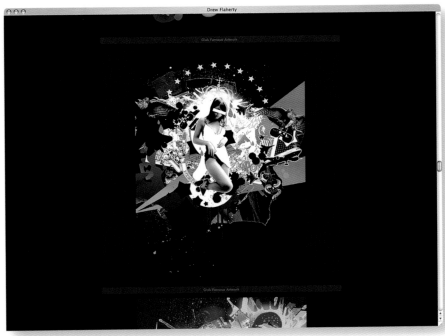

www.drewflaherty.com
D: drew flaherty
M: drew@drewflaherty.com

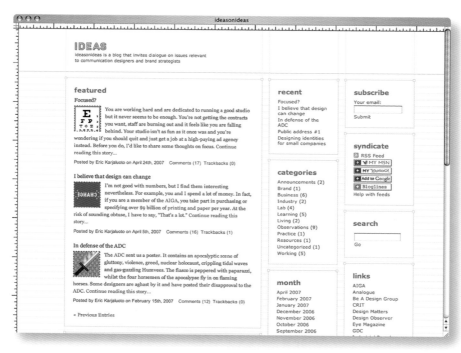

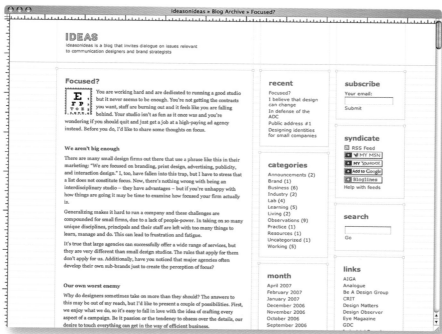

www.ideasonideas.com

D: eric karjaluoto **C:** eric shelkie

A: smashlab **M:** hello@smashlab.com

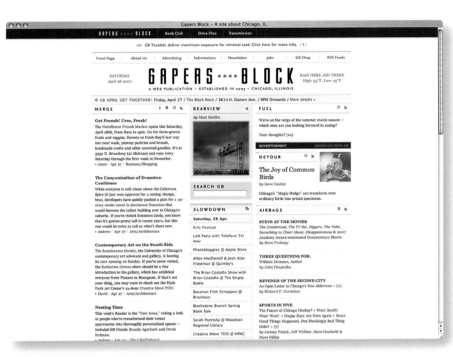

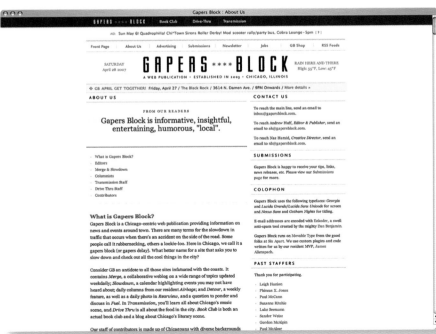

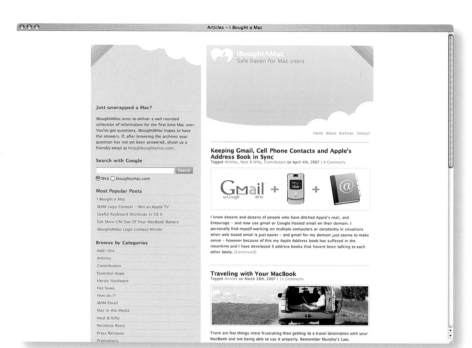

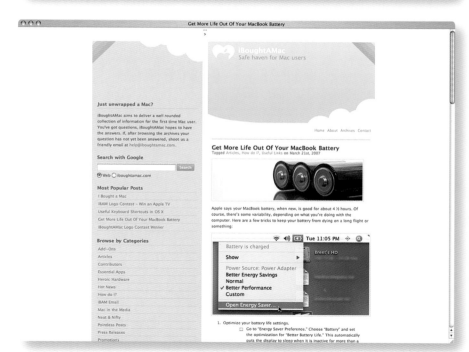

iboughtamac.com

D: derek punsalan P: brent spore
A: synergy M: hello@iboughtamac.com

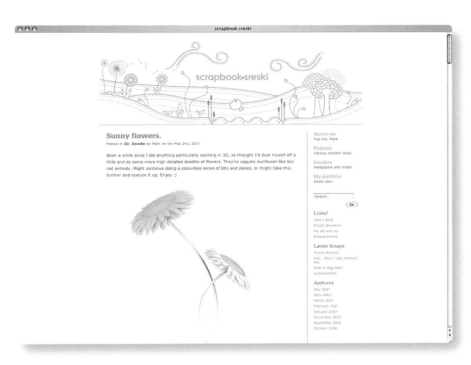

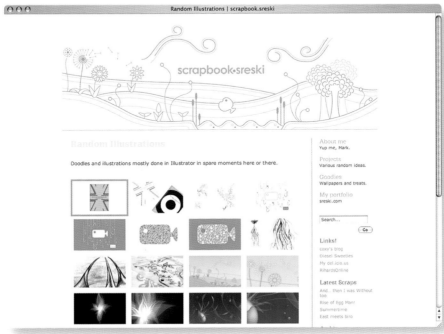

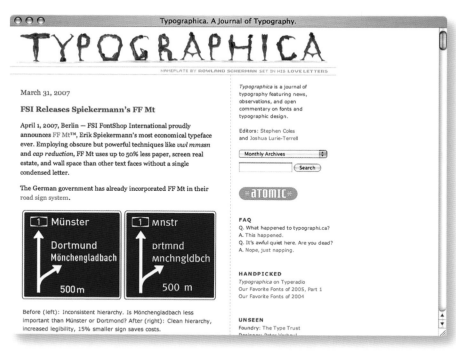

TYPOGRAPHICA

NAMEPLATE BY ROWLAND SCHERMAN SET IN HIS LOVE LETTERS

March 31, 2007

FSI Releases Spiekermann's FF Mt

April 1, 2007, Berlin — FSI FontShop International proudly announces FF Mt™, Erik Spiekermann's most economical typeface ever. Employing obscure but powerful techniques like *vwl mmssn* and *cap reduction*, FF Mt uses up to 50% less paper, screen real estate, and wall space than other text faces without a single condensed letter.

The German government has already incorporated FF Mt in their road sign system.

Before (left): Inconsistent hierarchy. Is Mönchengladbach less important than Münster or Dortmond? After (right): Clean hierarchy, increased legibility, 15% smaller sign saves costs.

Typographica is a journal of typography featuring news, observations, and open commentary on fonts and typographic design.

Editors: Stephen Coles and Joshua Lurie-Terrell

Monthly Archives

Search

ATOMIC

FAQ
Q. What happened to typographi.ca?
A. This happened.
Q. It's awful quiet here. Are you dead?
A. Nope, just napping.

HANDPICKED
Typographica on Typeradio
Our Favorite Fonts of 2005, Part 1
Our Favorite Fonts of 2004

UNSEEN
Foundry: The Type Trust

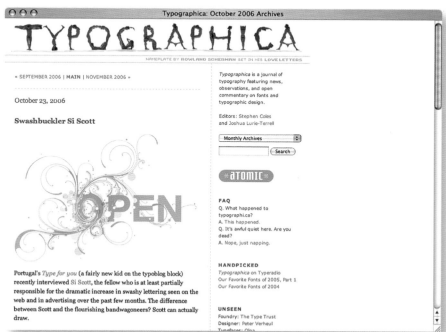

TYPOGRAPHICA

NAMEPLATE BY ROWLAND SCHERMAN SET IN HIS LOVE LETTERS

« SEPTEMBER 2006 | MAIN | NOVEMBER 2006 »

October 23, 2006

Swashbuckler Si Scott

Portugal's *Type for you* (a fairly new kid on the typoblog block) recently interviewed Si Scott, the fellow who is at least partially responsible for the dramatic increase in swashy lettering seen on the web and in advertising over the past few months. The difference between Scott and the flourishing bandwagoneers? Scott can actually draw.

Typographica is a journal of typography featuring news, observations, and open commentary on fonts and typographic design.

Editors: Stephen Coles and Joshua Lurie-Terrell

Monthly Archives

Search

ATOMIC

FAQ
Q. What happened to typographi.ca?
A. This happened.
Q. It's awful quiet here. Are you dead?
A. Nope, just napping.

HANDPICKED
Typographica on Typeradio
Our Favorite Fonts of 2005, Part 1
Our Favorite Fonts of 2004

UNSEEN
Foundry: The Type Trust
Designer: Peter Verheul
Typeface: Olga

typographica.org
D: graham hicks **C:** graham hicks **P:** stephen coles
M: grahamhicks.com

for this moment / photoblog / c h r o m a s i a

<<< gallery index // 71 comments // archives + galleries + thumbs // about + news // tutorials // white + black // purchase this print ••• c h r o m a s i a . c o m

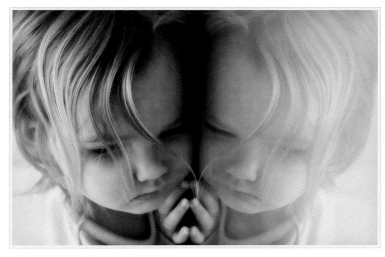

under the north pier / photoblog / c h r o m a s i a

<<< gallery index // 101 comments // archives + galleries + thumbs // about + news // tutorials // white + black // purchase this print ••• c h r o m a s i a . c o m

www.chromasia.com/iblog/
D: david j. nightingale
M: djn1@chromasia.com

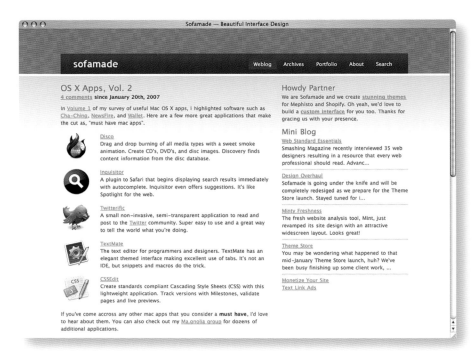

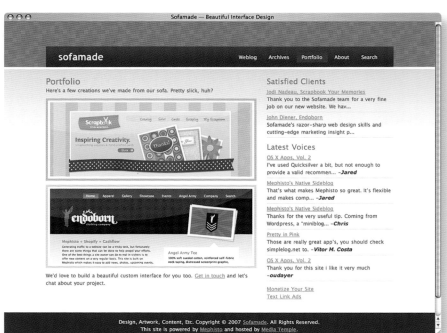

sofamade.com

D: jared burns

A: sofamade **M:** hello@sofamade.com

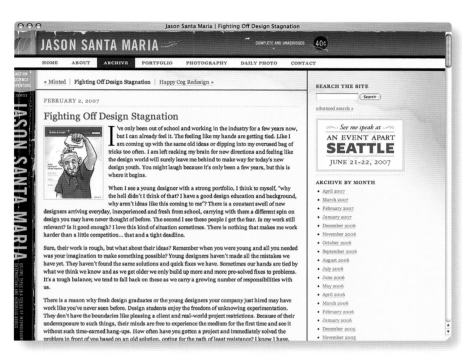

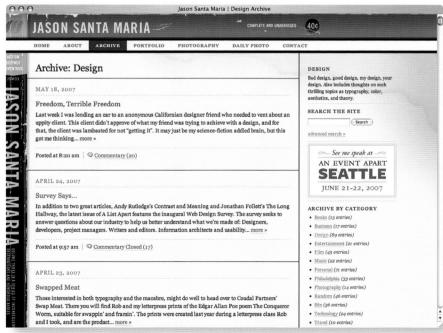

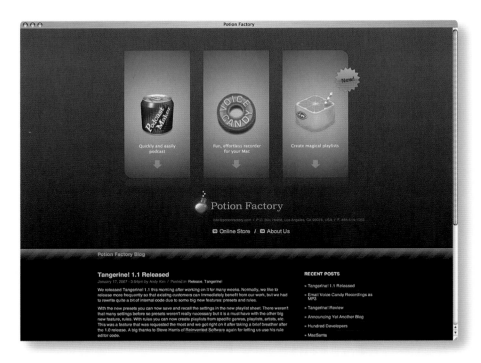

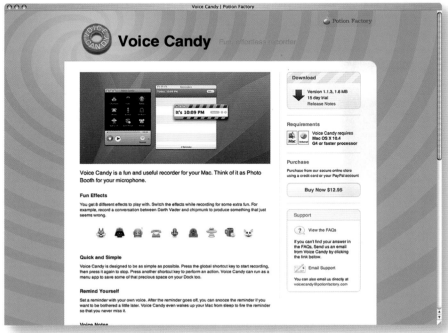

www.potionfactory.com

D: andy kim **C:** andy kim
A: potion factory llc **M:** info@potionfactory.com

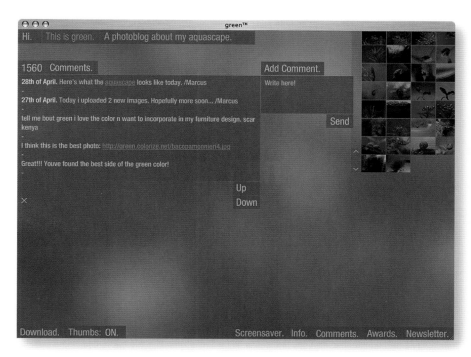

www.green.colorize.net
D: marcus wallinder C: marcus wallinder P: marcus wallinder
A: meanwhileinnowhere.se M: marcus@colorize.net

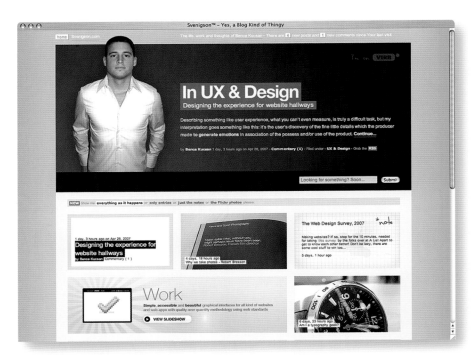

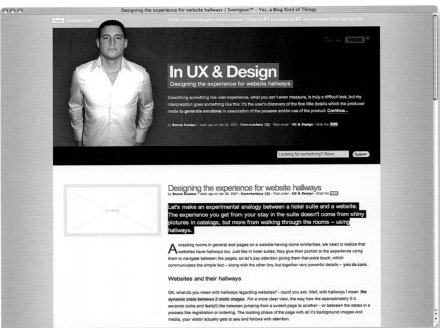

www.svenigson.com

D: bence kucsan C: bence kucsan P: bence kucsan
A: svenigson.com M: bence.kucsan@svenigson.com

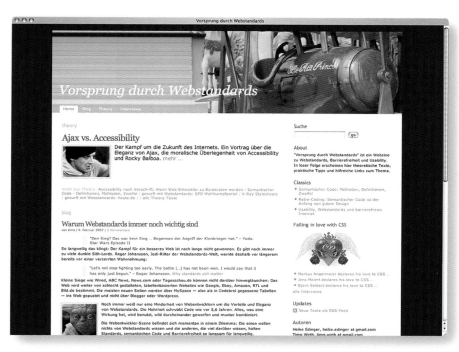

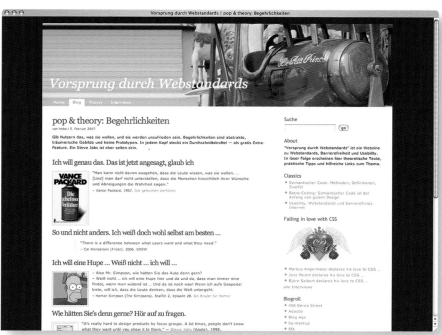

www.vorsprungdurchwebstandards.de
D: heike edinger, timo wirth
A: javajim **M:** mail@javajim.de

interactive | matafuka

matafuka | interactive
about |
contact |
[new] works |

interactive | matafuka

matafuka | interactive
about | --- | ...me gusta firmar mis trabajos como matafuka. bienvenido a mi portfolio digital.
contact |
[new] works | --- +++ | ron_brugal | grupo_orio | frank_en_el_intento |
concepto | web_corporativa_y_de_patrocinios_de_ron_brugal
diseño | brainstant_soup
desarrollo | matafuka
| ver

www.matafuka.com
D: josé m moreno **C:** josé m moreno
A: matafuka | interactive **M:** matafuka@matafuka.com

Pierre Vanni 's Portfolio

Tiré d'un principe d'anamorphose, l'objet polygonal de papier contient dans ses formes hétérogènes, celles du A, du L, du O du N et du E.

"ALONE" donc, car c'est seule que cette figure géométrique dessine les figures typographiques qui la définissent.

daté du 10/05/06

Pierre Vanni 's Portfolio

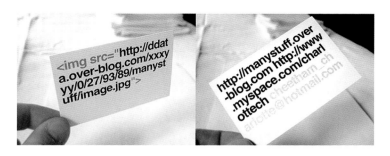

Cartes de visites pour MANYSTUFF (*http://manystuff.over-blog.com*)
Conception : Charlotte Cheetham (manystuff)
Direction artistique et réalisation: Pierre Vanni

Mars 2007

www.pierrevanni.com

D: pierre vanni **C:** pierre vanni **P:** pierre vanni
A: pierre vanni studio **M:** pvanni@hotmail.fr

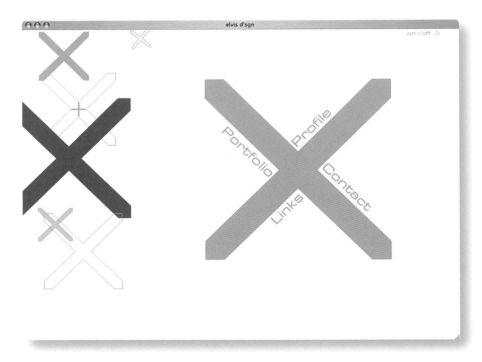

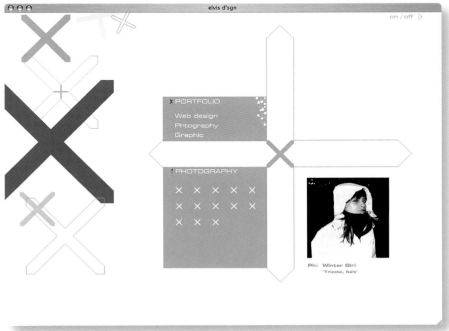

www.elvisdesign.it
D: alvise nardi **C:** alvise nardi **P:** alvise nardi
A: elvis d'sgn **M:** contact@elvisdesign.it

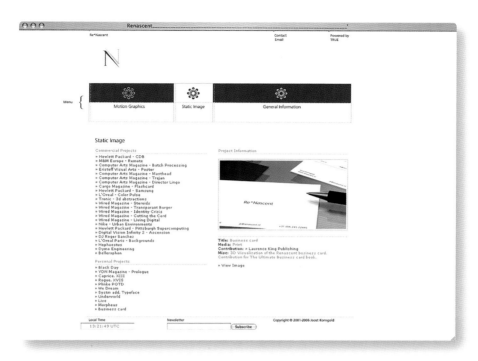

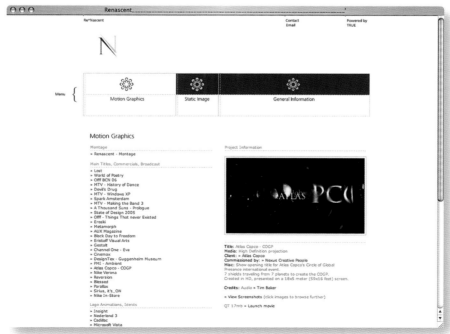

renascent.nl
D: joost korngold
A: renascent **M:** jk@renascent.nl

AEN DIRECT — Art Director

freelance art director aendirect.com aen@aendirect.com

AEN DIRECT

online media
print design
artfolio

home
about
links

latest writings latest works latest photos

Forbes List of World's Cleanest Cities, Where's Singapore?

more (12 replies)

Based on figures derived from studies by the Mercer Human Resources Consulting that cull from 300 cities, Forbes.com describes the top 25 cleanest cities in the world. Of the 13 countries listed, European and U.S. cities top the charts, followed by Japan, the only Asian country in the list. Singapore is not in the list. We try so hard to be clean but still we aren't the cleanest, considering the size of our tiny island, we have such a small room to maintain compared to the larger cities. I guess the studies don't just look at clean air and environments. Singapore probably lost marks due to our lack of clean people.

Random Stupidity from Singapore

more (8 replies)

I have been taking photos of random interesting scenes when I'm out, particularly stupid ones. Haven't really got the time to transfer them to my computer but nonetheless I did and here are some nice ones, in no particular order.

New Web Design Gallery from Japan

more (2 replies)

There are already lots of web design galleries online for CSS/Standards-based sites, flash sites, ugly sites but what I have come across today was quite different. I just like it. Maybe it's the way the previews are displayed, nice and big thumbnails and minimum text. Most importantly, the designs showcase are more worth checking out then most of the galleries out there. They also have separate sections for local and international designs. So if you are a sucker for Japanese web design, you should check this one out.

Wabi Sabi — Zen Principles of Aesthetics Chapter 1: FUKINSEI

more

This is a continuation of my original post on Wabi Sabi — Zen Principles of Aesthetics. If you have not read that article, I strongly recommend you read it before this one.

Beverly.sg (12 replies) AEN DIRECT Office (4 replies)

Claustrophobia (2 replies) Vivi's Goth Makeup (4 replies)

Bishamonten (4 replies) Mottie

artfolio — AEN DIRECT — Art Director

freelance art director aendirect.com aen@aendirect.com

AEN DIRECT

online media
print design
artfolio

home
about
links

archives latest works latest photos

Claustrophobia

more (2 replies)

Beverly.sg (12 replies) AEN DIRECT Office (4 replies)

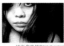

Claustrophobia (2 replies) Vivi's Goth Makeup (4 replies)

Bishamonten (4 replies) Mottie

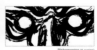
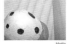

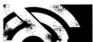

SevenStoryDrop Logo (1 reply) Me when I was a kid (3 replies)

aendirect.com
D: aen tan **C:** aen tan **P:** aen tan
A: aen direct **M:** aen@aendirect.com

www.antoninferla.com
D: antonin ferla **C:** julien ferla **P:** antonin ferla
A: antonin ferla **M:** info@antoninferla.com

2breed, voor een totaalpakket van logo tot huisstijl, website en overig grafisch ontwerp.

Opdrachtgever
goed is goed
theatrale producties (Tilburg)

Producten
logo
flyer
affiche

Grafisch ontwerp
2breed

press
Gianotten (Tilburg)

Print
DDA (Tilburg)

opdrachten product vrij werk

home wie wat waar hoe

2breed, voor een totaalpakket van logo tot huisstijl, website en overig grafisch ontwerp.

Opdrachtgever
goed is goed
theatrale producties (Tilburg)

Producten
logo
flyer
affiche

Grafisch ontwerp
2breed

press
Gianotten (Tilburg)

Print
DDA (Tilburg)

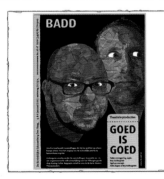

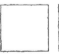

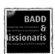
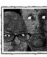
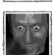

opdrachten product vrij werk

home wie wat waar hoe

www.2breed.nl
D: trees okhuijsen-schepman **C:** 2breed
M: info@2breed.nl

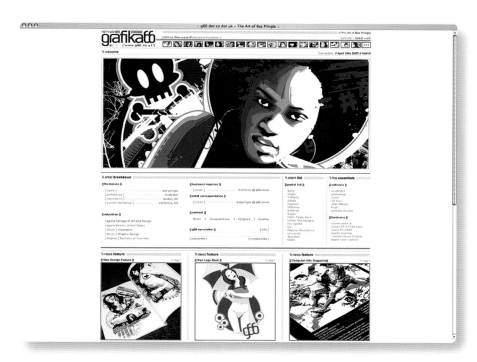

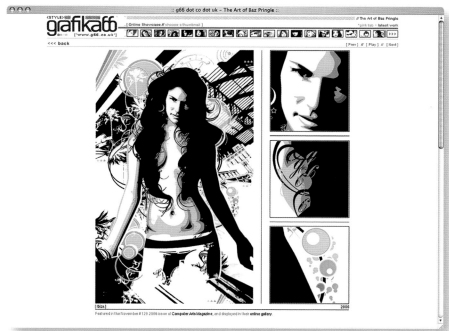

www.g66.co.uk
D: baz pringle **C:** baz pringle
A: grafika66 **M:** bazpringle@g66.co.uk

ricardo landim . art direction + design

INFO

RICARDO LANDIM
ART DIRECTOR / DESIGNER
WORKING @ GRIGO

Born in Brasília, Brazil
Living in São Paulo, Brazil

AWARDS *having effect*

oliver pencil @ the one show, cannes cyber lion finalist,
london int. advertising awards finalist, clio awards
finalist, premio about (gold), premio apple de criatividade
finalist, sXIV (online flash film festival) finalist, bifibia
festival finalist

CONTACT

ricardo@ricardolandim.com

OTHER LINKS

> www.grigo.ru
> www.ricardolandim.com/photo

PORTFOLIO

CLOSE MENU

19:24

ricardo landim . art direction + design

MENU

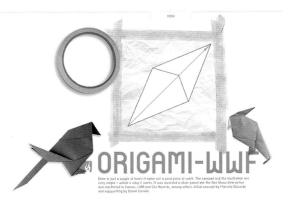

ORIGAMI-WWF

Done in just a couple of hours it came out a good piece of work. The concept and the illustration are
very simple — which is using it works. It was awarded a oliver pencil ate the One Show interactive
and shortlisted in Cannes, LIAA and Clio Awards, among others. Initial concept by Marcelo Eduardo
and copywriting by Daniel Cariello.

CLIENT ORIGAMI TYPE AGENCIA CLICK / WWF TAGS INTERACTIVE AD DATE MAY 2005

ricardolandim.com
D: ricardo landim C: ricardo landim
M: ricardo@ricardolandim.com

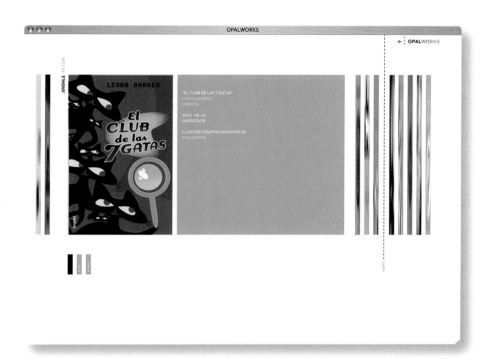

OPALWORKS

← OPALWORKS

JUVENILE FICTION

LEONA ANDREA

"EL CLUB DE LAS 7 GATAS"
LEONA ANDREA
UMERIEL

220 X 160 cm
HARDCOVER

ILLUSTRATION/PHOTOGRAPHY BY
OPALWORKS

HOME

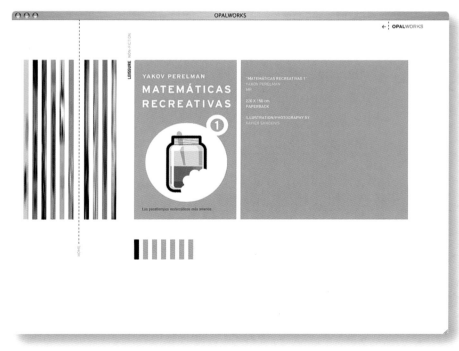

OPALWORKS

← OPALWORKS

LEISURE NON-FICTION

YAKOV PERELMAN

MATEMÁTICAS
RECREATIVAS

"MATEMÁTICAS RECREATIVAS 1"
YAKOV PERELMAN
MR

220 X 150 cm
PAPERBACK

ILLUSTRATION/PHOTOGRAPHY BY
XAVIER SANGENIS

Los pasatiempos matemáticos más amenos

HOME

www.opalworks.net
D: olivier grau, nuria reolid C: alberto botella P: vis-tek.com
A: vis-tek.com M: www.vis-tek.com

hicksdesign is a small creative studio based in Oxfordshire, UK. We create web sites and user interfaces built with web standards, as well as designing for print (we like branding in particular).

our clients

The Forgiveness Project // Westciv // The Forster Company // Mozilla Foundation // Attap // Open Doors UK // Agape UK // Harcourt Educational Publishing

recent work

contact

t: +44 (0)7917 391 536

Download my vCard

Work Status: I'm not currently taking on any new projects.

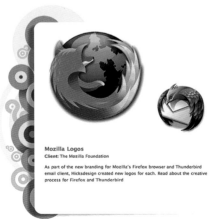

hicksdesign
print + new media

01 work
02 about
03 journal
04 extras
05 contact

Turn off styling

©2003–07 hicksdesign
RSS Feeds | Site map

hicksdesign: design for print and new media

Mozilla Logos
Client: The Mozilla Foundation

As part of the new branding for Mozilla's Firefox browser and Thunderbird email client, Hicksdesign created new logos for each. Read about the creative process for Firefox and Thunderbird

recent work

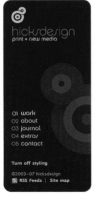

contact

t: +44 (0)7917 391 536

Download my vCard

Work with me, I'm currently available for new projects from August 2007.

hicksdesign
print + new media

01 work
02 about
03 journal
04 extras
05 contact

Turn off styling

©2003–07 hicksdesign
RSS Feeds | Site map

www.hicksdesign.co.uk
D: jon hicks
A: hicksdesign M: jon@hicksdesign.co.uk

Seth Drenner

Seth Drenner
illustration + design

paintings
prints
drawings

thursday, march 29, 2007

News

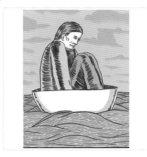

All is well, just getting over my California cold. Trying to get out to New York still
this spring to look for some work. A while back I helped Jason Holley get ready for
his solo show up in Berkeley. Thanks to Brendan Monroe for posting images so that
I could see everything up, check out this amazing work and wonderful review that
Brendan posted, fecalface
Nucleus Gallery in Alhambra recently had a show with Josh Cochran and Mark
Allen Miller. They both had some work made into these really great quality tote
bags. I bought one for Chelsea.

SETH / 11:25 PM

monday, march 12, 2007

Aaron Smith
Brendan Monroe
Calef Brown
Clayton Brothers
Esther Pearl Watson
Lee Bakofsky
Mark Todd
Martha Rich
Matt Groller
James Fish
Jeff McMillan
Jennifer Leong
Pamela Henderson
Rob Bellm
Souther Salazar
Yoko Tanaka
Youshi Li

Seth Drenner
illustration + design

paintings
prints
drawings

01 02 03

design

sethdrenner.com
D: kun che lu, seth drenner, uno C: kun che lu P: seth drenner
A: uno M: contact@uno.la

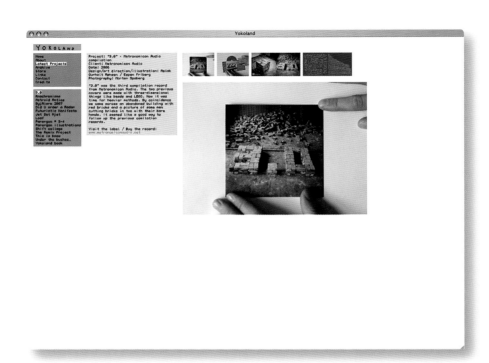

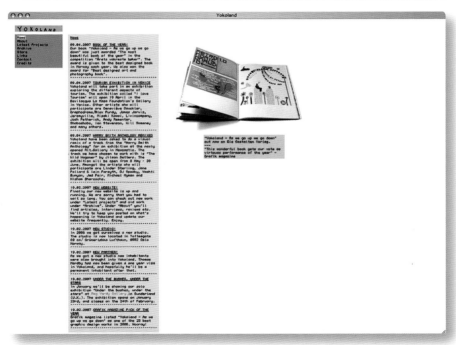

www.yokoland.com

D: yokoland C: elektrodynamisk byrå, bjørnar t. sund P: yokoland

A: yokoland M: info@yokoland.com

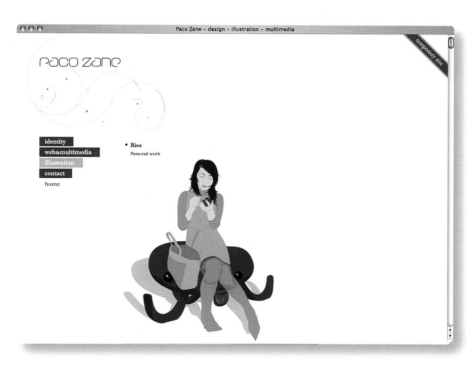

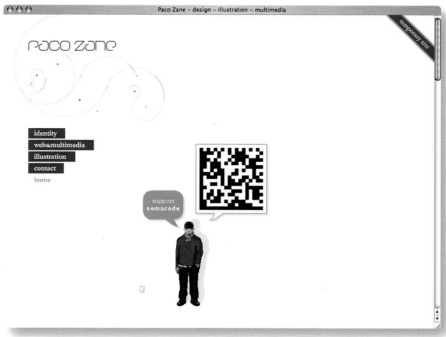

www.pacozane.it/illustration.htm

D: paco zane

M: paco.zane@gmail.com

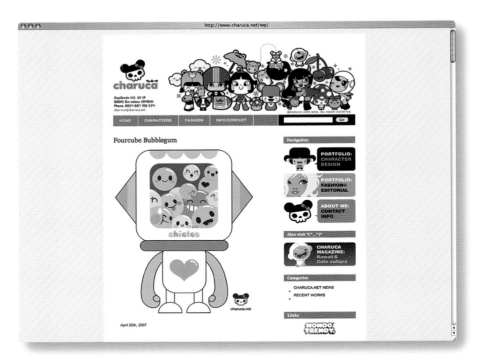

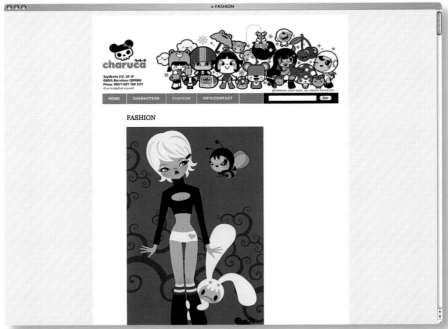

www.charuca.net
D: charuca vargas
A: the characters factory M: charuca@charuca.net

www.kant-1.com
D: kant1 **C:** bens
A: kant1graffix **M:** kant-1@kant-1.com

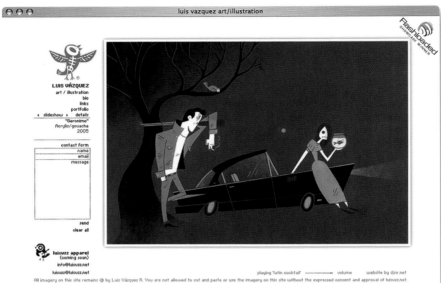

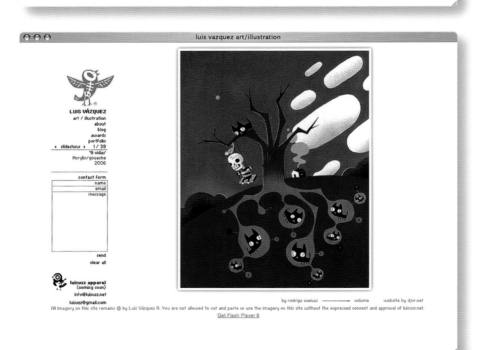

www.luisvzz.net
D: jenaro diaz **C:** jenaro diaz **P:** jenaro diaz
A: djnr.net **M:** djnr@djnr.net

acidbird.

2007/4/29
17:12

acidbird.
by johnny cheuk

info./ contact./

graphic design / illustration

04-07

DIGIT
Head
Eye
Coca Cola
untitled
Fever 01 02
Generation Cliche
Fantasy Love
Into the nature 01 02
Oblique
Own Studio
Color gradients
Jungle
Metrosexually
Redintegration
Fossick
Splitting Butterfly
Video art
Reborn
Pages online
Unbind
Heart

JUICE
Disappear
Dream 01 02
Cell
Leap
BF
Alone
Blueflame
Computer arts#112cover
Crown
Brilliance 01 02
Helvetica
Fischerspooner
Evolution 01 02
Indulge
Longing
State of affairs
Stuffy Show
Duress
Skull
Elephant

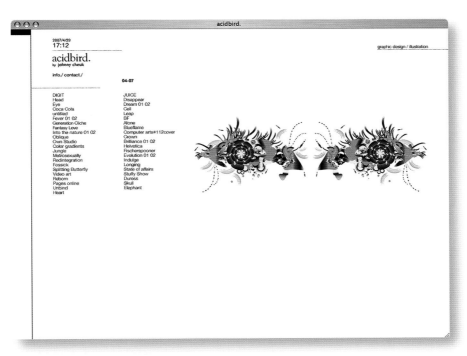

acidbird.

2007/4/29
17:13

acidbird.
by johnny cheuk

info./ contact./

graphic design / illustration

04-07

DIGIT
Head
Eye
Coca Cola
untitled
Fever 01 02
Generation Cliche
Fantasy Love
Into the nature 01 02
Oblique
Own Studio
Color gradients
Jungle
Metrosexually
Redintegration
Fossick
Splitting Butterfly
Video art
Reborn
Pages online
Unbind
Heart

JUICE
Disappear
Dream 01 02
Cell
Leap
BF
Alone
Blueflame
Computer arts#112cover
Crown
Brilliance 01 02
Helvetica
Fischerspooner
Evolution 01 02
Indulge
Longing
State of affairs
Stuffy Show
Duress
Skull
Elephant

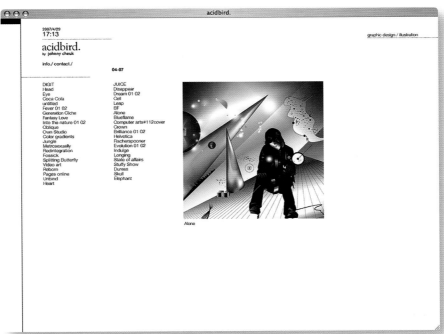

Alone

www.acidbird.com
D: johnny cheuk
M: contact@acidbird.com

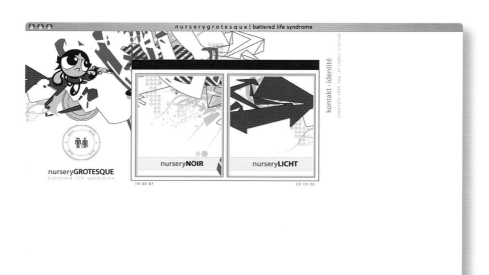

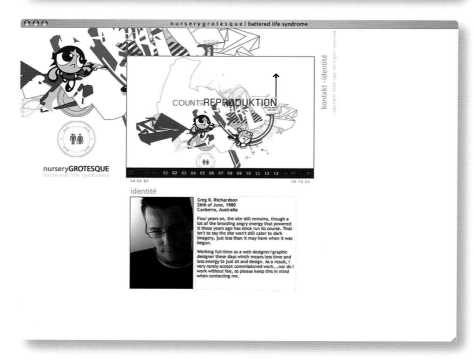

www.nurserygrotesque.com

D: greg r richardson

A: ngp **M:** ngp@nurserygrotesque.com

PROJEKT 2

PORTFOLIO
SWISSMISS
INSPIRATION
NETWORK

CURRENTLY:
- featured on AIGA Seattle
- collaborating with smart design

RECENTLY & UPCOMING:
- elected to International Academy of Digital Arts and Sciences
- judging the Webby Awards

BLOGS:
- swissmiss blog
- my flickr

SWISS DESIGNER GONE NYC | info@projekt.2com | © 2005 tina roth. all rights reserved

PROJEKT 2

PORTFOLIO
SWISSMISS
INSPIRATION
NETWORK

Enthusiasm is one of the most powerful engines of success. When you do a thing, do it with all your might. Put your whole soul into it. Stamp it with your own personality. Be active, be energetic, be enthusiastic and faithful, and you will accomplish your objective. Nothing great was ever achieved without enthusiasm.

– Ralph Waldo Emerson

SWISS DESIGNER GONE NYC | info@projekt.2com

www.projekt2.com
D: tina roth eisenberg **C:** tina roth eisenberg **P:** tina roth eisenberg
A: projekt 2 **M:** tina@projekt2.com

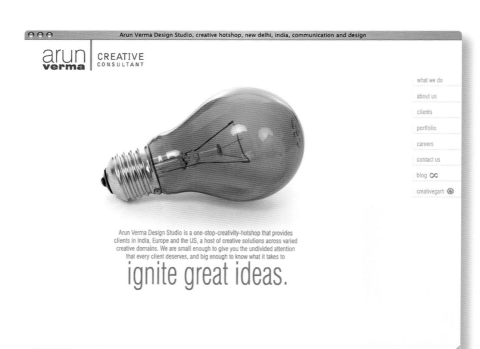

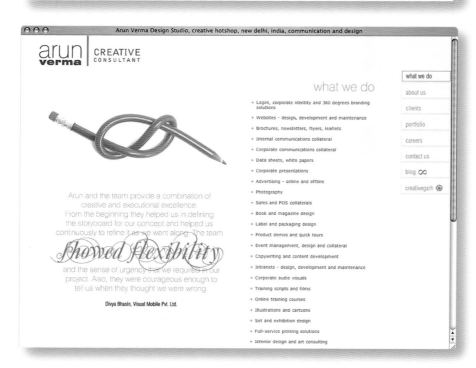

www.arunverma.com
D: arun verma, deepak saini **C:** sunil saini **P:** arun verma
A: arun verma design studio **M:** arun@arunverma.com

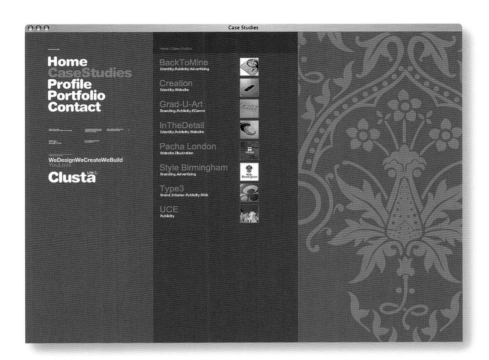

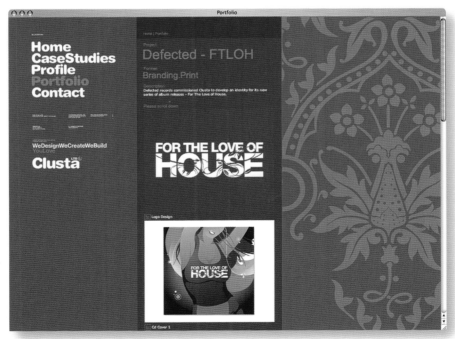

www.clusta.com
D: matthew clugston C: robert ellis, sean duffy P: clusta ltd
A: clusta ltd M: hello@clusta.com

○○○ Mono Industries : Clients

Mono Industries 28.04.07
Bespoke design for print and the internet. Cambridge, England.

Home • Clients • Services • Network • Art • FAQ • Contact Us

Welcome to the clients area of the site. This is where you'll find the
fruits of our labours. Simply select a category on the right. Go and
get a cup of coffee first though - there's lots to see. Enjoy.

Brand Development • Graphic Design • Internet Design • Internet Services

Brand Development
A Beautiful Noise
Adaptive Workshop
Alasdair Cant & Associates
Cambridge Economic Policy Associates
Gusto Arts Management & Consultancy
Parenting People

E-mail: enjoylife@monoindustries.com

Client:	**A Beautiful Noise**
Project:	**Identity creation & stationery design**
Site:	**www.abeautifulnoise.com**

Beautiful Noise Ltd is the brainchild of former Reverb Music and XL
Talent Partnership creative director Gordon Charlton, who formed the
company to release his favourite music, manage producers and
consult to anyone willing to pay him.

Gordon asked Mono Industries to design a vibrant and eye-catching
identity which was then used on various stationery items.

1. 2.

Powered by M.I. CMS © Mono Industries 2007

Brand Development • **Graphic Design** • **Internet Design** • **Internet Services** • **Site Map**

○○○ Mono Industries : internet design, corporate identity, graphic design, brand development, internet services

Mono Industries 28.04.07
Bespoke design for print and the internet. Cambridge, England.

Home • Clients • Services • Network • Art • FAQ • Contact Us

Hello
Welcome to the Mono Industries web site. Mono Industries is an internet design and
graphic design company based in Cambridge.

The aim of Mono Industries is to help my clients communicate their messages in clear,
coherent and interesting ways. I enjoy working with my clients; forming dynamic and
creative partnerships. Together we do great work that is on schedule and on budget.

The one thing I want all my work to do, be it web design, print graphics, identity
creation, photo shoots, vehicle livery or even a simple T-Shirt design, is communicate
the right message for my clients. Take a look around...if the work works for you, please
contact me.

Nick Welsh
Mono Industries, Cambridge.

E-mail: enjoylife@monoindustries.com

Powered by M.I. CMS © Mono Industries 2007

Brand Development • **Graphic Design** • **Internet Design** • **Internet Services** • **Site Map**

www.monoindustries.com
D: nick welsh **C:** patrick gordon
A: mono industries **M:** enjoylife@monoindustries.com

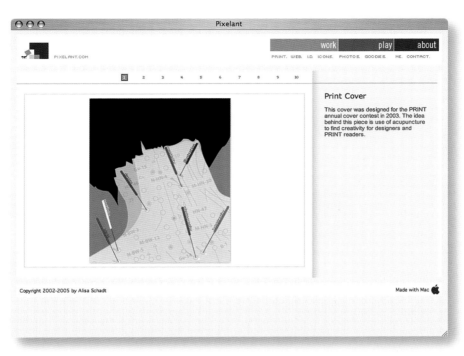

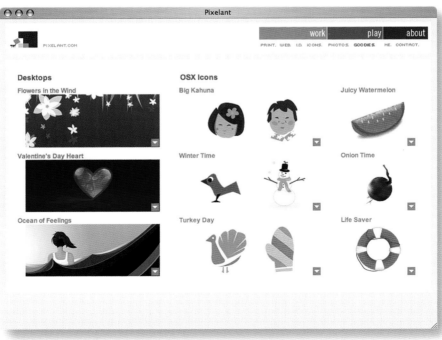

www.pixelant.com
D: alisa schadt **C:** alisa schadt **P:** alisa schadt
A: pixelant.com **M:** pixelant@gmail.com

○ ○ ○ Agent8 Design – Print – Creative Design Studio in Petersfield, Hampshire...Hampshire in the Portsmouth, Southampton, Guildford and Chichester area.

Agent8

Home Blog Profile Contact
Identity Print Interactive Motion

24hour affair
Chris Such Images
Connaught Mason
Creative Enterprise
Daltons Solicitors
EPCG
Live Flames
Mother Nature
Salomon
sawDust
Shoestring Theatre
Vanilla

Showcase/Print

Traditional print is invaluable in providing a tangible, physical representation of a company's identity. It can rapidly relay essential information about your business or service in a format that demands attention from the viewer, and is then available for future reference.

We create diverse solutions for print whether a business stationery system, corporate brochure, album cover, large format poster or product packaging.

○ ○ ○ Agent8 Design - Creative Design Studio in Petersfield, Hampshire +44 (0) 1730 231 132...raphics Animation work in the Portsmouth, Southampton, Guildford and Chichester area.

Agent8

Home Blog Profile Contact
Identity Print Interactive Motion

Photo Gallery
Disclaimer

Profile

Agent8 Design was formed in March 2003 by Nick Pye, a professional graphic designer for over five years. After graduating with a First Class Honours degree in 2002, Nick has received recognition from the design industry with membership of the British Design & Art Direction (D&AD), a first prize in the international Young Creative Network brief, and short-listing for the E4 E-Sting competition in 2004.

A process of research and exploration ensures we are motivated by new concepts and inspirational ideas. Our skills are diverse and the media used comprehensive. From print and interactive design to motion graphics and sound, the underlying principle of conceptual design drives our work. The sections of our showcase illustrate our approach to each discipline under the headings of Identity, Print, Interactive and Motion.

At Agent8 Design, client involvement with the creative process is an essential ingredient in achieving a meaningful and appropriate solution. Clear and creative thinking enables our graphic design output to communicate the essence of the client's business ethos. We enjoy a friendly relationship with clients, and consider ourselves a part of their businesses. Please get in contact for an informal discussion of your needs.

Here is a list of clients Agent8 has had the pleasure of working with:

Ann Louise Wool Shop / Bac2 / Banana PR / Bespoke Cleaning / B2c / Charlesworth Marquees / Chris Such Images / Cluett Reeve Recruitment / Compassion in World Farming / Daltons Solicitors / DataForensics / Dennys Quality Catering / Designhive Architectural Visualisation / East Hants Chamber of Commerce and Industry / The Environmental Project Consulting Group / Gabriella Shaw Ceramics / Gary Ward Communications / Global Restaurant / Hampshire Constabulary / Hermitage Housing Association / Inside Leadership / Joanna Howard / Jobpost Recruitment / Memorial Group Stonemasons / The Meon Survey Partnership / Oakley Hall / Parsons Construction / Scait Interior Design and Fit Out / Schindler Group / Shoestring Theatre Company / Solent Synergy Ltd / Spur Group / Tah Mac Entertainment / Thrive: Canada / VectorCommand Ltd / Vosper Thornycroft Group Plc

Design Community Links >

www.agent8.co.uk
D: nick pye
A: agent8 design ltd M: info@agent8.co.uk

HOME | **PROJECTS** | ABOUT | PRESS

FLAT

Flat is a multi-disciplinary design firm founded in 1996 and located in NYC. We work with a varied clientele to solve identity, interactive and editorial design challenges.

Our practice is predicated on the belief that good design facilitates the smooth flow of information and enlivens all forms of social discourse.

American Red Cross Isaac Mizrahi Tobias Fröberg ING NYC Marathon

Flat Inc. 391 Broadway 3rd fl. New York, NY 10013 T. 646 613 8833 info@flat.com

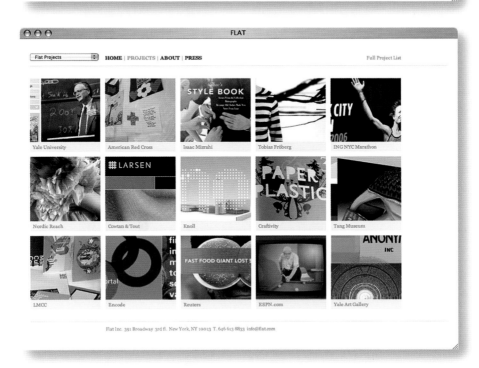

www.flat.com

D: petter ringbom, doug lloyd
A: flat inc. **M:** info@flat.com

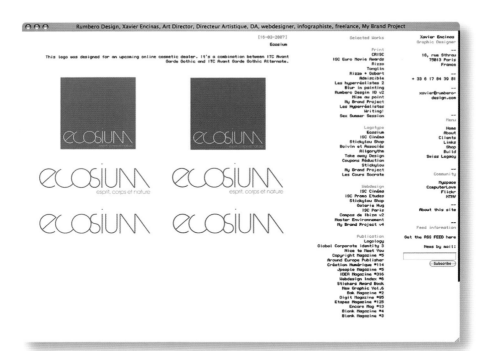

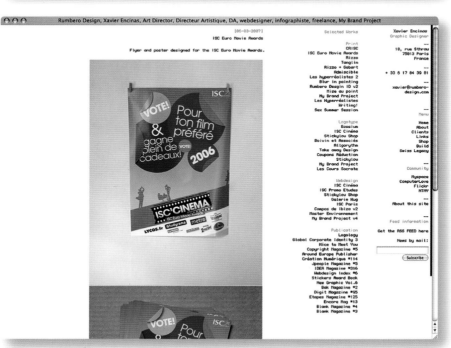

www.rumbero-design.com

D: xavier encinas C: xavier encinas

A: rumbero design M: info@rumbero-design.com

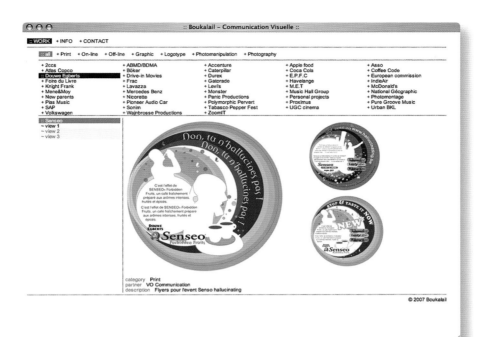

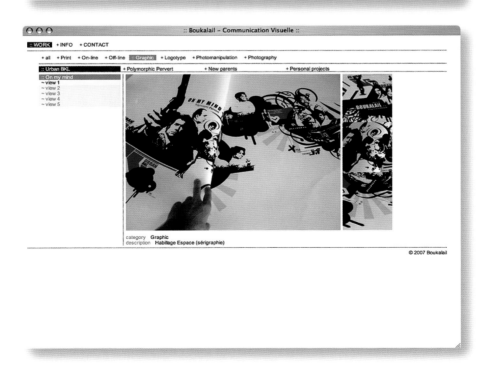

www.boukalail.com

D: cliquet laurent, cliquet.be C: marro luigi, zbang.be P: cliquet laurent
A: boukalail communication M: info@boukalail.com

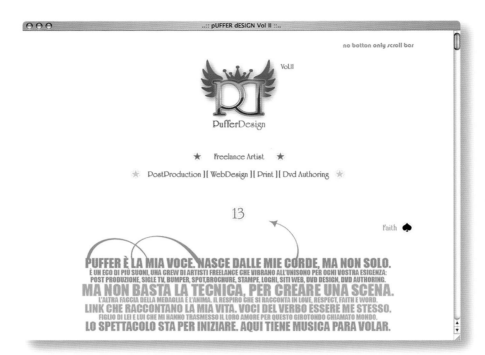

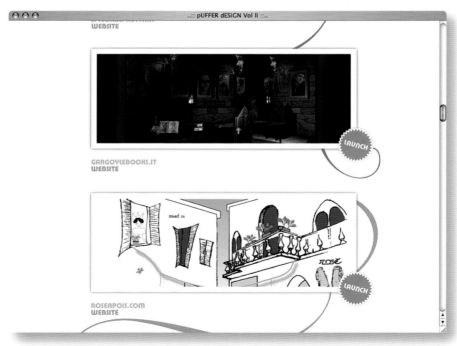

www.pufferdesign.com

D: riccardo pace

A: pufferdesign **M:** riccardo@pufferdesign.com

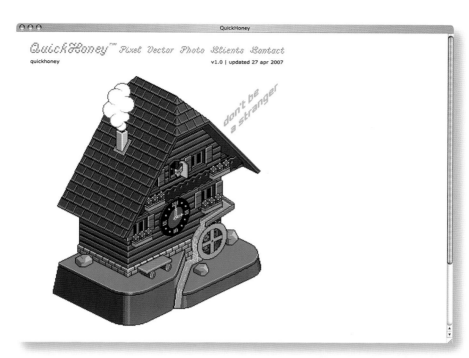

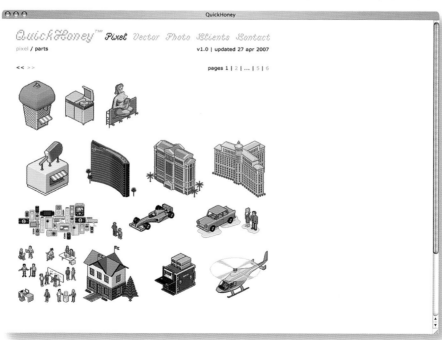

www.quickhoney.com
D: nana rausch, peter stemmler **C:** hans hübner
A: quickhoney **M:** contact@quickhoney.com

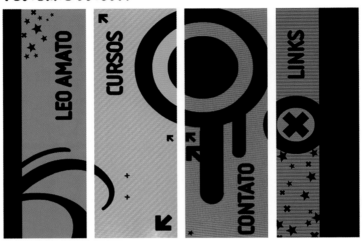

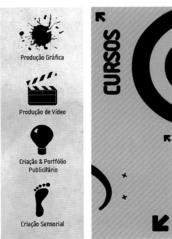

Produção Gráfica

Proporcionar ao aluno uma visão geral da atividade da produção gráfica e aproximar esta visão do cotidiano do profissional de comunicação. História da tipografia. Aplicabilidade da tipografia em peças publicitárias. Tipologia digital. Técnicas de impressão e suas aplicações no mercado de publicidade. Adequação do material gráfico. Tipos de acabamento (papel, dobras). Novas tecnologias de impressão e seu impacto no mercado de trabalho.

Download
de arquivos

Dúvidas
e Informações

www.leoamato.com
D: leo amato **C:** elisa pontes
M: contato@leoamato.com

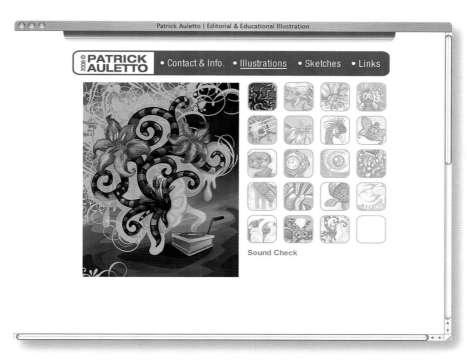

Sound Check

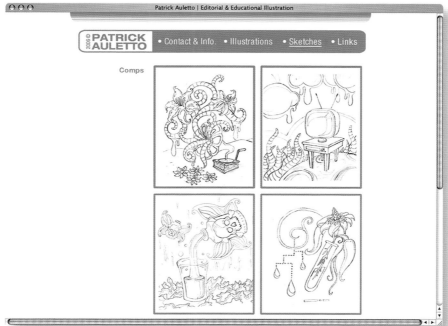

Comps

www.patrickauletto.com
D: patrick auletto
M: patrickauletto@mac.com

□ □ □

spür-bar | greif-bar | erleb-bar

spür-bar | **Grafik**

Alta Quota | Christoph`s Hotel der Sinne | DATA CONSULT | klima:aktiv mobil | Metz & Partner

Kunde
Christoph`s Hotel der Sinne | http://www.hoteldersinne.com
Christoph`s Hotel der Sinne das 4 Sterne Traditionshotel im Herzen von Schenna, Südtirol Italien. Hier finden Sie Ihr ganz persönliches Urlaubszuhause.

Ziel
Das Hotel wurde im Winter 2004 Umgebaut und Erweitert. Hier galt es für die Übergangszeit eine Pre-Openinglösung zu entwickeln, die die geplanten Erweiterungen präsentieren und den Rahmen für die dem Umbau folgenden Werbe - Maßnahmen bilden konnte. Darauf folgte dann der eigendliche Printauftritt vorrangig zweisprachig (Deutsch / Italienisch), teilweise auch Englisch.

Lösung
Die Besonderheiten lagen vor allem in einer Umfassenden Lösung für Web, Print, Imagebereich und im grenzüberschreitenden Produktionsablauf. Stete Kommunikation mit allen Beteiligten, ein offenes

brauch - bar

Home | Kontakt | Newsletter | AGB's | Downloads | Tools | Fun | Impressum

verlaut - bar

1234567890.at
Ab 19.09.2006 ist es in Österreich möglich, Domain-Namen zu registrieren, die nur aus Ziffern bestehen!
Führen Sie unseren Domain-Check aus und bestellen Sie online!

Ⓖ

sicht-bar
Beatrixgasse 14b / Top 4b
1030 Wien

Tel: +43 1 890 48 79
Fax: +43 1 890 48 79 - 22

office@sicht-bar.at
www.sicht-bar.at

□ □ □

spür-bar | greif-bar | erleb-bar

greif-bar | **Philosophie**

Vorteile | Transparenz | Integration | Gesamtheit | Interaktivität

Wir sind kein großer Konzern und maßen uns trotzdem an, Ihnen alle Arten von Hilfestellungen und Lösungen bieten zu können. Wir haben Partner, die genauso wie wir realisiert haben, dass nur ein gemeinsames Handeln den Erfolg bringt.

Unsere Kernkompetenzen decken einiges ab, und was sonst noch benötigt wird, erledigen unsere Partner. Und umgekehrt! Wir können Ihnen dadurch umfassende Konzepte anbieten.

Ihr Vorteil: Sie haben trotzdem nur **einen Ansprechpartner** im Projekt, auch wenn mehrere Firmen beteiligt sind.

... top

brauch - bar

Home | Kontakt | Newsletter | AGB's | Downloads | Tools | Fun | Impressum

verlaut - bar

1234567890.at
Ab 19.09.2006 ist es in Österreich möglich, Domain-Namen zu registrieren, die nur aus Ziffern bestehen!
Führen Sie unseren Domain-Check aus und bestellen Sie online!

Ⓖ

sicht-bar
Beatrixgasse 14b / Top 4b
1030 Wien

Tel: +43 1 890 48 79
Fax: +43 1 890 48 79 - 22

office@sicht-bar.at
www.sicht-bar.at

www.sicht-bar.at
D: veronika hölzl **C:** peter pruzina
A: sicht-bar **M:** office@sicht-bar.at

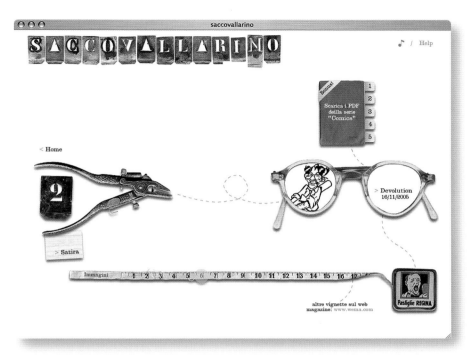

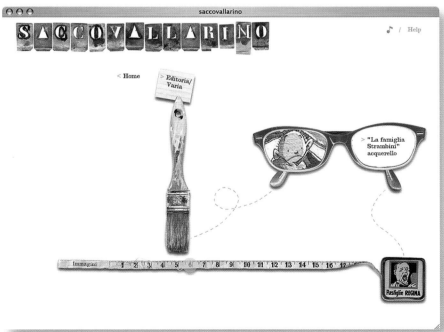

www.saccovallarino.it

D: paolo cagliero **C:** paolo cagliero **P:** sacco vallarino

M: www.paolocagliero.it

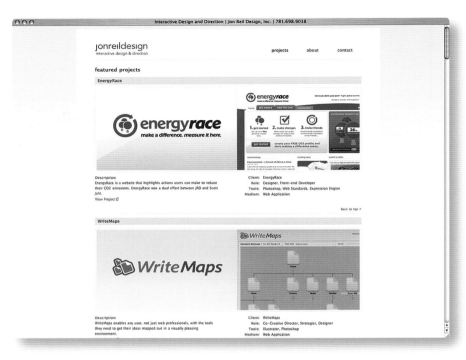

www.jonreil.com
D: jon reil C: jon reil, scott jehl P: jon reil
A: jon reil design, inc. M: business@jonreil.com

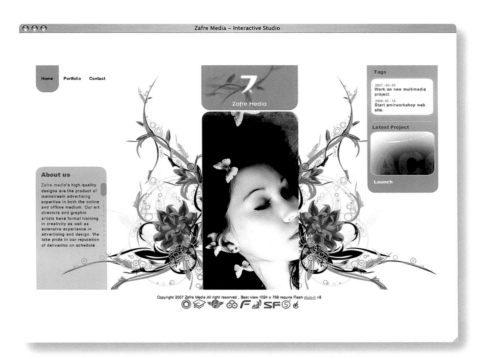

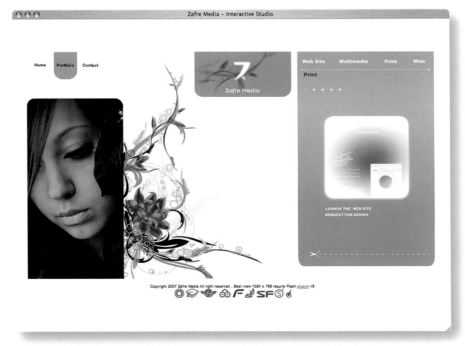

www.zafre.com

D: s.reza movahedi **C:** s.reza movahedi **P:** s.reza movahedi

A: zafre media **M:** info@zafre.com

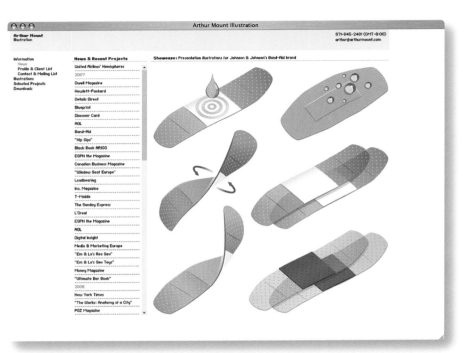

www.arthurmount.com
D: edvin lee, www.piperboy.com
M: arthur@arthurmount.com

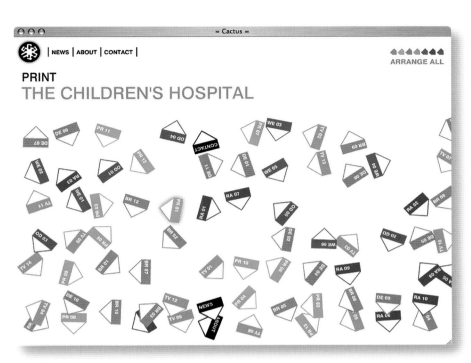

PRINT
THE CHILDREN'S HOSPITAL

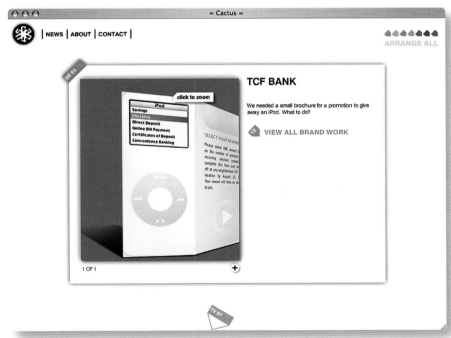

TCF BANK

We needed a small brochure for a promotion to give away an iPod. What to do?

VIEW ALL BRAND WORK

www.sharpideas.com
D: cactus marketing communications C: agencynet
A: cactus marketing communications M: growbrands@sharpideas.com

– very proud of you –

VERY PROUD OF YOU
The Official International Interweb Presence of Frank Campanella

contact

DESIGN PORTFOLIO · AUDIO DOWNLOADS · INFO

FEATURED PROJECT: Sony Walkman site

TEMPORARY SITE: Lomo photography

Project information:
Credits: lead designer, animation
Client: Sony, Y&R & Big Spaceship · view more projects

Information:
Photos taken all over new york city.
Visit photo site

VERY PROUD OF YOU IS >>

A website dedicated to displaying the recent graphic
design work and DJ sets of Frank Campanella. I'd like to
say that this is a temporary site, but i have the feeling that
it will take a while to get a full very proud of you
experience up and running. So check this out for now.

all work ©2004.

– very proud of you –

VERY PROUD OF YOU
The Official International Interweb Presence of Frank Campanella

homepage · contact

DESIGN PORTFOLIO · AUDIO DOWNLOADS · INFO

RECENT GRAPHIC DESIGN PROJECTS

Design is to plan out in systematic, usually graphic form (to quote
dictionary.com). Below are my recent and favorite attempts at
design. This is a long page, please deal with the wait.

SONY WALKMAN WEBSITE
Credits: lead designer, animation
Client: Sony, Y&R, Big Spaceship

launch site
>>

www.veryproudofyou.com
D: frank campanella
M: frank@veryproudofyou.com

http://www.studio-poana.com

SPRING 2007

Showcase Personal Features Profile Contacts

01 02 03 04 05 06 07 08 09 10 11 12 13 14 15 16 17 18 19 20 21 22 23 24 25 26 Archives
Previous | Next

Identity & Print // Numu02
Waz Records
Autumn 2006

Identity, cover design and stickers for jazz/funk band, Numu. Waz Records. Lille. France.
http://www.myspace.com/numu
http://numu.reshape-music.com/

Tags:
 Artwork | CD | Cover | ElectroJazz | Entertainment | Identity | Jazz Funk | Logotype | Packaging | Poana | Stickers

Showcase | Personal | Features | Profile | Contacts

http://www.studio-poana.com

SPRING 2007

Showcase Personal Features Profile Contacts

01 02 03 04 05 06 07 08 09 10 11 12 13 14 15 16 17 18 19 20 21 22 23 24 25 26 Archives
Previous | Next

 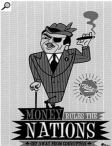 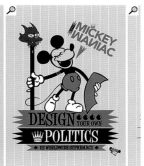

Print // Design Politics
Design Politics Exhibition
Winter 2007

Illustrations for Design Politics Exhibition. Buenos Aires. Argentina
http://www.designpolitics.org/

Tags: Event | Exhibition | Personal | Poana | Poster | Print

Showcase | Personal | Features | Profile | Contacts

www.studio-poana.com
D: thibault choquel, nicolas dhennin
A: studio poana M: contact@studio-poana.com

Yonderland

INFO.

YONDERLAND.
WORK.

INTERNET. LOGOTYPE. ILLUSTRATION.

Adidas a3 pt. 2	Yonderland	Rockets
Adidas Rugby	Gamepepper	The Crystal Committee
Adidas Climacool	Abel & Baker	SvD - New Noise
Adidas a3 pt. 1	Chiba	Sus Jpn
Absolut Tracks	KIM	BRIS - Robot
Exp. Robinson	Kem	On-john
13-klubben	Faxine	SvD - Casino
RSV	Deportees	Self portrait
Kanal 5	Damascus	
Nokia N-gage	M-tattoo	
Fujifilm	Softish	
Oddset EM	Battery	
Electrolux		
Abel & Baker		
Årets Kock		

DESCRIPTION.

The Crystal Committee

Client: The Crystal Committee
Role: Art Director / Illustrator

Illustration and record cover for The Crystal Committee album "Forever Overhead".

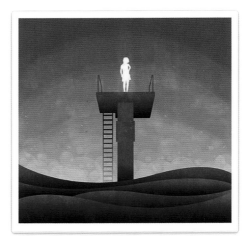

Yonderland

INFO.

YONDERLAND.
WORK.

INTERNET. LOGOTYPE. ILLUSTRATION.

Adidas a3 pt. 2	Yonderland	Rockets
Adidas Rugby	Gamepepper	The Crystal Committee
Adidas Climacool	Abel & Baker	SvD - New Noise
Adidas a3 pt. 1	Chiba	Sus Jpn
Absolut Tracks	KIM	BRIS - Robot
Exp. Robinson	Kem	On-john
13-klubben	Faxine	SvD - Casino
RSV	Deportees	Self portrait
Kanal 5	Damascus	
Nokia N-gage	M-tattoo	
Fujifilm	Softish	
Oddset EM	Battery	
Electrolux		
Abel & Baker		
Årets Kock		

DESCRIPTION.

Yonderland logotyp

Client: Yonderland
Role: Art Director / Graphic designer

Logo made for my own company. No longer used.

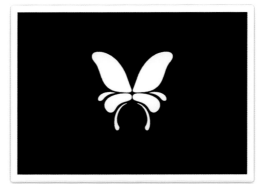

www.yonderland.com
D: bjarne melin C: bjarne melin P: bjarne melin
A: yonderland M: hello@yonderland.com

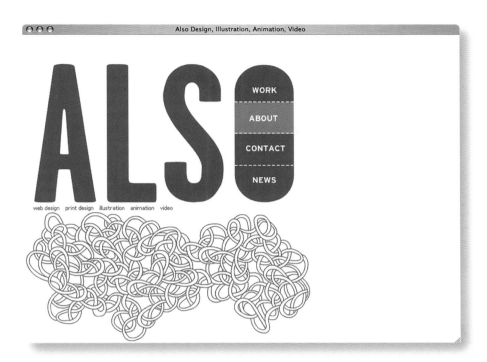

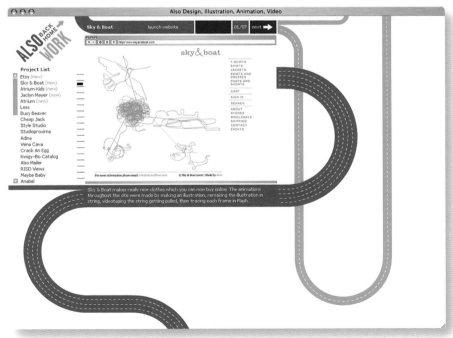

www.also-online.com

D: matt lamothe, julia rothman, jenny volvovski C: the also team P: the also team

A: also llc M: info@also-online.com

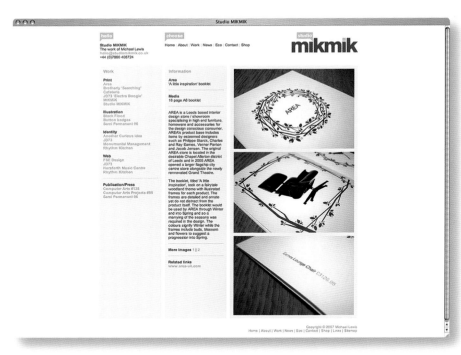

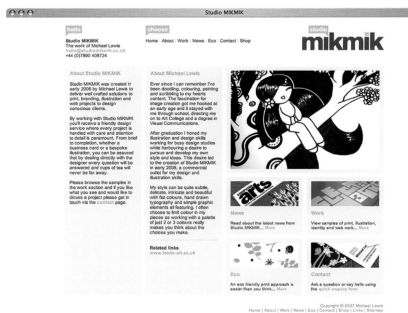

www.studiomikmik.co.uk
D: michael lewis C: michael lewis P: michael lewis
A: studio mikmik M: hello@studiomikmik.co.uk

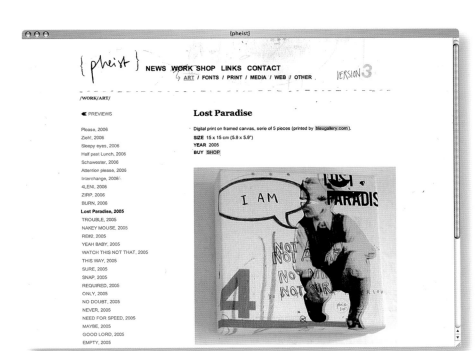

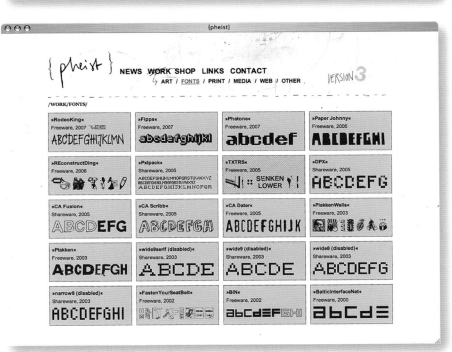

pheist.net
D: stefanie koerner C: stefanie koerner P: stefanie koerner
M: monochrom@gmx.de

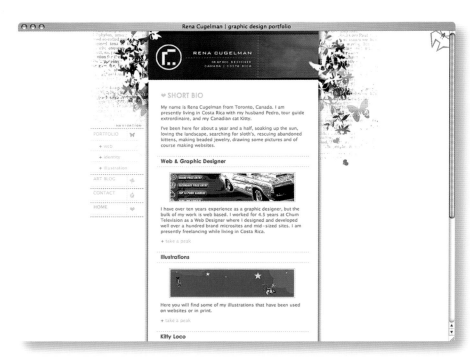

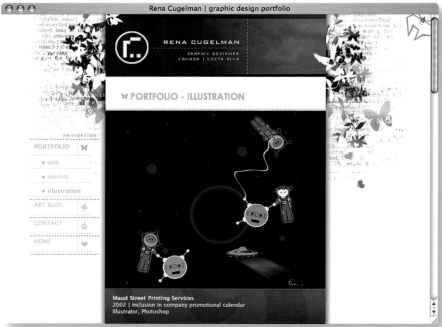

www.renacugelman.com
D: rena cugelman
M: info@kittyloco.com

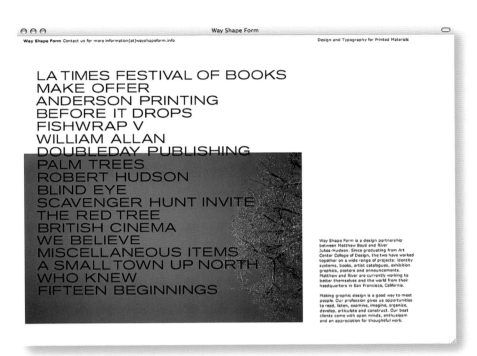

Way Shape Form Contact us for more information(at)wayshapeform.info

Design and Typography for Printed Materials

LA TIMES FESTIVAL OF BOOKS
MAKE OFFER
ANDERSON PRINTING
BEFORE IT DROPS
FISHWRAP V
WILLIAM ALLAN
DOUBLEDAY PUBLISHING
PALM TREES
ROBERT HUDSON
BLIND EYE
SCAVENGER HUNT INVITE
THE RED TREE
BRITISH CINEMA
WE BELIEVE
MISCELLANEOUS ITEMS
A SMALL TOWN UP NORTH
WHO KNEW
FIFTEEN BEGINNINGS

Way Shape Form is a design partnership between Matthew Boyd and River Jukes-Hudson. Since graduating from Art Center College of Design, the two have worked together on a wide range of projects: identity systems, books, artist catalogues, exhibition graphics, posters and announcements. Matthew and River are currently working to better themselves and the world from their headquarters in San Francisco, California.

Making graphic design is a good way to meet people. Our profession gives us opportunities to read, listen, examine, imagine, organize, develop, articulate and construct. Our best clients come with open minds, enthusiasm and an appreciation for thoughtful work.

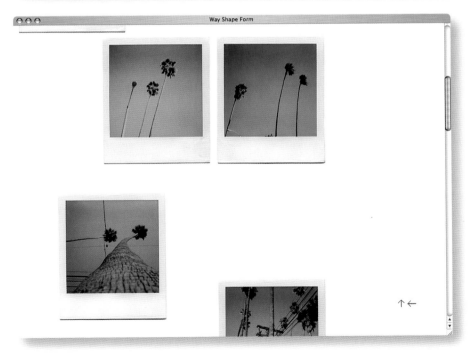

www.wayshapeform.info

D: r. jukes-hudson, m. boyd **C:** r. jukes-hudson & m. boyd **P:** r. jukes-hudson & m. boyd
A: way shape form **M:** information@wayshapeform.info

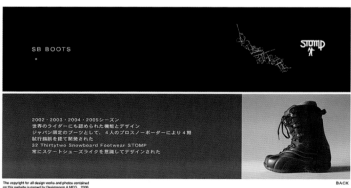

www.designroom-s.com
D: soichi nishikawa
A: designroom M: info@designroom-s.com

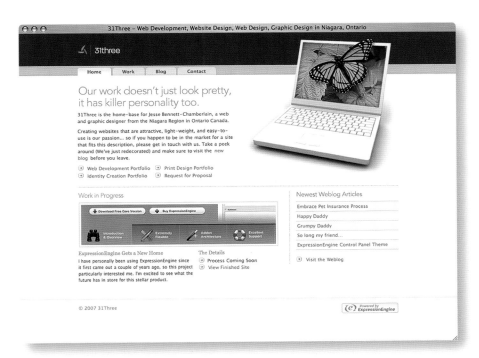

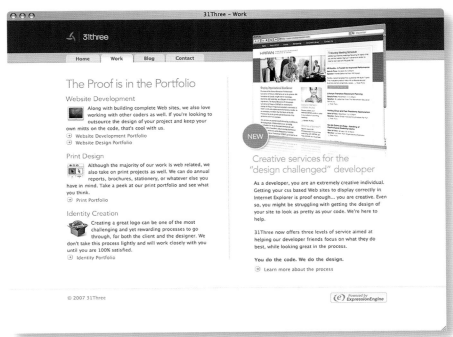

D: jesse bennett-chamberlain **C:** jesse bennett-chamberlain **P:** jesse bennett-chamberlain
A: 31three **M:** jessebc@31three.com

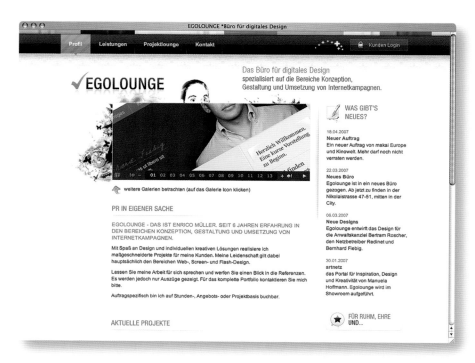

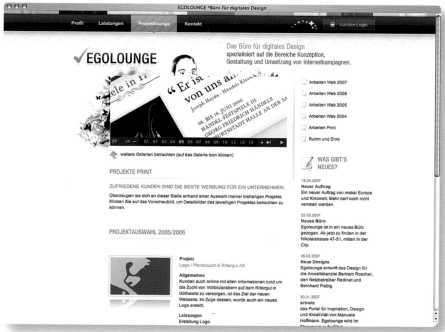

www.egolounge.de

D: enrico müller **C:** enrico müller **P:** enrico müller
A: egolounge **M:** info@egolounge.de

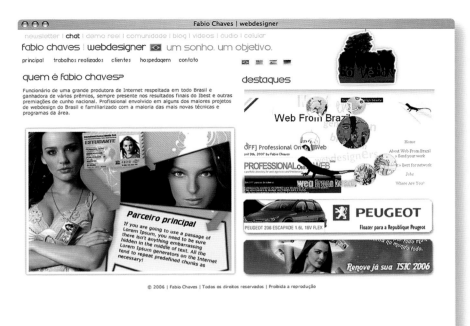

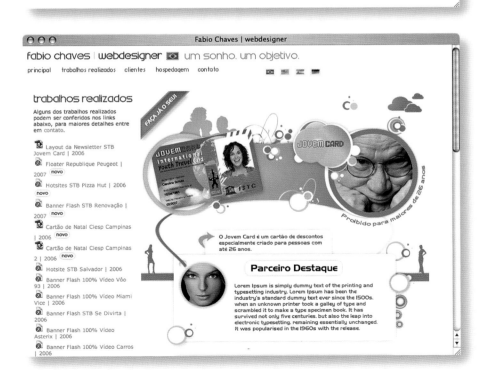

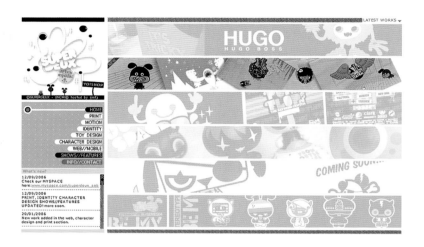

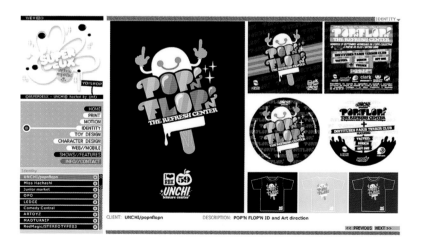

www.superdeux.com
D: sebastien roux **C:** tepat
A: unchi leisure center **M:** info@superdeux.com

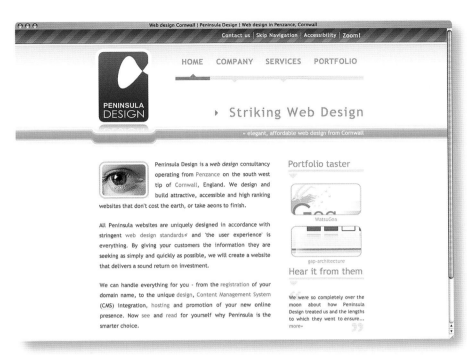

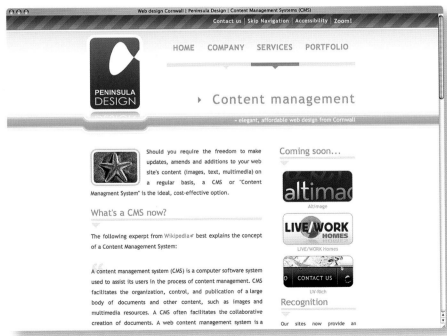

www.peninsuladesign.co.uk
D: tom white **C:** tom white **P:** peninsula design
A: peninsula design **M:** info@peninsuladesign.co.uk

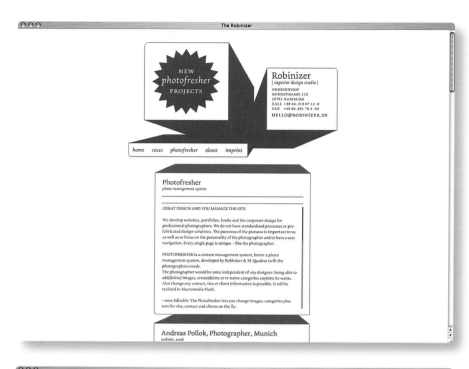

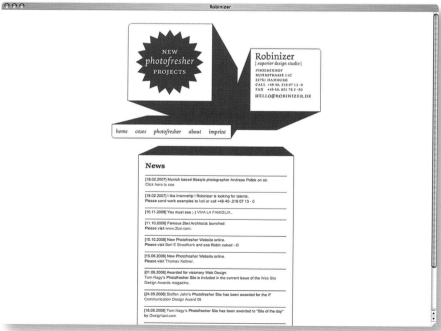

www.robinizer.de

D: wolfgang von geramb **C:** david beermann

A: robinizer | superior design studio for image communication **M:** hello@robinizer.de

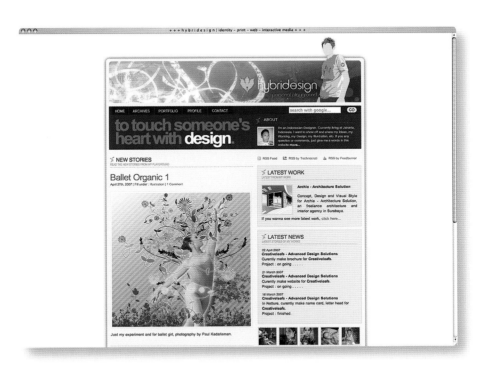

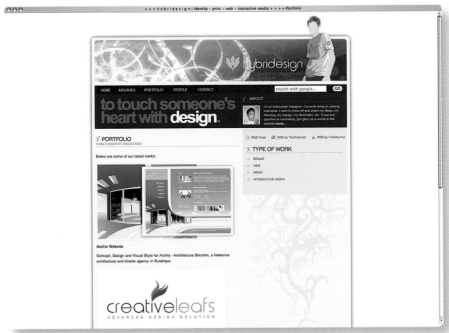

blog.behybrid.net

D: yoppi adhijaya C: yoppi adhijaya P: yoppi adhijaya
A: hybridesign M: yoppi@behybrid.net

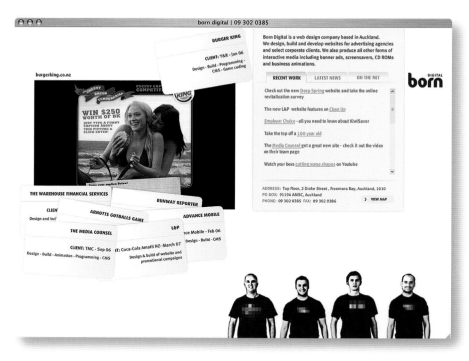

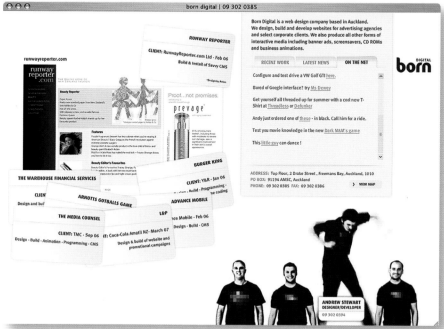

www.borndigital.co.nz
D: owen johnston **C:** yaron shamir & andrew stewart **P:** brett hancock
A: born digital **M:** brett@borndigital.co.nz

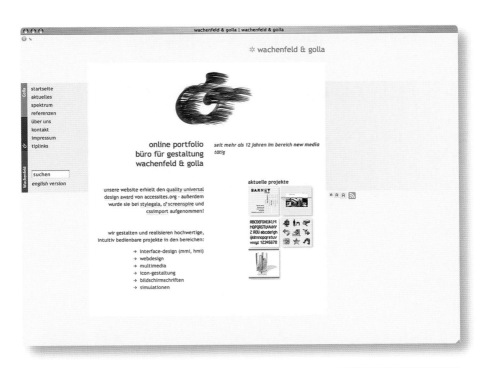

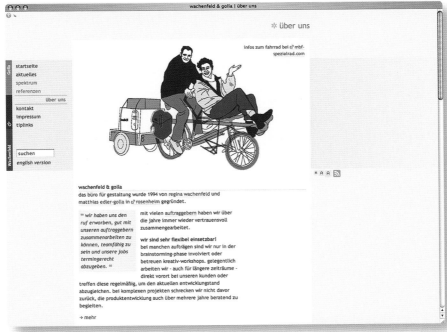

www.wachenfeld-golla.de

D: matthias edler-golla, regina wachenfeld **C:** matthias edler-golla
A: wachenfeld & golla, new media design **M:** rw@wachenfeld-golla.de

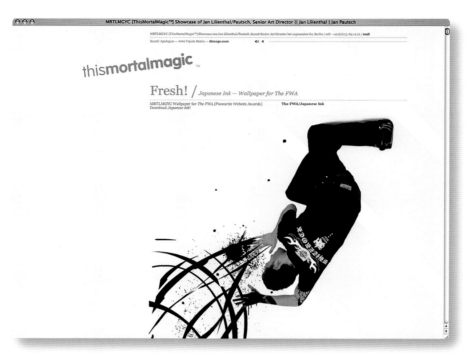

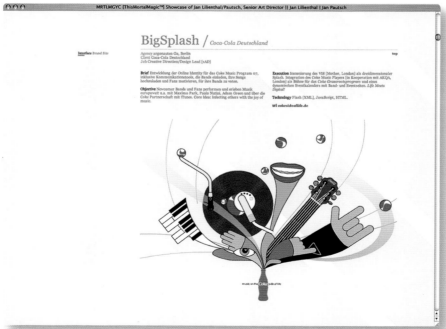

www.thismortalmagic.com
D: jan lilienthal.pautsch
A: mrtlmgyc [thismortalmagic™] **M:** hit@thismortalmagic.com

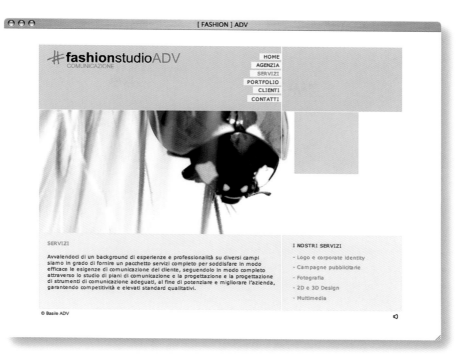

[FASHION] ADV

#fashionstudioADV
COMUNICAZIONE

HOME
AGENZIA
SERVIZI
PORTFOLIO
CLIENTI
CONTATTI

SERVIZI

Avvalendoci di un background di esperienze e professionalità su diversi campi siamo in grado di fornire un pacchetto servizi completo per soddisfare in modo efficace le esigenze di comunicazione del cliente, seguendolo in modo completo attraverso lo studio di piani di comunicazione e la progettazione e la progettazione di strumenti di comunicazione adeguati, al fine di potenziare e migliorare l'azienda, garantendo competitività e elevati standard qualitativi.

I NOSTRI SERVIZI

- Logo e corporate identity
- Campagne pubblicitarie
- Fotografia
- 2D e 3D Design
- Multimedia

© Basile ADV

[FASHION] ADV

#fashionstudioADV
COMUNICAZIONE

HOME
AGENZIA
SERVIZI
PORTFOLIO
CLIENTI
CONTATTI

ALCUNE DELLE NOSTRE REALIZZAZIONI

Siniscalchi	Vini Longo	Torre di Cesare	Trucillo caffè
Italcatering	Leo Autotras..	Gallozzi SCT	Lello Fortunato
Lions Club	Docteur Nature	Rari Nantes SA	Severi
Hotel Mec	Di Iorio	Rugalift	In & Out
Hotel Cerere	Arredogamma	Fontanarosa	
Sposi ma non..	Nigato	Distrib. Alluminio	

RARI NANTES

Seri A pallanuoto
Salerno

Realizzazione Spot video televisivo.

© Basile ADV

www.fashionstudioadv.it
D: andrea basile C: basile advertising P: basile advertising
A: basile advertising M: info@basileadvertising.com

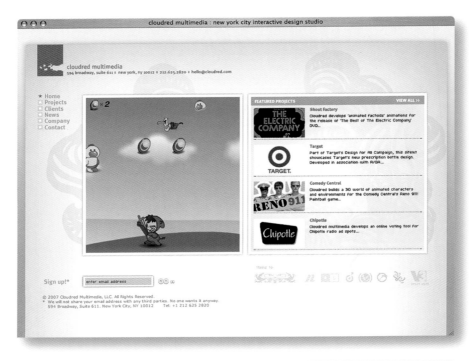

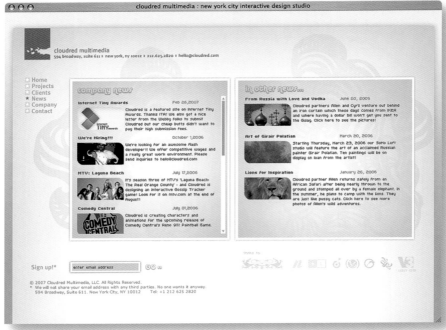

www.cloudred.com
D: c. tsiboulski, a. yee, m. smalley, m. hess **C:** c. tsiboulski, m. dabas **P:** a. yee
A: cloudred **M:** hello@cloudred.com

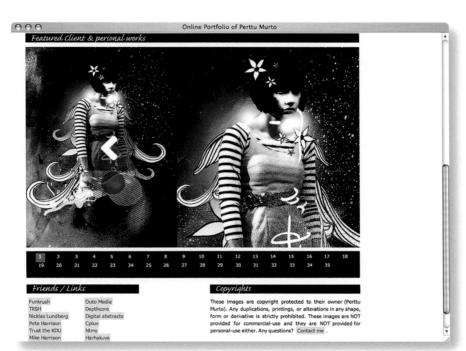

Featured Client & personal works

| 1 | 2 | 3 | 4 | 5 | 6 | 7 | 8 | 9 | 10 | 11 | 12 | 13 | 14 | 15 | 16 | 17 | 18 |
| 19 | 20 | 21 | 22 | 23 | 24 | 25 | 26 | 27 | 28 | 29 | 30 | 31 | 32 | 33 | 34 | 35 | |

Friends / Links

Funkrush
TKSH
Nicklas Lundberg
Pete Harrison
Trust the KDU
Mike Harrison

Outo Media
Depthcore
Digital abstracts
Cpluv
Ntmy
Harhakuva

Copyrights

These images are copyright protected to their owner (Perttu Murto). Any duplications, printings, or alterations in any shape, form or derivative is strictly prohibited. These images are NOT provided for commercial-use and they are NOT provided for personal-use either. Any questions? Contact me .

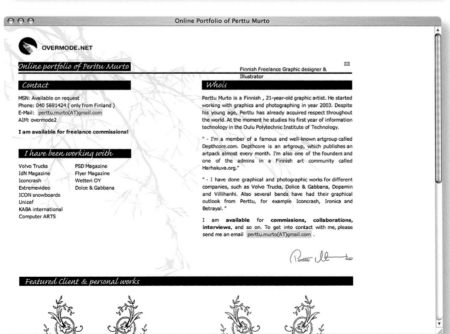

OVERMODE.NET

Online portfolio of Perttu Murto

Finnish Freelance Graphic designer & Illustrator

Contact

MSN: Available on request
Phone: 040 5691424 (only from Finland)
E-Mail: perttu.murto(AT)gmail.com
AIM: overmode2

I am available for freelance commissions!

I have been working with

Volvo Trucks
IdN Magazine
Iconcrash
Extremevideo
ICON snowboards
Unicef
KABA international
Computer ARTS

PSD Magazine
Flyer Magazine
Wetteri OY
Dolce & Gabbana

Whois

Perttu Murto is a Finnish , 21-year-old graphic artist. He started working with graphics and photographing in year 2003. Despite his young age, Perttu has already acquired respect throughout the world. At the moment he studies his first year of information technology in the Oulu Polytechnic Institute of Technology.

" - I'm a member of a famous and well-known artgroup called Depthcore.com. Depthcore is an artgroup, which publishes an artpack almost every month. I'm also one of the founders and one of the admins in a Finnish art community called Harhakuva.org."

" - I have done graphical and photographic works for different companies, such as Volvo Trucks, Dolce & Gabbana, Dopamin and Villihanhi. Also several bands have had their graphical outlook from Perttu, for example Iconcrash, Ironica and Betrayal. "

I am **available** for **commissions, collaborations, interviews**, and so on. To get into contact with me, please send me an email perttu.murto(AT)gmail.com .

Featured Client & personal works

www.overmode.net
D: perttu murto
M: perttu.murto@gmail.com

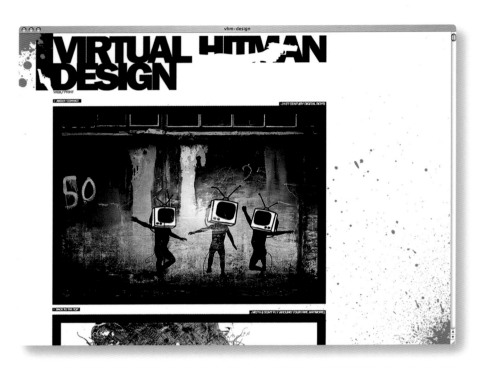

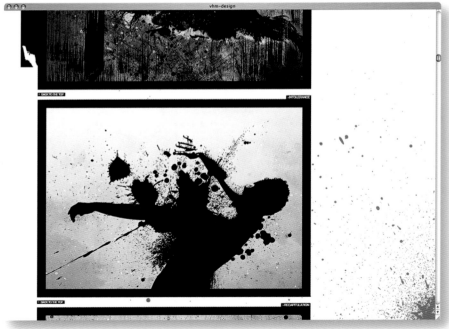

vhm-design.com
D: alex cherry
M: alex@ofsoundandvision.com

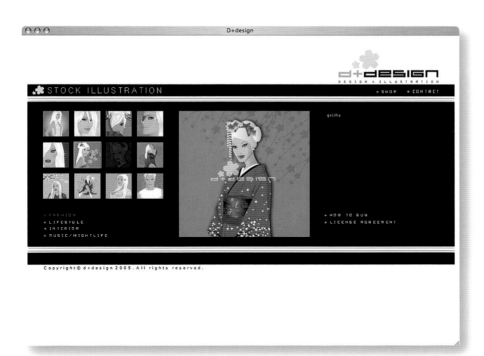

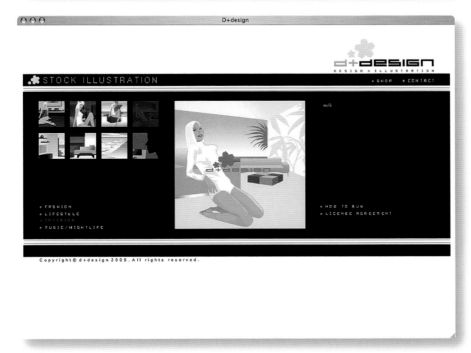

www.dpiudesign.com
D: d+design
M: info@dpiudesign.com

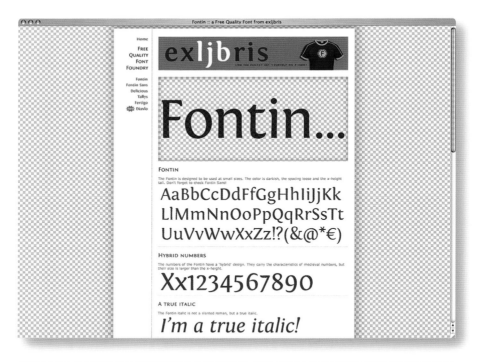

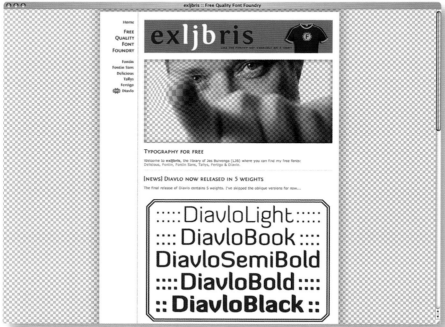

www.josbuivenga.demon.nl

D: jos buivenga **C:** jos buivenga **P:** jos buivenga

A: exljbris **M:** contact@josbuivenga.demon.nl

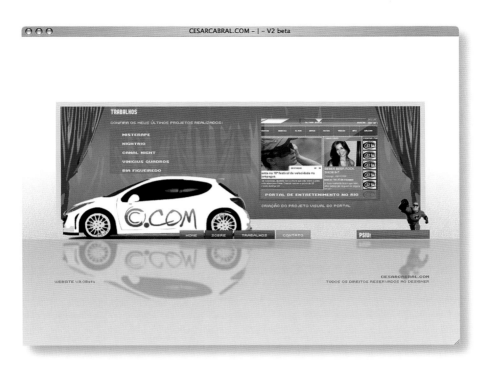

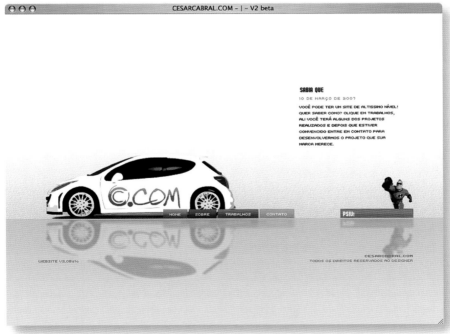

www.cesarcabral.com

D: césar cabral C: césar cabral P: césar cabral
A: cesarcabral.com M: cesarcabral@cesarcabral.com

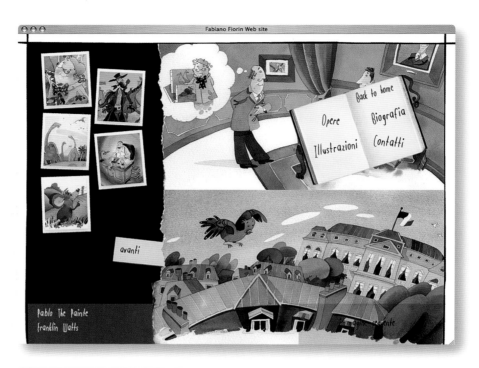

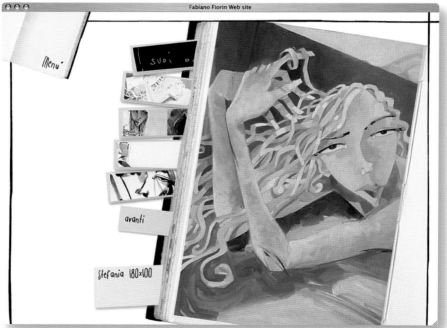

www.fabianofiorin.it
D: mia pontano, andrea modenese
A: pixelica snc M: info@pixelica.it

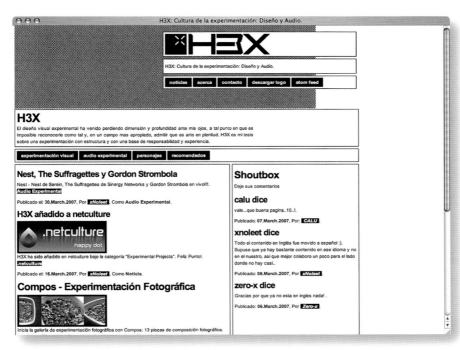

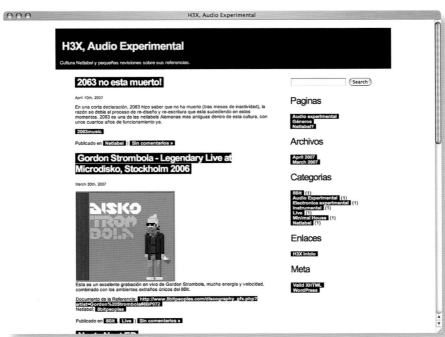

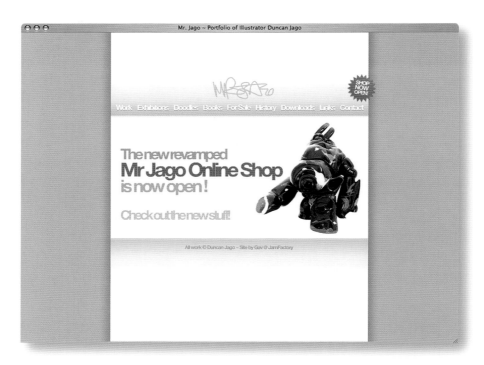

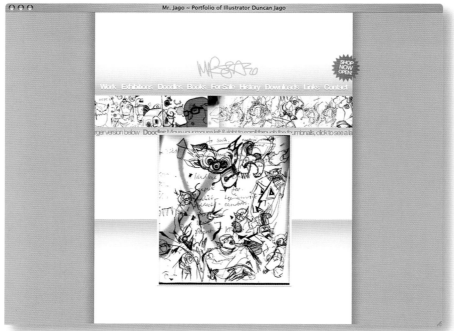

www.mrjago.com
D: jamfactory C: jamfactory P: duncan jago
A: mr jago M: mrjago@mrjago.com

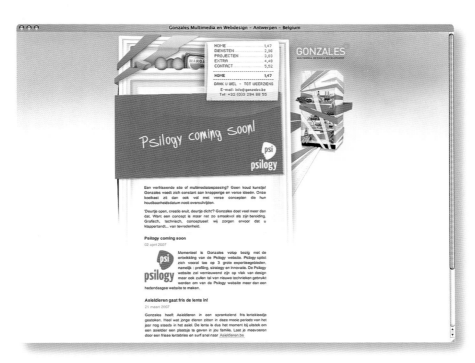

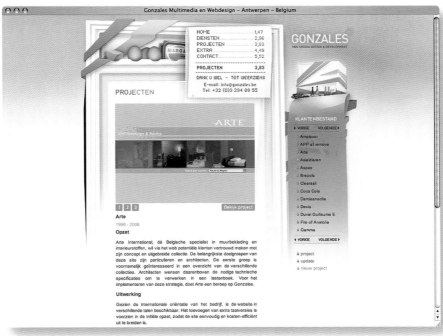

www.gonzales.be
D: sacha krinstinsky, adriaan huigenbaert **C:** tom odul, filip vanderstappen **P:** basily
A: gonzales **M:** sacha@gonzales.be

Home | About | Clients | Newsletter | Contact

PATRICIA-CARVALHO.COM
WEB+GRAPHIC DESIGN

WEB DESIGN | GRAPHIC DESIGN | ILLUSTRATION

web design corporate web sites portals online stores community + web services backend interface e-mailings banners media center interface graphic design logo design posters brochures magazine adds leaflets booth graphics illustration editorial web

Home | About | Clients | Newsletter | Contact

PATRICIA-CARVALHO.COM
WEB+GRAPHIC DESIGN

WEB DESIGN | GRAPHIC DESIGN | ILLUSTRATION

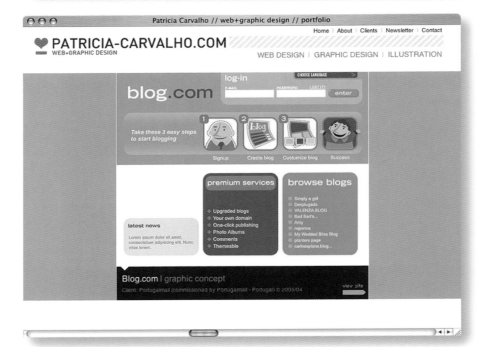

www.patricia-carvalho.com
D: patricia carvalho C: patricia carvalho
A: patricia-carvalho.com | freelance web designer M: info@patricia-carvalho.com

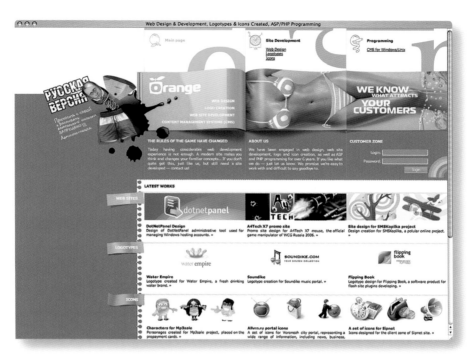

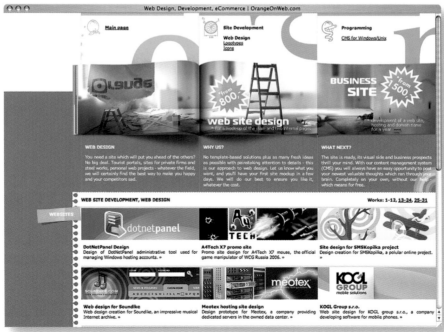

www.orangeonweb.com
D: daria lobunets **P:** denis protsenko
A: orangeonweb **M:** orange@orangeonweb.com

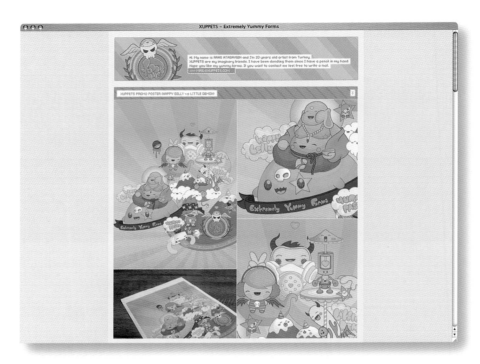

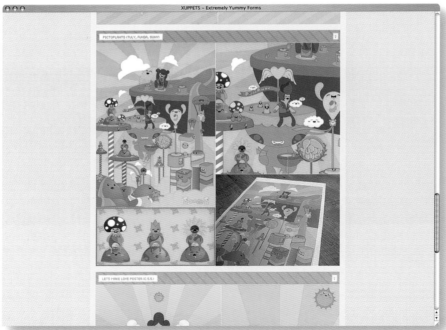

www.xuppets.com
D: aras atasaygin **C:** aras atasaygin **P:** aras atasaygin
A: xuppets **M:** mail@xuppets.com

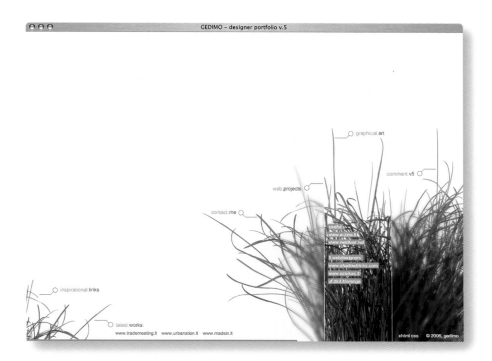

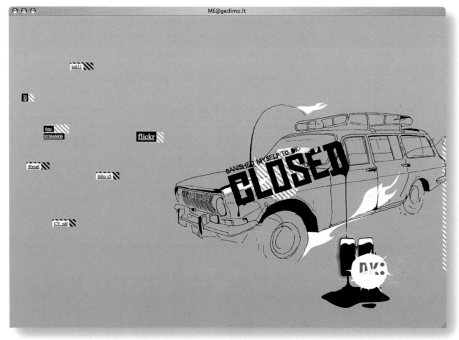

www.gedimo.lt
D: gediminas saulis
M: me@gedimo.lt

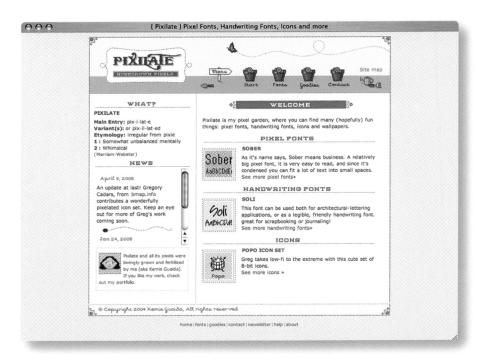

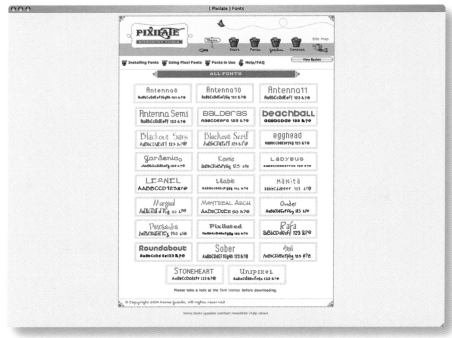

www.pixilate.com
D: kemie guaida
A: monolinea.com **M:** fonts@pixilate.com

www.genotyp.com

D: michael schmitz **C:** michael schmitz **P:** michael schmitz
A: non square pigs **M:** info@genotyp.com

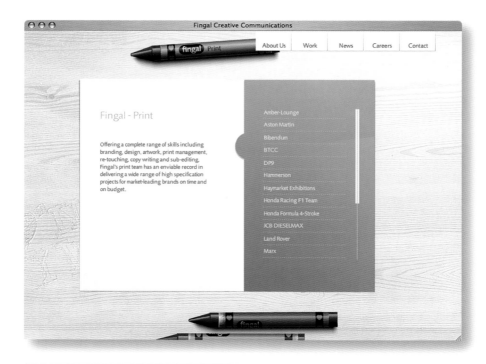

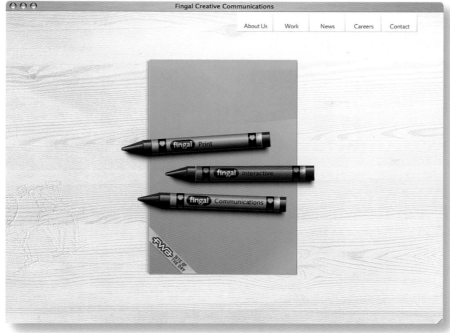

www.fingal.co.uk
D: jason loader, andrew rees C: daniel goulding P: francis jago
A: fingal M: francis.jago@fingal.co.uk

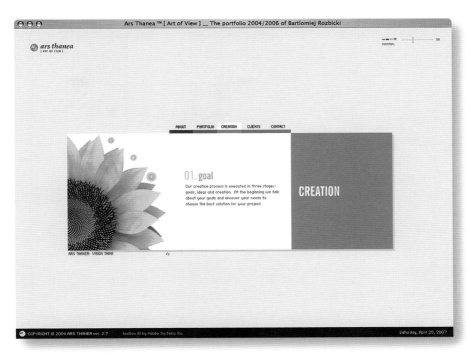

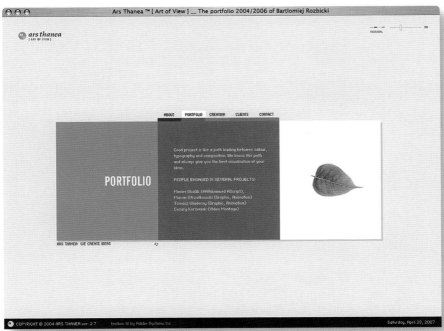

www.thanea.com/v1

D: bartlomiej rozbicki C: bartlomiej rozbicki, thx to maciek wcislik

A: ars thanea M: br@arsthanea.com

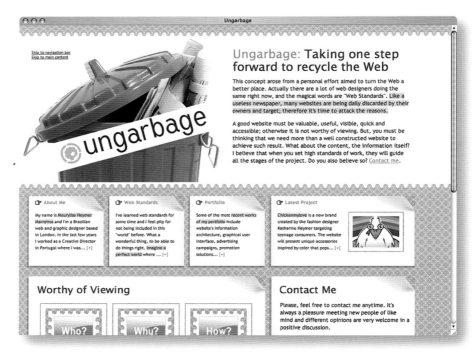

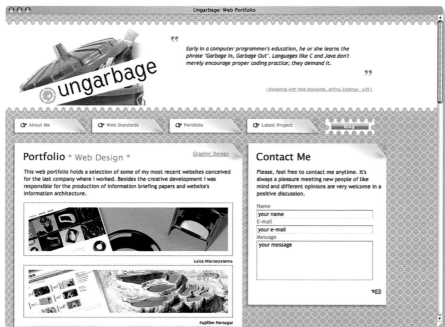

www.ungarbage.com
D: mourylise heymer marreiros **C:** mourylise heymer marreiros, filipe marreiros
M: mheymer@gmail.com

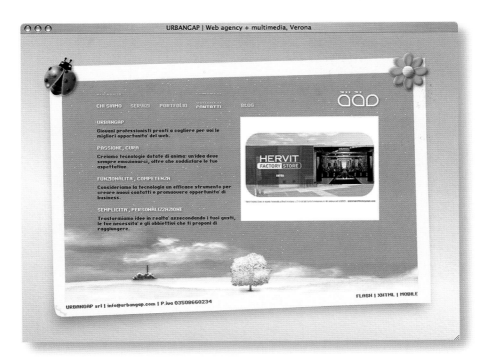

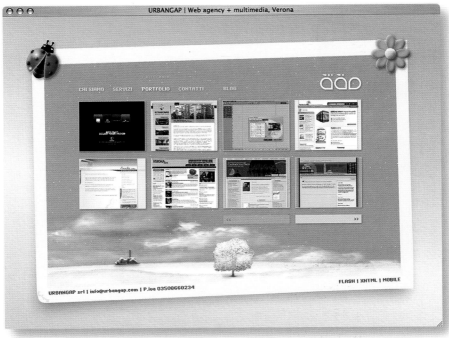

www.urbangap.com
D: urbangap
M: info@urbangap.com

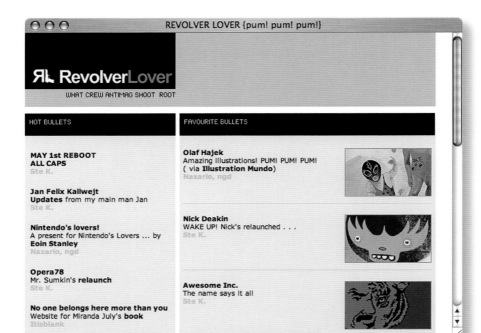

REVOLVER LOVER {pum! pum! pum!}

ЯL RevolverLover

WHAT CREW ANTIMAG SHOOT ROOT

HOT BULLETS

**MAY 1st REBOOT
ALL CAPS**
Ste K.

**Jan Felix Kallwejt
Updates** from my main man Jan
Ste K.

Nintendo's lovers!
A present for Nintendo's Lovers ... by
Eoin Stanley
Nazario, ngd

Opera78
Mr. Sumkin's **relaunch**
Ste K.

No one belongs here more than you
Website for Miranda July's **book**
Itisblank

FAVOURITE BULLETS

Olaf Hajek
Amazing illustrations! PUM! PUM! PUM!
(via **Illustration Mundo**)
Nazario, ngd

Nick Deakin
WAKE UP! Nick's relaunched . . .
Ste K.

Awesome Inc.
The name says it all
Ste K.

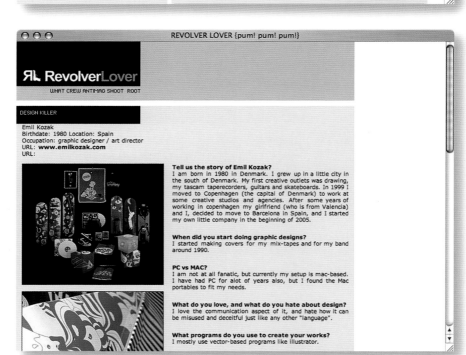

REVOLVER LOVER {pum! pum! pum!}

ЯL RevolverLover

WHAT CREW ANTIMAG SHOOT ROOT

DESIGN KILLER

Emil Kozak
Birthdate: 1980 Location: Spain
Occupation: graphic designer / art director
URL: **www.emilkozak.com**
URL:

Tell us the story of Emil Kozak?
I am born in 1980 in Denmark. I grew up in a little city in
the south of Denmark. My first creative outlets was drawing,
my tascam taperecorders, guitars and skateboards. In 1999 I
moved to Copenhagen (the capital of Denmark) to work at
some creative studios and agencies. After some years of
working in copenhagen my girlfriend (who is from Valencia)
and I, decided to move to Barcelona in Spain, and I started
my own little company in the beginning of 2005.

When did you start doing graphic designs?
I started making covers for my mix-tapes and for my band
around 1990.

PC vs MAC?
I am not at all fanatic, but currently my setup is mac-based.
I have had PC for alot of years also, but I found the Mac
portables to fit my needs.

What do you love, and what do you hate about design?
I love the communication aspect of it, and hate how it can
be misused and deceitful just like any other "language".

What programs do you use to create your works?
I mostly use vector-based programs like illustrator.

www.revolverlover.net
D: nazario graziano **P:** nazario graziano
M: shoot@revolverlover.net

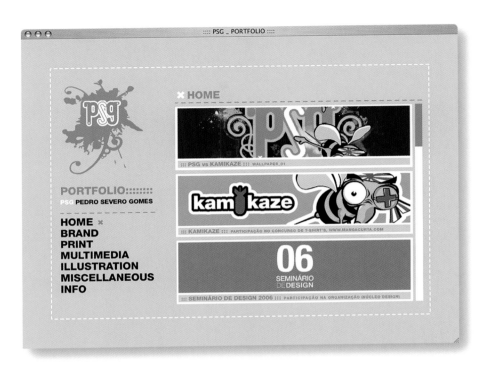

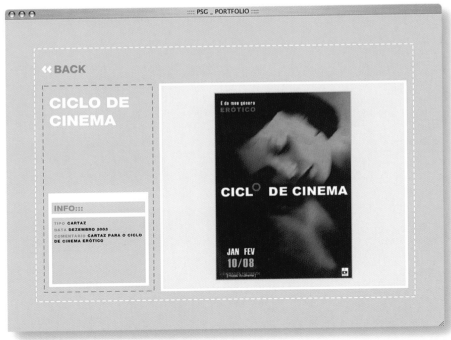

www.psgdesigner.com

D: pedro m. severo gomes
M: psg.design@gmail.com

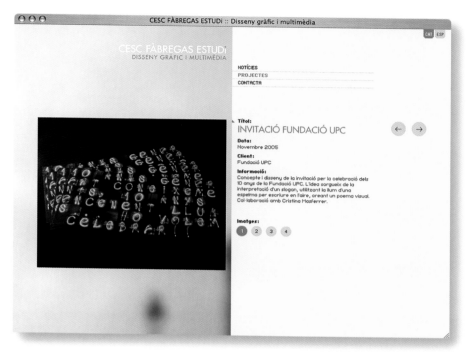

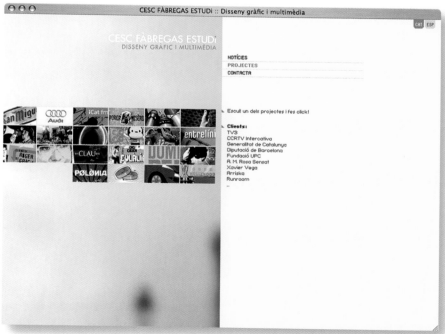

www.cescfabregasestudi.com

D: cesc fàbregas **C:** cesc fàbregas **P:** cesc fàbregas

A: cesc fàbregas estudi **M:** home@cescfabregasestudi.com

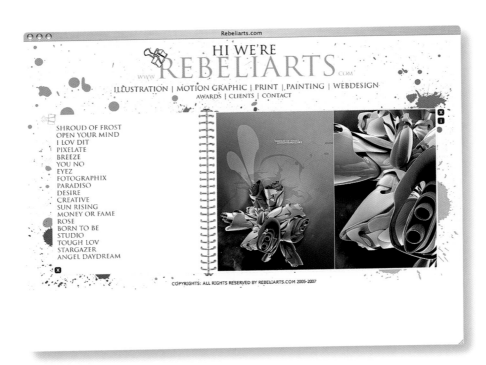

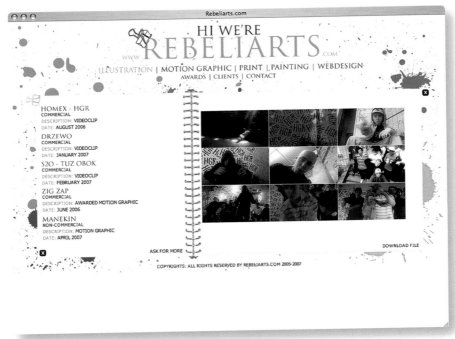

www.rebeliarts.com

D: wojciech zalot, lukasz wrona **C:** wojciech zalot **P:** rebeliarts

A: rebeliarts **M:** info@rebeliarts.com

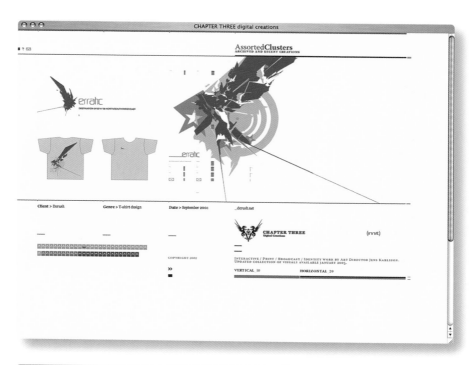

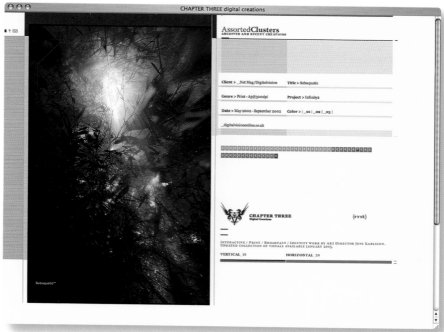

www.chapter3.net
D: jens magnus karlsson C: jens magnus karlsson P: jens magnus karlsson
A: chapter three M: jens@your-majesty.com

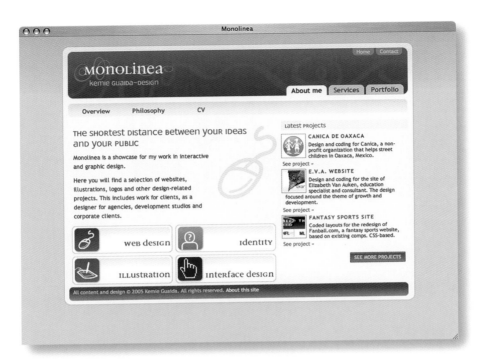

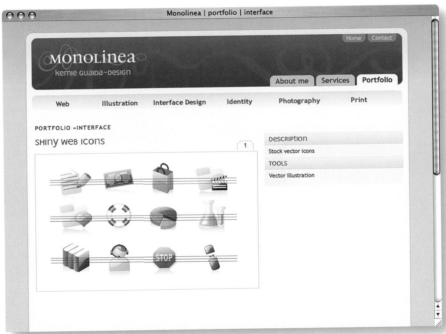

monolinea.com
D: kemie guaida
A: monolinea.com **M:** kemie@monolinea.com

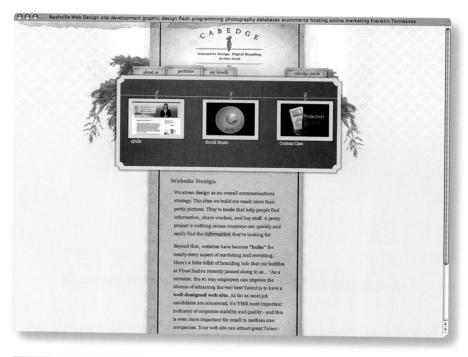

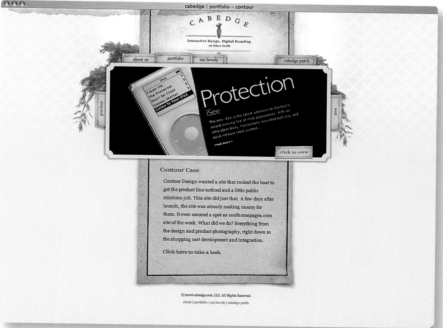

www.cabedge.com

D: chris blanz, blake allen, matt reed C: matt reed, patrick hunton P: chris blanz
A: cabedge.com, llc M: howdy@cabedge.com

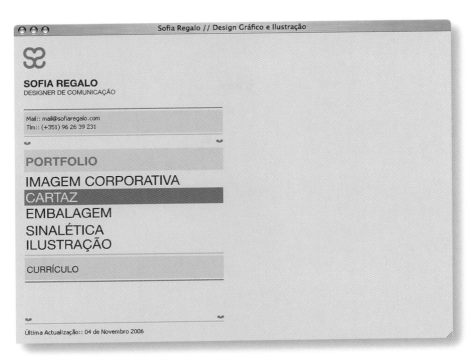

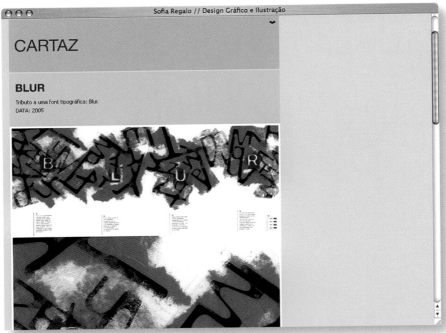

www.sofiaregalo.com
D: sofia regalo
A: rua design **M:** mail@sofiaregalo.com

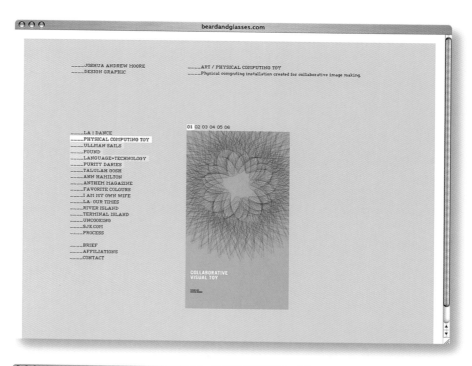

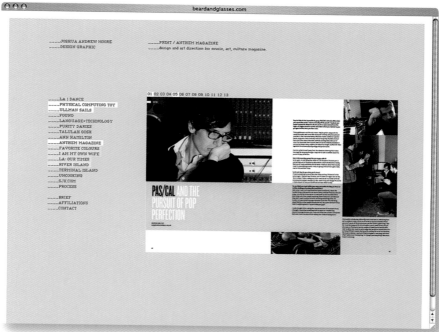

www.beardandglasses.com

D: joshua moore C: joshua moore

M: hello@beardandglasses.com

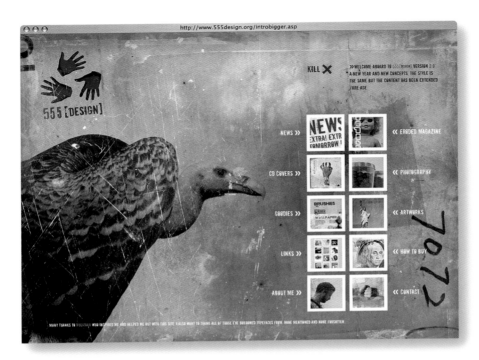

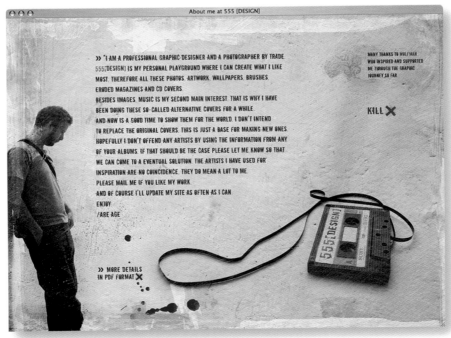

www.555design.org

D: are age **C:** are age **P:** are age

A: 555[design] **M:** areage@gmail.com

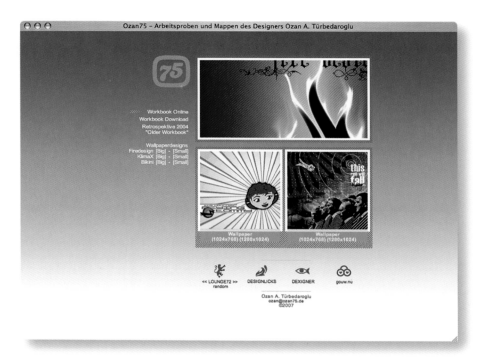

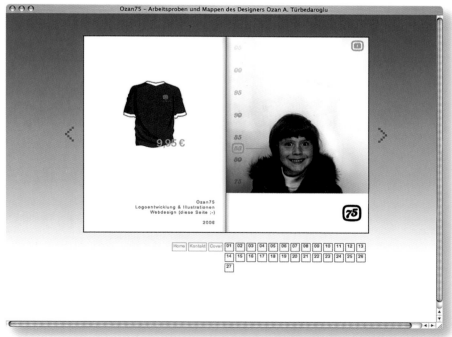

www.ozan75.de

D: ozan a. türbedaroglu C: ozan a. türbedaroglu P: ozan a. türbedaroglu

A: ozan75 M: ozan@ozan75.de

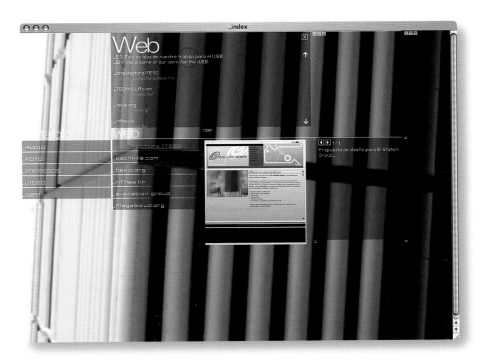

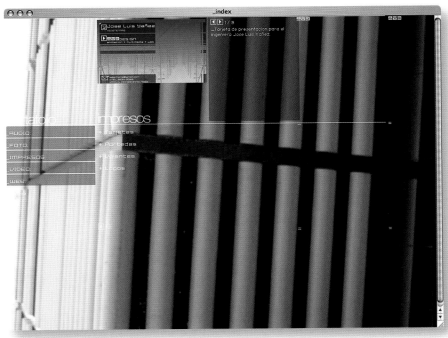

963design.com
D: ricardo yañez C: ricardo yañez P: ricardo yañez
A: 963design M: info@963design.com

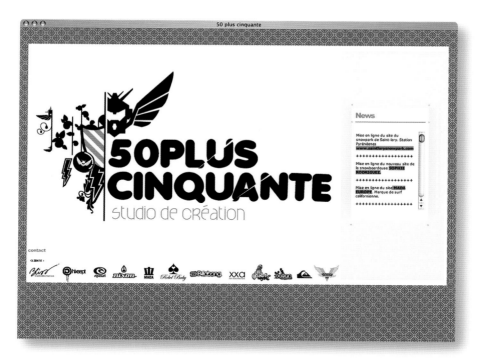

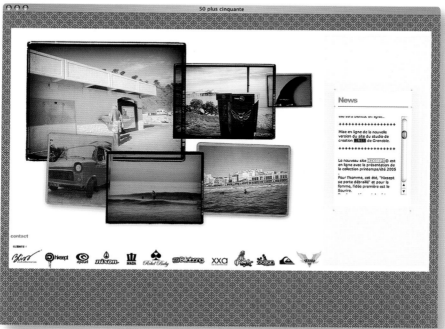

www.50pluscinquante.com

D: eymard franck

M: 50plus50@50pluscinquante.com

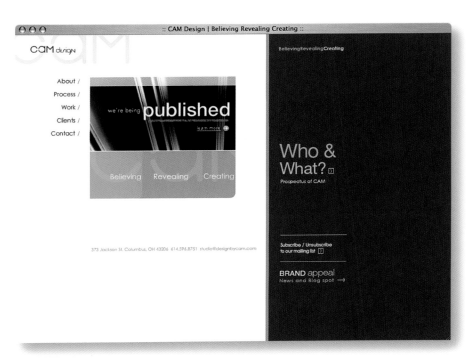

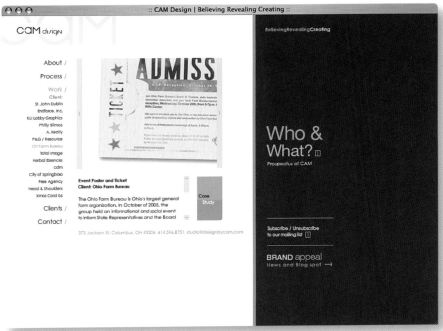

www.designbycam.com

D: craig murray C: levi mendes P: craig murray
A: cam design M: studio@designbycam.com

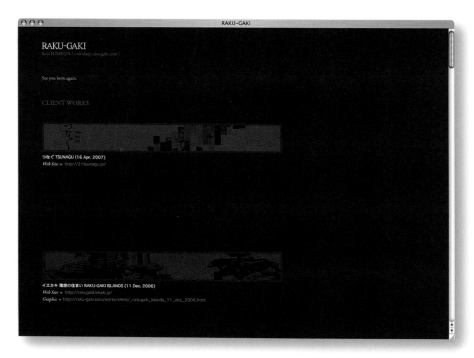

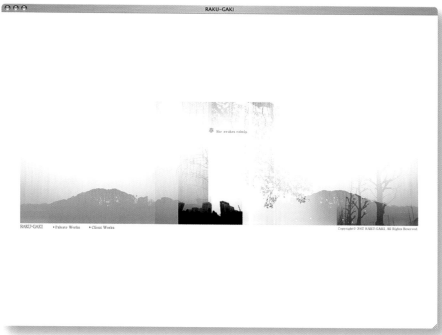

raku-gaki.com

D: koji nishida

A: raku-gaki **M:** nishida@raku-gaki.com

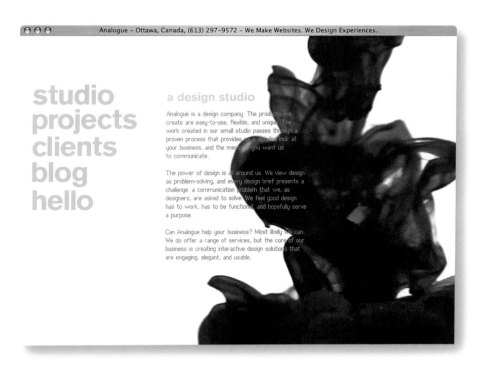

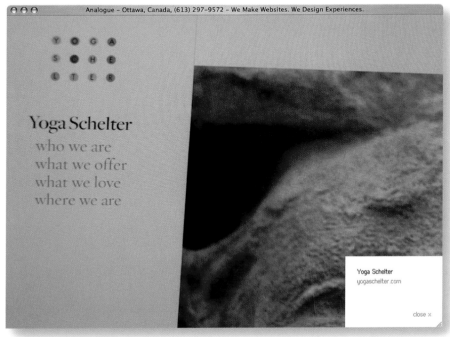

www.analogue.ca
D: craig hooper, jory kruspe **C:** craig hooper, jory kruspe **P:** craig hooper, jory kruspe
A: analogue **M:** info@analogue.ca

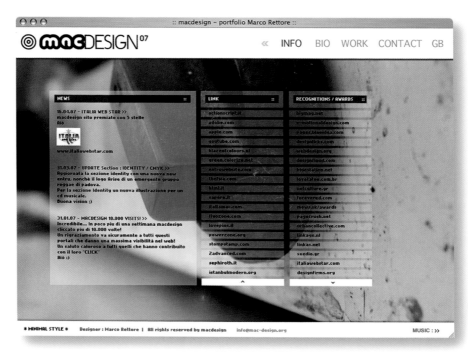

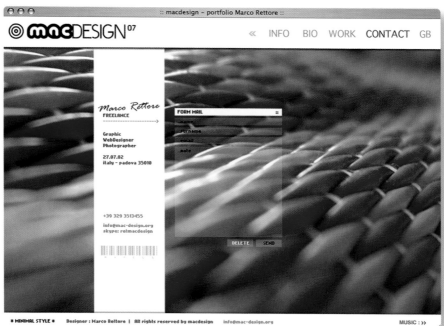

www.mac-design.org
D: marco rettore
M: info@mac-design.org

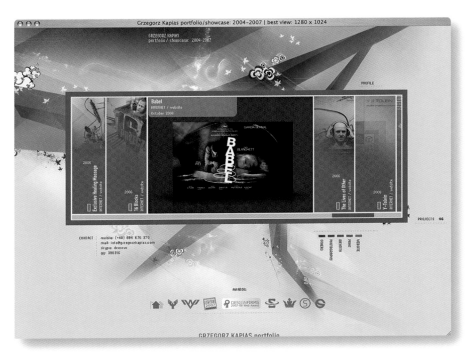

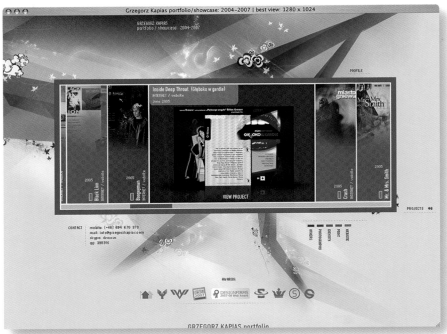

www.grzegorzkapias.com
D: grzegorz kapias **C:** grzegorz kapias
A: wizja ksztaltu (vision of shape) **M:** info@grzegorzkapias.com

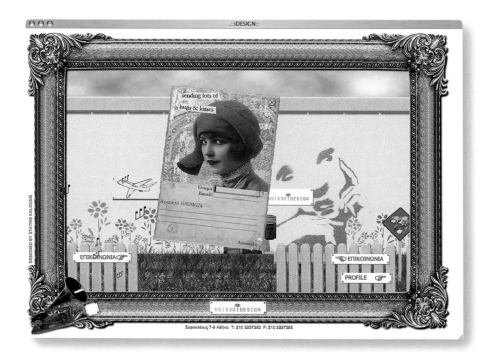

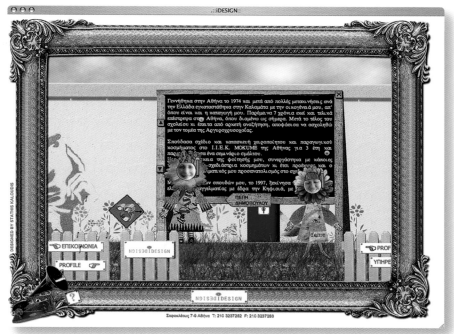

www.i-design.gr
D: stathis kaloudis
M: skaloudis@yahoo.com

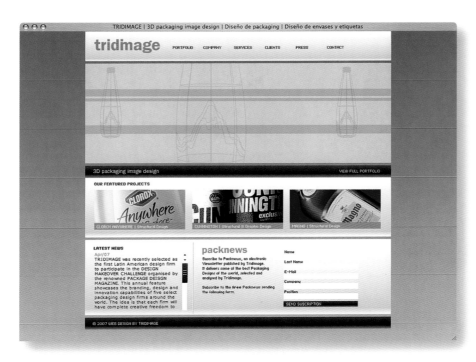

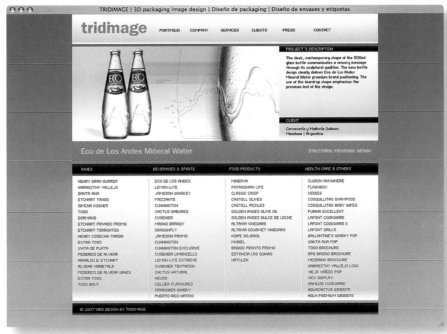

**www.tridimage.com**
D: cinthia cabero mencia, tridimage C: cinthia cabero mencia P: tridimage
A: tridimage | 3d packaging image design M: design@tridimage.com

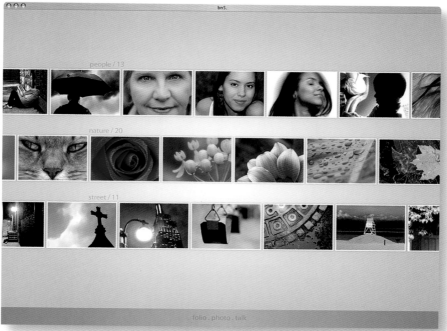

www.clintbalcom.com
D: clint balcom
A: balcom & nobody M: clint@clintbalcom.com

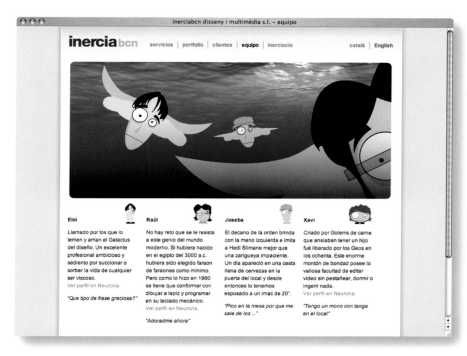

inerciabcn servicios | portfolio | clientes | **equipo** | inerciocio català | English

Eloi

Llamado por los que lo temen y aman el Galactus del diseño. Un excelente profesional ambicioso y sediento por succionar o sorber la vida de cualquier ser viscoso.
Ver perfil en Neurona.

"Que tipo de frase graciosa?"

Raül

No hay reto que se le resista a este genio del mundo moderno. Si hubiera nacido en el egipto del 3000 a.c. hubiera sido elegido faraon de faraones como mínimo. Pero como lo hizo en 1980 se tiene que conformar con dibujar a lapiz y programar en su teclado mecánico.
Ver perfil en Neurona.

"Adoradme ahora"

Joseba

El decano de la orden brinda con la mano izquierda e imita a Hedi Slimane mejor que una zarigueya impaciente. Un dia apareció en una cesta llena de cervezas en la puerta del local y desde entonces lo tenemos esposado a un imac de 20".

"Pico en la mesa por que me sale de los ..."

Xavi

Criado por Golems de carne que ansiaban tener un hijo fué liberado por los Geos en los ochenta. Este enorme montón de bondad posee la valiosa facultad de editar video sin pestañear, dormir o ingerir nada.
Ver perfil en Neurona.

"Tengo un mono con tanga en el local"

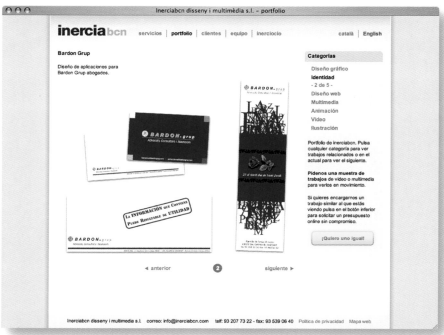

inerciabcn servicios | **portfolio** | clientes | equipo | inerciocio català | English

Bardon Grup

Diseño de aplicaciones para Bardon Grup abogados.

Categorías

Diseño gráfico
Identidad
- 2 de 5 -
Diseño web
Multimedia
Animación
Video
Ilustración

Portfolio de inerciabcn. Pulsa cualquier categoría para ver trabajos relacionados o en el actual para ver el siguiente.

Pídenos una muestra de trabajos de video o multimedia para verlos en movimiento.

Si quieres encargarnos un trabajo similar al que estás viendo pulsa en el botón inferior para solicitar un presupuesto online sin compromiso.

[¡Quiero uno igual!]

◀ anterior 2 siguiente ▶

Inerciabcn disseny i multimedia s.l. correo: info@inerciabcn.com telf: 93 207 73 22 - fax: 93 539 06 40 Politica de privacidad Mapa web

www.inerciabcn.com
D: raül fornell gómez **C**: raül fornell gómez **P**: eloi carbó
A: inerciabcn **M**: info@inerciabcn.com

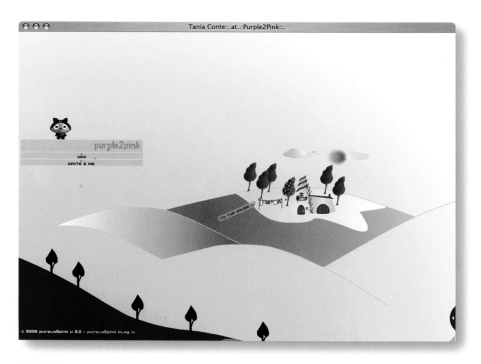

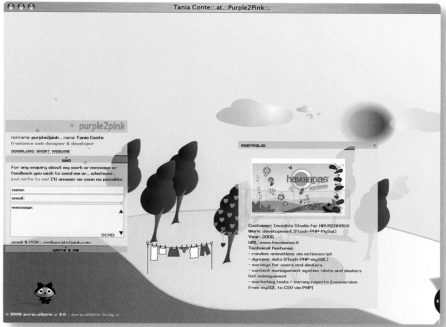

www.purple2pink.com/main.php
D: tania conte **C:** tania conte **P:** tania conte
A: conte antonietta **M:** me@purple2pink.com

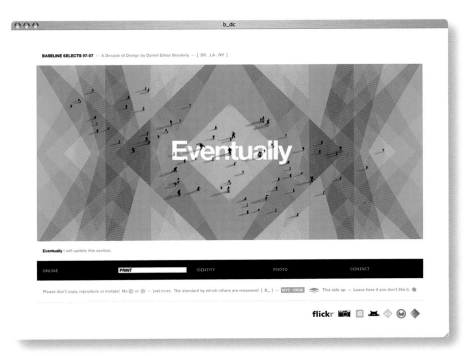

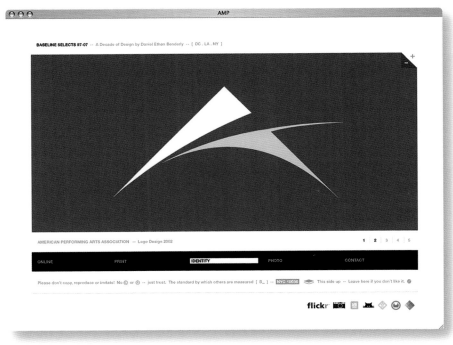

www.baselinedc.com

D: daniel ethan benderly

M: dan@baselinedc.com

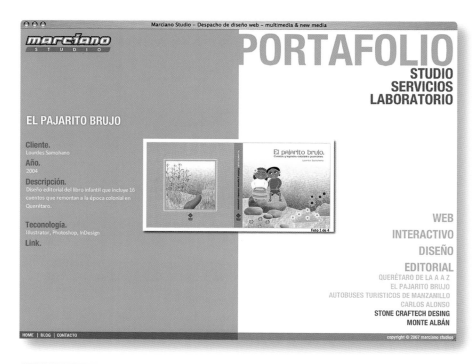

www.marciano.com.mx
D: sandra gómez alcántara **C:** fernando torres losa
A: marciano studio **M:** info@marciano.com.mx

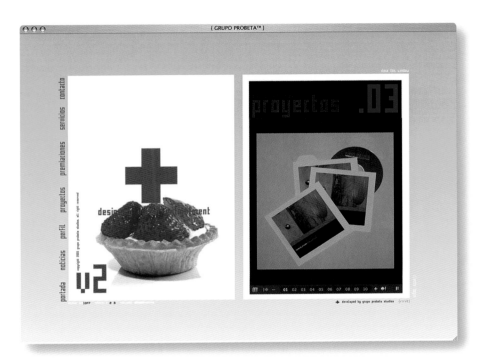

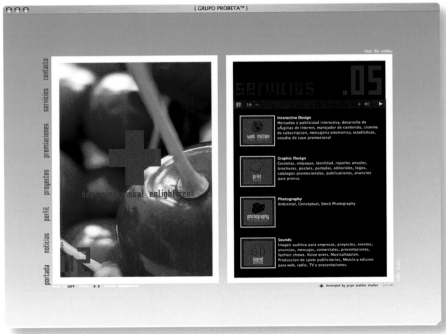

www.grupoprobeta.com

D: a roman, lilliam nieves **C**: daniel arnaldo roman **P**: grupo probeta studios
A: grupo probeta studios **M**: www.grupoprobeta.com

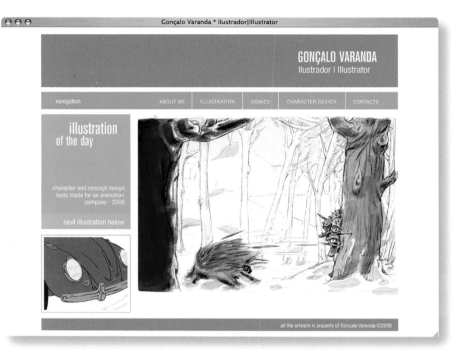

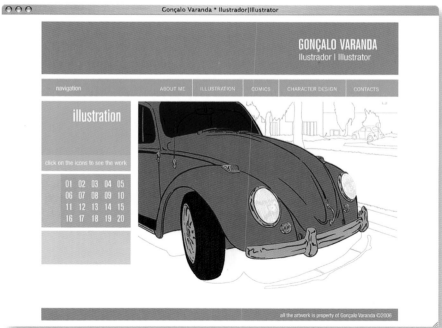

www.goncalovaranda.com

D: joao pedro canhenha **C:** joao pedro canhenha **P:** joao pedro canhenha
A: goncalo varanda **M:** geral@joaopedrocanhenha.com

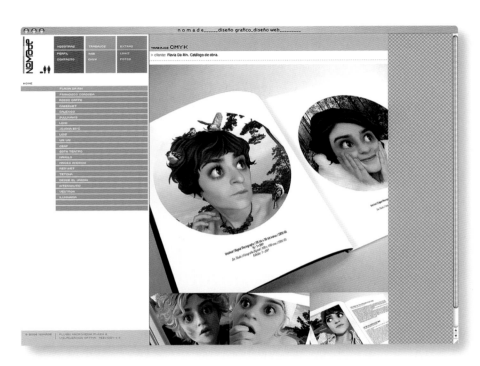

www.paginanomade.com.ar
D: renata cymlich, carolina cruz
A: nomade M: www.paginanomade.com.ar

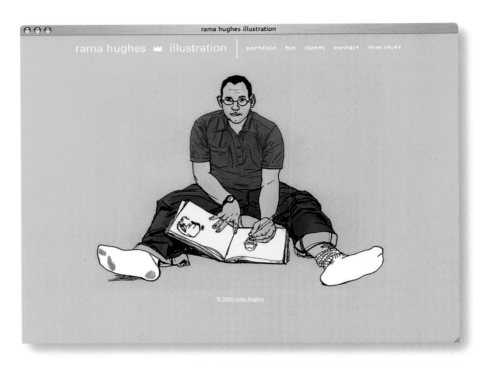

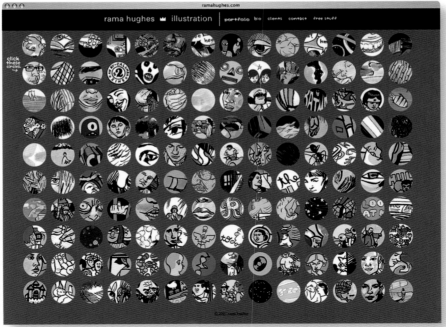

www.ramahughes.com

D: rama hughes C: rama hughes P: rama hughes
A: rama hughes illustration M: rama hughes

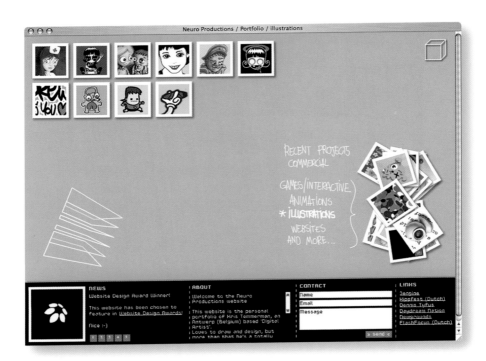

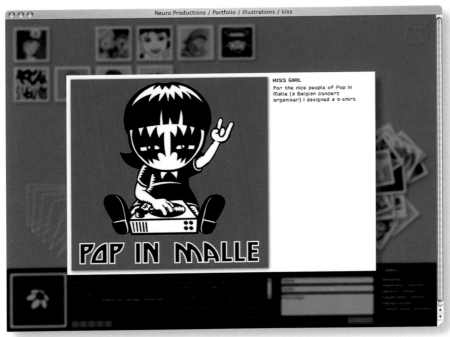

www.neuroproductions.be

D: kris temmerman C: kris temmerman P: kris temmerman
A: neuro productions M: info@neuroproductions.be

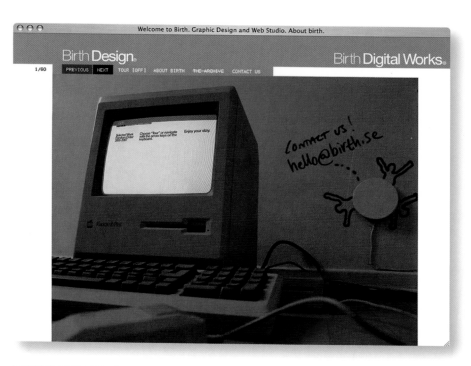

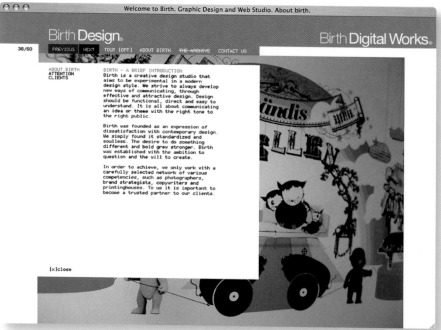

www.birth.se

D: magnus eckhéll, mattias brodén C: martin sandström

A: birth M: hello@birth.se

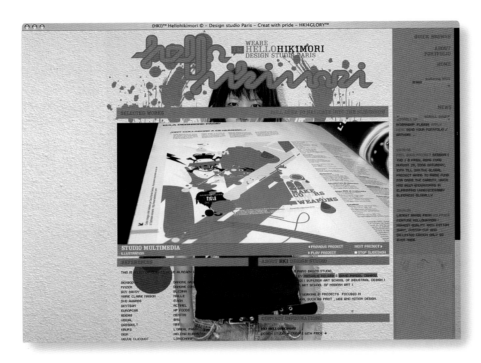

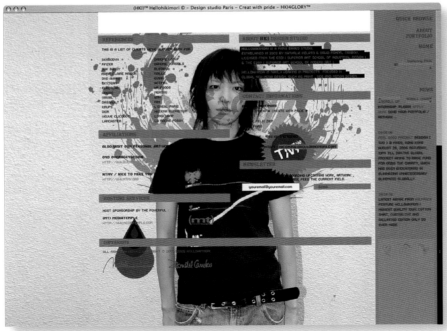

hellohikimori.com
D: nathalie melato, david rondel cambou C: vincent legrand
A: (hki) hellohikimori M: incoming@hellohikimori.com

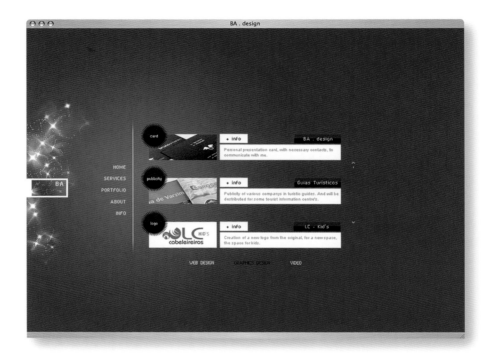

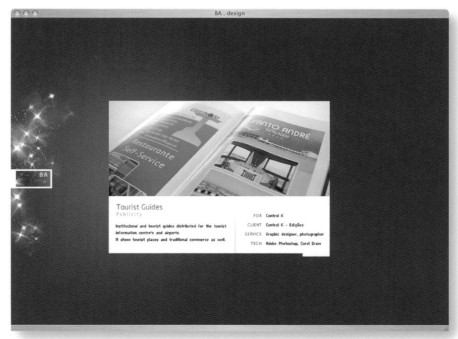

www.bruno-amorim.com
D: bruno amorim C: bruno amorim P: bruno amorim
M: geral@bruno-amorim.com

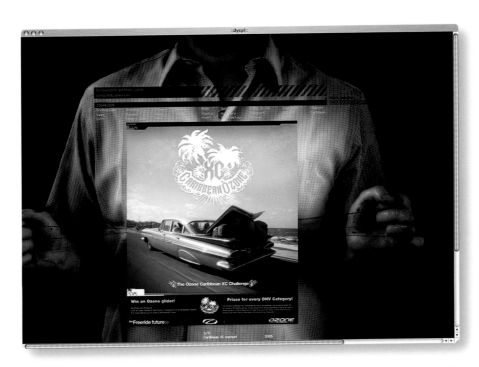

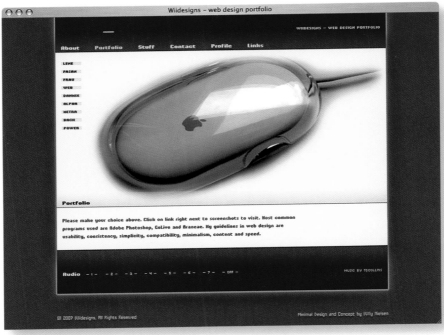

www.wiidesigns.com

D: willy nielsen **C:** willy nielsen **P:** willy nielsen
A: wiidesigns.com **M:** wii@onebox.com

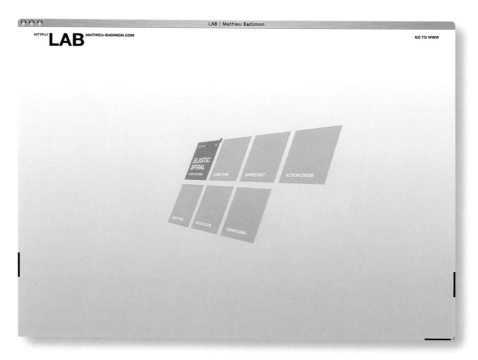

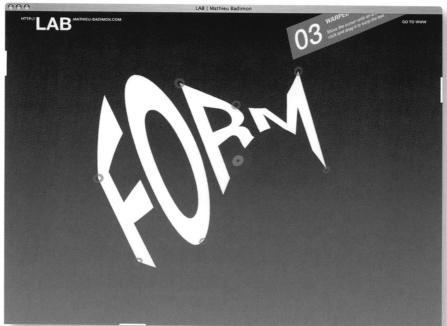

lab.mathieu-badimon.com

D: mathieu badimon **C:** mathieu badimon **P:** mathieu badimon
A: mathieu badimon (freelance) **M:** contact@mathieu-badimon.com

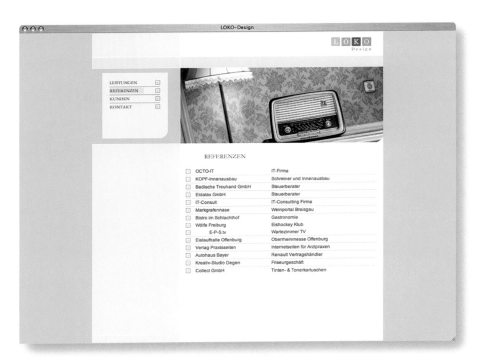

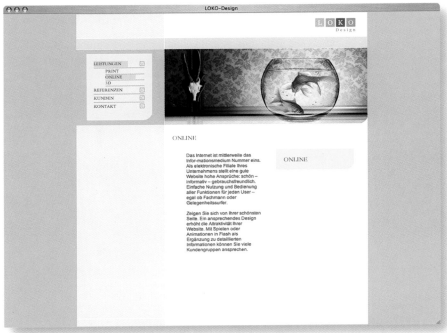

www.loko-design.com
D: markus matuschyk **C:** markus matuschyk **P:** markus matuschyk
A: loko-design **M:** info@loko-design.com

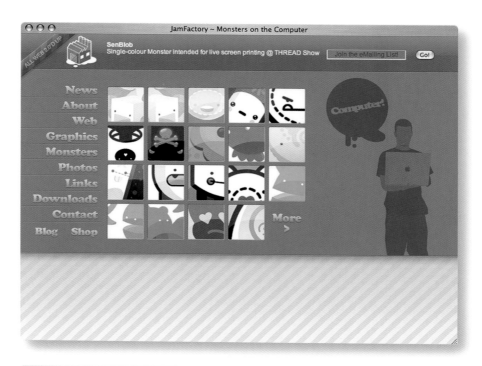

www.jam-factory.com
D: gavin strange **C:** gavin strange **P:** gavin strange
A: jamfactory **M:** gav@jam-factory.com

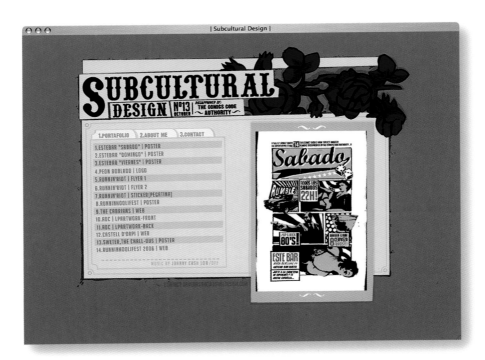

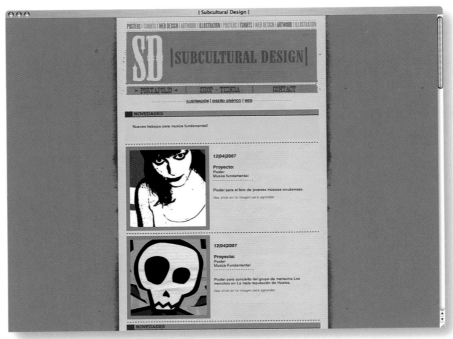

www.subculturaldesign.com
D: david sánchez fernández
A: factoría norte M: ruben@factorianorte.com

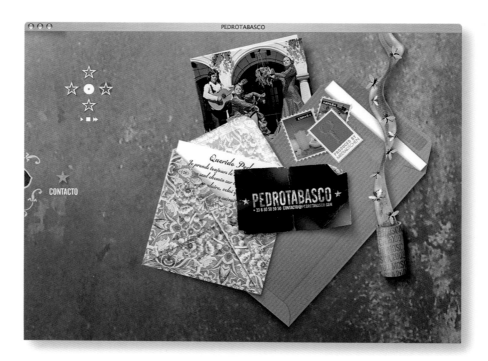

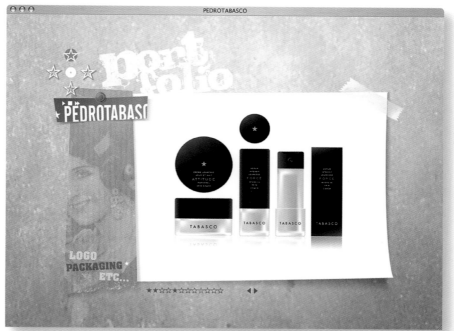

www.pedrotabasco.com

D: pedrotabasco **C:** mediakitchen **P:** pedrotabasco
A: pedrotabasco **M:** contacto@pedrotabasco.com

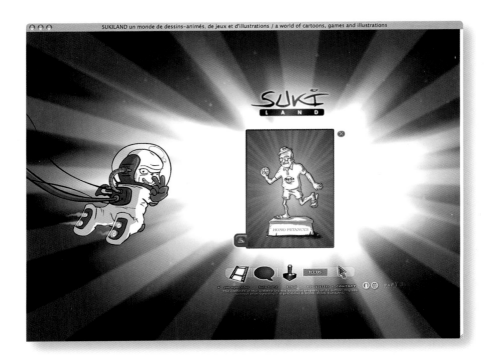

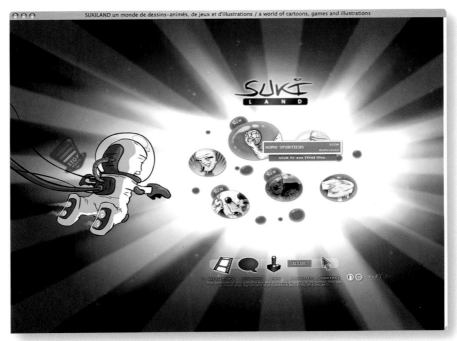

www.sukiland.com

D: suki **C:** suki **P:** suki
A: sukiland **M:** contact@sukiland.com

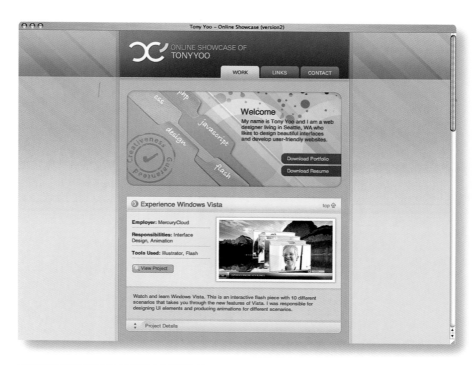

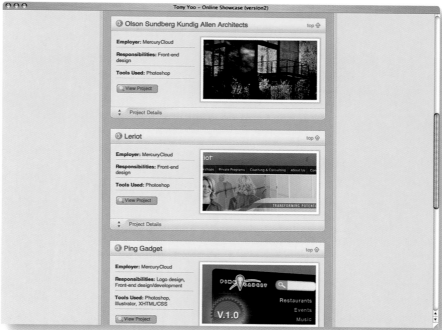

www.tonyyoo.com
D: tony yoo
M: info@tonyyoo.com

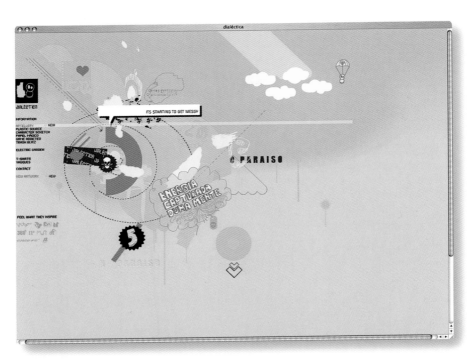

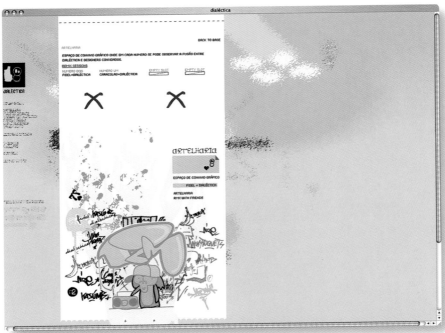

www.dialectica.net
D: carlos matias
M: carlos@dialectica.net

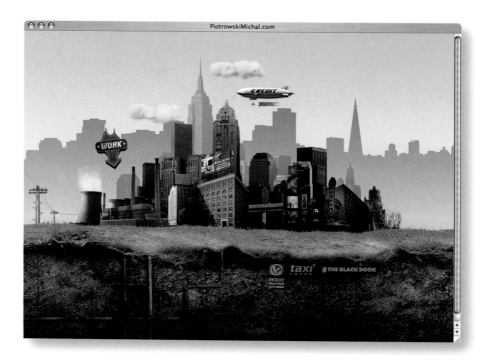

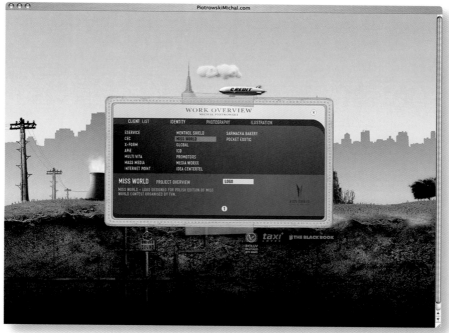

www.piotrowskimichal.com
D: michal piotrowski C: wojtek szklarski, waldi P: michal piotrowski
M: piotrowskimichal@yahoo.com

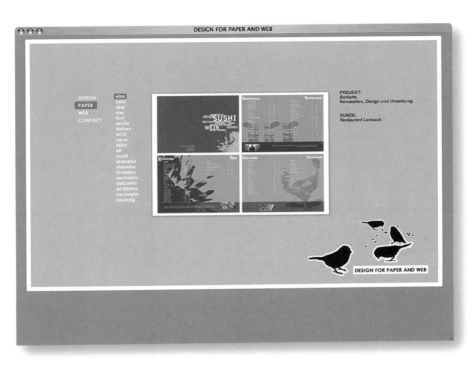

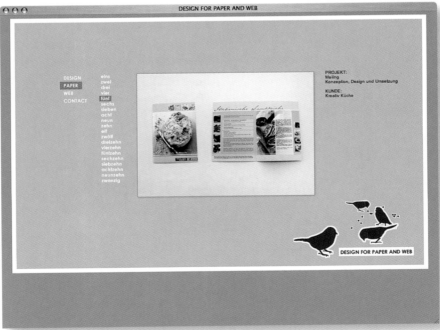

www.designforpaperandweb.de

D: simone friedenberger C: simone friedenberger P: simone friedenberger

A: design for paper and web M: info@designforpaperandweb.de

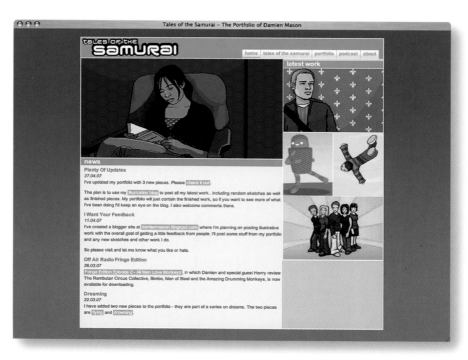

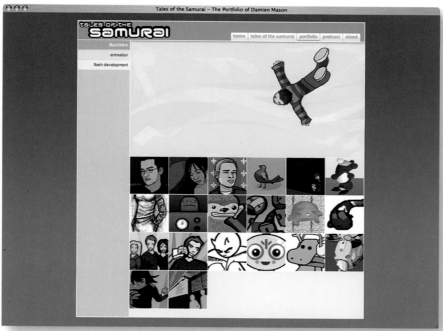

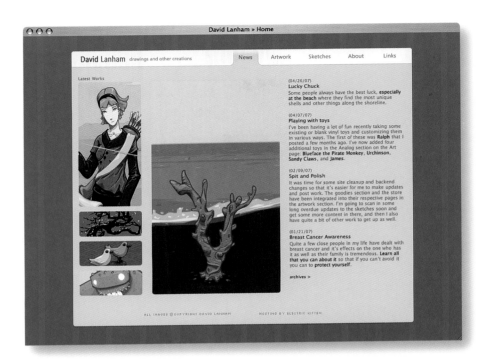

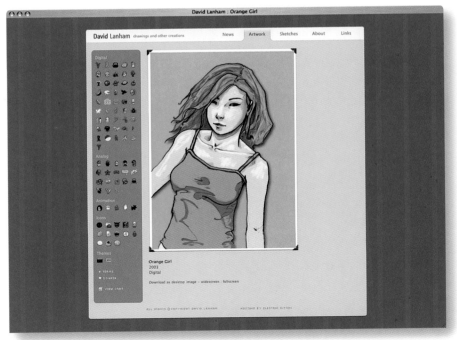

dlanham.com
D: david lanham C: david lanham P: david lanham
M: contact@dlanham.com

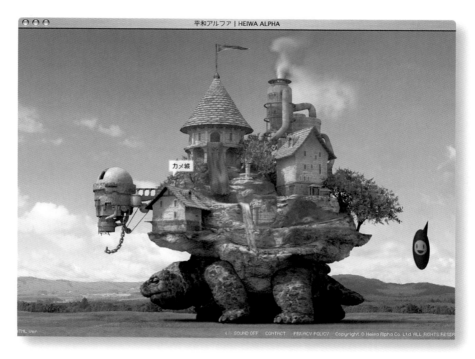

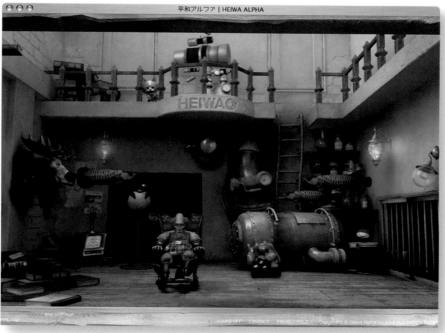

www.heiwa-alpha.co.jp
D: heiwa alpha co.
A: heiwa alpha co. M: go.takahashi@exsa.jp

www.garn.com.br
D: d. miguel **C:** d. miguel **P:** d. miguel
A: s. garn **M:** miguel@garn.com.br

www.dawebsiteb4dawebsite.com

D: alon zouaretz C: alon zouaretz P: alon zouaretz

A: da website b4 da website M: dainfo@dawebsiteb4dawebsite.com

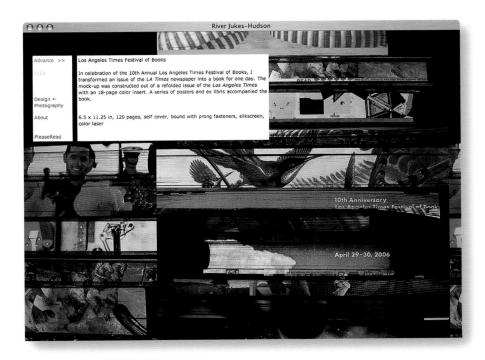

Los Angeles Times Festival of Books

In celebration of the 10th Annual Los Angeles Times Festival of Books, I transformed an issue of the *LA Times* newspaper into a book for one day. The mock-up was constructed out of a refolded issue of the *Los Angeles Times* with an 18-page color insert. A series of posters and ex libris accompanied the book.

6.5 x 11.25 in, 120 pages, self cover, bound with prong fasteners, silkscreen, color laser

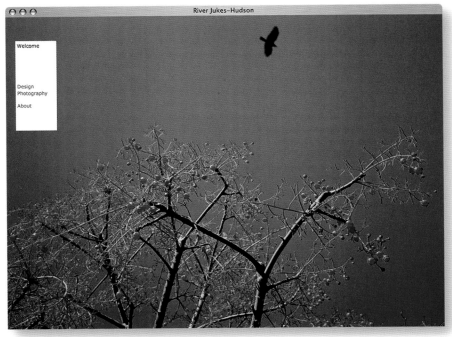

www.pleaseread.us

D: river jukes-hudson C: river jukes-hudson P: river jukes-hudson
A: please read M: info@pleaseread.us

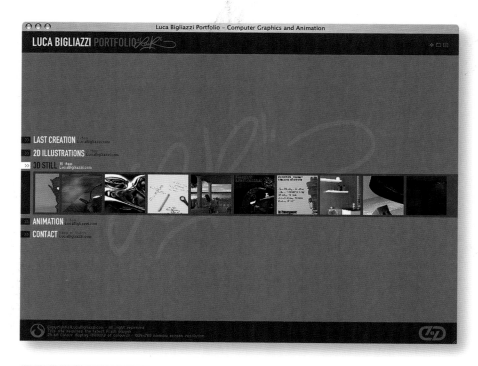

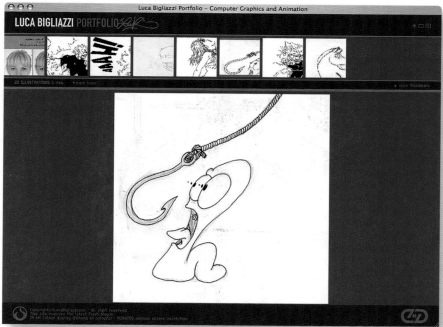

www.lucabigliazzi.com

D: enzo li volti **C:** enzo li volti

A: design officine **M:** info@design-officine.com

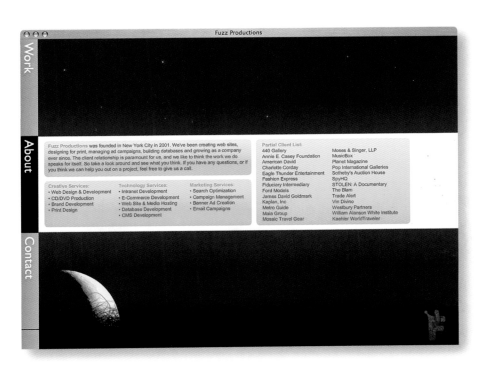

Fuzz Productions

Fuzz Productions was founded in New York City in 2001. We've been creating web sites, designing for print, managing ad campaigns, building databases and growing as a company ever since. The client relationship is paramount for us, and we like to think the work we do speaks for itself. So take a look around and see what you think. If you have any questions, or if you think we can help you out on a project, feel free to give us a call.

Creative Services:
- Web Design & Development
- CD/DVD Production
- Brand Development
- Print Design

Technology Services:
- Intranet Development
- E-Commerce Development
- Web Site & Media Hosting
- Database Development
- CMS Development

Marketing Services:
- Search Optimization
- Campaign Management
- Banner Ad Creation
- Email Campaigns

Partial Client List:

440 Gallery	Moses & Singer, LLP
Annie E. Casey Foundation	MusicBox
American David	Planet Magazine
Charlotte Corday	Pop International Galleries
Eagle Thunder Entertainment	Sotheby's Auction House
Fashion Express	SpyHQ
Fiduciary Intermediary	STOLEN: A Documentary
Ford Models	The Blam
James David Goldmark	Trade Alert
Kaplan, Inc	Vin Divino
Metro Guide	Westbury Partners
Mais Group	William Alanson White Institute
Mosaic Travel Gear	Kaehler WorldTraveler

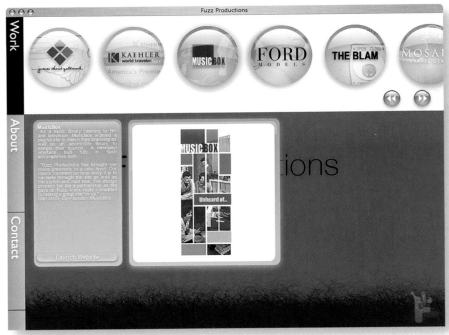

Fuzz Productions

MusicBox
As a music library catering to film and television, MusicBox wanted a playful site to match their branding as well as an accessible library to sample their sounds. A minimalist interface built fully in Flash accomplishes both.

"Fuzz Productions has brought our online presence to a new level. Our clients comment on how easy it is to navigate through the site as well as the stylish and mod look. The design process felt like a partnership, as the guys at Fuzz were really committed to making a great site for us."
Dan Stein, Co-Founder, MusicBox

Launch Website

www.fuzzproductions.com
D: will trienens C: nick trienens P: nathanial trienens
A: fuzz productions M: info@fuzzproductions.com

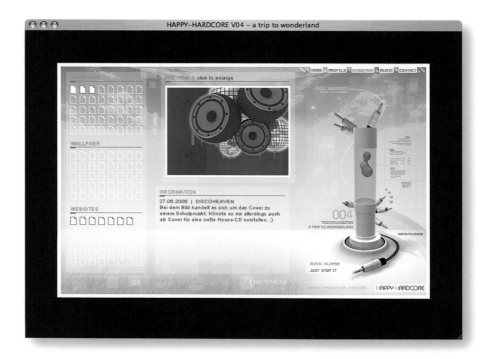

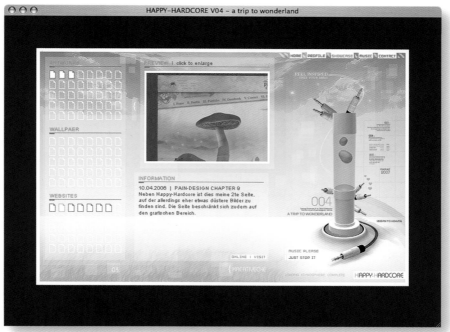

happy-hardcore.de
D: patrick weisbecker
M: pain-design@web.de

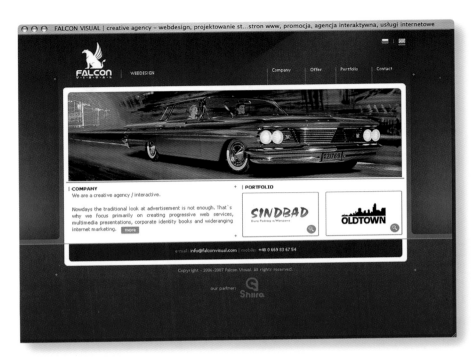

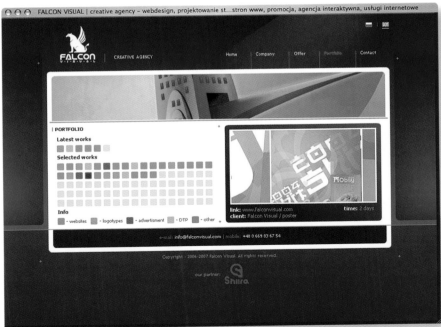

www.falconvisual.com

D: michał cicho **C:** micha cicho **P:** micha cicho
A: falcon visual | creative agency **M:** info@falconvisual.com

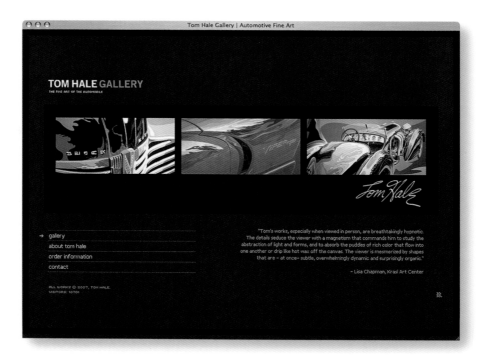

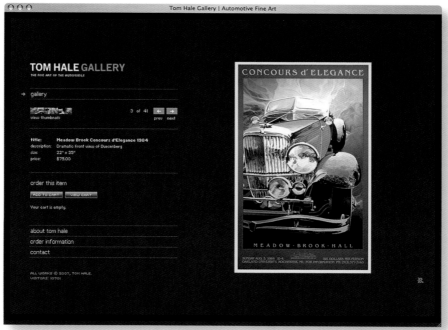

www.tomhalegallery.com

D: richard thompson C: richard thompson P: tom hale
A: richard thompson new media communications design M: info@richardthompson.com

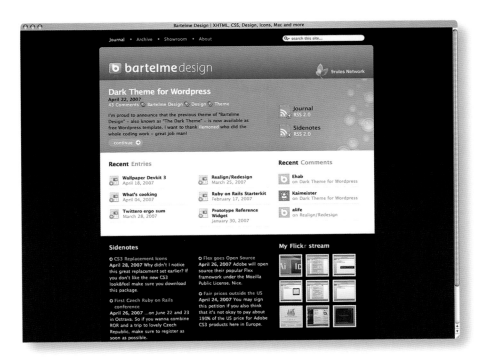

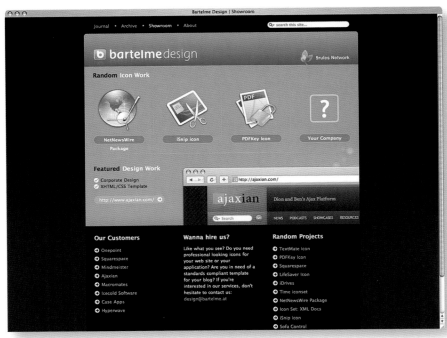

www.bartelme.at

D: wolfgang bartelme **C:** wolfgang bartelme **P:** wolfgang bartelme

A: bartelme design **M:** design@bartelme.at

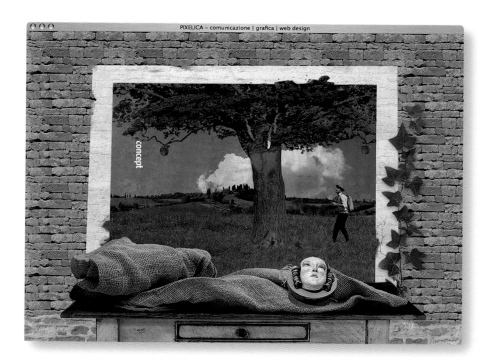

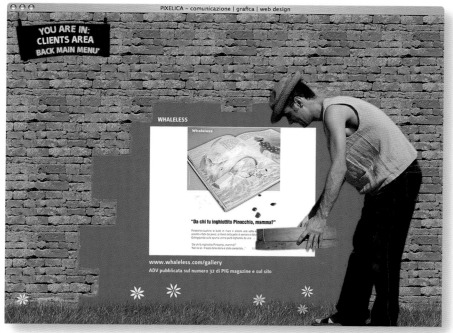

www.pixelica.it
D: mia pontano, andrea modenese
A: pixelica snc M: info@pixelica.it

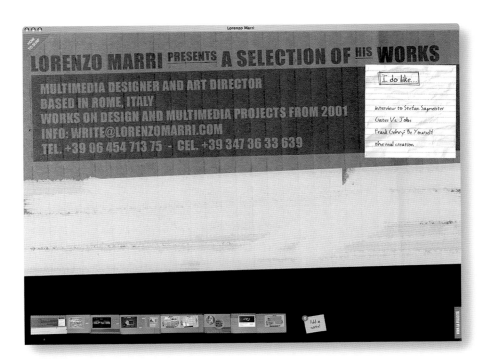

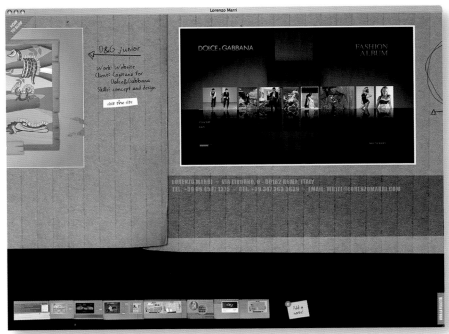

www.lorenzomarri.com
D: lorenzo marri C: lorenzo marri
M: write@lorenzomarri.com

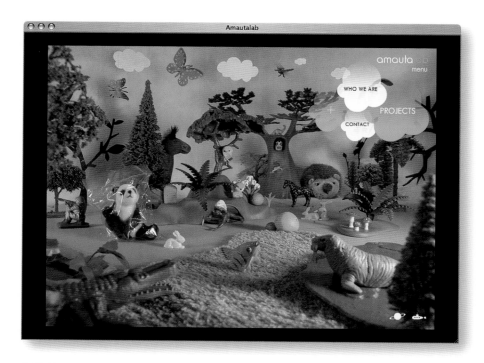

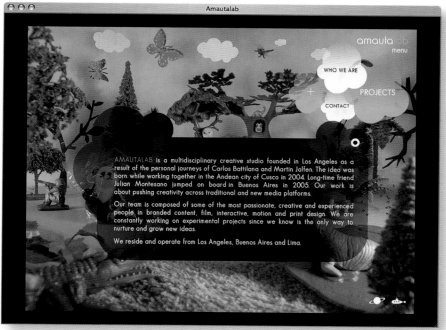

www.amautalab.com

D: martin jalfen, julian montesano C: pedro leon P: carlos battilana, melisa rodriguez
A: amautalab M: carlos@amautalab.com

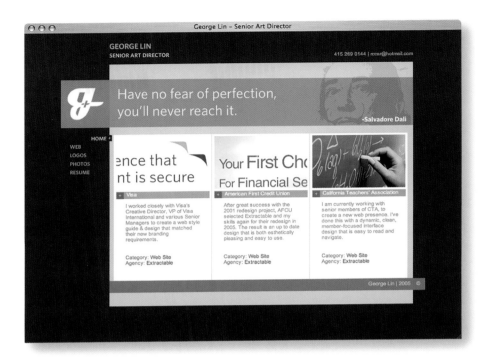

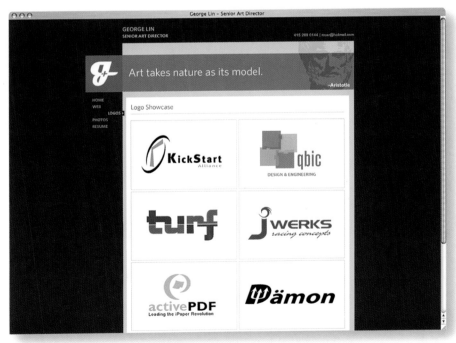

www.georgeplus.com

D: george lin **C:** pasquale scerbo **P:** george lin
A: georgeplus designs **M:** george@georgeplus.com

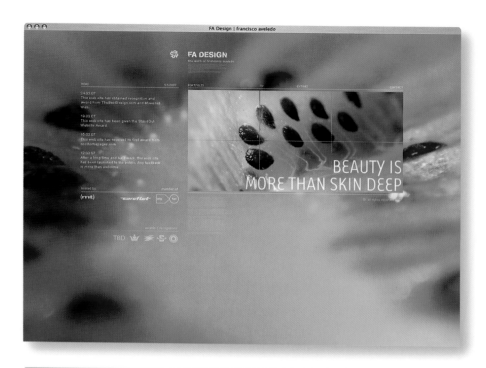

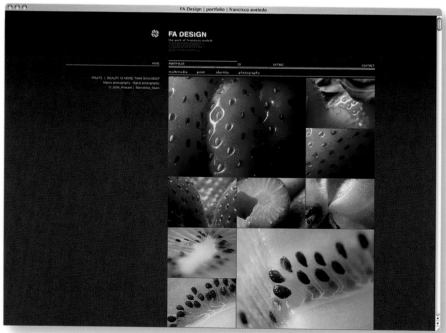

www.fa-d.com

D: francisco aveledo C: francisco aveledo P: francisco aveledo
M: info@fa-d.com

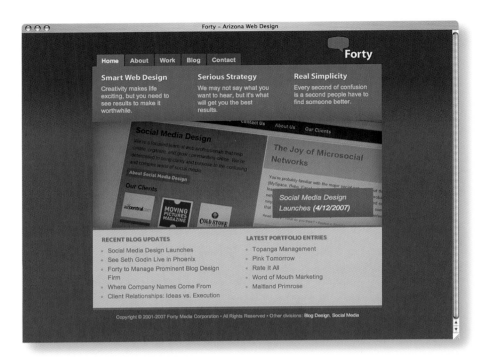

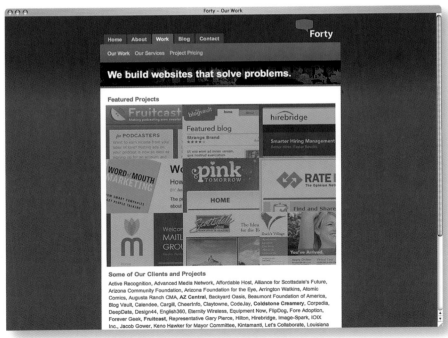

www.fortymedia.com

D: dan ritzenthaler C: james archer P: aaron post
A: forty M: info@fortymedia.com

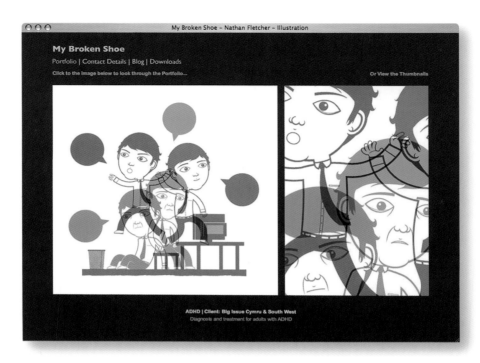

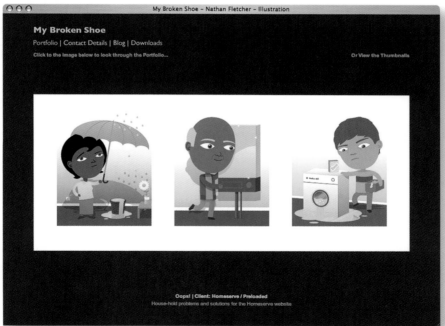

www.mybrokenshoe.com
D: nathan fletcher
M: sayhello@mybrokenshoe.com

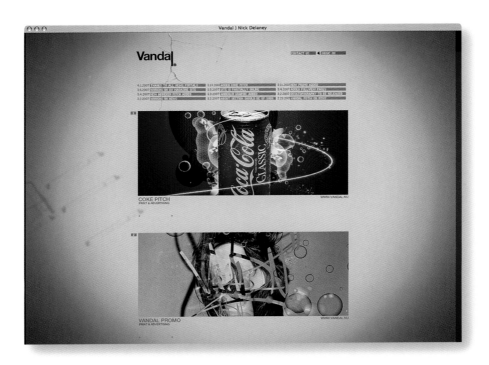

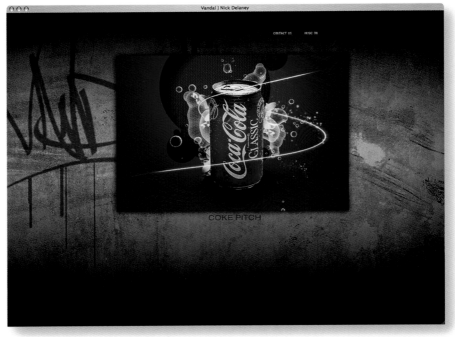

vandal.nu
D: nick delaney **C:** nick delaney **P:** nick delaney
A: vandal creative **M:** wegrow@gmail.com

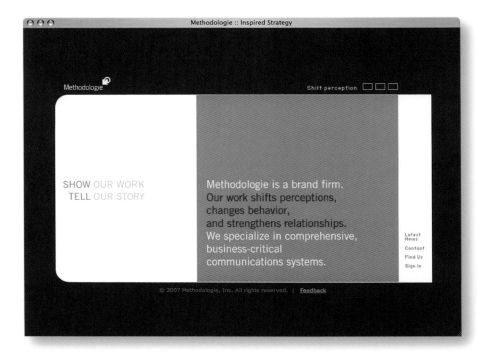

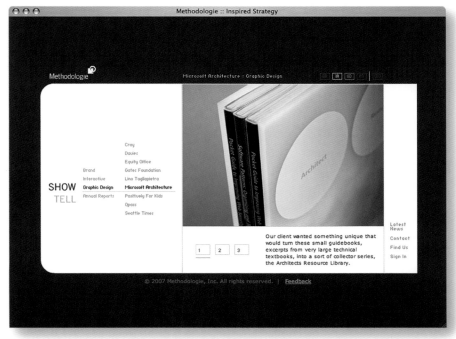

www.methodologie.com
D: paul ingram, daniele monti **C:** dan vaslow
A: methodologie, inc. **M:** info@methodologie.com

www.konnectdesign.com
D: sarah rainwater, karen knecht C: sarah rainwater P: karen knecht
A: konnectdesign M: look@konnectdesign.com

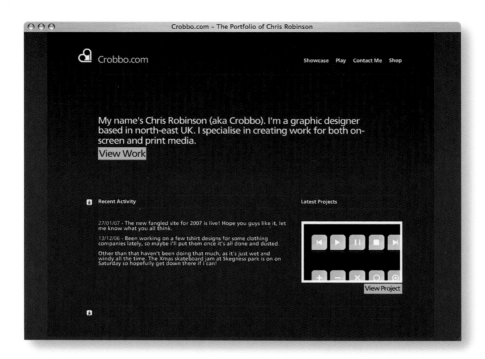

www.crobbo.com
D: chris robinson C: chris robinson P: chris robinson
A: crobbo M: info@crobbo.com

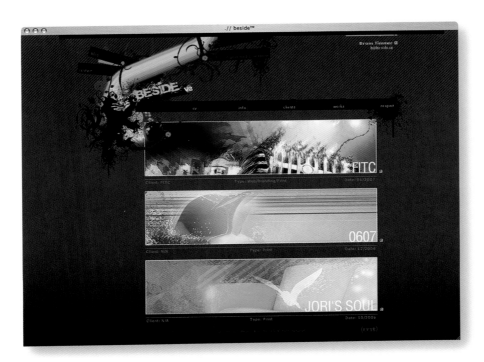

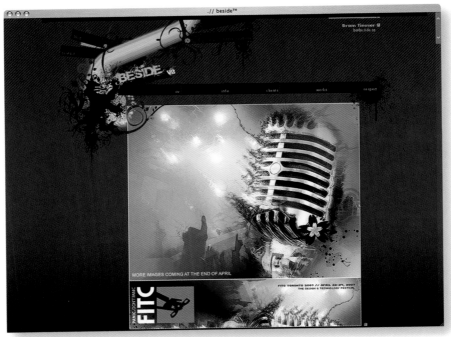

www.beside.ca
D: bram timmer
M: b@beside.ca

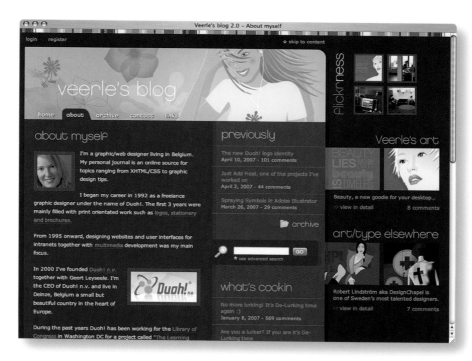

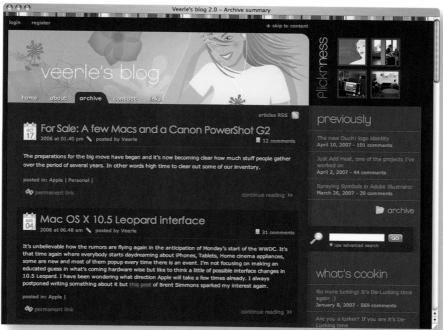

veerle.duoh.com/blog/about/
D: veerle pieters C: veerle pieters P: veerle pieters, geert leyseele
A: duoh! n.v. M: info@duoh.com

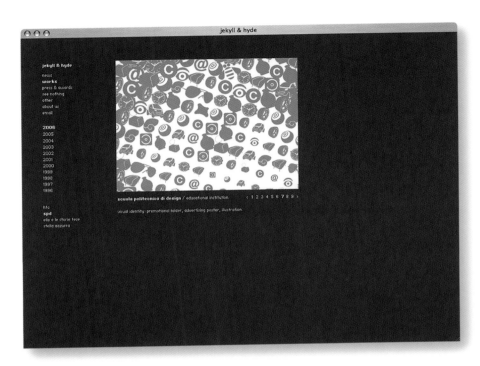

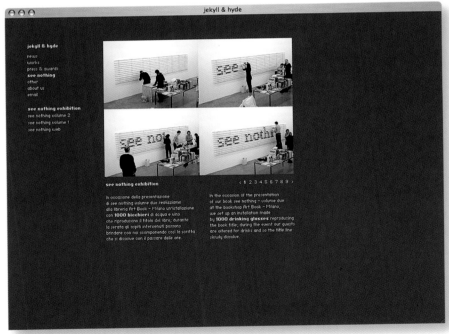

www.jeh.it

D: marco molteni, margherita monguzzi **C:** jorge pomareda **P:** jekyll & hyde
A: jekyll & hyde **M:** info@jeh.it

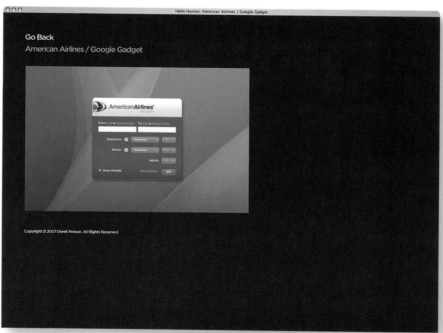

www.hellohuman.net

D: derek nelson

A: hello human **M:** derek.nelson@hellohuman.net

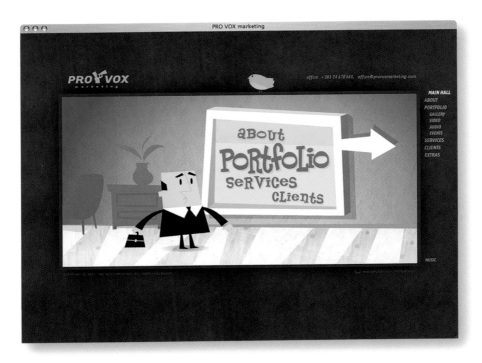

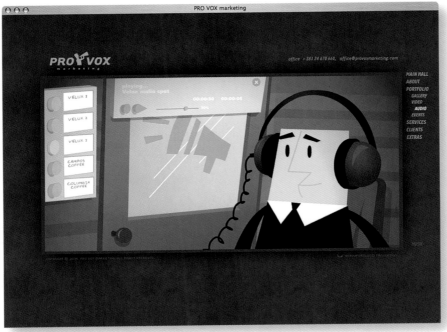

www.provoxmarketing.com

D: heavyform C: heavyform P: pro vox marketing
A: pro vox marketing M: office@provoxmarketing.com

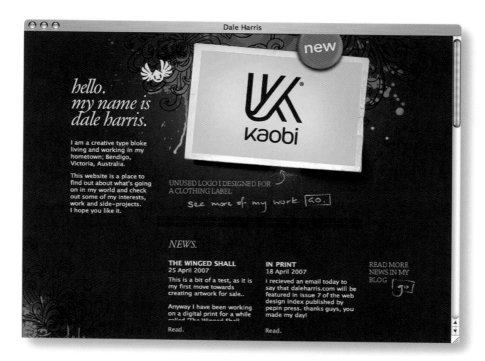

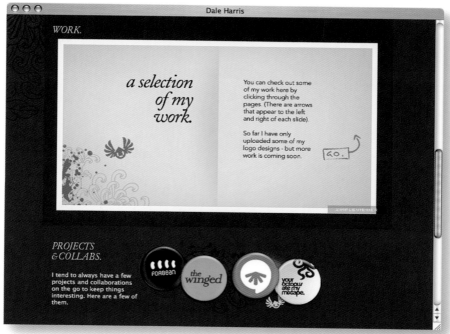

www.daleharris.com

D: dale harris **C:** dale harris

M: hello@daleharris.com

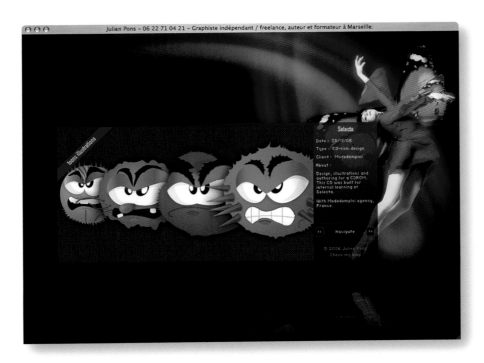

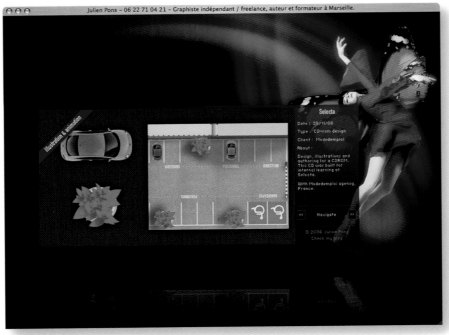

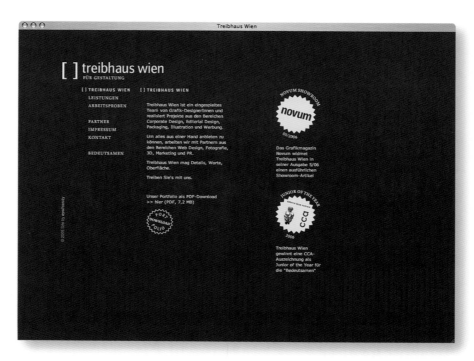

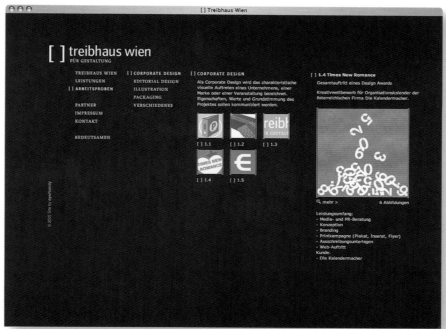

treibhaus-wien.at

D: ulrike dorner, georg leditzky **C:** tobias hildebrandt, www.eyecandy.at

A: treibhaus wien **M:** info@treibhaus-wien.at

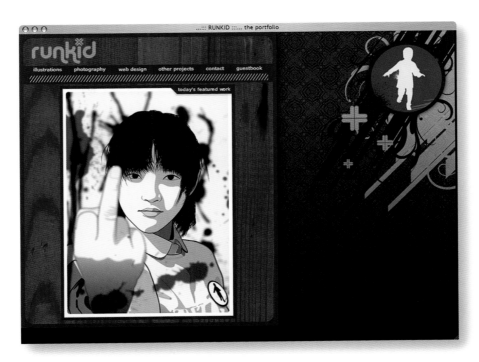

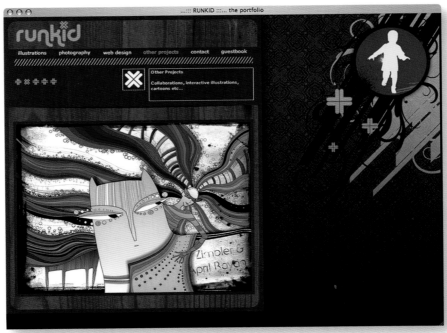

www.runkid.at
D: maksim marcenkevic
A: runkid **M:** good.looking.blues@gmail.com

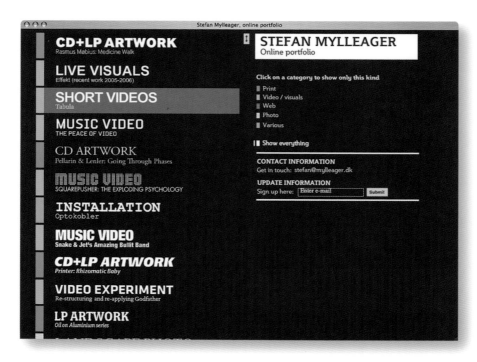

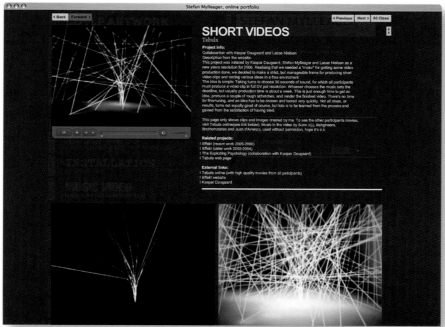

www.mylleager.dk
D: stefan mylleager C: stefan mylleager
M: stefan@mylleager.dk

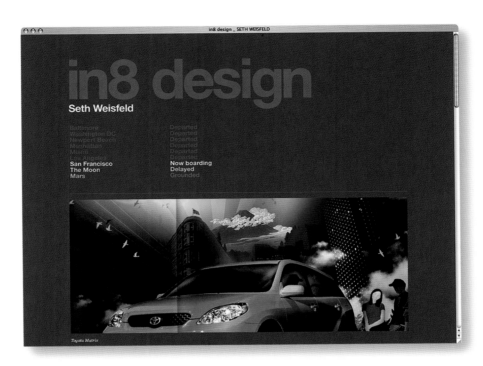

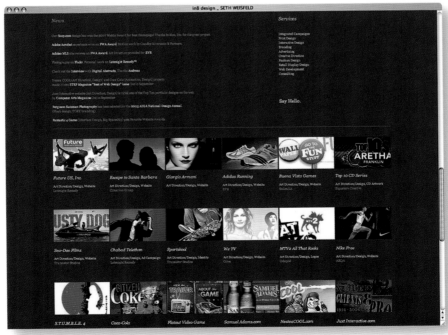

www.in8design.com
D: seth weisfeld **C:** seth weisfeld **P:** seth weisfeld
A: in8 design **M:** bonjour@in8design.com

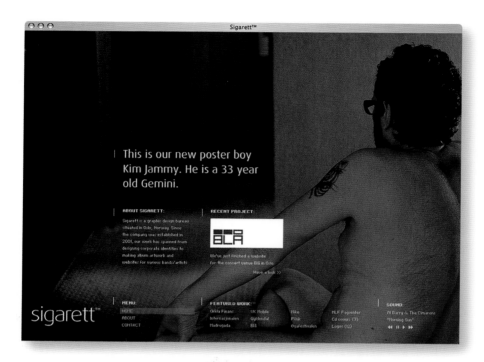

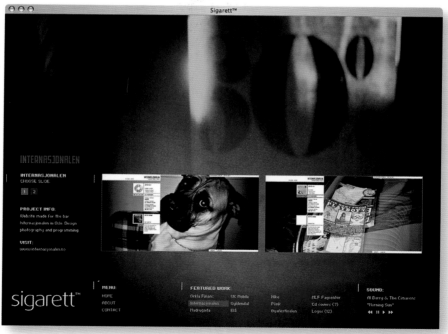

www.sigarett.com

D: kaare saatvedt, morten iveland C: kaare saatvedt, morten iveland P: sigarett design
A: sigarett design as M: rune@sigarett.com

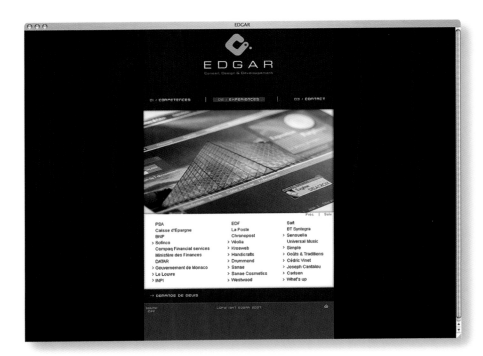

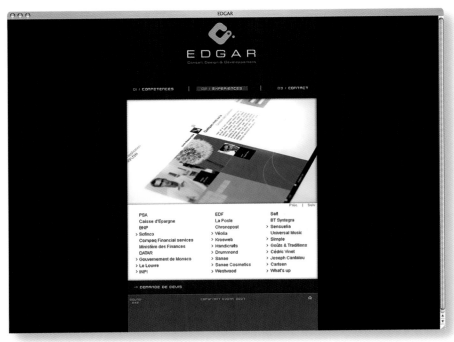

www.edgarstudio.fr

D: cédric vinet **C:** cédric vinet **P:** cédric vinet

A: edgar **M:** contact@edgarstudio.fr

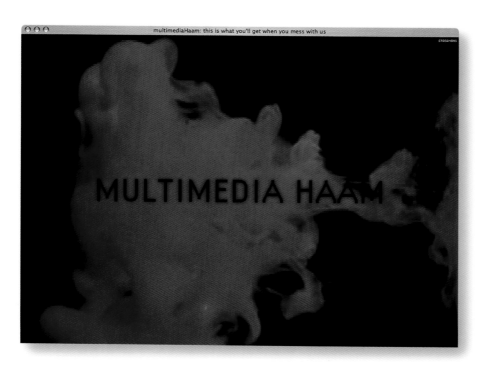

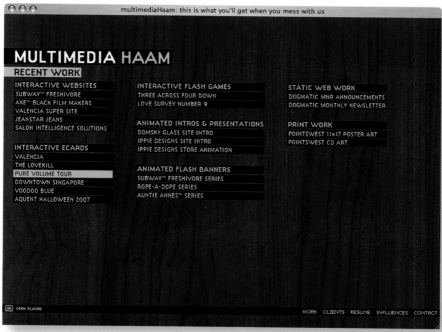

www.multimediahaam.com
D: aragorn ligocki **C:** aragorn ligocki **P:** aragorn ligocki
A: multimediahaam **M:** anxiousarms@gmail.com

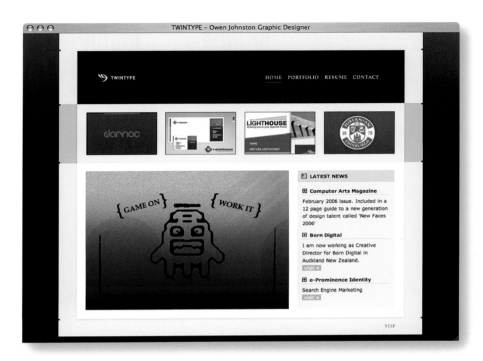

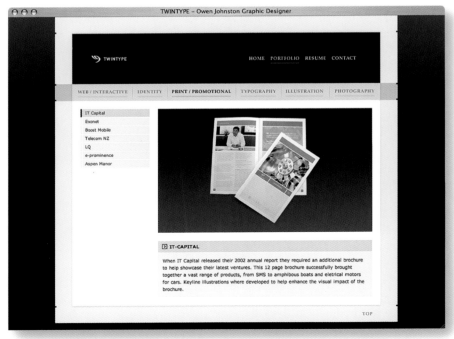

www.twintype.com

D: owen johnston C: owen johnston P: owen johnston

A: twintype M: owen@twintype.com

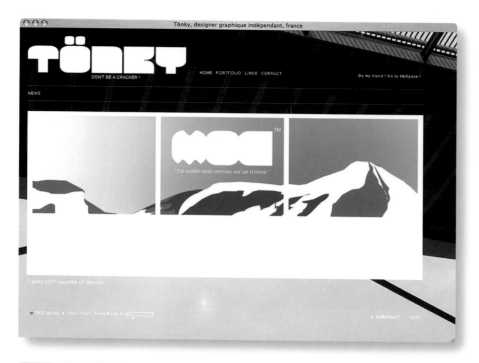

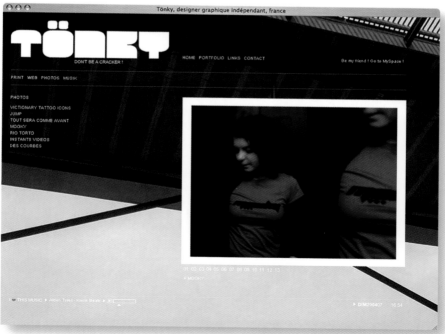

www.tonky.fr
D: franck valayer
M: tonky@tonky.fr

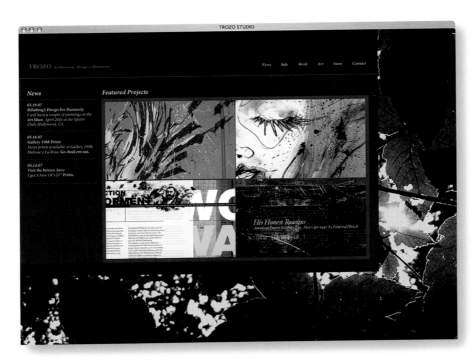

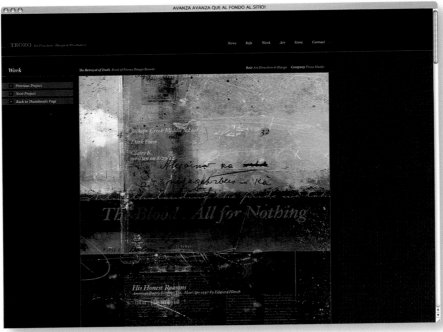

www.trozostudio.com

D: eduardo valdivieso C: eduardo valdivieso P: eduardo valdivieso

A: trozo studio M: eduardo@trozostudio.com

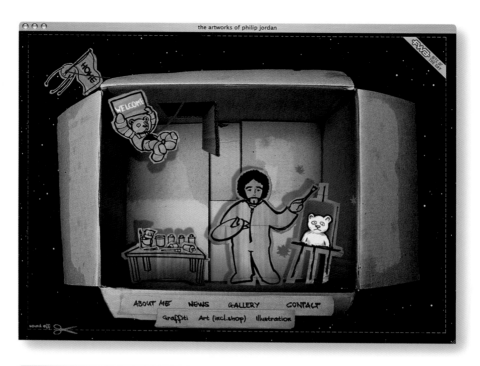

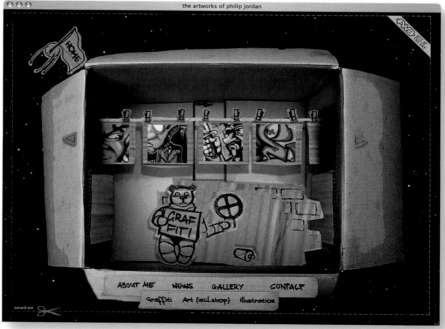

teddiesinspace.com
D: ingo j. ramin C: ingo j. ramin P: ingo j. ramin
A: 247 media studios M: info@24-7media.de

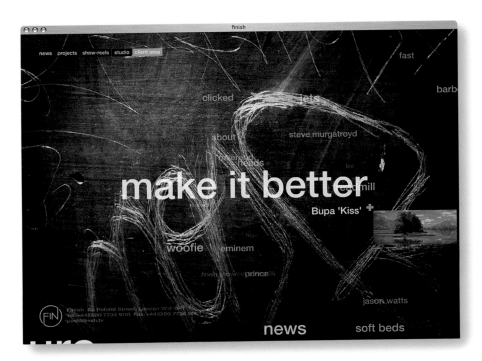

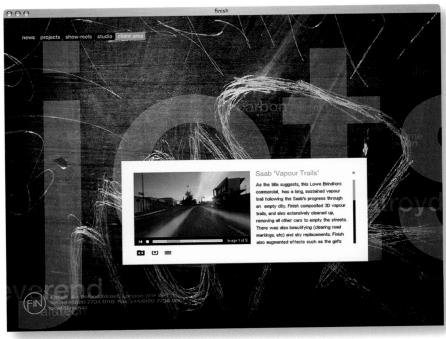

finish.tv

D: preloaded C: preloaded

A: finish M: justine white

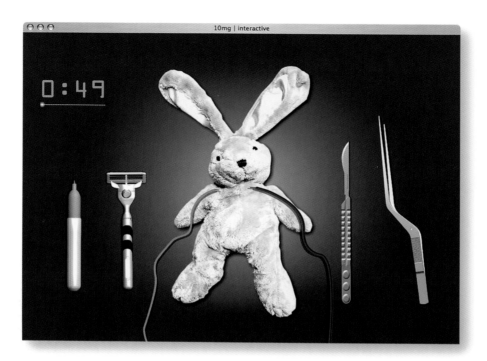

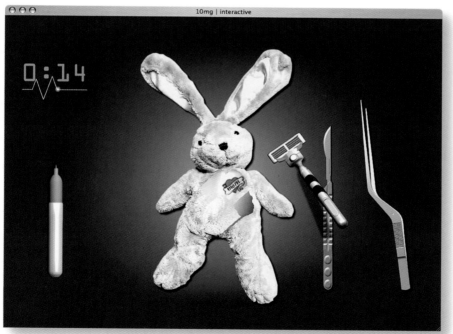

www.10mg.nl
D: demmy onink C: marc selhorst P: demmy onink, marc selhorst
A: 10mg | interactive M: info@10mg.nl

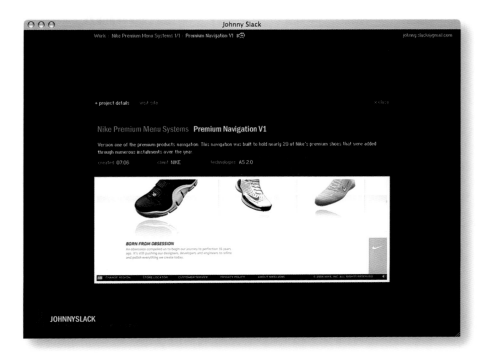

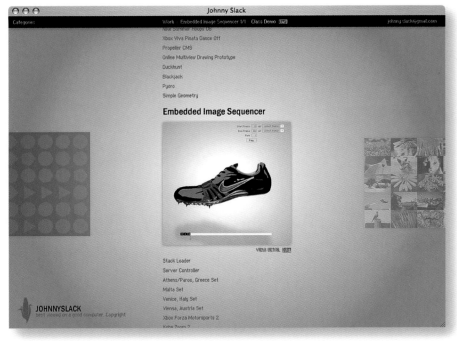

www.johnnyslack.com
D: johnny slack
M: johnny.slack@gmail.com

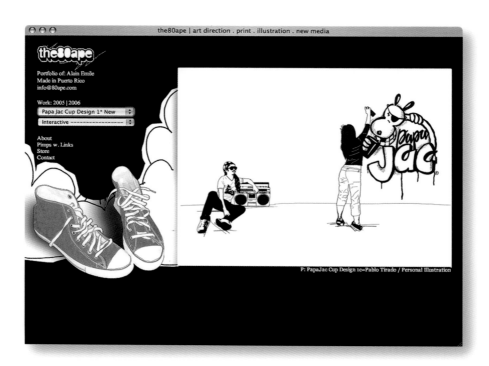

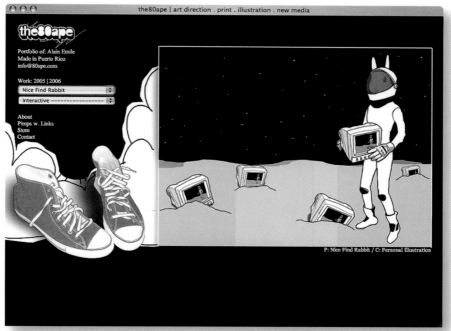

www.80ape.com
D: alain emile
A: the80ape M: info@80ape.com

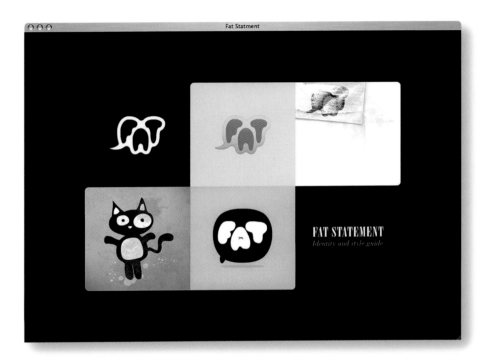

For work samples, nude photos, illegal designer drugs, and any other inquiries:

ANDY@
GIRLYMAC.
COM

Cheers

www.frozentoast.com
D: andy fandango
M: andy@frozentoast.com

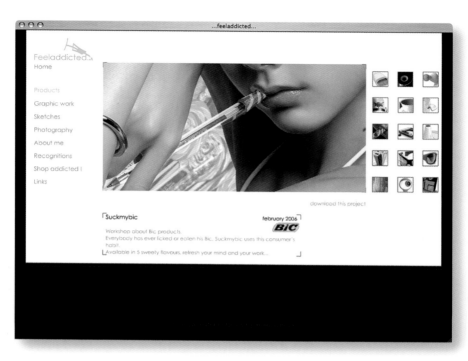

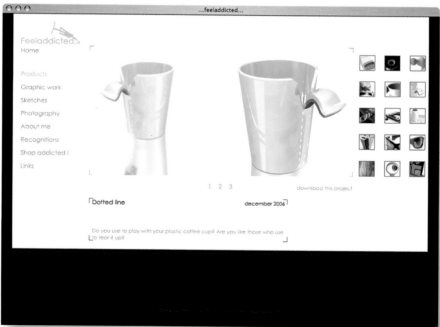

www.feeladdicted.com
D: clement eloy
M: clem_eloy@yahoo.fr

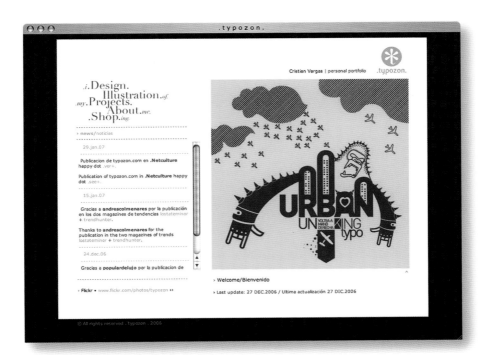

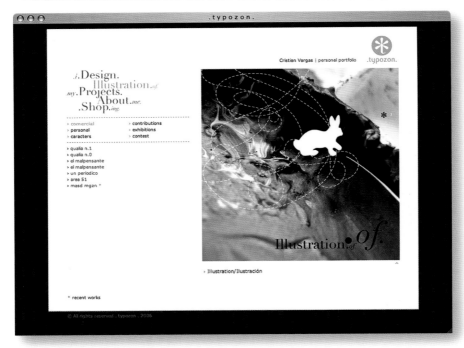

www.typozon.com

D: cristian vargas C: cristian vargas P: cristian vargas

A: .typozon. M: info@typozon.com

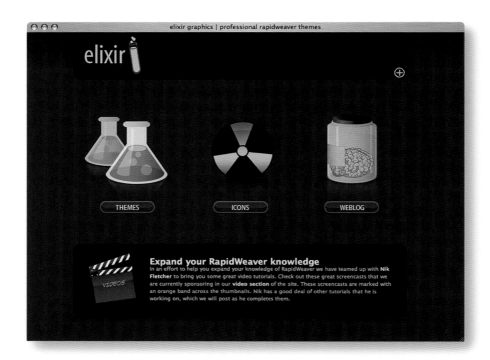

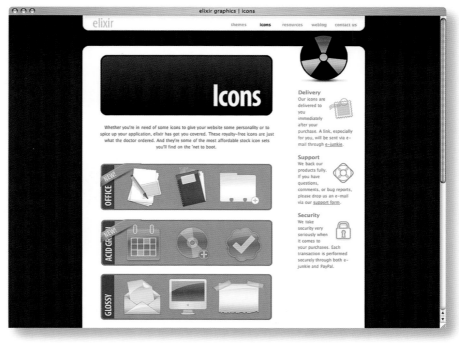

www.elixirgraphics.com
D: adam shiver C: adam shiver P: adam shiver
A: elixir graphics M: adam@elixirgraphics.com

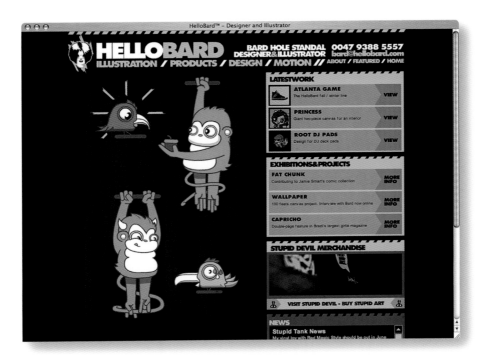

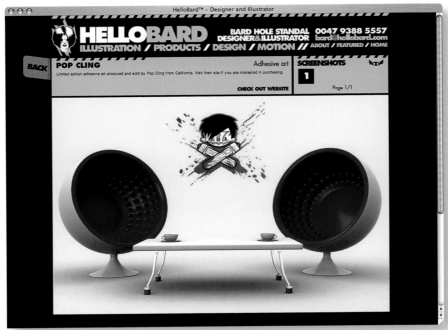

www.hellobard.com
D: bard hole standal C: odin hole standal P: bard hole standal
A: hellobard M: bard@hellobard.com

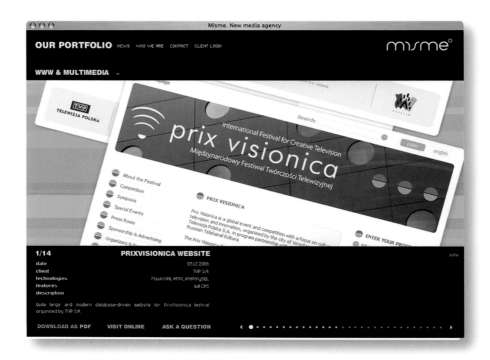

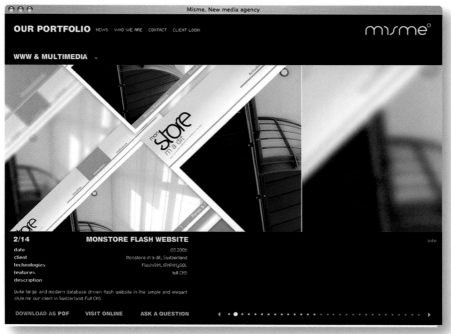

misme.pl
D: patryk kizny C: patryk kizny P: patryk kizny
A: misme new media agency M: misme.pl

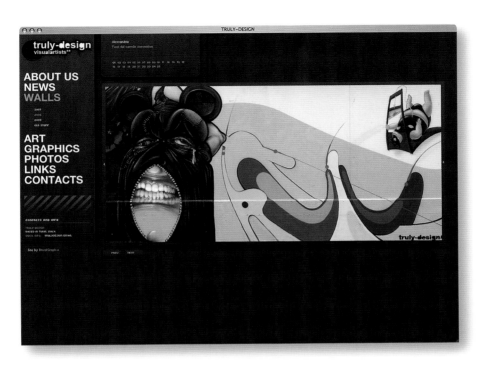

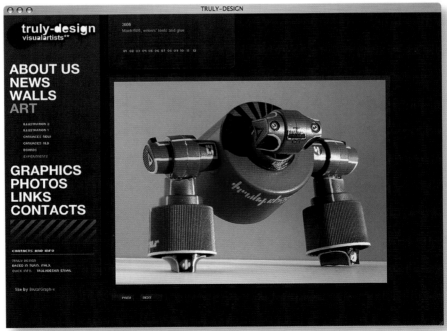

www.truly-design.com
D: emanuele tortolone **C:** emanuele tortolone **P:** emanuele tortolone
A: brutal graph-x **M:** contacts@brutalgraph-x.com

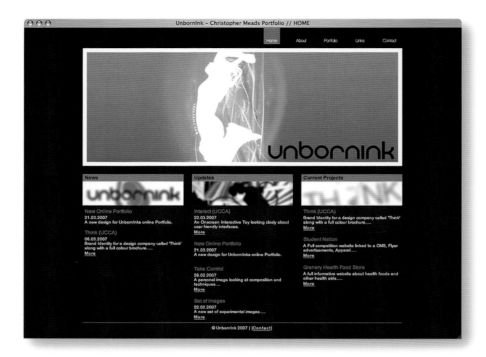

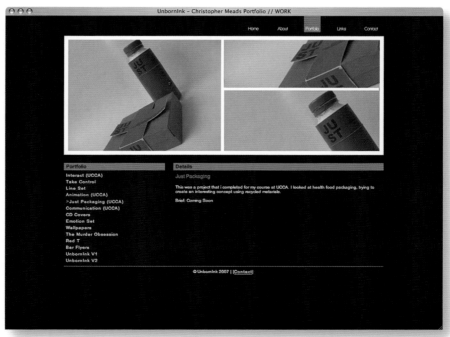

www.unbornink.com
D: christopher mead C: christopher mead P: christopher mead
A: unbornink M: admin@unbornink.com

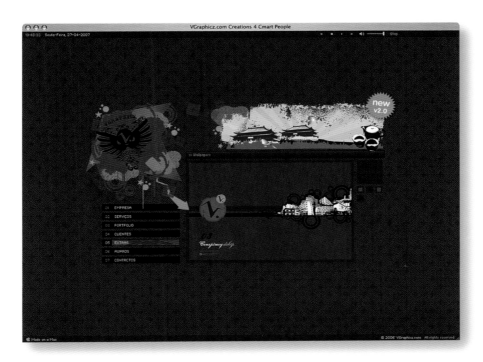

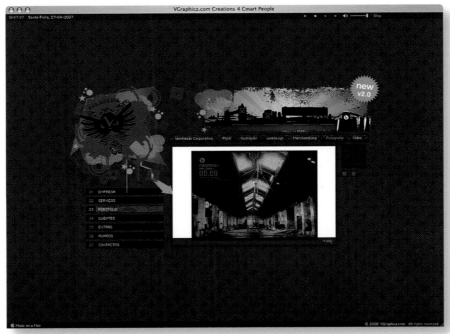

www.vgraphicz.com
D: paulo veiga C: paulo veiga P: paulo veiga
A: vgraphicz.com M: info@vgraphicz.com

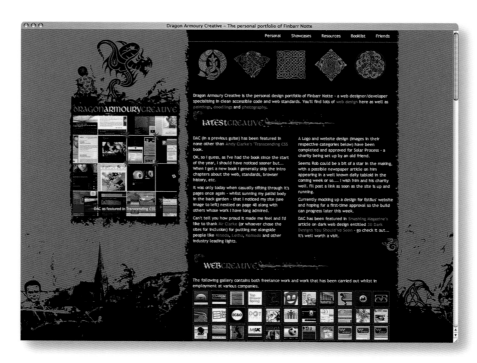

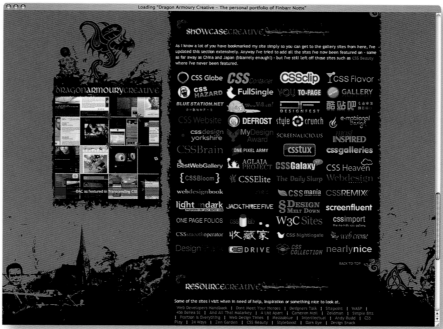

www.dacreate.co.uk
D: finbarr notte **C:** finbarr notte **P:** finbarr notte
A: dragon armoury creative **M:** finbarr@dacreate.co.uk

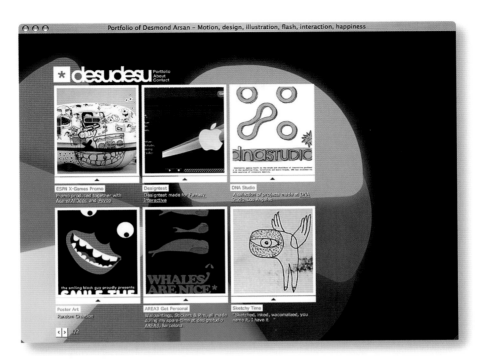

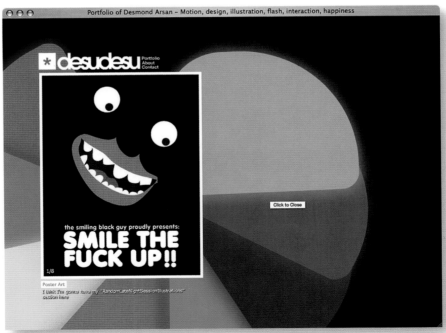

www.desudesu.com
D: desmond arsan **C:** desmond arsan
A: desudesu **M:** info@desudesu.com

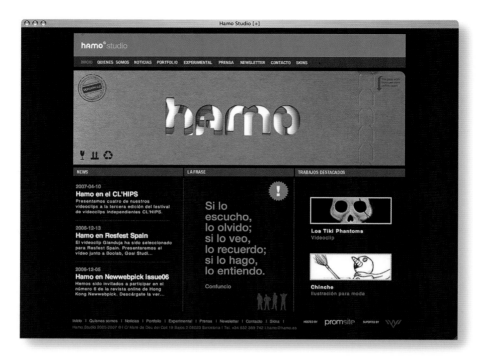

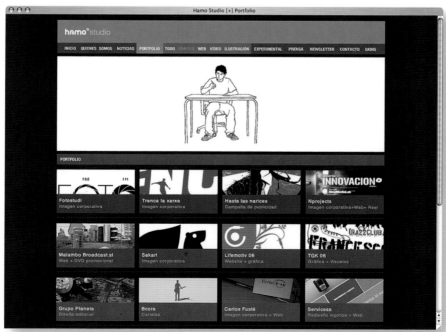

www.hamo.es

D: hamo studio

M: hamo@hamo.es

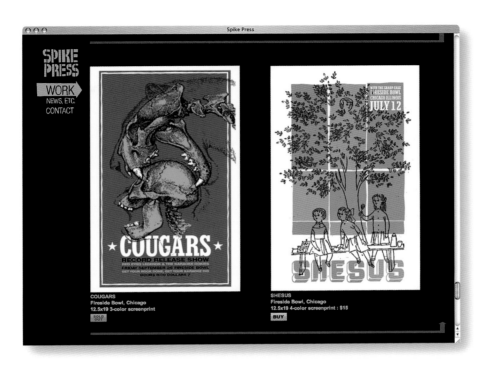

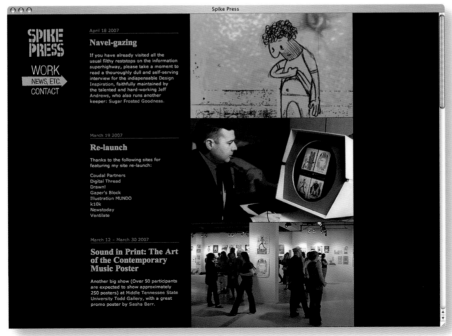

www.spikepress.com
D: john solimine **C:** daniel edwards
A: spike press **M:** spikepress@spikepress.com

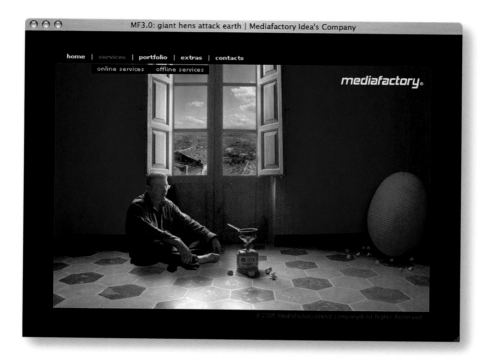

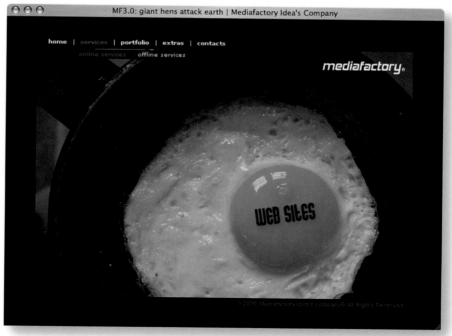

www.mediafactory.it
D: graziano romanelli C: giovanni di gregorio P: mediafactory
A: mediafactory M: romanelli@mediafactory.it

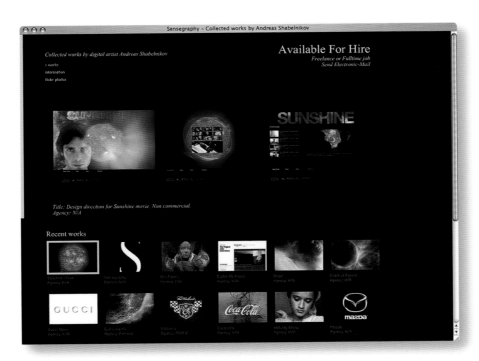

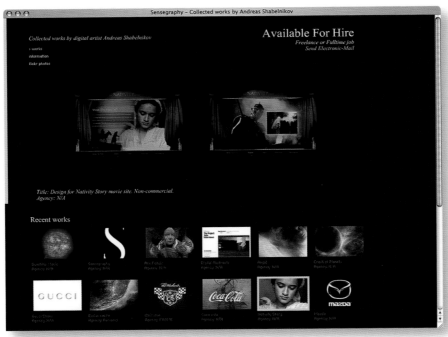

www.sensegraphy.com
D: andreas shabelnikov
M: andreas@sensegraphy.com

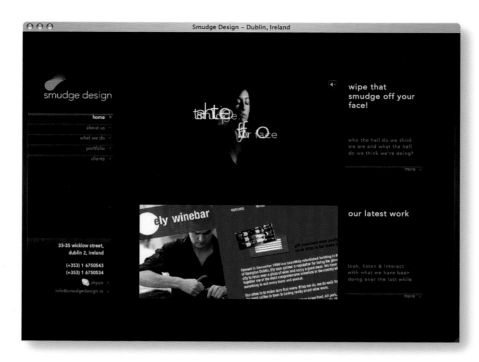

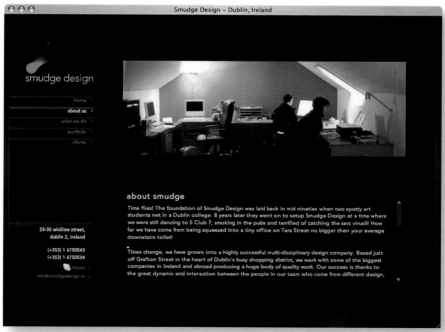

www.smudgedesign.ie

D: david jackson **C:** eddie raos **P:** david jackson

A: smudge design **M:** davejacko@gmail.com

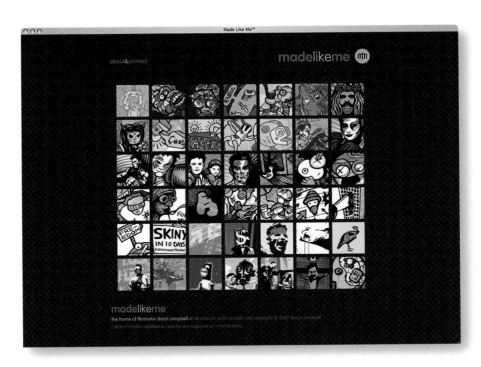

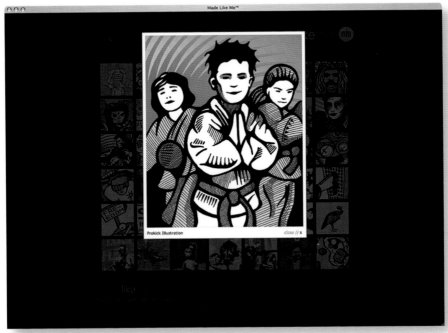

www.madelikeme.com

D: daryl campbell **C:** daryl campbell **P:** daryl campbell
A: made like me **M:** me@madelikeme.com

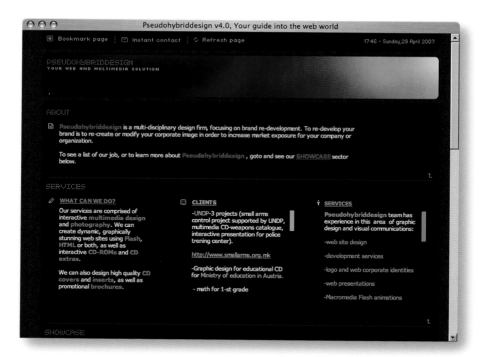

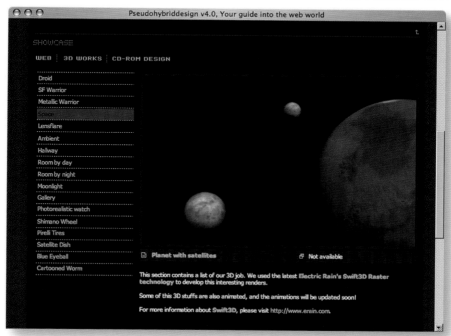

www.pseudohybriddesign.co.nr
D: minovski nikola **C:** minovski nikola
A: pseudohybriddesign **M:** minopharma_3@hotmail.com

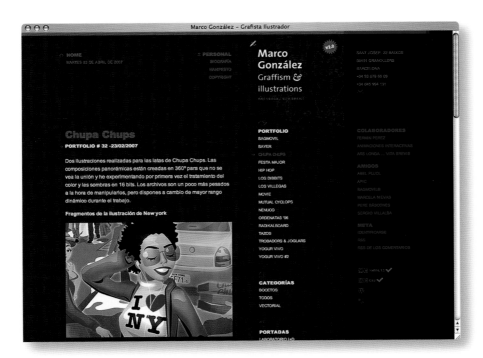

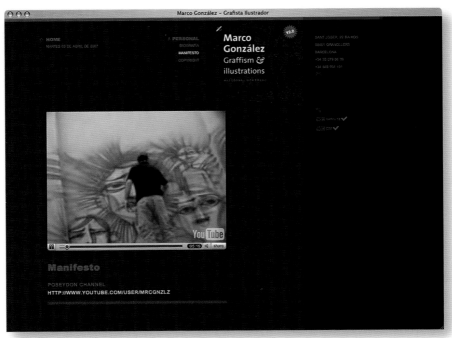

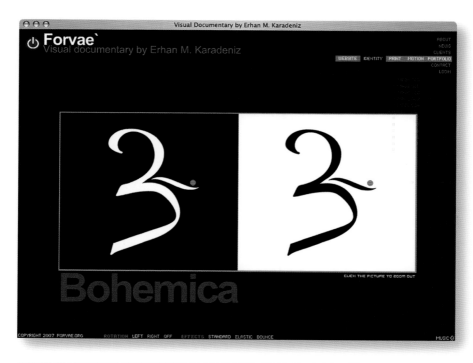

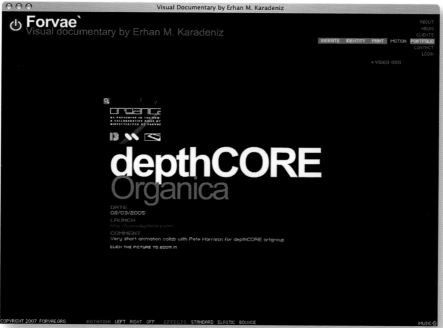

www.forvae.org

D: erhan m. karadeniz C: erhan m. karadeniz P: erhan m. karadeniz

A: forvae M: erhan@forvae.org

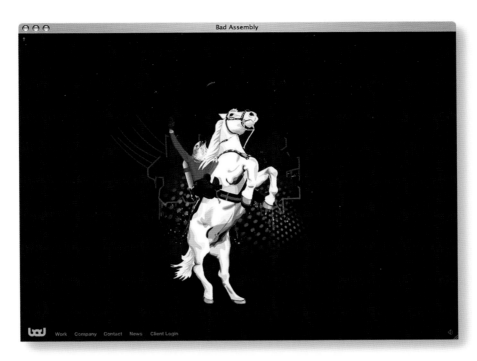

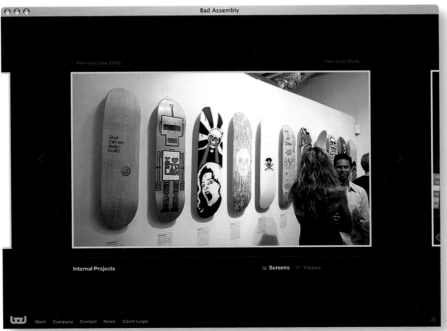

www.badassembly.com

D: jimmy walker, scott baggett C: scott baggett, nathan holloway P: scott baggett
A: bad assembly M: info@badassembly.com

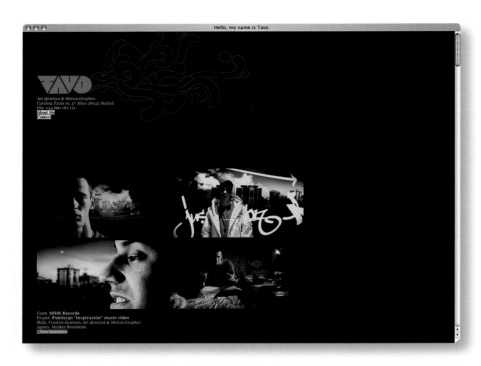

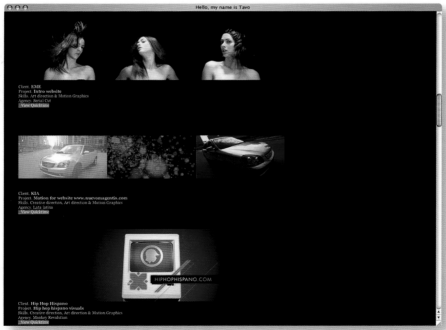

www.tavo.es

D: tavo ponce

A: tavo **M:** tavo@tavo.es

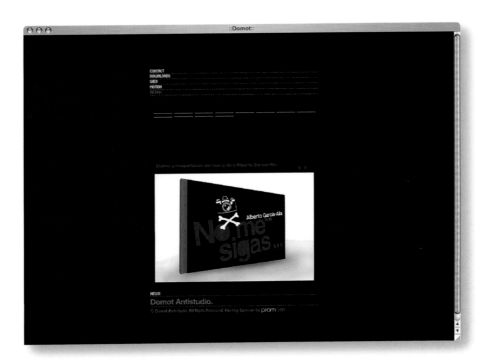

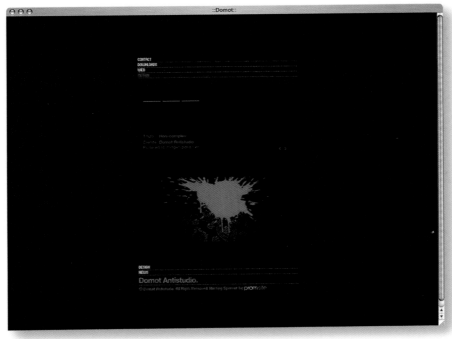

www.domot.es
D: domot antistudio
M: info@domot.es

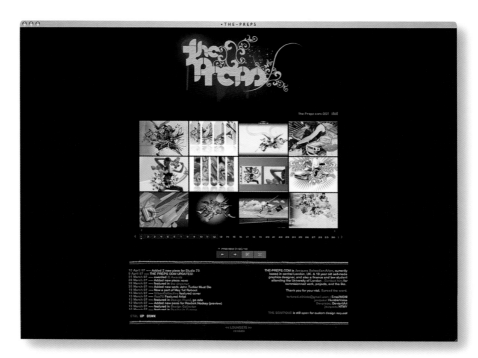

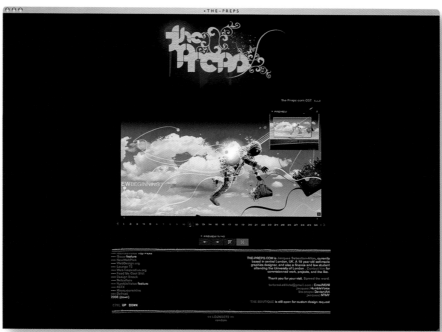

www.the-preps.com
D: jacques sebastian-alton
M: tortured.athlete@gmail.com

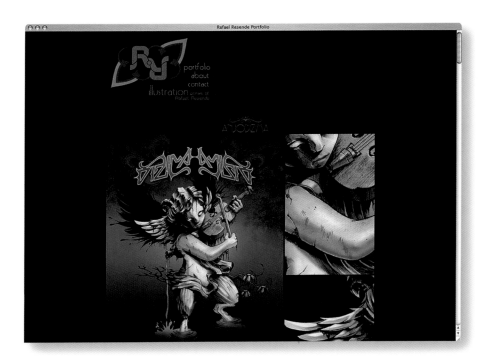

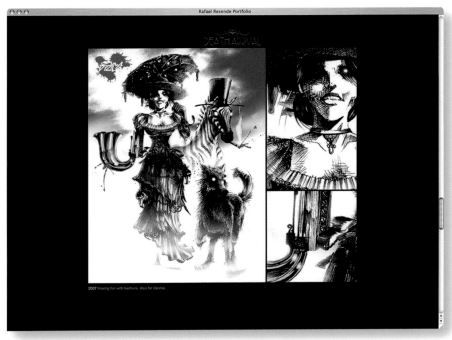

www.rafaelresende.com
D: rafael resende **C:** lívia kizli **P:** rafael resende
M: hire@rafaelresende.com

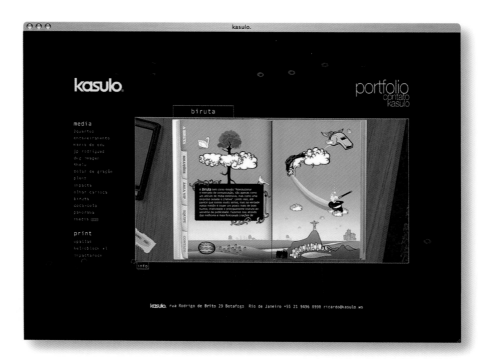

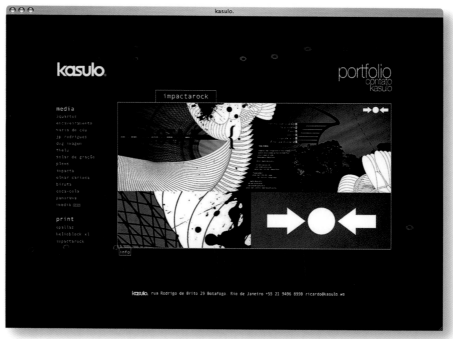

www.kasulo.ws
D: ricardo dias C: ricardo dias P: ricardo dias
A: kasulo. M: ricardo@kasulo.ws

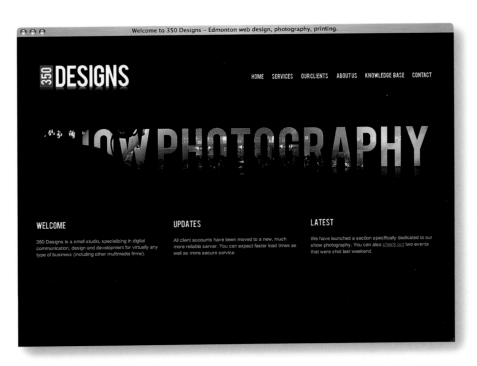

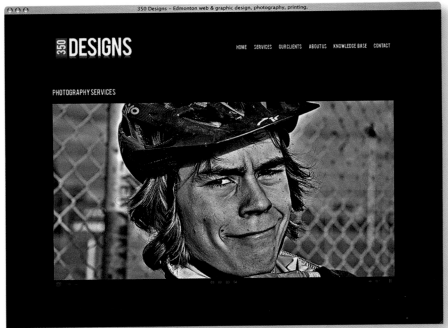

350designs.com
D: yura sklyar
A: 350 designs M: info@350designs.com

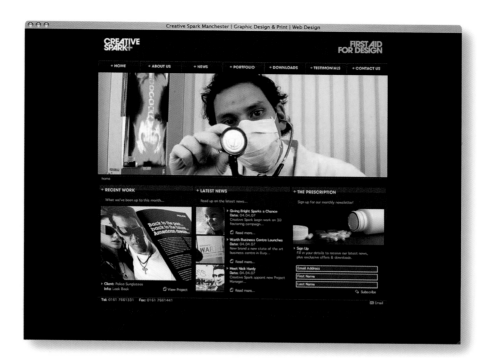

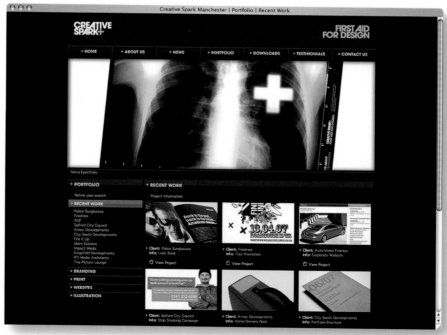

www.creativespark.co.uk
D: andy mallalieu, neil marra, carl sadd C: simon foster P: simon foster
A: creative spark M: info@creativespark.co.uk

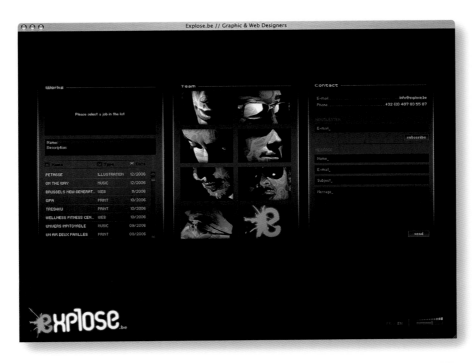

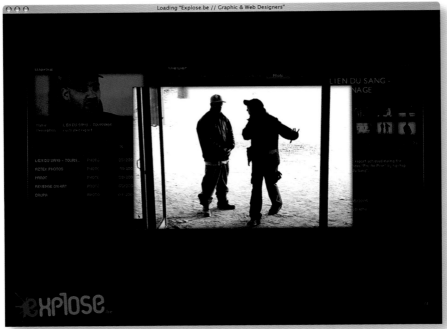

www.explose.be
D: n. sli, s. van boxtel, a. simionescu, treshku C: m. hills, r. brisson P: explose
A: explose M: info@explose.be

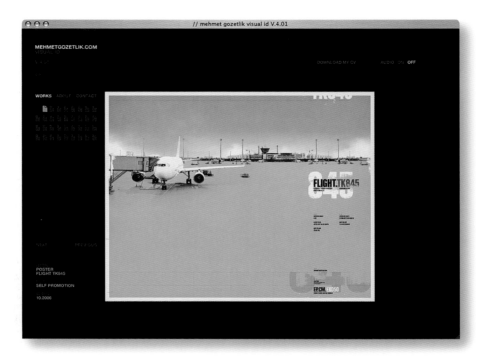

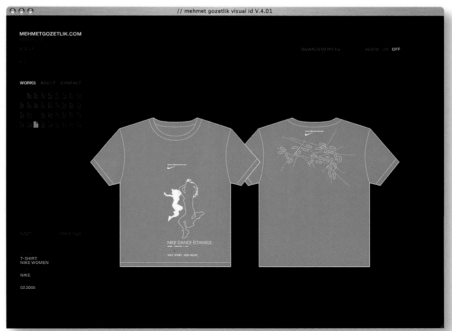

www.mehmetgozetlik.com
D: mehmet gozetlik **C:** mehmet gozetlik
M: mail@mehmetgozetlik.com

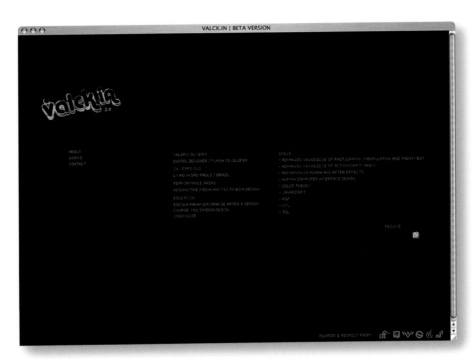

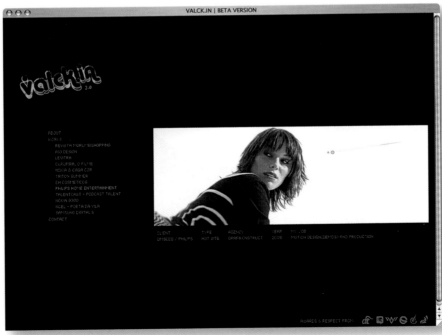

www.valck.in

D: valério oliveira (valck) **C:** valério oliveira (valck) **P:** valério oliveira (valck)

A: personal portfolio **M:** contact@valck.in

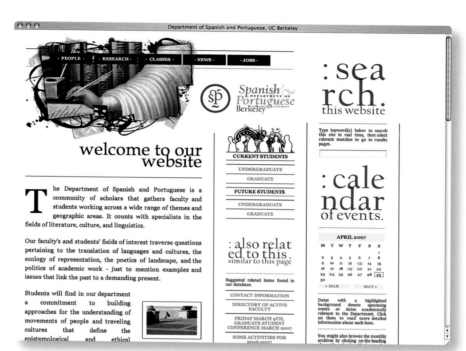

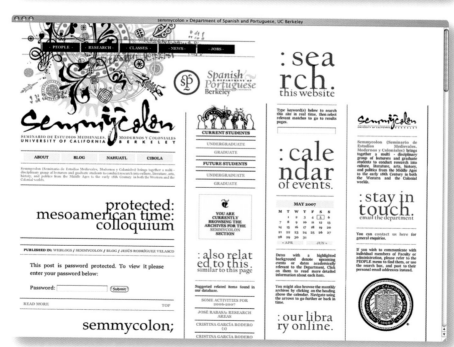

spanish-portuguese.berkeley.edu
D: miguel ripoll **P:** josé rabasa, jesús rodríguez velasco
A: www.miguelripoll.com **M:** miguel@miguelripoll.com

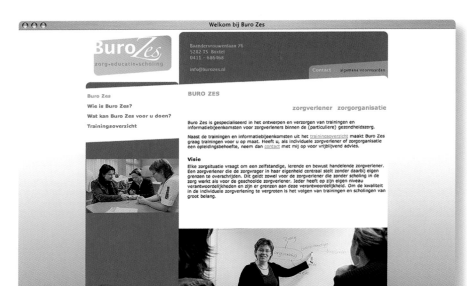

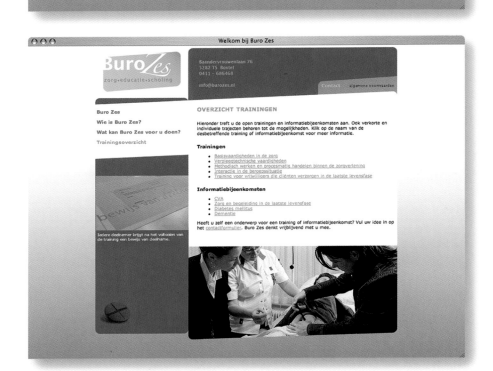

www.burozes.nl

D: roeland heesbeen **C:** mark elissen **P:** roeland heesbeen
A: kippenvel ontwerp **M:** ontwerp@kippenvel.nu

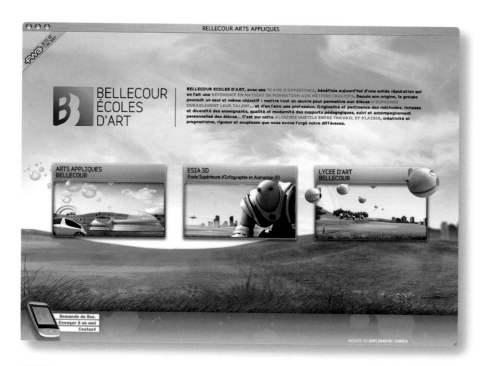

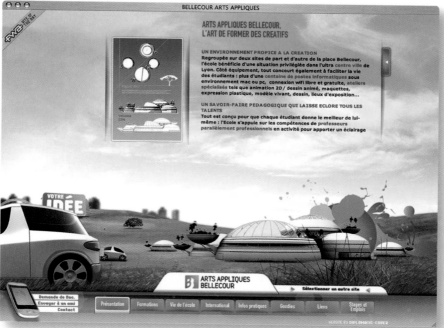

www.bellecour.fr

D: diplomatic-cover
M: studio@diplomatic-cover.com

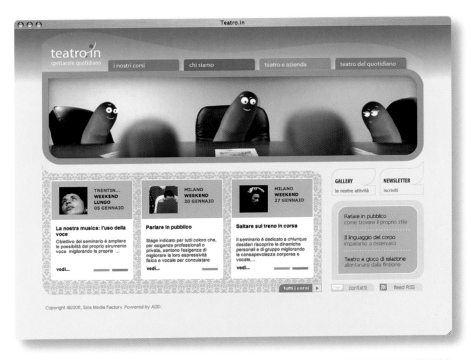

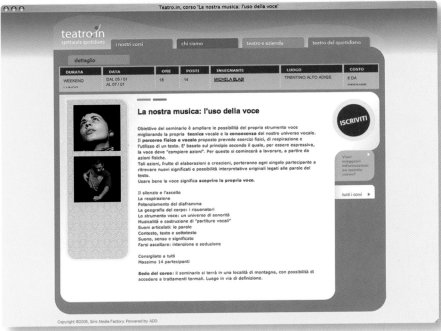

www.teatro.in

D: graziano romanelli **C:** giovanni di gregorio **P:** siris mediafactory

A: mediafactory **M:** romanelli@mediafactory.it

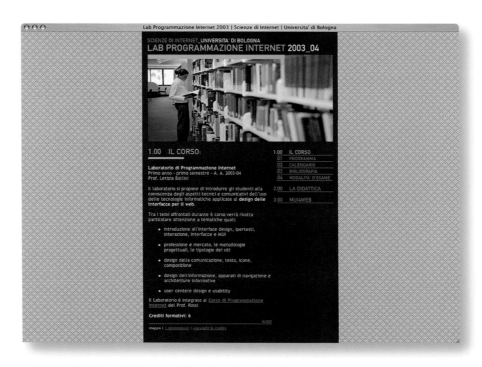

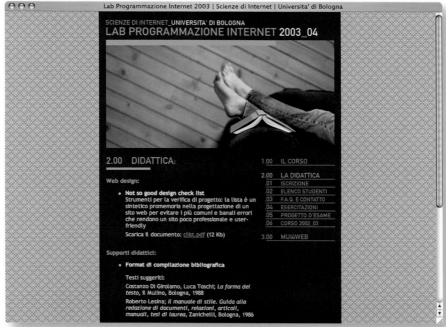

uni.extrasmallstudio.com/mui4web/labpiO3
D: letizia bollini **C:** criticalbit
A: extrasmall **M:** www.extrasmall.it

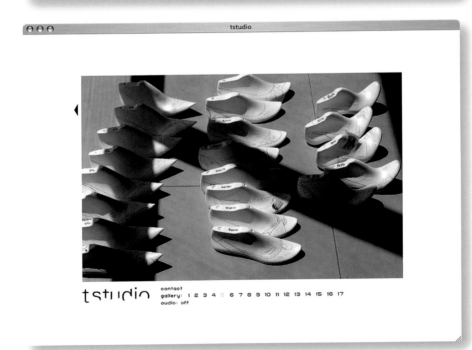

www.tstudio.com

D: samuel gentile, up3 C: samuel gentile P: t studio
A: liquid diamond, up3 M: samuel@liquiddiamond.it

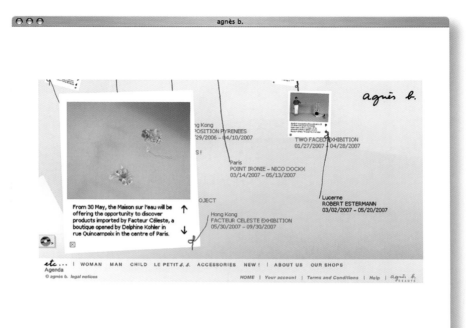

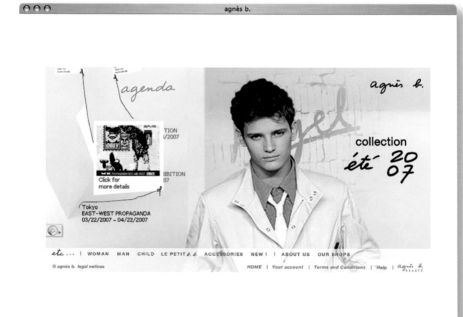

www.agnesb.com

D: agnès b., www.duke-interactive.com

A: agnès b. M: info@agnesb.fr

iD VALUES

iD VALUES SUMMER 07 / BODY

iD VALUES

iD VALUES WINTER 07/08 / BODY

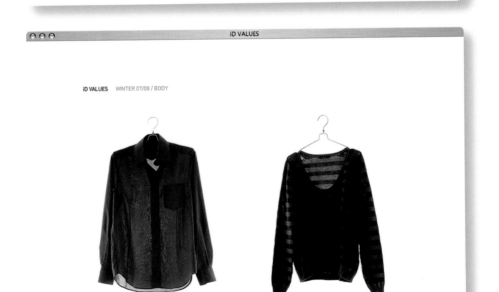

www.idvalues.com
D: mm +a, isabel vasques **C:** bizview - sistemas e comunicação **P:** id values
A: id values **M:** info@idvalues.com

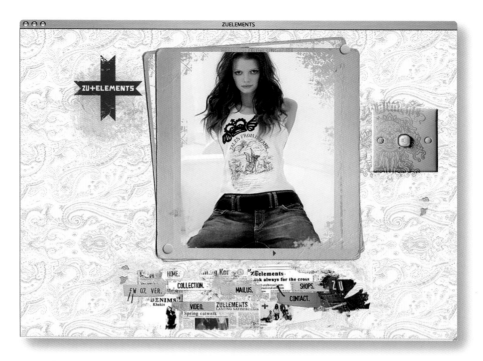

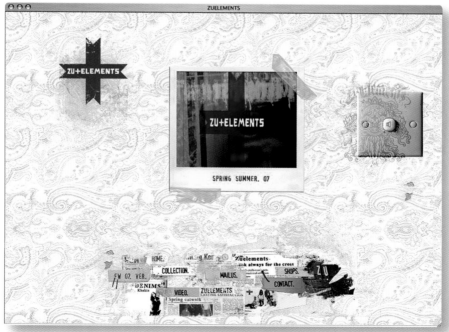

www.zuelements.com
D: dante guerrini C: phard graphics and web dept P: phard s.p.a.
A: zuelements M: dante@phard.it

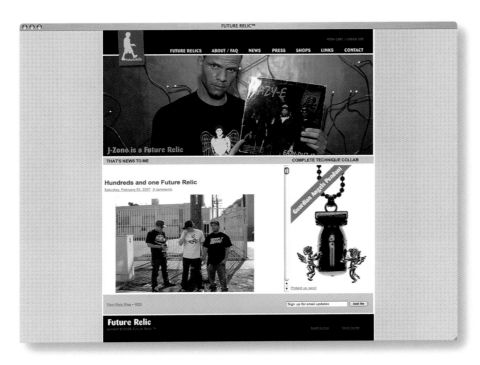

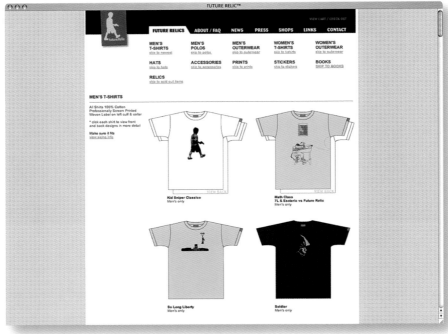

www.futurerelic.com
D: kenyon bajus
A: future relic **M:** paul@futurerelic.com

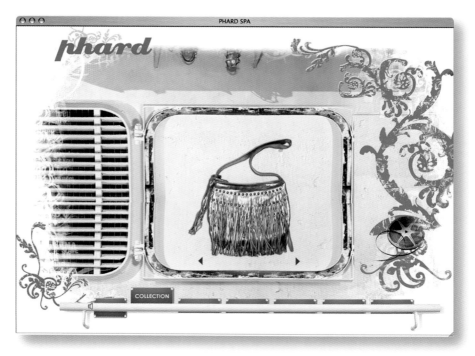

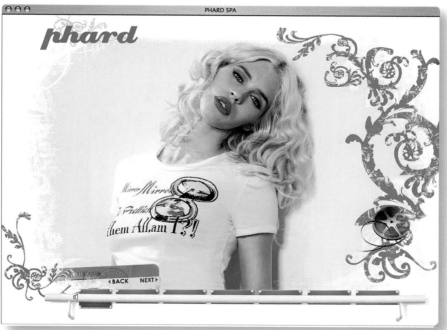

www.phard.it
D: dante guerrini C: phard graphics and web dept P: phard s.p.a.
A: phard s.p.a. M: dante@phard.it

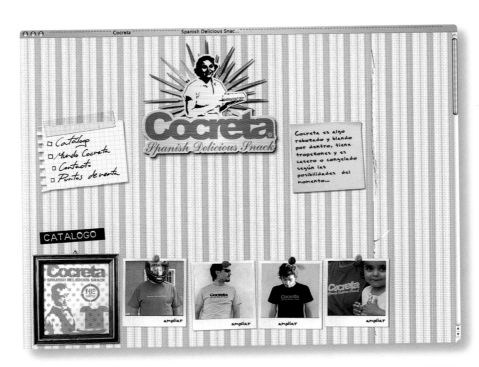

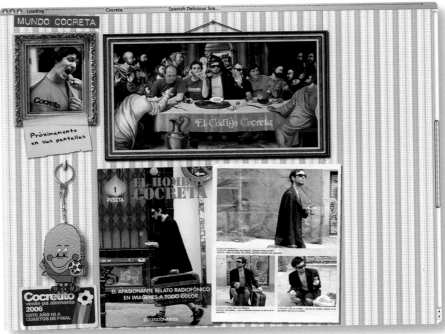

www.cocreta.com

D: rubén martínez , fernando morante C: fernando morante P: cocreta
A: cocreta M: info@cocreta.com

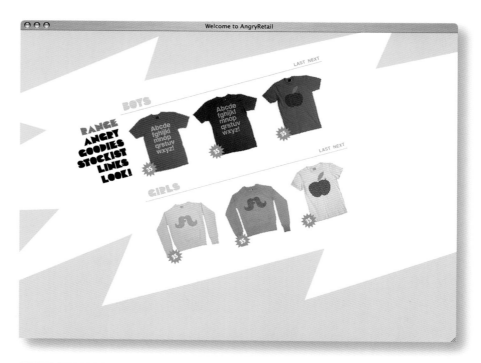

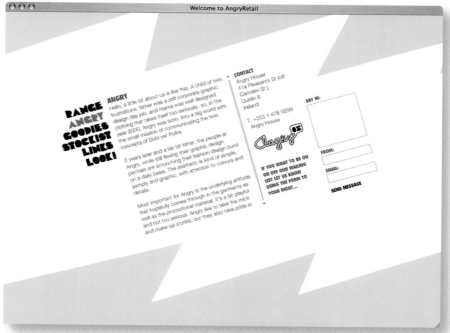

www.angryretail.com
D: karl toomey C: kevin horan P: renate henschke
A: angry M: mail@angryretail.com

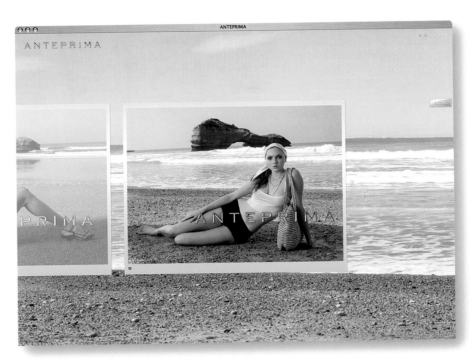

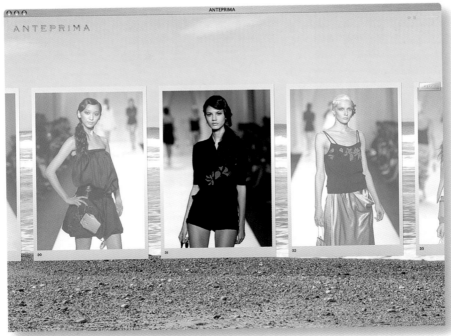

www.anteprima.com
D: takashi wakita C: akira fukuoka
A: ficc inc. M: info@ficc.jp

www.urboedzino.com
D: sergio muñoz, niktoprojekt **C:** sergio muñoz, niktoprojekt **P:** sergio muñoz, niktoprojekt
A: niktoprojekt **M:** www.niktoprojekt.com

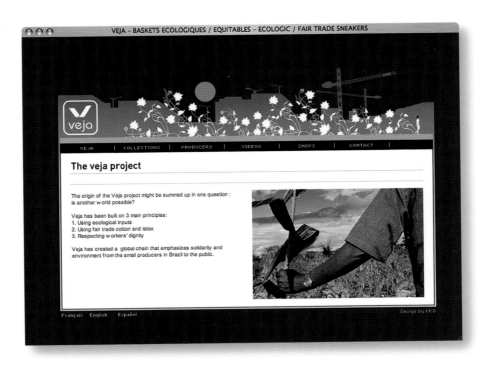

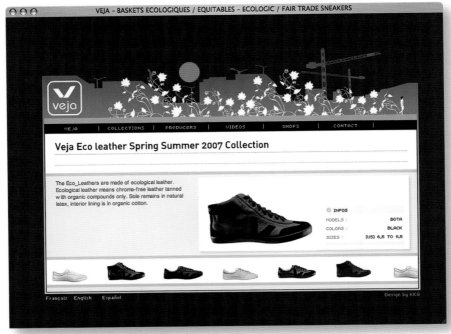

www.veja.fr
D: alexandre bommelaer
M: alexandre.bommelaer@gmail.com

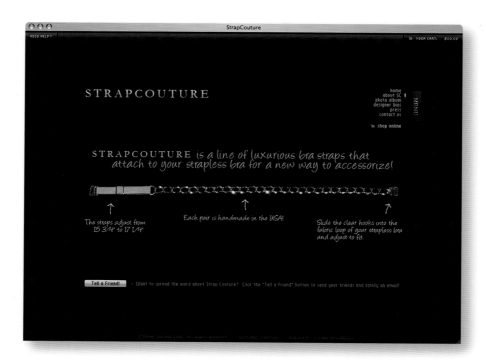

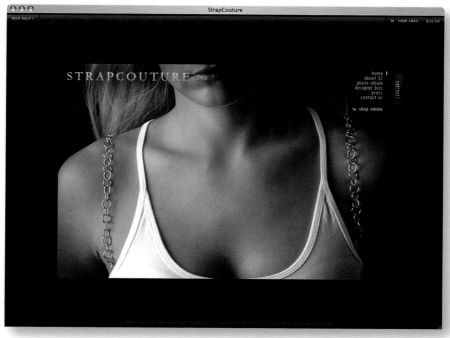

www.strapcouture.com
D: clint balcom
A: balcom & nobody **M:** vipinfo@strapcouture.com

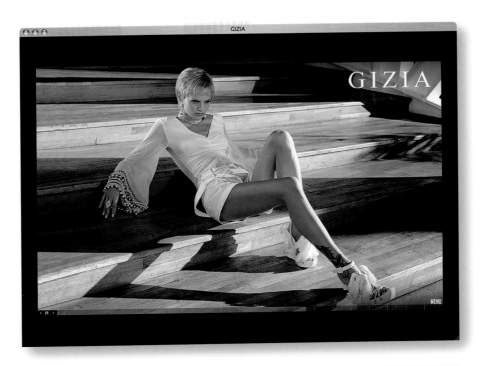

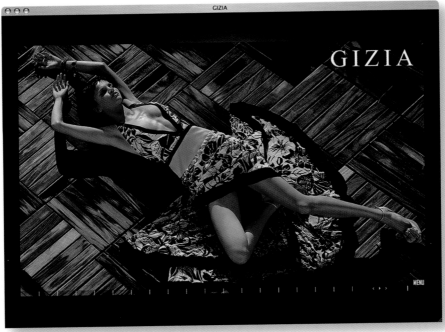

www.gizia.com

D: murat canbaz C: selcuk safci P: d4d
A: d4d digital brand solutions M: info@d4d.com.tr

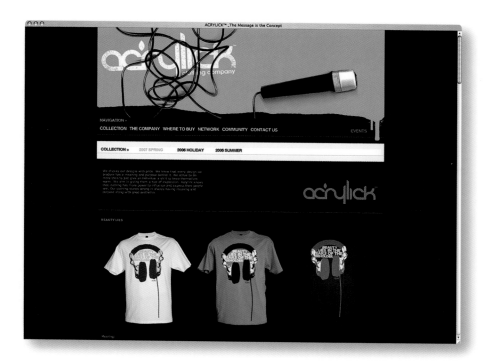

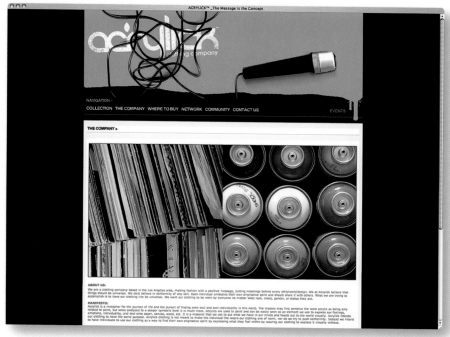

acrylick.net

D: michael valenzuela C: michael valenzuela P: michael valenzuela

A: acrylick clothing company M: michael@acrylick.net

Bearfootfilms /// 3D Animation Studio

Bearfootfilms 3D ANIMATION STUDIO

HOME FEATURED WORK PORTFOLIO SERVICES CONTACT

CGTalk Award, 12/04/07
CGtalk Award. Future station has been awarded a CGtalk choice award at
the website. This award is given only to a handful of artists in the world
and so is a great privilege.

Expose 5, 11/04/07
Expose 5.Overlander image has been selected for the book Expose 5. This
book is the premier publication for 3d and 2d art in the world.

Future Station, 02/04/07

Bearfootfilms /// 3D Animation Studio

Bearfootfilms 3D ANIMATION STUDIO

HOME FEATURED WORK **PORTFOLIO** SERVICES CONTACT

CLOSE

OceanRaiders
Conceptual Enviroment and aircraft design. Modeled , textured and rendered in Lightwave 3d. The
backdrop and water were hand painted in Photoshop and the image retouched in post production
also using photoshop.

www.bearfootfilms.com
D: gordy frank C: gordy frank
A: 3signs M: contact@3signs.com

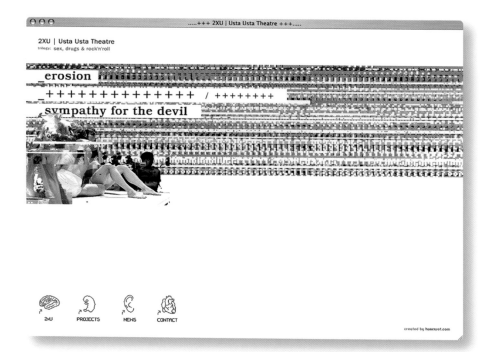

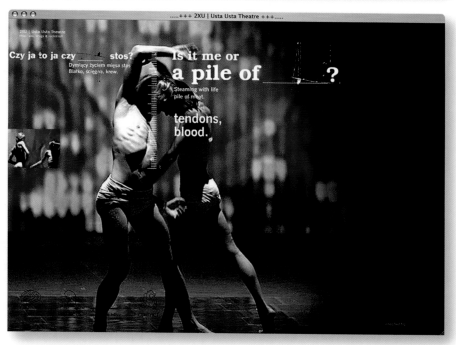

www.2xu.pl
D: arek romanski **C:** lukasz knasiecki
A: huncwot **M:** info@huncwot.com

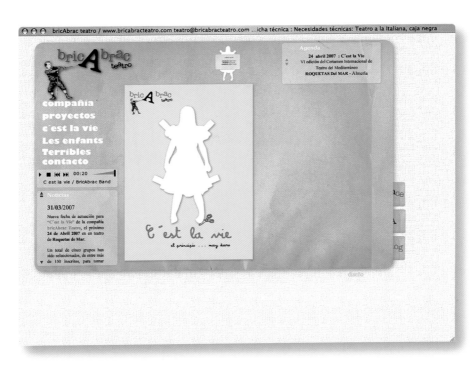

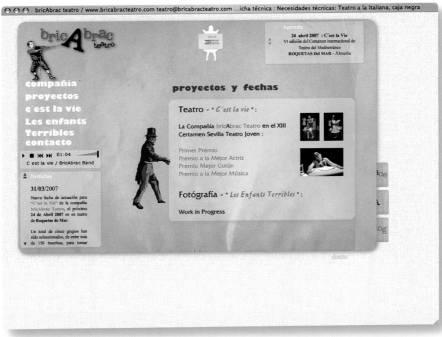

www.bricabracteatro.com

D: berth99 C: berth99 P: matthieu berthelot

A: berth99 productions M: contacto@berth99.com

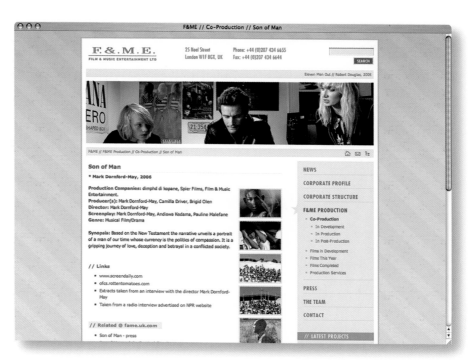

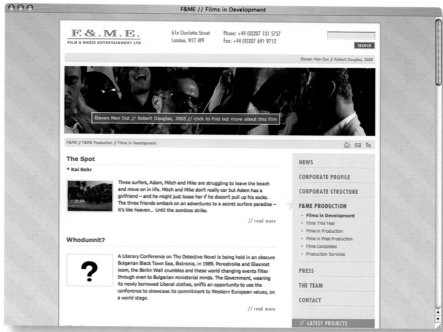

www.fame.uk.com

D: sasa huzjak **C:** branko jevtic, sasa huzjak **P:** sasa huzjak
A: plastikfantastik * **M:** sale@plastikfantastik.net

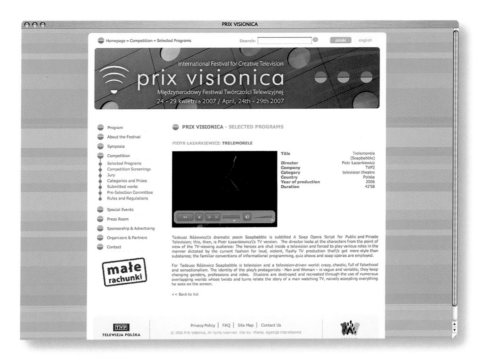

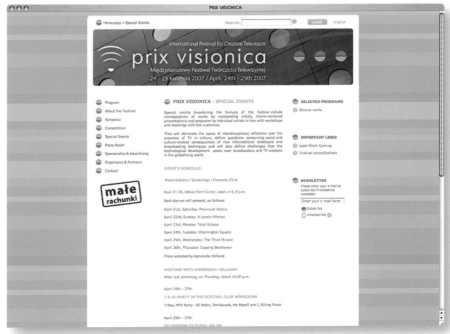

www.prixvisionica.pl
D: patryk kizny, dominik turek C: misme, development team P: patryk kizny
A: misme. new media agency. www.misme.pl M: office@misme.pl

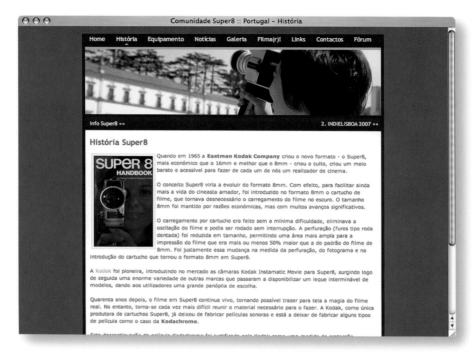

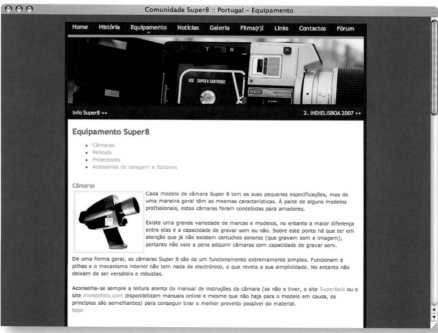

www.comunidadesuper8.com
D: pedro simão C: fernando marques
A: velcro graphic design M: www.velcrodesign.com

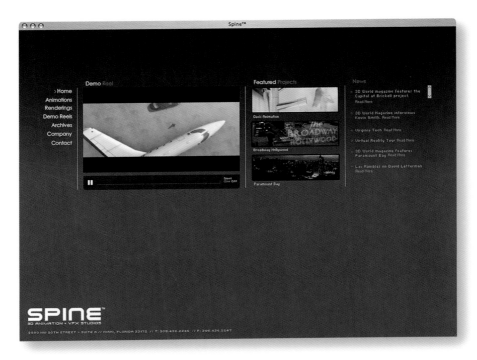

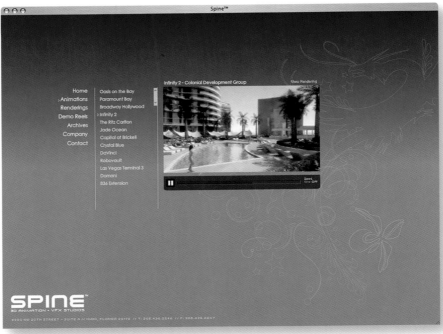

www.spine3d.com
D: yuccastudio.com C: yuccastudio.com P: eddie leon
A: spine3d M: miami@spine3d.com

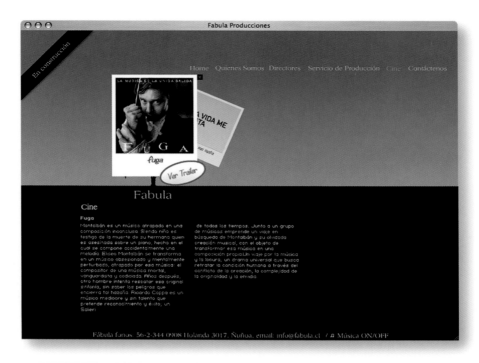

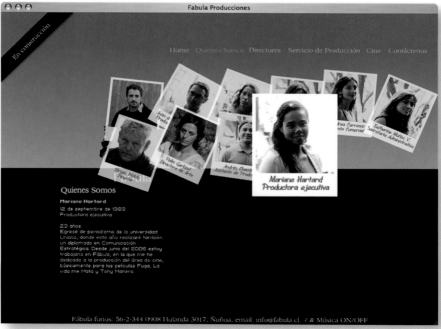

www.fabula.cl
D: gonzalo mancini C: luis guajardo P: luis guajardo
A: theguaz.com, elemento.cl M: luis@theguaz.com

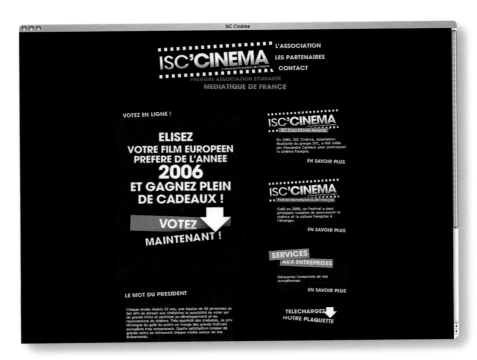

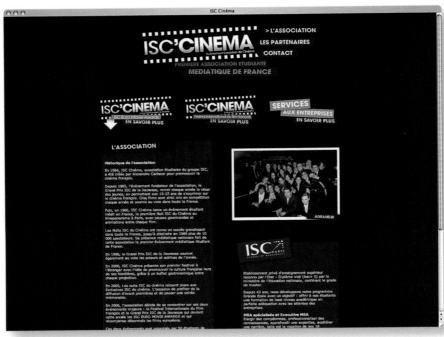

www.isccinema.com

D: xavier encinas **C:** xavier encinas

A: rumbero design **M:** info@rumbero-design.com

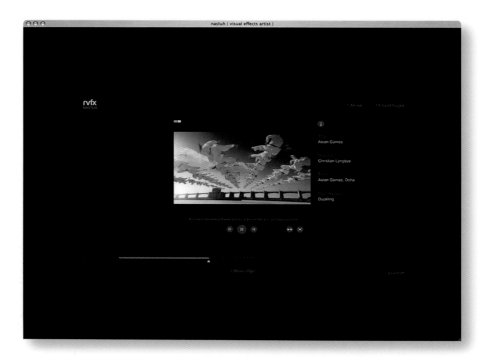

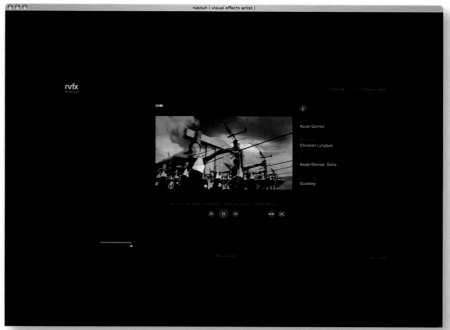

www.nastuh.com

D: noe, kreutzer C: gülensoy, kreuder, hermann, kraft P: tannenberger, brockmann
A: scholz & volkmer gmbh, wiesbaden M: www.s-v.de

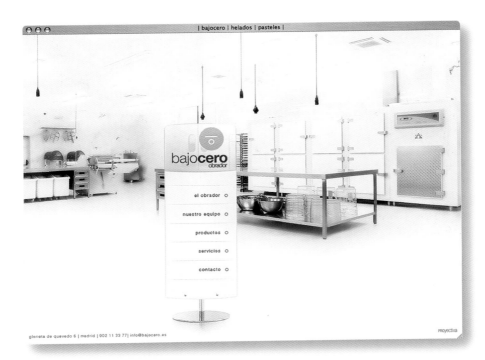

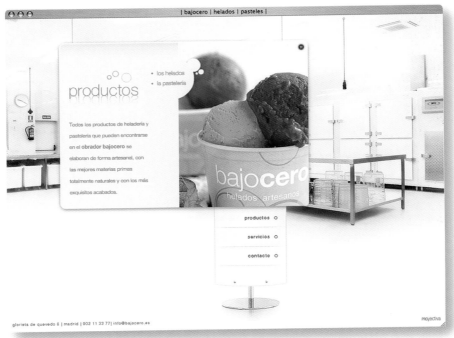

www.bajocero.es

D: maximiliano sablayrolles

A: tasty concepts M: max@tastyconcepts.us

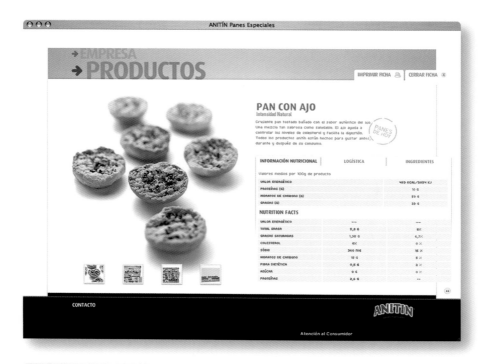

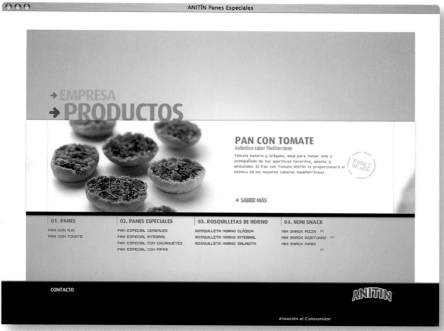

www.anitin.com

D: david navarro **C:** claudio guglieri **P:** miguel simon
A: observer.es **M:** www.observer.es

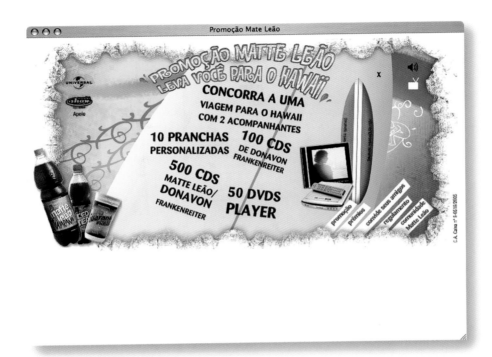

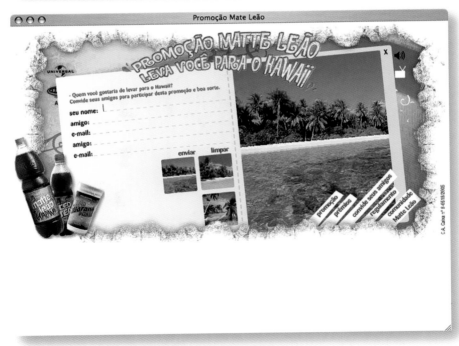

www.opusmultipla.com.br/web/awards/matteleao

D: rafael ribeiro C: bruno piza, fabio lonardoni P: fabiano cruz

A: opusmúltipla M: web@opusmultipla.com.br

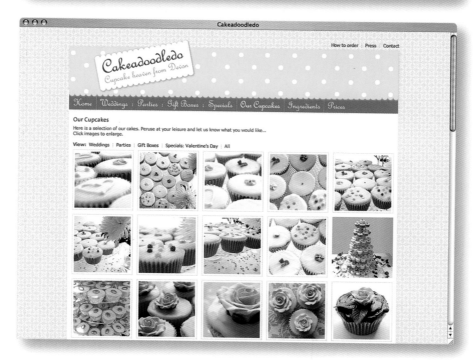

www.cakeadoodledo.co.uk
D: kate kronreif C: mark burrett
A: blossom M: www.blossom.at

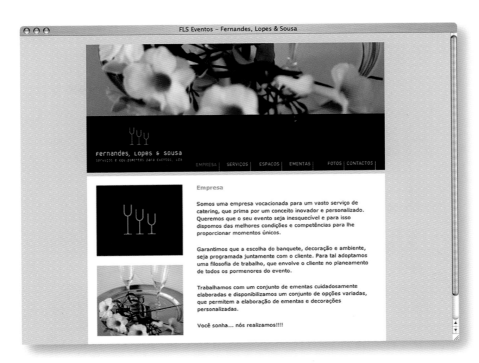

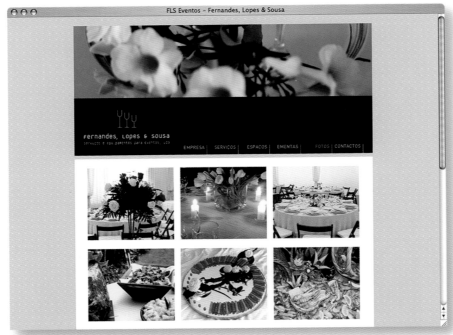

www.flseventos.pt

D: joana fernandes C: bizview - rui nobre ferreira P: bizview
A: bizview M: info@bizview.pt

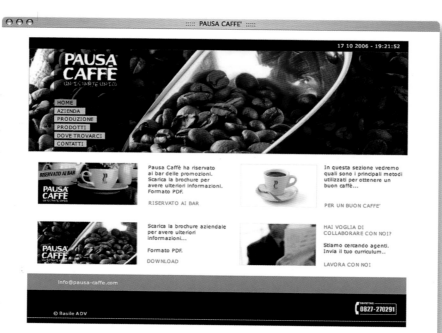

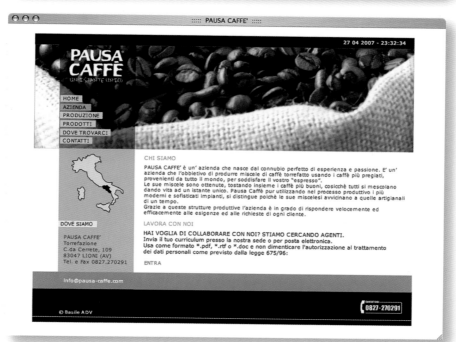

www.pausa-caffe.com

D: andrea basile C: basile advertising P: basile advertising
A: basile advertising M: info@basileadvertising.com

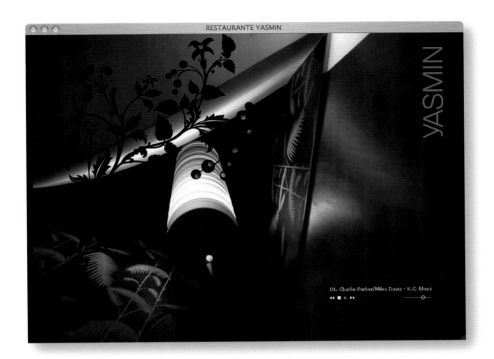

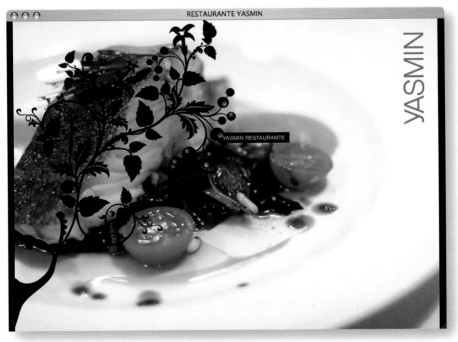

www.yasmin-lx.com

D: catarina lente, luisa lente, sofia mestre **C:** yoyoteam **P:** yoyoteam

A: yoyoteam **M:** www.yoyo.es

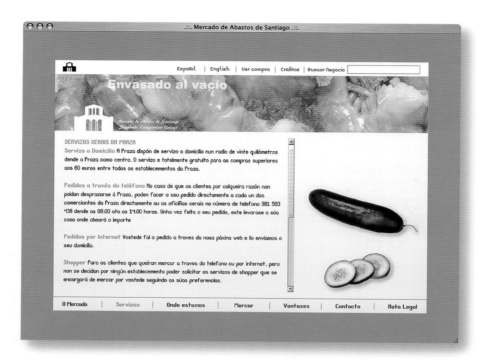

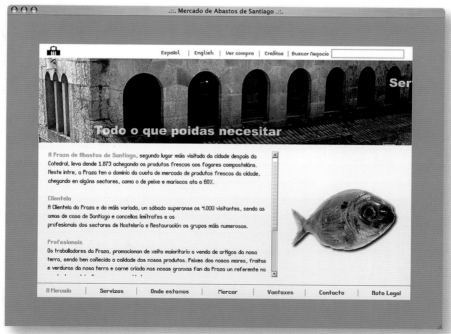

www.mercadodeabastosdesantiago.com
D: desoños
M: multimedia@desonhos.net

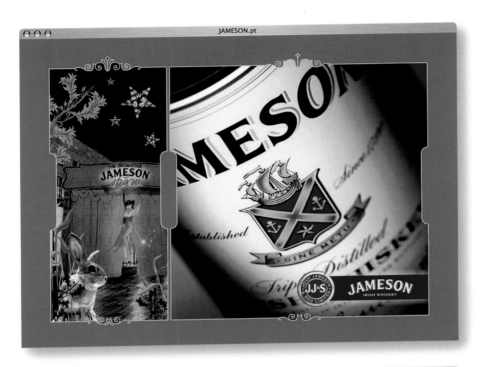

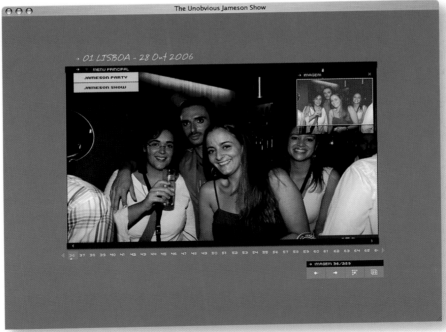

www.jameson.pt

D: andré domingues **C:** andré domingues **P:** hora zero comunicação

A: adomingues.com comunicação **M:** www.adomingues.com

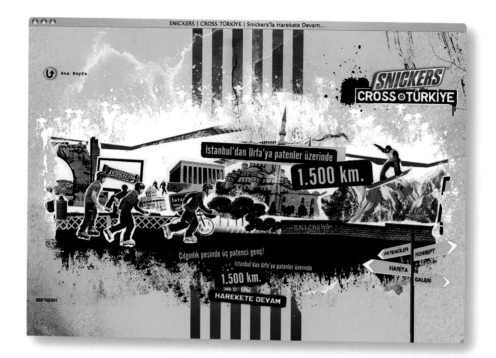

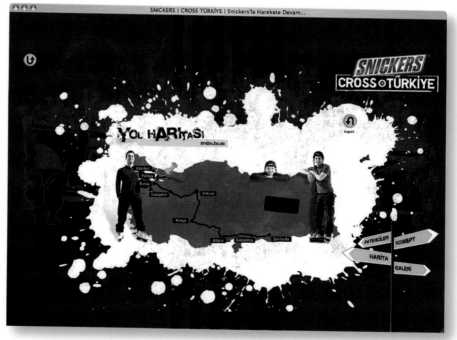

www.snickers.com.tr
D: 2fresh
M: contact@2fresh.com

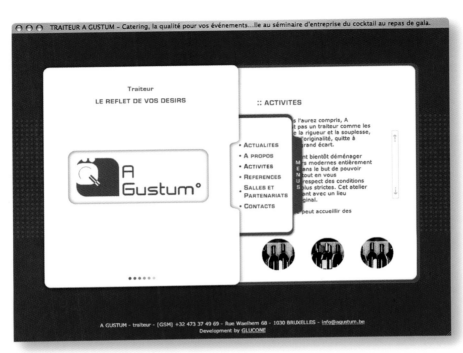

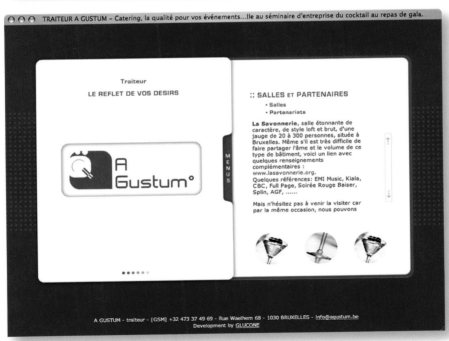

www.agustum.be
D: sophie hollebecq **C:** patrick videira
A: glucone **M:** info@glucone.com

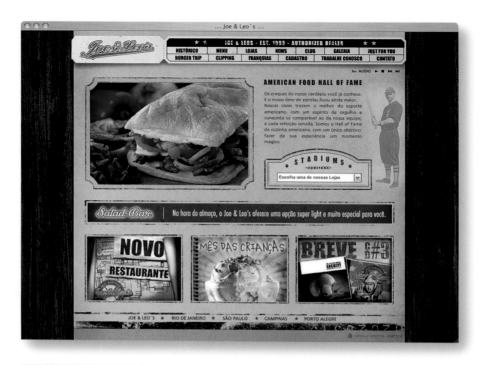

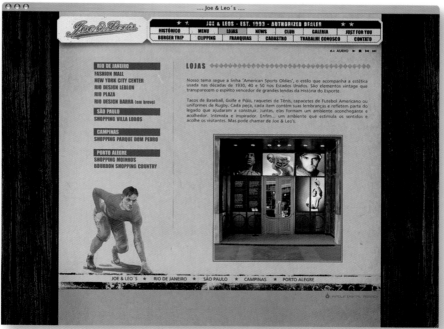

www.joeleos.com.br
D: bruno chamma **C:** maylor bax **P:** gustavo peixoto
A: kindle digital agency **M:** chamma@kindle.com.br

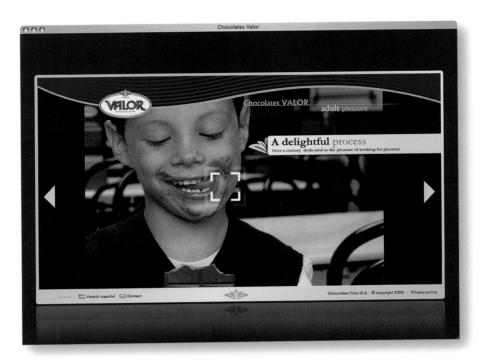

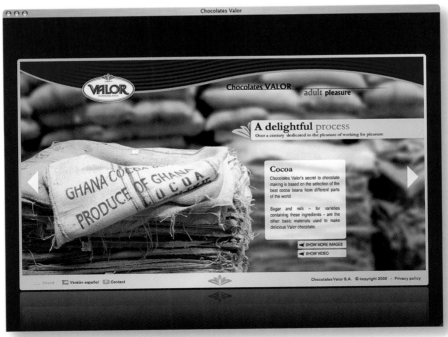

www.valor.es

D: javier frades, rafael castillo C: francisco estradera P: ana poveda and leles lopez
A: grupo enfoca M: info@grupoenfoca.com

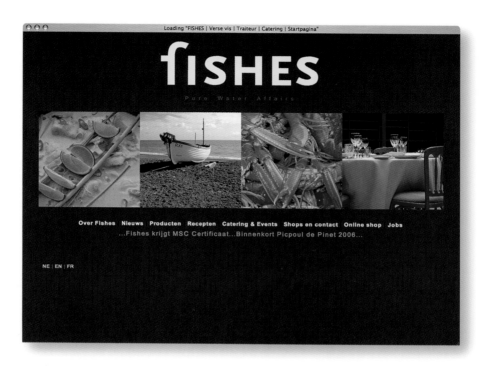

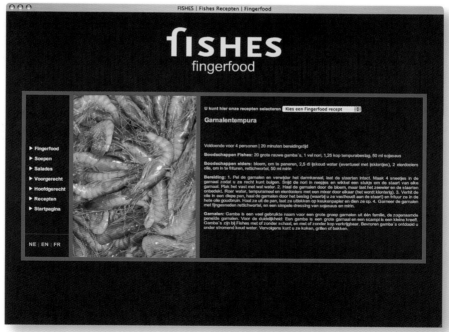

www.fishes.nl
D: edgar leijs C: idem P: idem
A: ed-designer M: www.ed-designer.eu

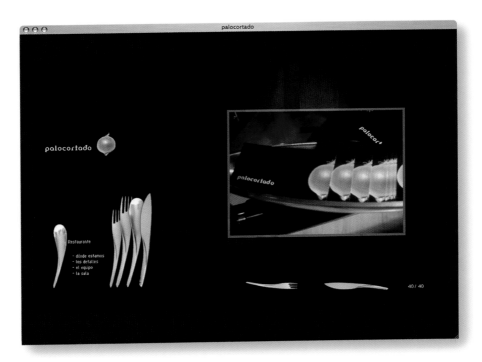

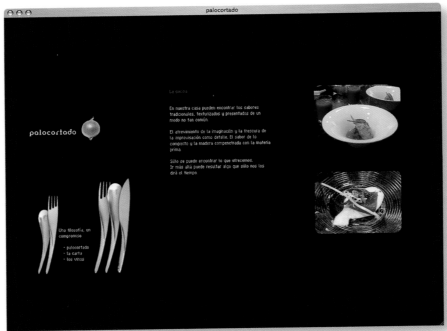

www.palocortado.com

D: takeone dsgn **C:** q-interactiva **P:** lourdes molina
A: takeone.es **M:** www.takeone.es

○○○ Vedure MediBoutique

THE VEDURE INDULGENCE | TREATMENT MENU | VEDURE PRODUCT RANGE

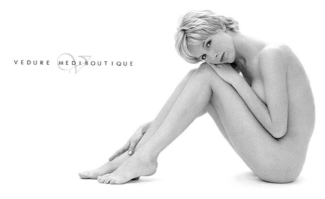

VEDURE MEDIBOUTIQUE

MILLENIA WALK • WHEELOCK PLACE

playing 2s / 20s
pause ▮▯▯▯▯▯▯▯▯▯▯▯▯▯▯▯▯▯

○○○ Vedure MediBoutique

The Vedure Indulgence

Vedure is a haven for bespoke
services and products which
resolve a variety of face and body
concerns. Treatments include our
signature non-surgical face lifting
treatment popular with Hollywood
celebrities and royalties.

This luxurious treatment simulates
circulation, eliminates toxins and
reintroduces elasticity into your
face while having a sublime effect
on your mental wellbeing. At
Vedure, experience the treatments
in a spacious and lush environment,
and let us inspire ways to optimize
your overall well being and
appearance, creating the Most
Beautiful You.

Painless Treatments

[X] Close Window

playing 64s / 157s
pause ▮▮▮▮▮▮▯▯▯▯▯▯▯▯▯▯▯▯

www.vedure.com
D: vedure marcom **P:** ken chan
A: vedure mediboutique **M:** mb@vedure.com

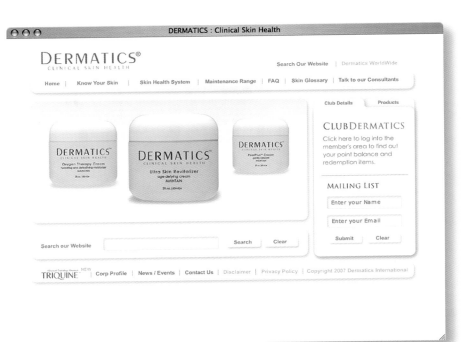

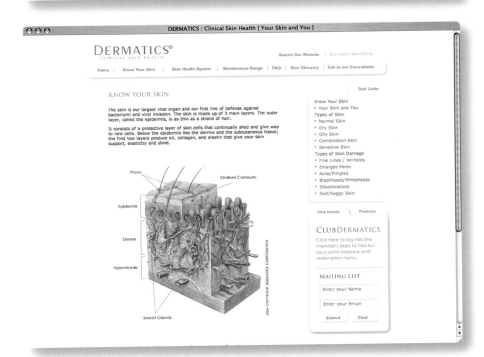

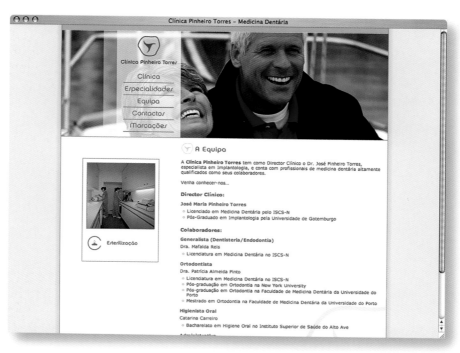

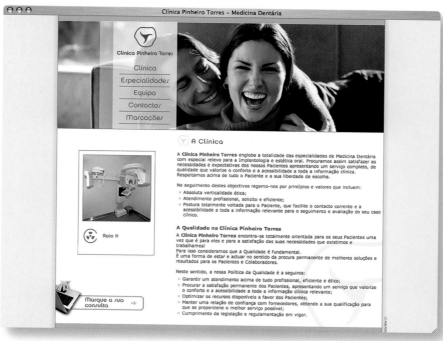

www.clinicapinheirotorres.com
D: bizview - rui nobre ferreira C: bizview - hugo teixeira P: bizview
A: bizview M: info@bizview.pt

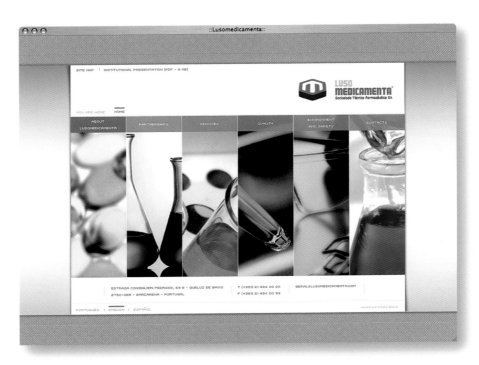

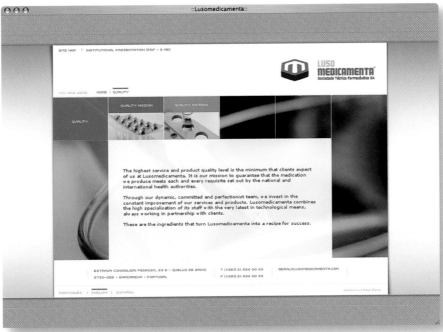

www.lusomedicamenta.com
D: norma carvalho C: vitor reis P: bruno brás
A: metacriações M: www.metacriacoes.com

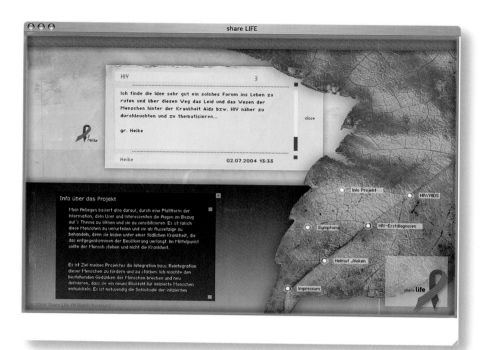

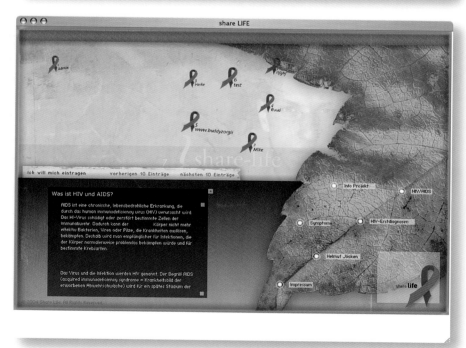

www.share-life.de

D: domeniceau | dominik welters **C:** domeniceau | dominik welters

A: domeniceau | dominik welters **M:** www.domeniceau.de

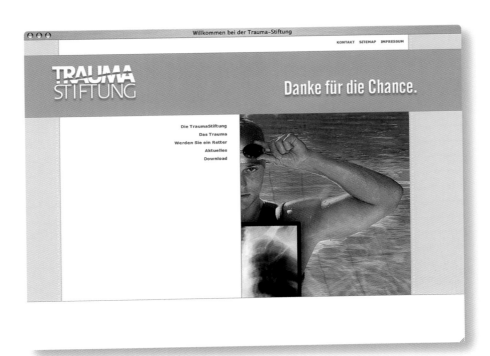

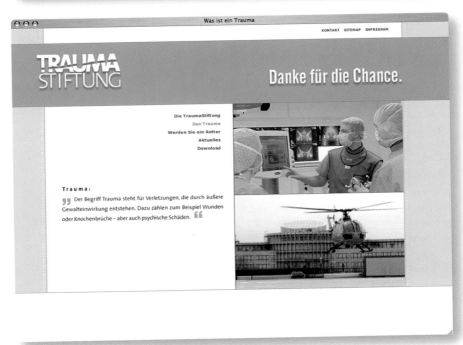

Trauma:

" Der Begriff Trauma steht für Verletzungen, die durch äußere Gewalteinwirkung entstehen. Dazu zählen zum Beispiel Wunden oder Knochenbrüche – aber auch psychische Schäden. "

www.traumastiftung.de

D: saskia pierschek C: saskia pierschek, tim-oliver schulz
A: iconnewmedia M: saskia.pierschek@iconnewmedia.de

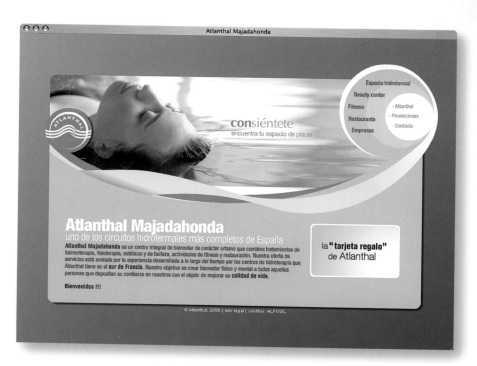

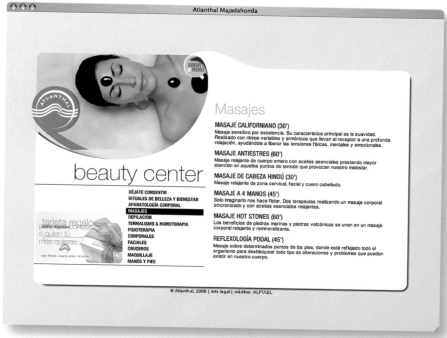

www.atlanthalmajadahonda.es

D: josep gonzález, javier alonso **C:** oscar rey, roberto gonzalo, pedro ortiz
A: alpixel estudio de diseño **M:** www.alpixel.com

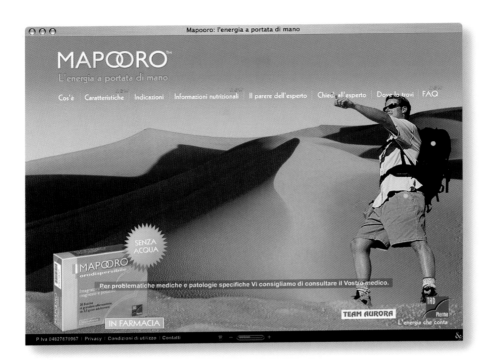

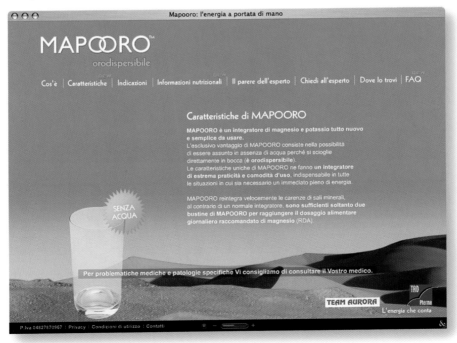

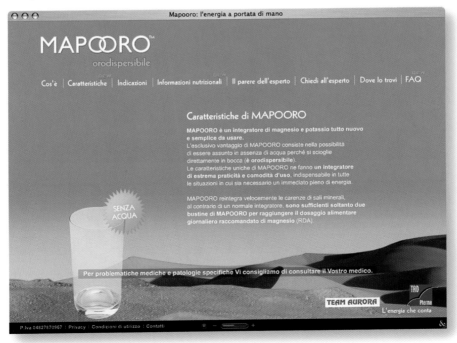

www.mapooro.com

D: daniele lodi rizzini C: daniele giusti P: daniele lodi rizzini
A: segno&forma M: www.segnoeforma.it

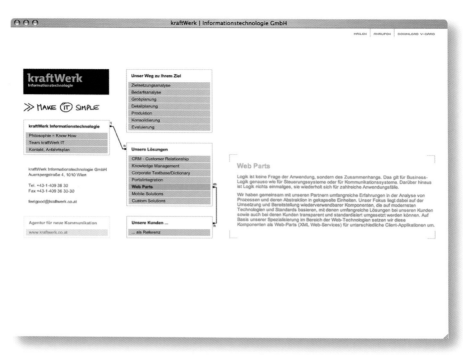

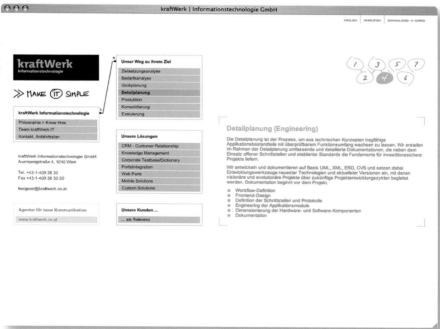

www.kraftwerk.co.at/informationstechnologie
D: jürgen oberguggenberger P: kraftwerk | agentur für neue kommunikation gmbh
A: kraftwerk | agentur für neue kommunikation gmbh M: feelgood@kraftwerk.co.at

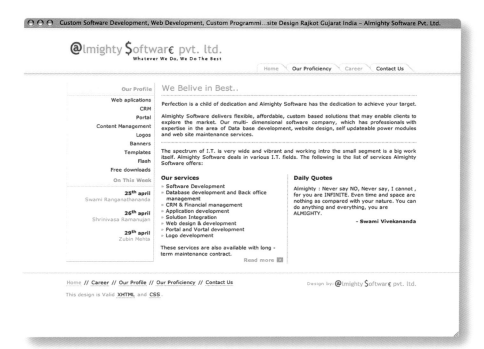

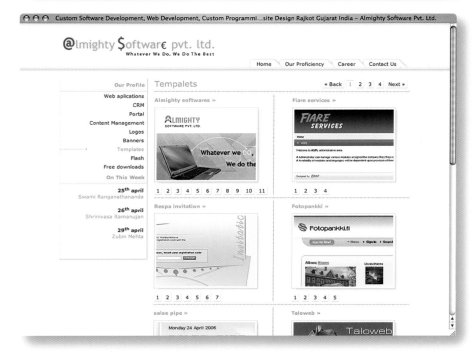

www.aspl.in

D: samir bhimbha, dharmesh nakum **C:** parishesh ranipa **P:** kalpana mehta

A: almighty software pvt. ltd. **M:** parishesh@aspl.in

Goplan – Online project management and collaboration tool

Goplan is a web-based collaboration application. It makes you productive by giving you the tools and getting out of the way.

What is goplan?

Goplan is an online project management solution. It allows teams and individuals to collaborate through tasks, file management, real-time chat, online calendaring, and many other features. As an always-on access-anywhere hosted solution it saves companies the trouble of purchasing, maintaining and securing a platform for collaboration.

Why we built it

We built Goplan because we needed a way to stay in touch with our clients and on top of our projects. The current solutions out there weren't flexible enough, so we built our own. We're opening it to the public because others may have the same problem.

Features

Goplan offers modules for note-taking, calendaring (with iCal export), task management, issue tracking, file management and online real-time chat. You are not forced to use everything – when you create a project, you're able to pick just the features you need, in order to un-clutter your environment. Click here for more details.

See Flickr for bigger (and more) screenshots

Login or sign-up (goplan.org)

Goplan Blog (blog.goplan.info)

Developer information (api.goplan.org)

Want to try the app before signing up? Use "demo@goplan.org" as email and "demodemo" as password.

How much does it cost?

We have several plans, including one that is completely free. Plans differ on number of projects, number of people and storage, so you may choose the plan that best fits your needs. Click here for a feature comparison and pricing details.

Our feature-set and pricing information:

Goplan

[goplan logo]

One month of Goplan

Posted by Fred Oliveira, April 20, 2007. On: News

It's now been one month since we officially launched Goplan (our collaboration product) built by ourselves, for ourselves (and now for you guys) – we've built others in the past since our business is to help companies launch web-apps, but this one's our own baby. So it makes sense to look at how last month was, and how it's going to influence our future.

The comparison with Basecamp

The first thing that happened – and we were expecting it to a certain extent –, was that Goplan was compared to Basecamp by 37Signals. It is a valid comparison given how the two solutions serve a similar purpose. However, our goal is not to eat away at 37Signals's audience and here's why:

We built our product because existing solutions (Basecamp included) did not fit our needs. Basecamp lacks a few features we need (issue tracking being the obvious one), and somehow their navigation never "clicked" for us. There's people who share these problems – and thats the kind of people we want to help.

Ultimately web-based collaboration is about using tools that become second nature to you – that help your team's process (even if the team's only you). If Goplan's not the tool for you, find the right one and kick ass with it. But tell us why you didn't like our product and we'll make it better with your input.

The reactions and requests

There's been hundreds of posts on the blogosphere about the product – we're really happy about that. And there's been some amazing feedback, both positive and negative. A lot of people sent in feature requests for things they'd love to have, and with quite a few issues we overlooked (it happens, even with 6 months of testing) were found and fixed.

We've always had an open attitude when it comes to talking about the things we want to build into the product, and those we don't. We openly published known issue lists in the past, and the things we're working on. We'll continue building on top of Goplan in the exact same way – we'll let you know and listen to you first, and then push it out.

Subscribe to this feed

Goplan is an online project management solution. It allows teams and individuals to collaborate through tasks, file management, real-time chat, online calendaring, and many other features. Click here for more info.

Ten latest articles:

One month of Goplan
Goplan's been tweaked
Email delivery problems
Bug in free accounts – Fixed!
Due thanks
Some things you might not know yet
We have just (really, seriously) launched!
We're twittering!
Video – 2min to productivity
Sssh, we're launching

Post categories:

Development (21)
Hints and Tips (6)
News (33)

www.goplan.info
D: fred oliveira
A: webreakstuff **M:** goplan@webreakstuff.com

Création de site | Contenu Off-Line | Réalisations | Nous connaître

● ● ● Nous connaître

ZIMAGINE :
- Une équipe
- Localisation
- Contact

Créée en 2006, Zimagine est une jeune agence web. Pilotée par une webmaster pleine d'idées, elle a déjà à son actif quelques belles réalisations.

Gaëlle a, à la base, une formation de graphiste dans l'imprimerie. Elle a complété son cursus par une formation dans les métiers du multimédia (Supinfocom à Valenciennes).
Pendant 5 ans, elle a exercé ses talents chez un grand éditeur, étant plus spécialement chargée du graphisme et de l'intégration. Ces deux domaines, elle les maîtrise sans conteste sur le bout des doigts !

Mais la création de contenu multimedia requiert des compétences très diverses, tantôt très techniques notamment pour les développements. Une seule personne ne peut pas prétendre réunir toutes ces qualités. Zimagine connaît ses points forts et n'exploite que ceux-ci. Pour le reste, l'agence s'appuie sur un solide réseau.
Interlocuteur unique, Zimagine vous donne des garanties en terme de délai et de qualité.

● ● ● Nous contacter
Pour tout renseignement, vous pouvez nous contacter par e-mail ou par téléphone.
E-mail : contact@zimagine.fr
Tél. : +33 (0)3 20 30 18 12

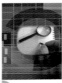

150%

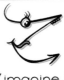
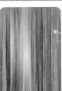

Création de site | Contenu Off-Line | Réalisations | Nous connaître

● ● ● Création de site

VOTRE SITE WEB
- Création de votre site web
- Webdesign

ACCOMPAGNEMENT
- Noms de domaines et hébergement
- Statistiques
- Formations
- Modularité et mise à jour

AUDIENCE
- Référencement
- Publicité
- Générez du revenu
- Votre communication

➤ Création de votre site Internet

A qui s'adresse votre site ? Quel est son but ? Est-ce un site vitrine de votre activité ? Comptez-vous vendre vos produits en ligne ? Autant de questions à se poser, autant de réponses à donner pour démarrer le projet.

Nous vous écoutons, cernons au mieux votre projet. En constante collaboration, nous prenons les premières options techniques. Chez Zimagine, on vous exposera simplement les avantages et les inconvénients de chacune des options.

Vous souhaitez un site vitrine ? Un site statique en html vous convient parfaitement. Vous voulez piloter un site marchand ? Un site dynamique intégrant une base de données (Php, MYSQL) vous est alors plus indiqué. Vous voulez mixer les deux techniques, c'est également possible.

Vos besoins sont spécifiques. Nos développements aussi. Nous savons aussi bien mettre en place un outil de téléchargement de photos, que créer un back office fonctionnel qui vous permettra de vous occuper de votre site internet sans posséder un lourd bagage technique.

● ● ● Nous contacter
Pour tout renseignement, vous pouvez nous contacter par e-mail ou par téléphone.
E-mail : contact@zimagine.fr
Tél. : +33 (0)3 20 30 18 12

150%

www.zimagine.fr
D: gaelle depoorter C: gaelle depoorter P: gaelle depoorter
A: zimagine M: gaelle@zimagine.fr

M
studio

○ ○ ○ M Studio – Alex Motzenbecker – Web development

M Studio programs websites, games and applications that combine sophisticated technology with innovative problem-solving. Our detailed and comprehensive approach ensures that our solutions remain agile, customizable, and user-friendly.

>

M
studio

○ ○ ○ M Studio – Alex Motzenbecker – Web development

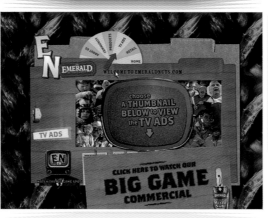

< >

Emerald Nuts

Designed by Goodby, Silverstein & Partners, this promotional site welcomes visitors to replay the brand's TV ads and interact with product-related games and animation. Since its launch, the website has been honored by the Webby Awards, Flash Forward, the Dotties, and the Art Director's Club.

Technical information

www.mstudio.com
D: marc s. levitt, sheri l. koetting, mslk C: alex motzenbecker P: mslk
A: m studio M: info@mstudio.com

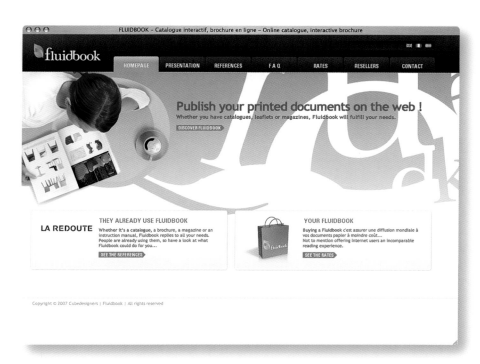

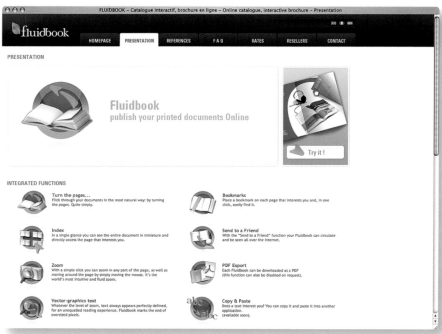

www.fluidbook.com

D: mathieu pesme **C:** jens lofberg **P:** mathieu pesme, jens lofberg, jeff castel

A: cubedesigners **M:** info@fluidbook.com

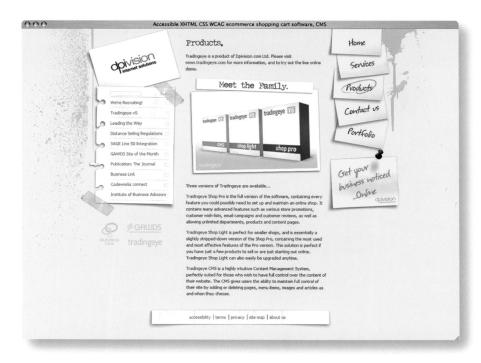

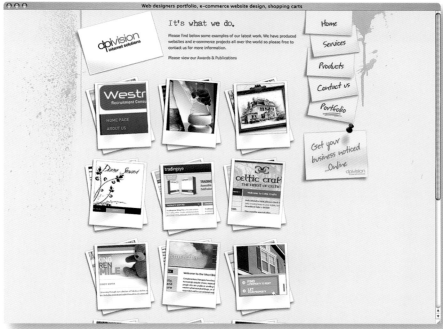

www.dpivision.com
D: ian sidaway **P:** wladimir baranoff-rossine
A: dpivision.com ltd **M:** info@dpivision.com

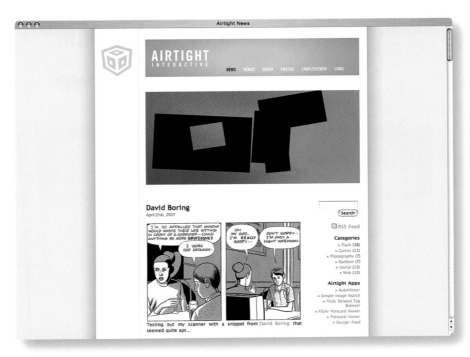

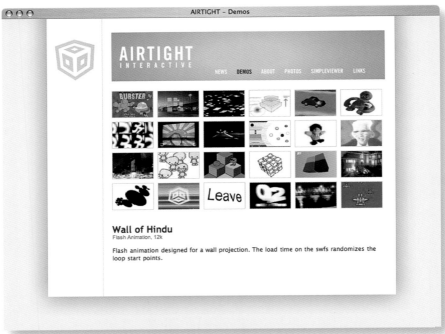

www.airtightinteractive.com
D: felix turner **C:** felix turner **P:** felix turner
A: airtight interactive **M:** felix@airtightinteractive.com

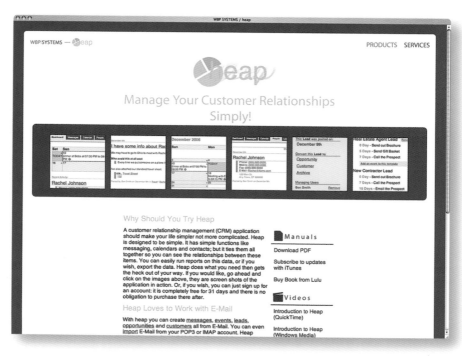

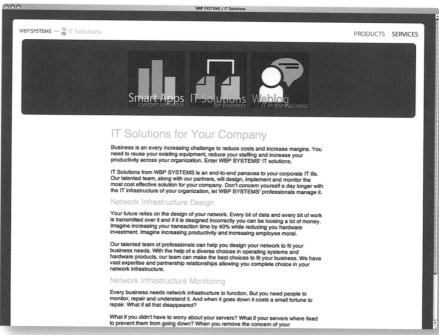

heap.wbpsystems.com

D: ben smith

M: ben@wbpsystems.com

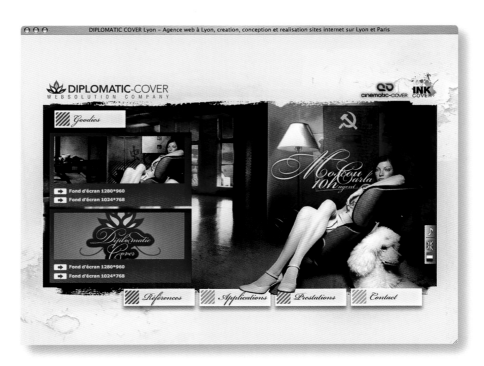

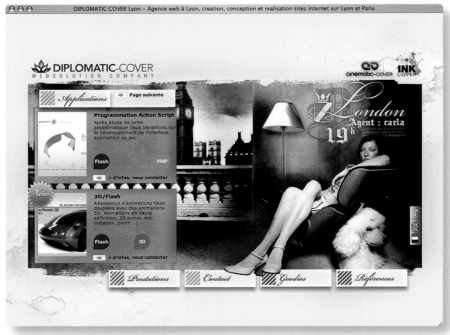

www.diplomatic-cover.com

D: diplomatic-cover

M: studio@diplomatic-cover.com

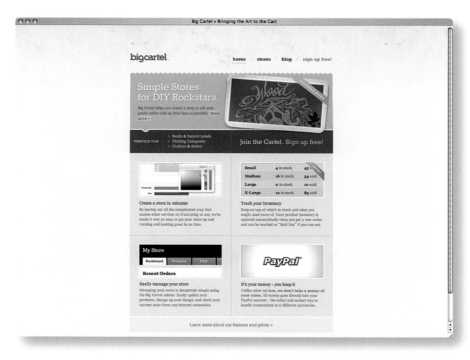

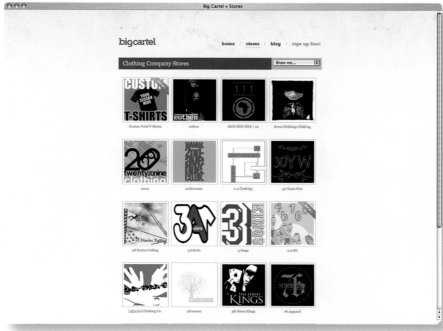

www.bigcartel.com
D: eric turner **C:** matt wigham
A: indie labs **M:** contact@indielabs.com

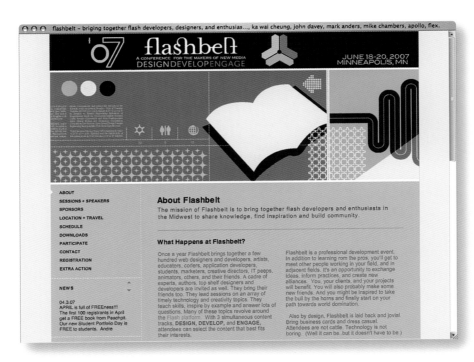

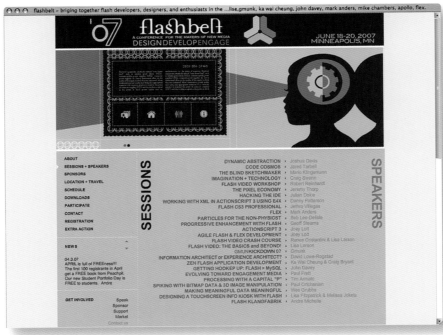

www.flashbelt.com

D: katie kirk, nathan strandberg, eighthourday.com C: flash4hire P: dave schroeder
A: pilotvibe, flashbelt M: dave@pilotvibe.com

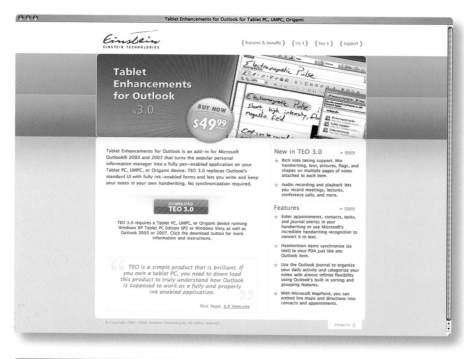

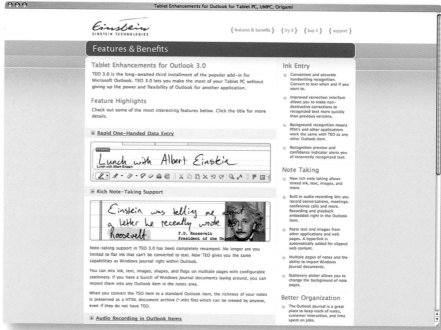

www.tabletoutlook.com
D: wojciech grzanka, kamil pelka
A: helldesign **M:** info@helldesign.net

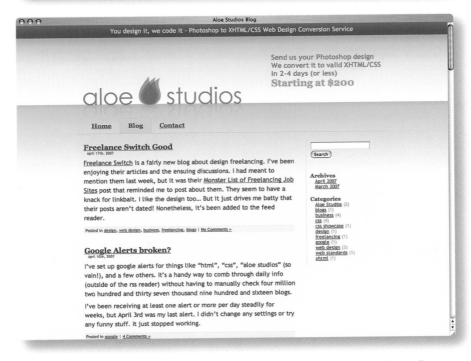

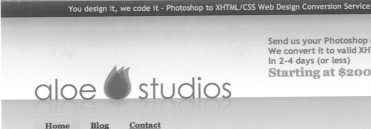

aloestudios.com

D: andy ford **C:** andy ford **P:** andy ford
A: aloe studios **M:** andy@aloestudios.com

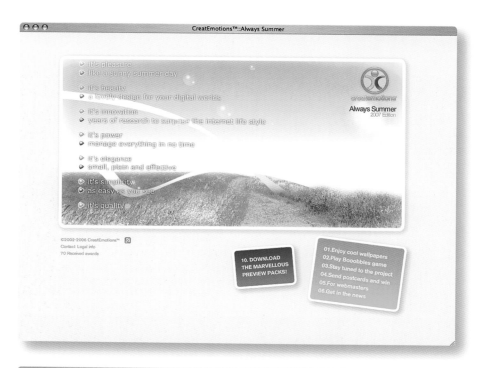

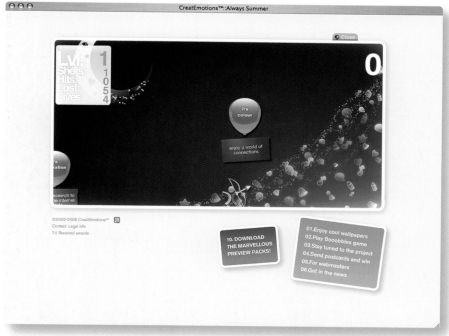

www.spreadcreatemotions.com
D: roberto della pasqua C: roberto della pasqua P: roberto della pasqua
A: createmotions™ M: info@createmotions.com

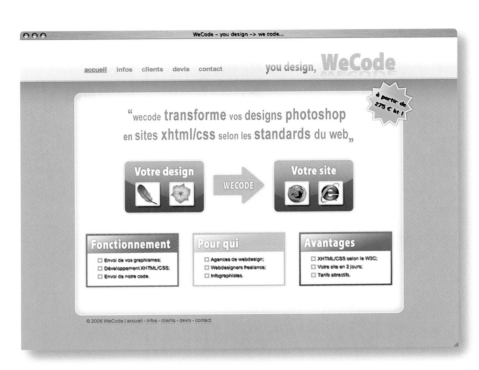

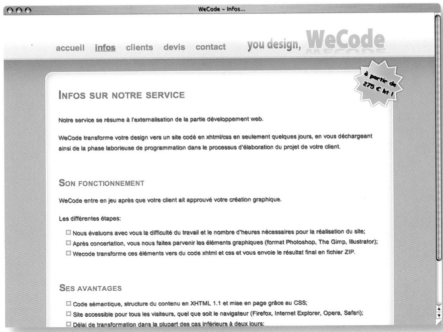

www.wecode.fr
D: nicolas koenig
A: cclair.nl **M:** info@cclair.nl

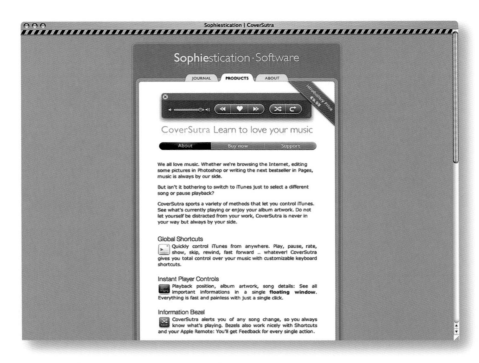

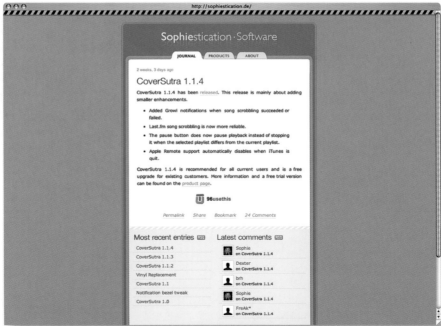

coversutra.com
D: sophia teutschler, laurent baumann C: sophia teutschler
A: sophiestication software M: info@sophiestication.de

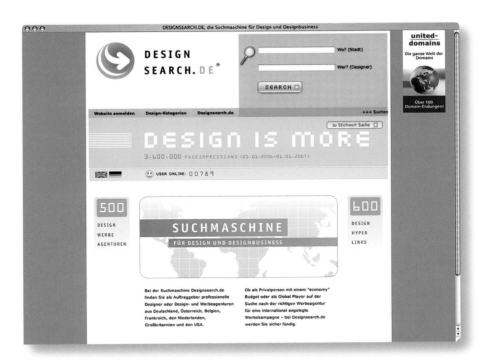

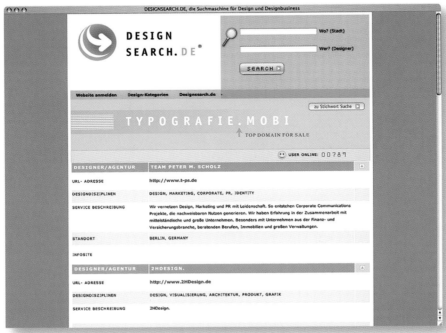

www.designsearch.de

D: sergej lebedew **C:** sergej lebedew **P:** sergej lebedew
A: designsearch ltd **M:** info@designsearch.de

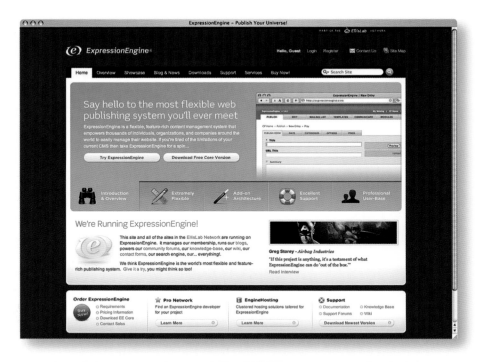

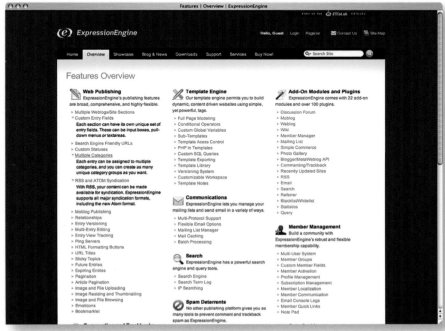

expressionengine.com
D: jesse bennett-chamberlain C: paul burdick, derek jones, rick ellis P: rick ellis
A: ellislab, inc. M: media@ellislab.com

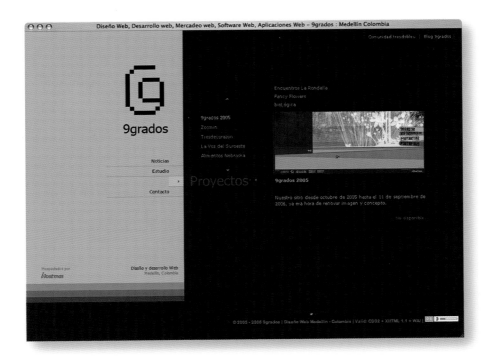

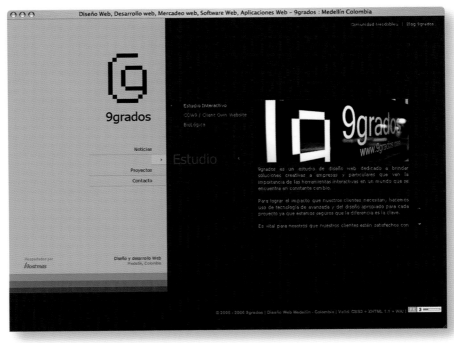

www.9grados.com

D: andres acosta **C:** jose david bedoya, juan carlos arango **P:** 9grados
A: 9grados **M:** info@9grados.com

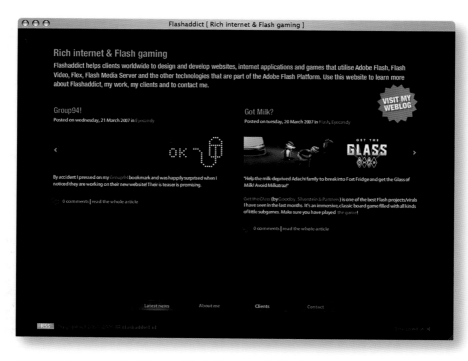

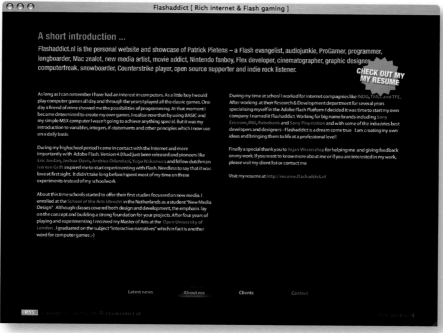

www.flashaddict.nl
D: patrick pietens **C:** patrick pietens
A: flashaddict **M:** info@flashaddict.nl

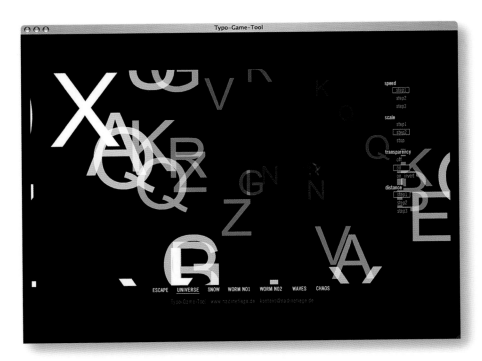

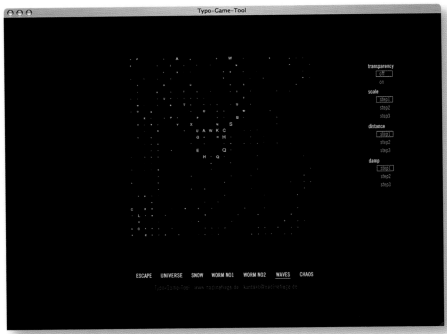

typogametool.nadinefiege.de

D: nadine fiege **C:** nadine fiege **P:** nadine fiege
A: hochschule mannheim **M:** kontakt@nadinefiege.de

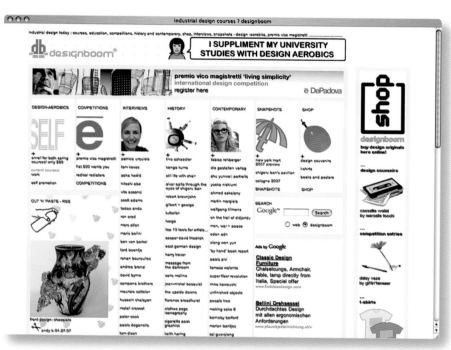

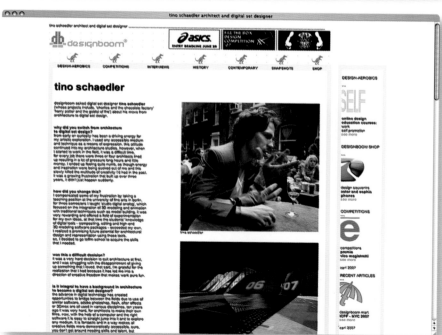

www.designboom.com

D: birgit lohmann

A: designboom **M:** mail@designboom.com

About
Reismagos
Contact
Friends

Back to top

info [at]
estudiomopa.com

Capricho Magazine #1013

One-page illustration
Check this magazine.

Revista Colectiva #8

Contributions for the Circus edition
Check the magazine.

Back to top

info [at]
estudiomopa.com

www.estudiomopa.com

D: alline luz, daniel gizo, felipe mello, rogério lionzo **C:** daniel gizo

A: mopa **M:** info@estudiomopa.com

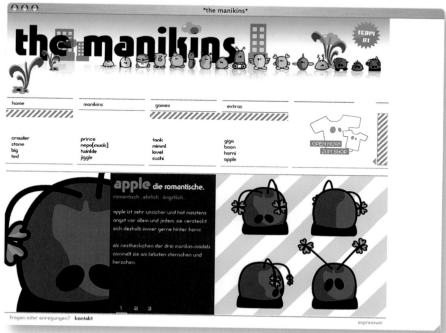

www.themanikins.de

D: jana balkwitz, julia balkwitz **C:** balkwitz
A: balkwitz gbr **M:** design@balkwitz.de

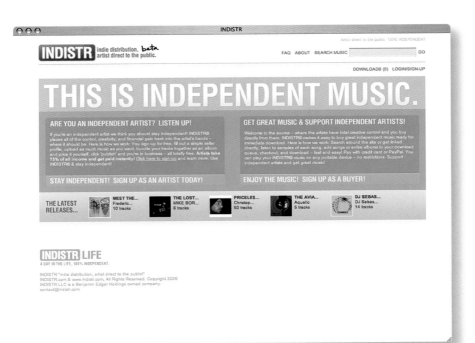

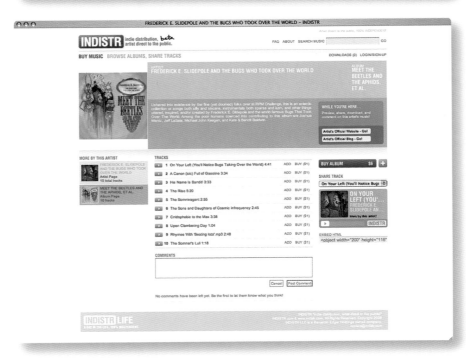

D: mike carnevale, benjamin gott C: nusoft solutions P: benjamin gott

A: indistr, llc M: contact@indistr.com

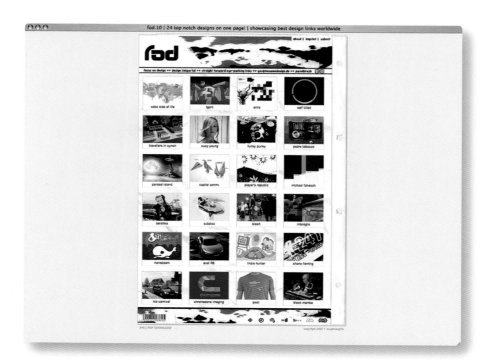

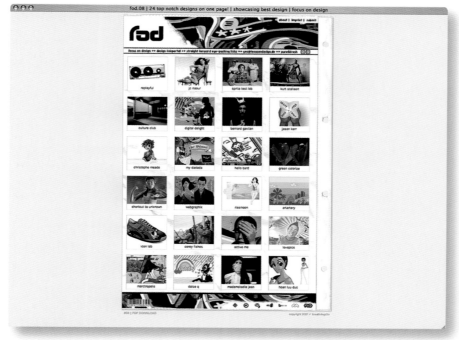

www.focusondesign.de
D: jan weiss C: jan weiss
A: kreativkopf.tv M: j.weiss@kreativkopf.tv

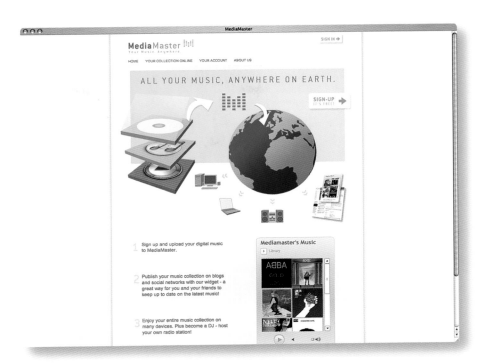

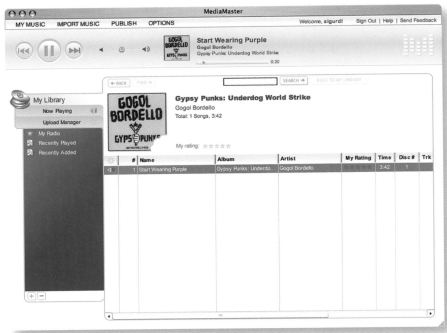

www.mediamaster.com

D: frank ramirez **P:** neil day

A: mediamaster, inc. **M:** nmday@mediamaster.com

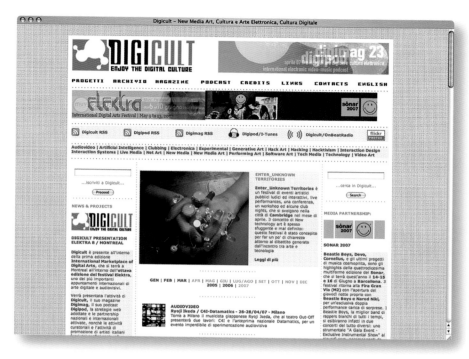

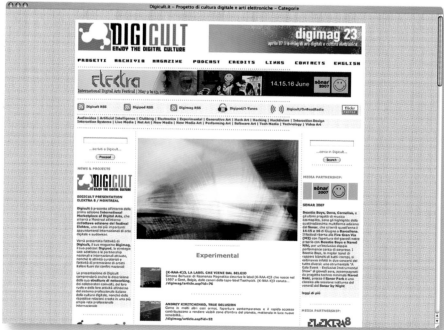

www.digicult.it

D: marco mancuso, luca pertegato, riccardo vescovo C: luca restifo P: marco mancuso

A: digicult productions M: info@digicult.it

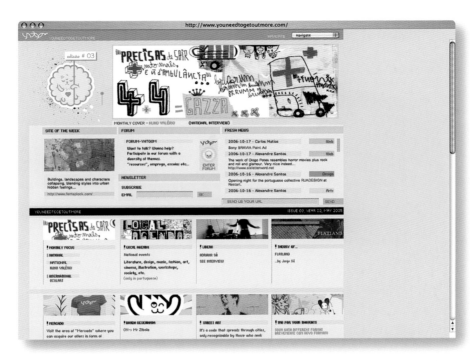

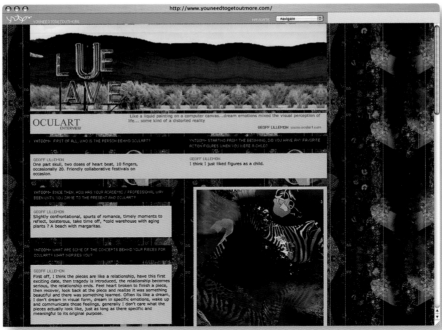

www.youneedtogetoutmore.com

D: carlos matias, alexandre santos, pedro mateus

M: info@youneedtogetoutmore.com

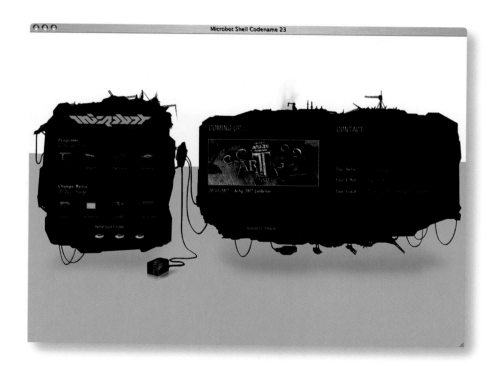

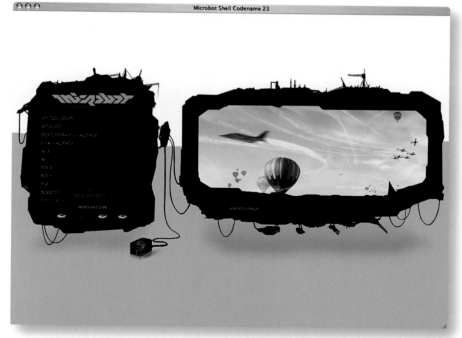

www.microbot.ch
D: david fuhrer C: david fuhrer P: david fuhrer
A: microbot M: shell@microbot.ch

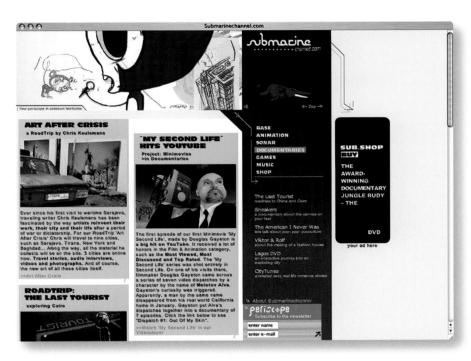

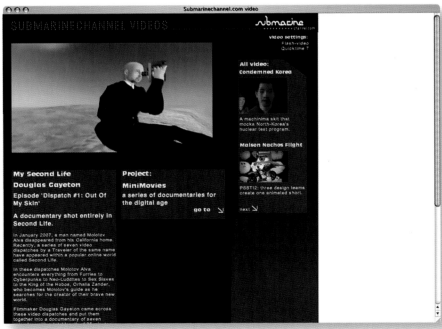

www.submarinechannel.com

D: fons schiedon, madelinde hageman **C:** s. veenhof, r. prein **P:** f. wolting, b. felix

A: submarinechannel **M:** info@submarinechannel.com

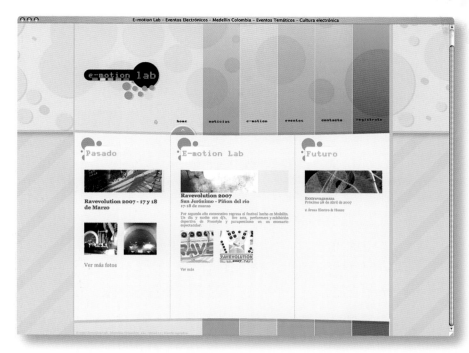

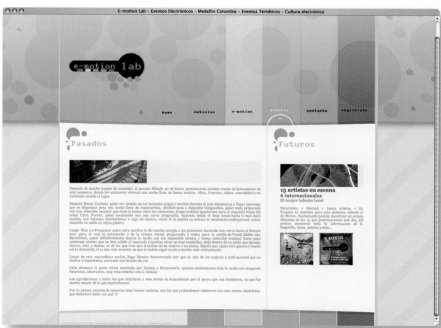

www.e-motionlab.com
D: andres acosta **C:** jose david bedoya, juan carlos arango **P:** 9grados
A: 9grados estudio interactivo **M:** info@9grados.com

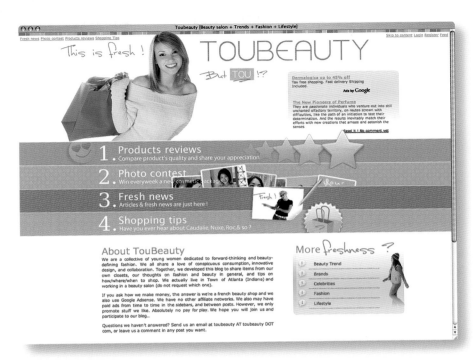

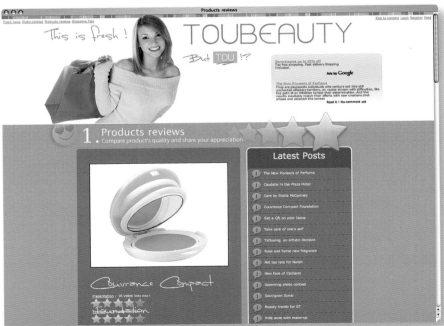

www.toubeauty.com

D: cédric morelle **C:** cédric morelle **P:** cédric morelle

A: toucouleur **M:** toubeauty@toucouleur.fr

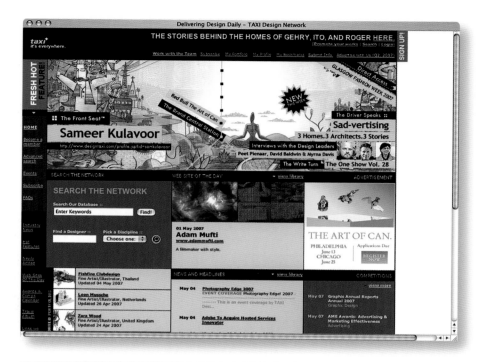

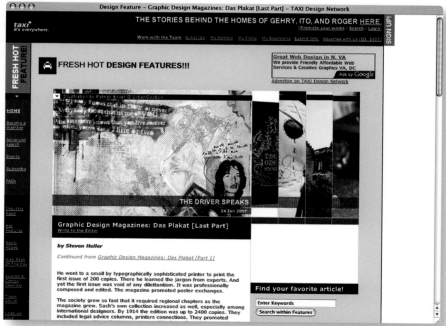

www.designtaxi.com
D: alex goh k.c. C: ting zien lee P: taxi design network
A: hills creative arts pte ltd M: 65.6100.arts

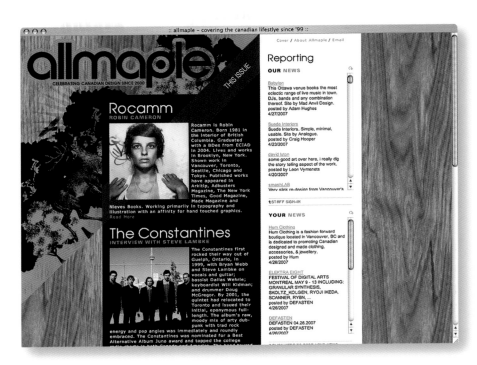

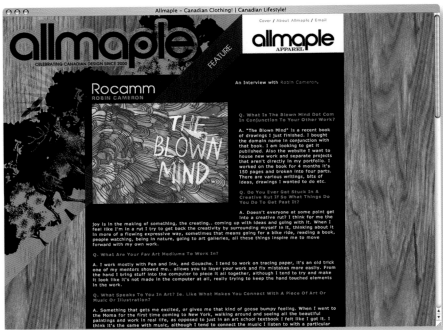

www.allmaple.com

D: allmaple staff C: brett gossman, dave hetesi P: dave smith, eric vardon

A: allmaple M: editor@allmaple.com

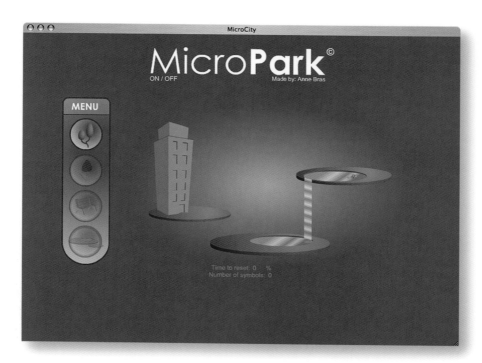

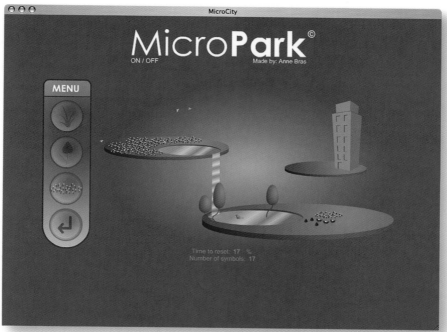

www.annebras.nl/World/micro/All.html
D: anne bras C: anne bras P: anne bras
M: its_no_life@hotmail.com

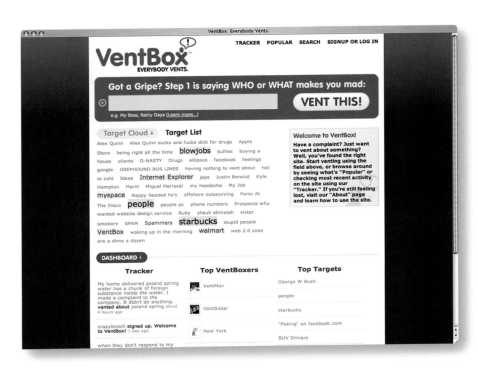

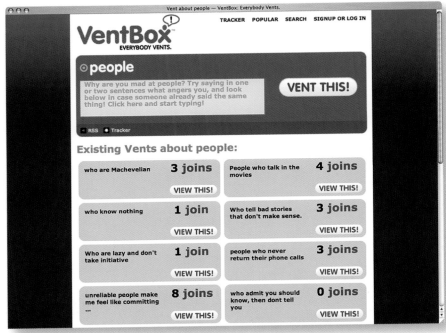

www.ventbox.com

D: kyle bragger **C:** aaron quint, kyle bragger **P:** nate westheimer

A: bricabox **M:** info@bricabox.com

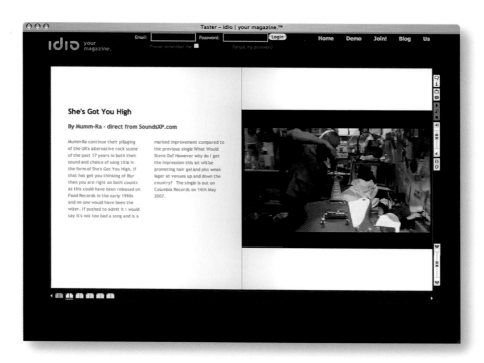

She's Got You High

By Mumm-Ra - direct from SoundsXP.com

Mumm-Ra continue their pillaging of the UK's alternative rock scene of the past 17 years in both their sound and choice of song title in the form of She's Got You High. If that has got you thinking of Blur then you are right on both counts as this could have been released on Food Records in the early 1990s and no one would have been the wiser. If pushed to admit it I would say it's not too bad a song and is a marked improvement compared to the previous single What Would Steve Do? However why do I get the impression this lot will be promoting hair gel and piss weak lager at venues up and down the country? The single is out on Columbia Records on 14th May 2007.

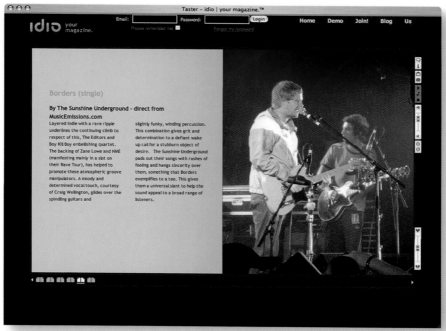

Borders (single)

By The Sunshine Underground - direct from MusicEmissions.com

Layered indie with a rave ripple underlines the continuing climb to respect of this, The Editors and Boy Kill Boy embellishing quartet. The backing of Zane Lowe and NME (manifesting mainly in a slot on their Rave Tour), has helped to promote these atmospheric groove manipulators. A moody and determined vocal touch, courtesy of Craig Wellington, glides over the spindling guitars and slightly funky, winding percussion. This combination gives grit and determination to a defiant wake up call for a stubborn object of desire. The Sunshine Underground pads out their songs with rushes of feeling and hangs sincerity over them, something that Borders exemplifies to a tee. This gives them a universal slant to help the sound appeal to a broad range of listeners.

www.idiomag.com
D: ed barrow, planet new media C: ed barrow, thrusites P: ed barrow
A: idio ltd M: info@idiomag.com

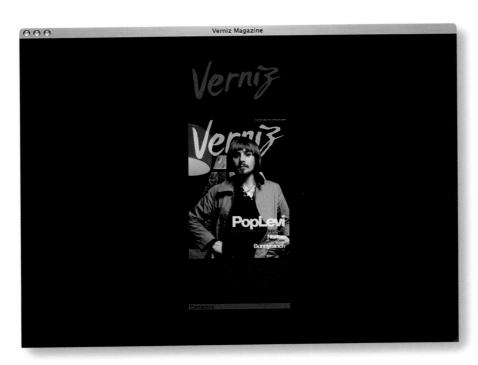

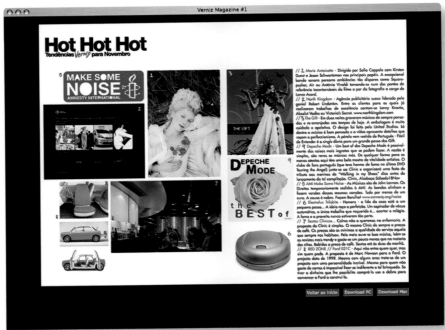

www.vernizmagazine.com
D: davide silva C: fernando marques
A: velcro graphic design M: www.velcrodesign.com

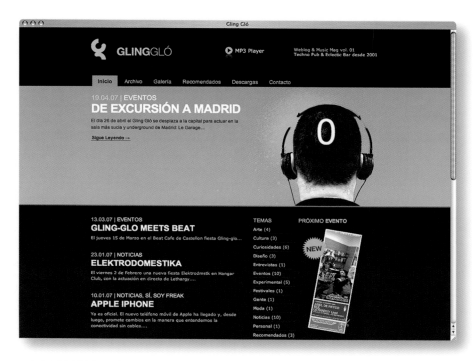

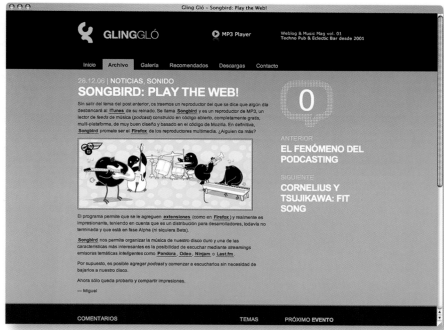

www.glingglo.net
D: miguel ángel sánchez rubio **C:** miguel ángel sánchez rubio **P:** dj bul
A: xtencil **M:** miguel@xtencil.com

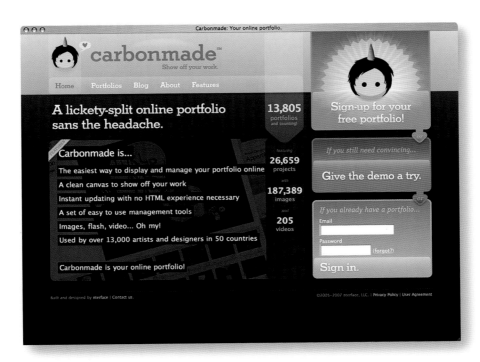

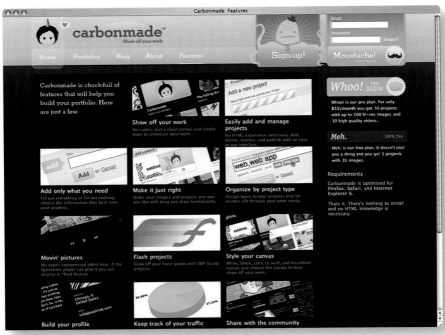

www.carbonmade.com

D: dave gorum **C:** jason nelson
A: nterface **M:** hello@nterface.com

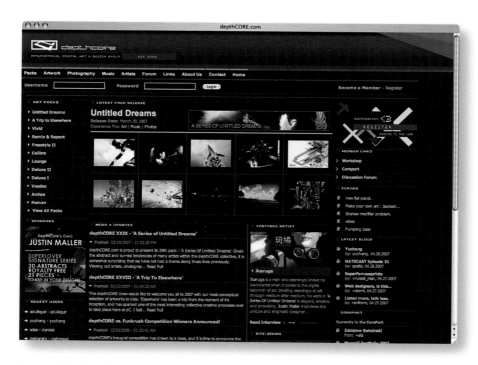

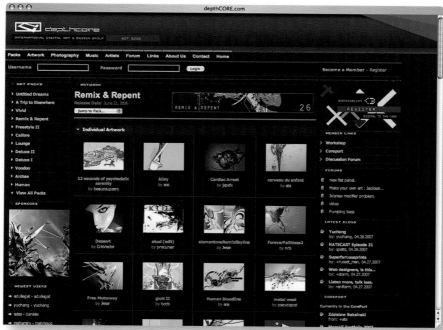

www.depthcore.com

D: brian smith **C:** brian smith **P:** justin maller

A: depthcore.com **M:** contact@depthcore.com

<dakota-diesel>

INTRO

WHO
WHAT
WHEN
HOW

WE'RE NOT DIFFERENT
THAN ANY OTHER AGENCY THAT COMBINES CREATIVITY WITH SOLID MARKETING PRINCIPLES.

WE'VE WORKED WITH THE LARGE BRANDS, MANAGED THE HUGE ACCOUNTS AND CAME UP WITH THE BIG IDEA.

SO THERE IS NO DIFFERENCE. WELL JUST ONE - THE PRICE TAG

<dakota-diesel>

INTRO

WHO
WHAT
WHEN
HOW

TWO WORDS: PURE SKILL
THAT'S RIGHT, WE'RE GOOD AT COMMUNICATING IDEAS TO PEOPLE WHO NEED PEOPLE THAT ARE GOOD AT COMMUNICATING IDEAS TO THEM... OR SOMETHING LIKE THAT.

(YOU'LL HAVE TO CLICK HERE TO REALLY FIND OUT HOW.)

www.dakota-diesel.com
D: steve klein
A: dakota-diesel, inc. **M:** steve@dakota-diesel.com

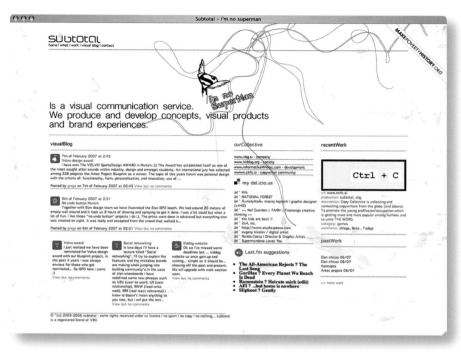

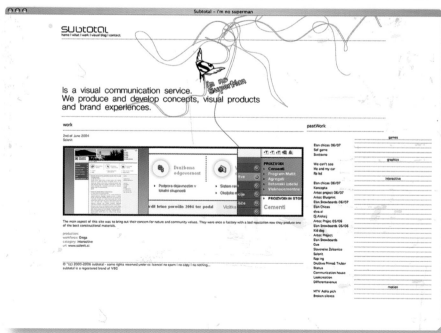

www.subtotal.nu
D: gregor zakelj **C:** bostjan zakelj **P:** gregor zakelj
A: subtotal by vbg **M:** grega@subtotal.nu

BÜRO FÜR VISUELLE KOMMUNIKATION

VIENNA ¶ GRAZ ¶ VÖCKLAMARKT – SINCE 2004

Threadless: Top
15. September 2006, 00:40:43

Die Chicagoer Jungs von Threadless machen ihre Sache ziemlich gut, muss man neidlos anerkennen. Die Webseite ist top ausgestattet, mit sehr hohem Community-Faktor. Also: Ziemlich gute Adresse, wenn es um grafisch hochqualitative T-Shirts geht. Unser Partner für Illustrations-Fragen Michael Fuchs ist auch vertreten, siehe Abbildung.
Das österreichische Gegenstück: Merchzilla — jedoch mit Schwerpunkt Auftragsproduktion. Zumindest unser Lieferant des Vertrauens, für die letzten Shirt-Produktionen.

ABGELEGT UNTER THIS BOOKMARKS, WE LOVE …, SHIRTS | KOMMENTARE (1) | PERMALINK

176 Pixel: Smart!
5. September 2006, 21:56:03

Der Brite Mark James stellt auf seiner Homepage Fam Fam Fam zahlreiche bezaubernde Icons zur Verfügung. Die Flaggen sind bereits beim Tabellenlayout beim Projekt 08 – Endlich zuhause! zum Einsatz gekommen.

ABGELEGT UNTER THIS BOOKMARKS, WE LOVE …, 08 — ENDLICH ZUHAUSE! | KOMMENTARE (1) | PERMALINK

SUCHEN

[] (Suchen)

INHALT
Kontakt
Partner | Team
Presse

KATEGORIEN
We love … (12)
5 (3)
08 — endlich zuhause! (3)
beta phase (4)
bob (3)
shirts (3)
this bookmarks (3)
weekly fresh (1)

ARCHIV
Oktober 2006
September 2006
August 2006

KEEP IT SIMPLE AND SMART

BÜRO FÜR VISUELLE KOMMUNIKATION: VIENNA ¶ GRAZ – SINCE 2004

Zu Besuch in der Argentinierstrasse bei Oe1
26. November 2006, 20:00:32

Mit Bob-Kollegen Wolfgang Haas zu Besuch bei Oe1. Wir sprechen mit Kristin Scheucher über Bob, Club Bellevue, Plattformen und Handel. Am Samstag 02.12. (17.05 bis 19.00) im Rahmen der Sendung Diagonal. Oe1-Liveradio: http://oe1.orf.at/konsole_live.html

ABGELEGT UNTER WE LOVE …, BOB | KOMMENTARE (0) | PERMALINK

Logo, 03, 2004
6. November 2006, 20:00:06

Entwickelt wurde das Logo für das Magazin Bob bereits im Herbst 2004! Foto von Wolfgang Hummer, Model: Yueshin Lin. Zur Merchandisingseite gehts hier. Eine druckfähige Version des Bildes findet man im Presse-Bereich.

" Wenn Zeitschriften Kneipen wären, dann hätte sich das Magazin Bob innerhalb kurzer Zeit von der glatten Neue Mitte After Work-Stimmung zum tiefgründig-unrenovierten Kreuzberger Flair mit schummrigen Licht gewandelt. (Tadeusz Szewczyk in seiner Rezension auf Phlow)

ABGELEGT UNTER WE LOVE …, BOB, SHIRTS | KOMMENTARE (0) | PERMALINK

SUCHEN

[] (Suchen)

INHALT
Kontakt
Partner | Team
Presse

KATEGORIEN
We love … (15)
5 (3)
08 — endlich zuhause! (3)
beta phase (3)
bob (4)
photos (1)
shirts (3)
this bookmarks (4)
vienna (1)
weekly fresh (1)

ARCHIV
Februar 2007
Dezember 2006
November 2006
Oktober 2006
September 2006
August 2006

www.blois.at

D: alois gstöttner C: alois gstöttner, wordpress P: alois gstöttner
A: blois.at - büro für visuelle kommunikation, vienna M: tag@blois.at

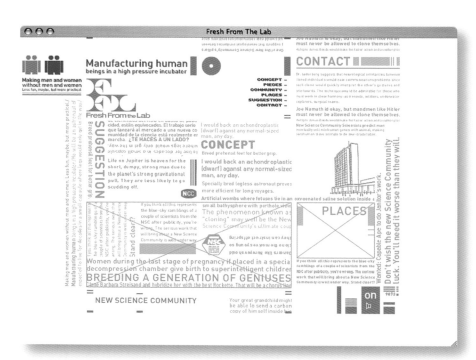

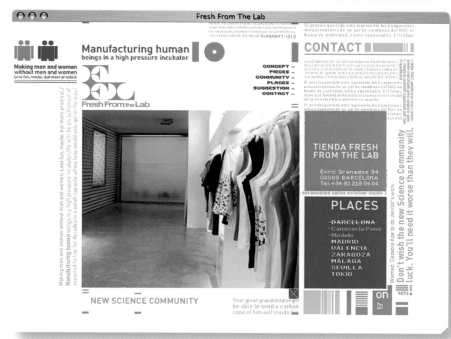

www.freshfromthelab.com
D: nuria reolid, olivier grau, miriam martí **C:** alberto botella **P:** vis-tek.com
A: vis-tek.com **M:** www.vis-tek.com

○ ○ ○ FLOTATS – Imagen y Comunicación – Diseño grafico, internet, p...àfica, editorial, eventos, stands, webs, todo para su empresa

FLOTATS ◆ IMAGEN Y COMUNICACIÓN who we are | clients area

corporate image	graphic communication	publications	packaging	events / stands	multimedia / webs
bcn-tv	bass beer	generalitat catalunya	bufalo	autogrill	ambipur
cees	brabantia	mario bedini	oleaurum	consorci de policies i bombers	bcn-tv
colabors	bufalo	mey hofmann	sal costa	generalitat catalunya	brabantia
gong discos	generalitat catalunya	pere coll	soley	grup disbesa damès	el village
ioca	grupo miralles	sant joan de deu		grupo miralles	grupo miralles
serca	incavi			incavi	sara lee
wildfish	oils de catalunya			**quesos de suiza**	schwarzkopf
	schwarzkopf			sara lee	
	serca			schwarzkopf	
	taylor woodrow			taylor woodrow	

Client: Ulled / Switzerland Cheese Marketing
Presentation of Swiss Cheeses at Maremagnum, Barcelona

+ more works

www.flotats.net · Balmes, 331 1º 2ª · 08006 Barcelona · T. +34 932 121 450 · F. +34 934 188 409 · flotats@flotatsbcn.com

○ ○ ○ FLOTATS – Imagen y Comunicación – Diseño grafico, internet, p...àfica, editorial, eventos, stands, webs, todo para su empresa

FLOTATS ◆ IMAGEN Y COMUNICACIÓN who we are | clients area

corporate image	graphic communication	publications	packaging	events / stands	multimedia / webs
bcn-tv	bass beer	**generalitat catalunya**	bufalo	autogrill	ambipur
cees	brabantia	mario bedini	oleaurum	consorci de policies i bombers	bcn-tv
colabors	bufalo	mey hofmann	sal costa	generalitat catalunya	brabantia
gong discos	generalitat catalunya	pere coll	soley	grup disbesa damès	el village
ioca	grupo miralles	sant joan de deu		grupo miralles	grupo miralles
serca	incavi			incavi	sara lee
wildfish	oils de catalunya			quesos de suiza	schwarzkopf
	schwarzkopf			sara lee	
	serca			schwarzkopf	
	taylor woodrow			taylor woodrow	

Client: Client: Departament d'Agricultura Ramaderia i Pesca (Department of Agriculture, Livestock and Fisheries)
Productes de la Terra (Products of the Land)

www.flotats.net · Balmes, 331 1º 2ª · 08006 Barcelona · T. +34 932 121 450 · F. +34 934 188 409 · flotats@flotatsbcn.com

www.flotatsbcn.com
D: jacinto lana C: jacinto lana P: monica flotats
A: masmac media M: www.masmac.com

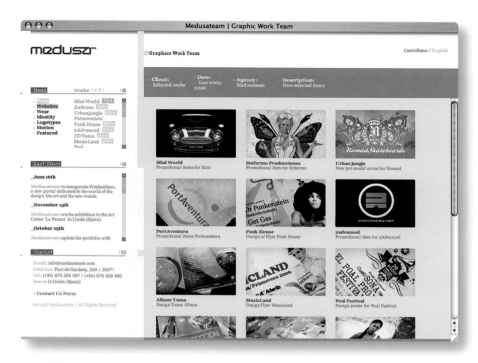

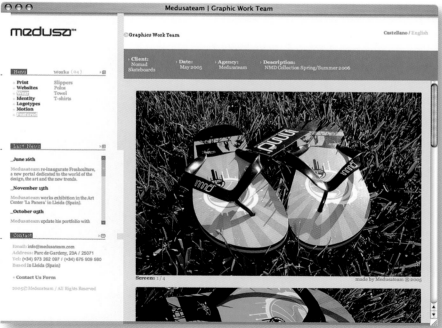

www.medusateam.com

D: eduard mateo, jordi oró **C:** joel barberà

A: medusateam **M:** info@medusateam.com

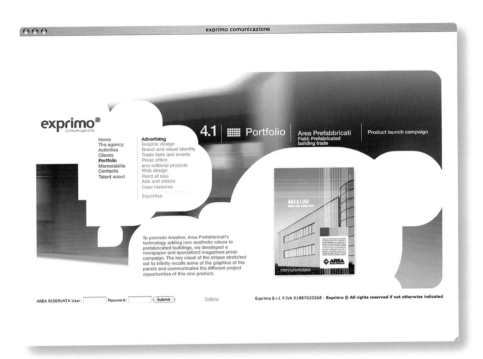

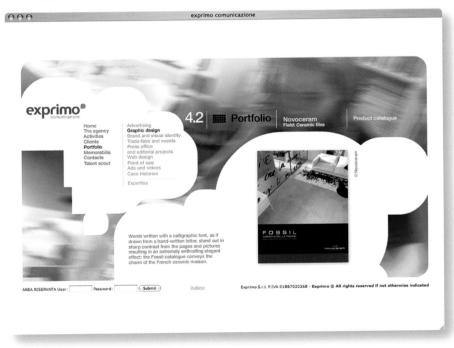

www.exprimo.it
D: andrea cristofaro C: andrea cristofaro P: exprimo comunicazione
A: exprimo comunicazione M: gsala@exprimo.it

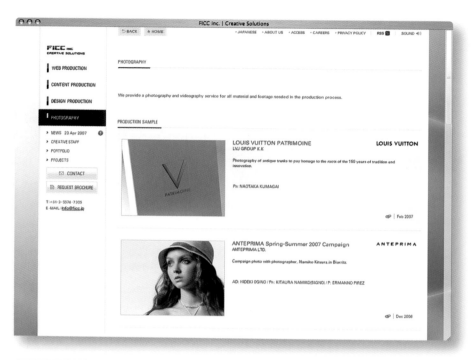

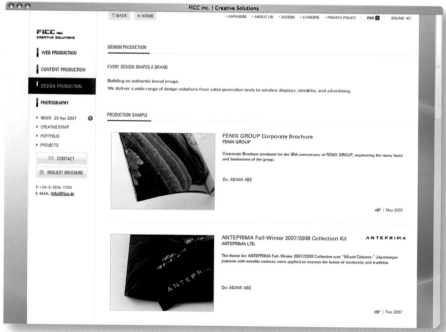

ficc.jp

D: kenichi suzuki C: masaru ando
A: ficc inc. M: info@ficc.jp

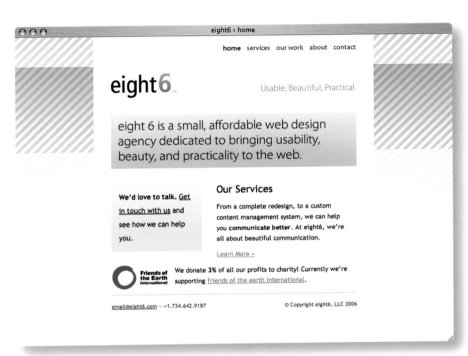

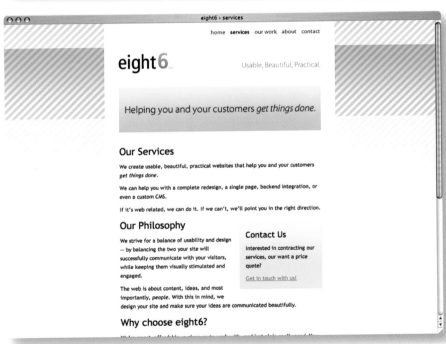

www.eight6.com

D: noel jackson **C:** noel jackson **P:** noel jackson

A: eight6 **M:** email@eight6.com

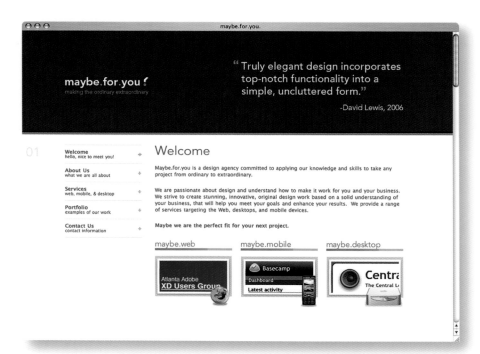

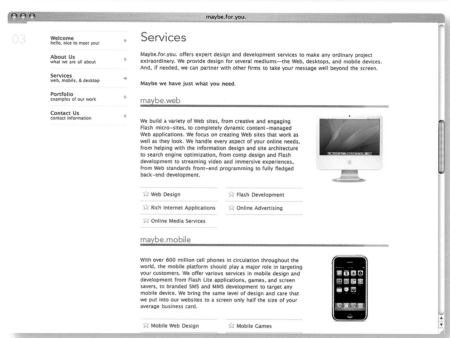

www.maybeinc.com
D: michael hagel **C:** michael hagel
A: maybe.for.you **M:** hello@maybeinc.com

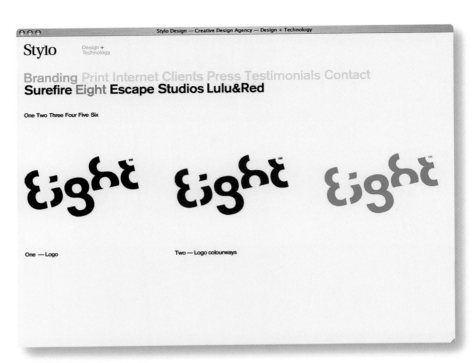

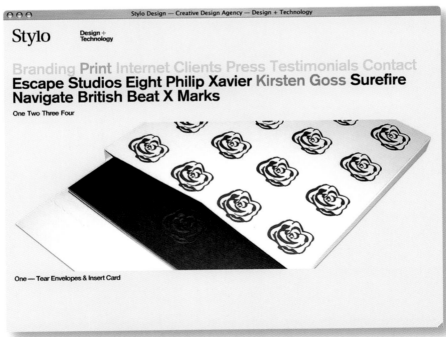

www.stylodesign.co.uk
D: tom lancaster C: tom lancaster P: tom lancaster
A: stylo design M: info@stylodesign.co.uk

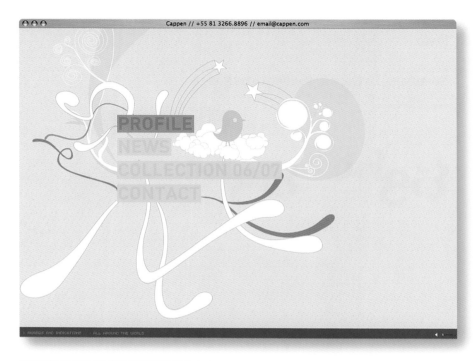

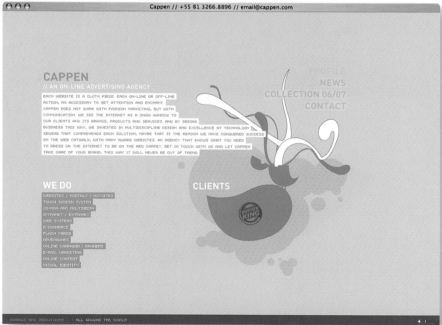

www.cappen.com

D: mauricio nunes, felipe medeiros **C:** andré ponce **P:** felipe medeiros, mauricio nunes
A: cappen **M:** email@cappen.com

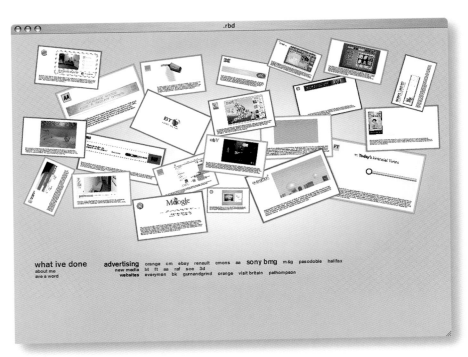

what ive done advertising orange cm ebay renault cmons aa sony bmg m&g pasodoble halifax
about me
ave a word new media bt ft aa raf soe 3d
 websites everyman bk gurnandgrind orange visit britain pathompson

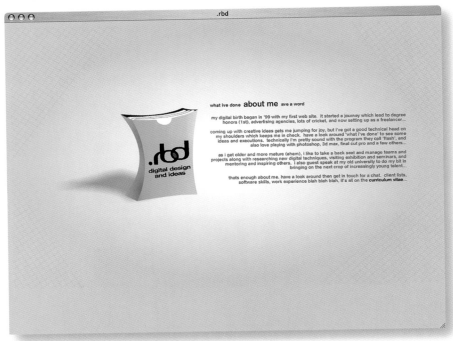

what ive done **about me** ave a word

my digital birth began in '99 with my first web site. it started a journey which lead to degree honors (1st), advertising agencies, lots of cricket, and now setting up as a freelancer...

coming up with creative ideas gets me jumping for joy, but i've got a good technical head on my shoulders which keeps me in check. have a look around 'what i've done' to see some ideas and executions. technically i'm pretty sound with the program they call 'flash', and also love playing with photoshop, 3d max, final cut pro and a few others...

as i get older and more mature (ahem), i like to take a back seat and manage teams and projects along with researching new digital techniques, visiting exhibition and seminars, and mentoring and inspiring others. i also guest speak at my old university to do my bit in bringing on the next crop of increasingly young talent...

thats enough about me. have a look around then get in touch for a chat. client lists, software skills, work experience blah blah blah, it's all on the **curriculum vitae**...

dot-rbd.com

D: robert dewell **C:** robert dewell **P:** robert dewell

A: .rbd **M:** rbd@robdewell.co.uk

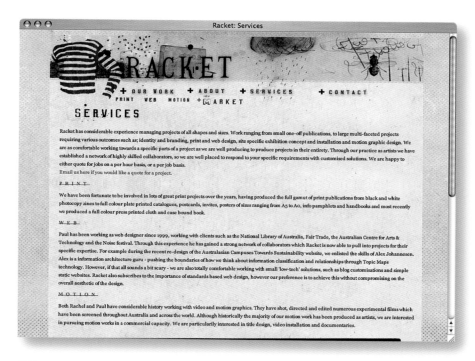

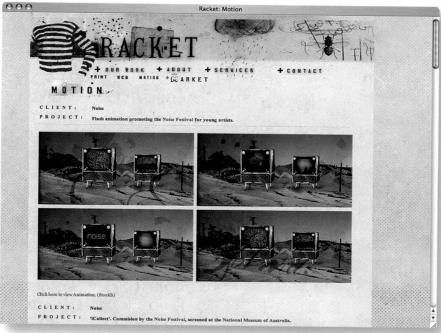

www.studioracket.org

D: paul mosig, rachel peachey C: paul mosig

A: studio racket M: contact@studioracket.org

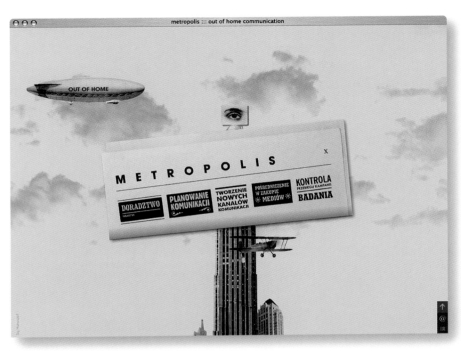

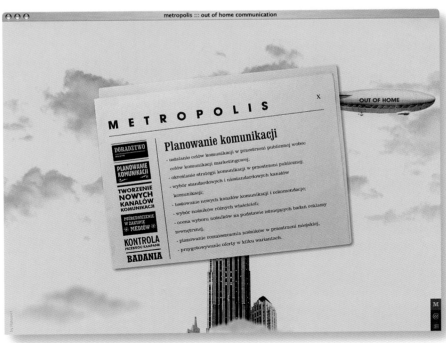

www.metropolis-media.com.pl
D: arek romanski C: lukasz knasiecki
A: huncwot M: info@huncwot.com

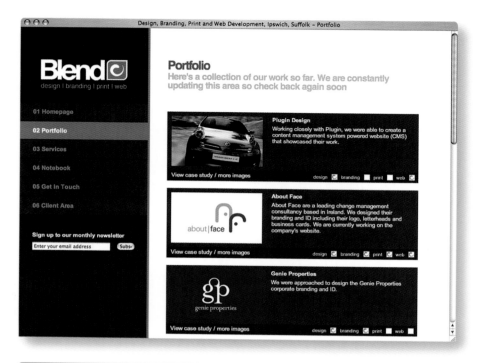

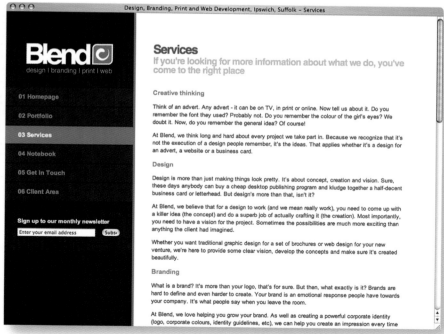

www.blend.uk.com

D: lee wilson

A: blend creative ltd. **M:** hello@blend.uk.com

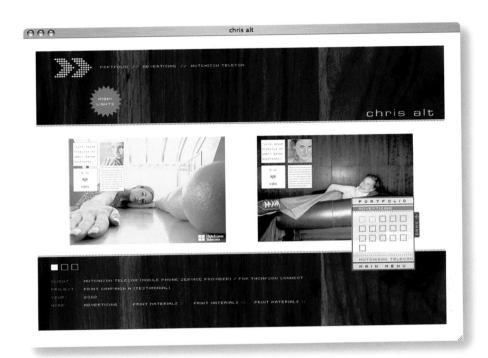

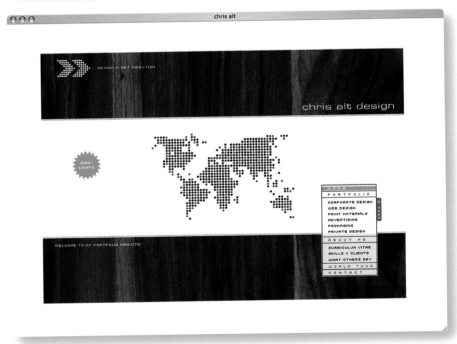

www.chrisalt.com

D: chris alt **C:** uli müller **P:** chris alt
A: chris alt design **M:** design@chrisalt.com

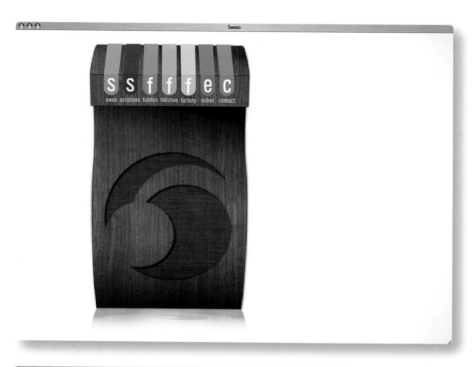

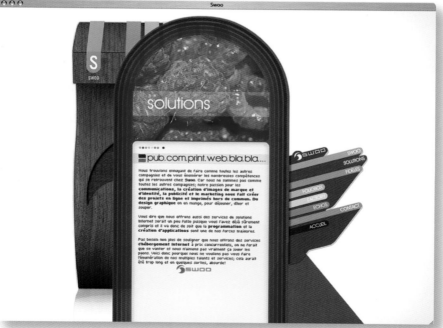

www.swoo.ca

D: maxime st-pierre **C:** maxime st-pierre **P:** maxime fleurant

A: swoo **M:** info@swoo.ca

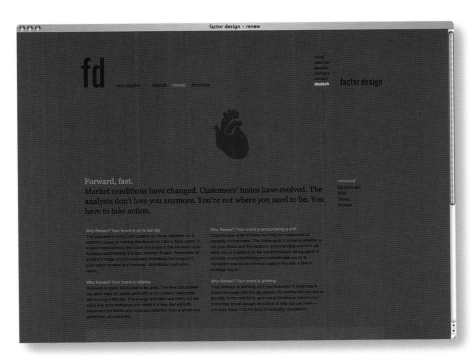

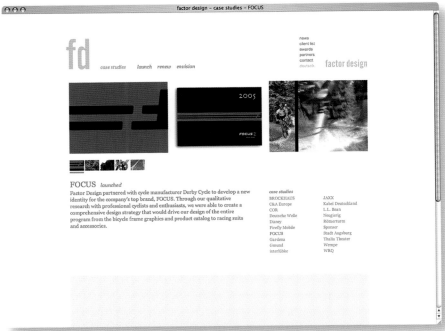

D: gabe campodonico, jeff zwerner, olaf stein **C**: factor design, inc. **P**: helen o'leary
M: jeff@factordesign.com

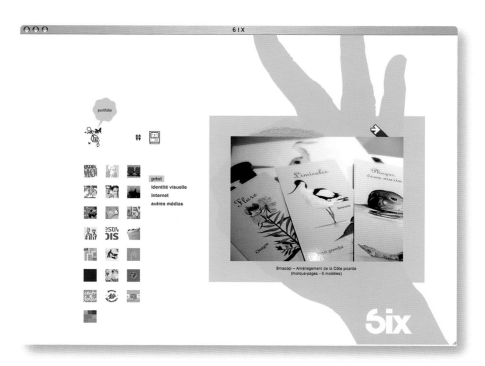

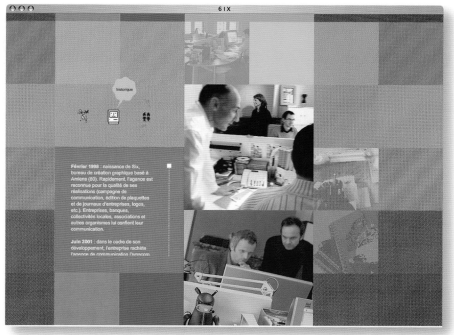

www.six.fr

D: laurent schymik

A: six **M:** six@six.fr

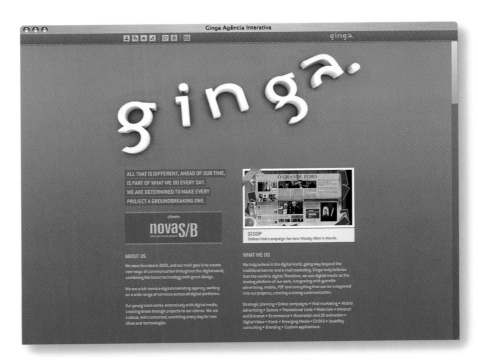

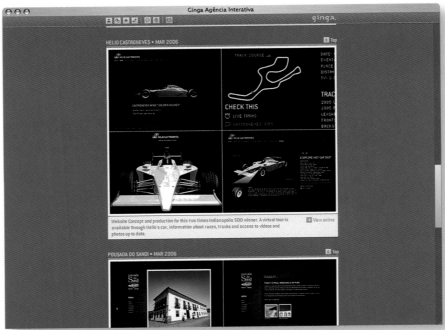

www.agenciaginga.com.br
D: felipe bachian
A: ginga M: www.agenciaginga.com.br

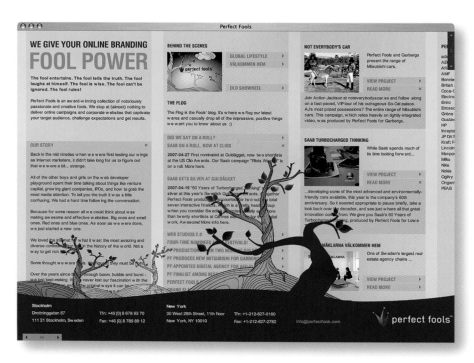

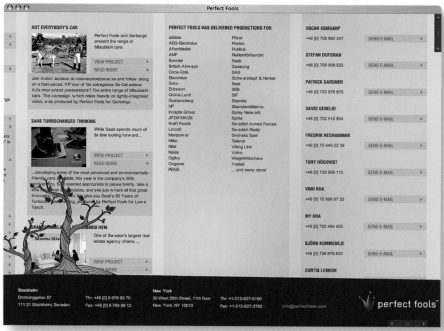

www.perfectfools.com

D: tony högqvist, illustrations by vinh kha **C:** björn kummeneje **P:** patrick gardner
A: perfect fools **M:** info@perfectfools.com

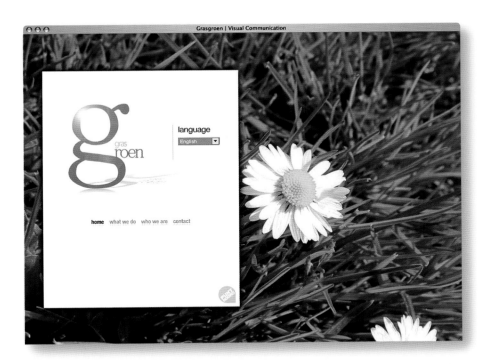

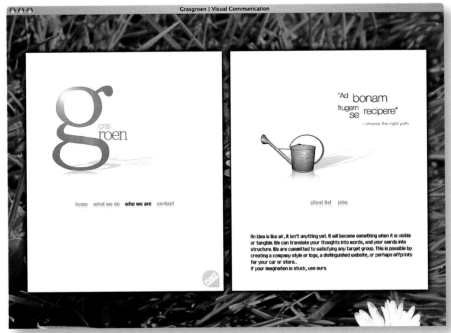

www.grasgroen.com
D: wouter stokkel **C:** wouter stokkel **P:** wouter stokkel
A: grasgroen | visual communication **M:** wouter@grasgroen.com

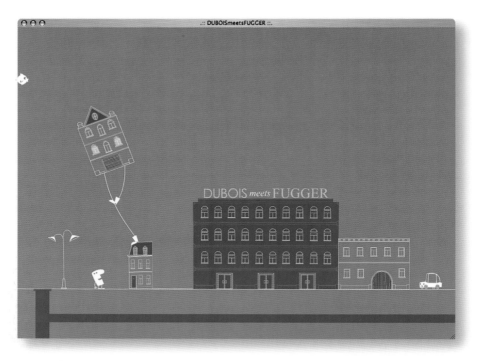

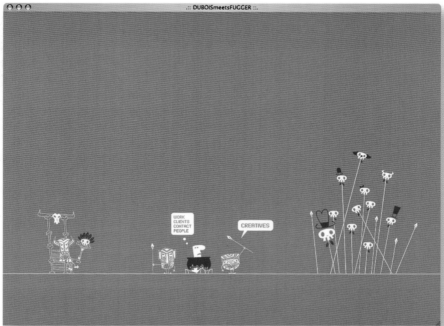

www.duboismeetsfugger.com
D: ben van asbroeck, caroline vermaerken C: studio plum
A: ben van asbroeck, caroline vermaerken M: info@duboismeetsfugger.com

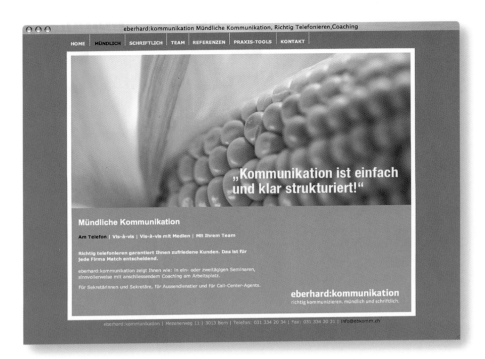

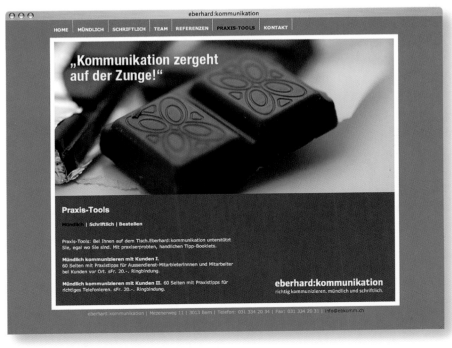

www.eberhardkommunikation.ch

D: gregory gasser, michael ziska **C:** g.g/m.z **P:** id-k kommunikationsdesign
A: id-k kommunikationsdesign **M:** info@id-k.com

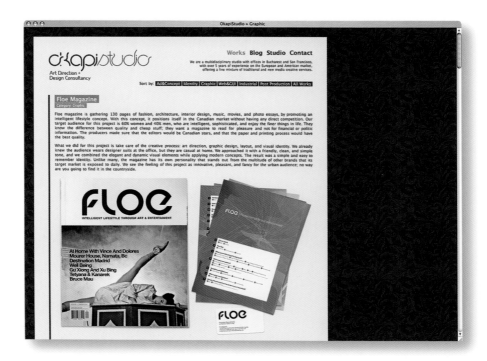

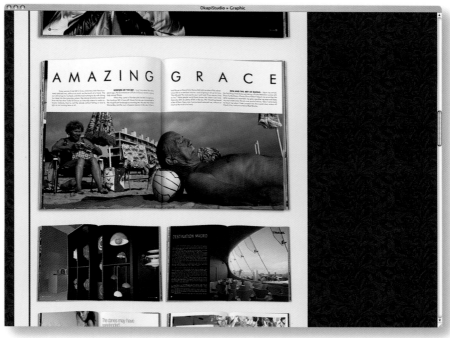

www.okapistudio.com

D: gabi lungu, andrei ostacie

A: okapistudio **M:** hello@okapistudio.com

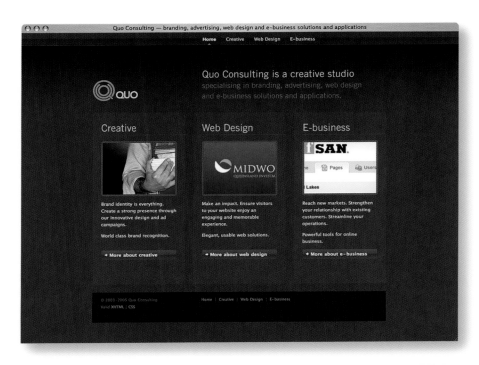

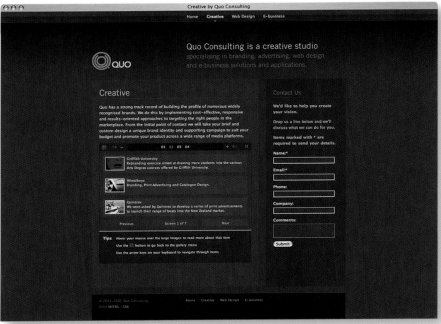

www.quo.com.au
D: adam morris, saul jarvie C: simon litchfield
A: quo consulting M: simon@quo.com.au

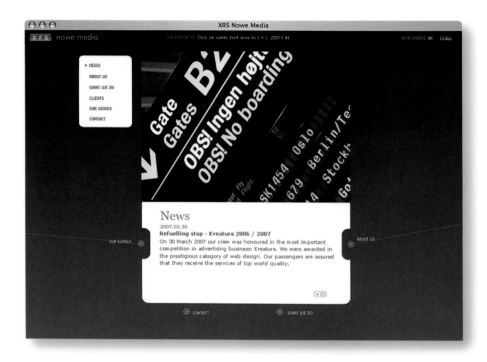

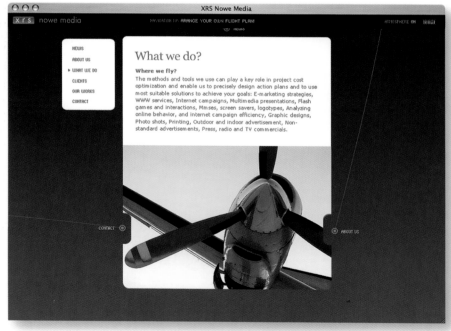

www.xrs.pl
D: bartlomiej rozbicki C: pawel piotrzkowski P: tomasz kolodziejczyk
A: xrs nowe media M: info@xrs.pl

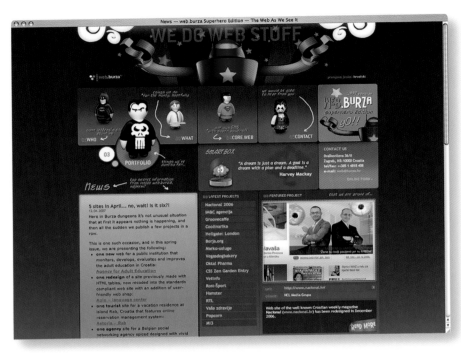

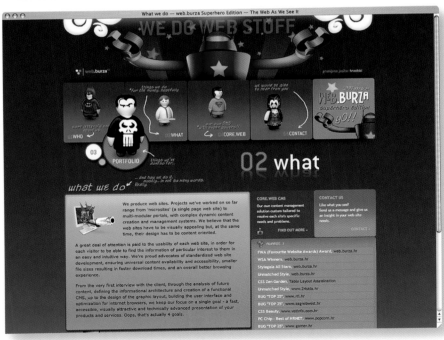

web.burza.hr

D: marko krsul, slavko janjic **C:** tomas trkulja, marko dugonjic **P:** vanja bertalan

A: web.burza **M:** web@burza.hr

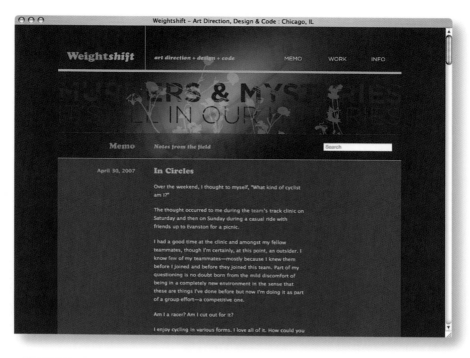

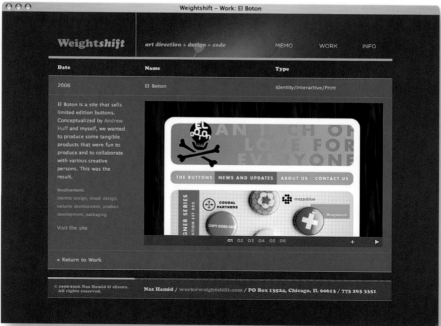

www.weightshift.com
D: naz hamid **C:** naz hamid **P:** naz hamid
A: weightshift **M:** work@weightshift.com

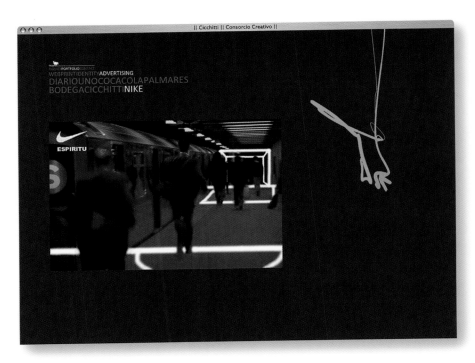

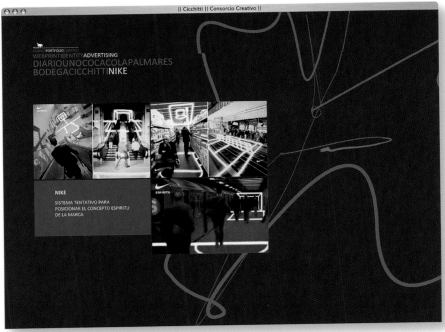

www.cicchitti.com
D: juan ignacio cicchitti P: juan ignacio cicchitti
A: cicchitti consorcio creativo M: info@cicchitti.com

www.waxpartnership.com/waxcam
D: jonathan herman, nick asik, scott shymko, jon jungwirth **C:** stem **P:** whiteiron
A: wax partnership **M:** joe@waxpartnership.com

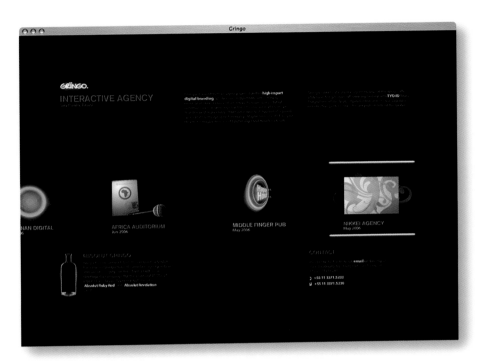

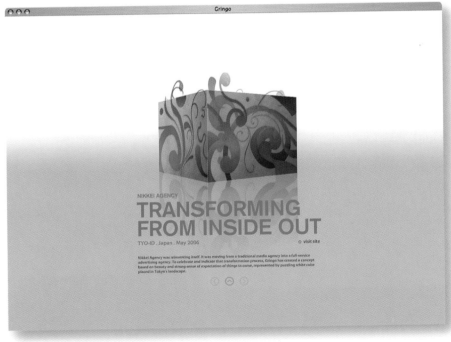

www.gringo.nu

D: andre matarazzo, a. souza **C:** gabriel laet, arthur debert **P:** fernanda de jesus

A: gringo **M:** andre@gringo.nu

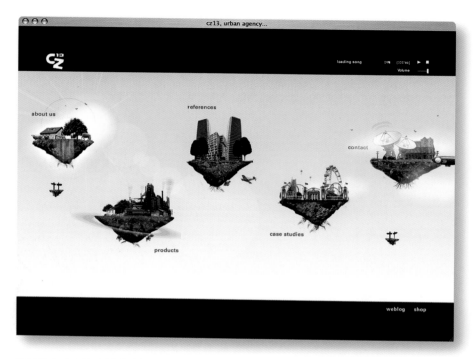

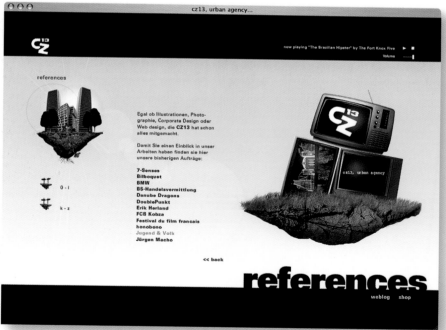

www.cz13.at

D: mario debout C: mario debout P: mario debout, michael diwald
A: cz13 M: office@cz13.at

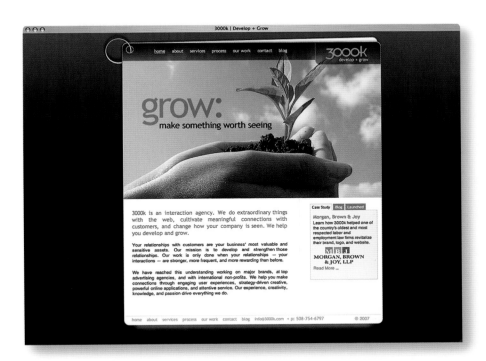

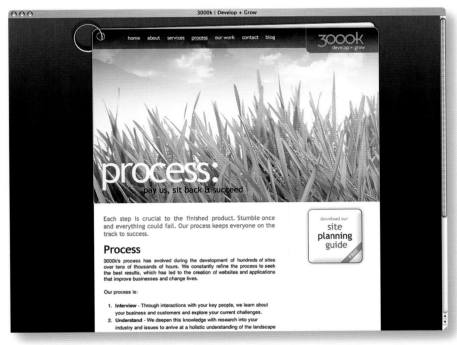

D: jim farris C: ali aslam P: sam costello
A: 3000k, inc. M: info@3000k.com

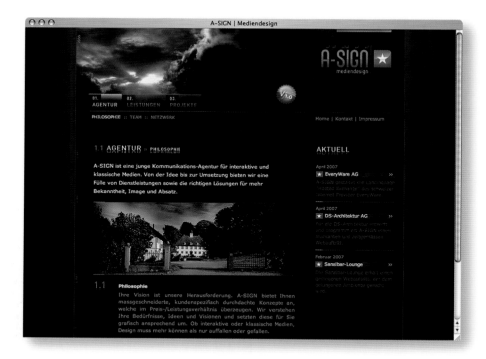

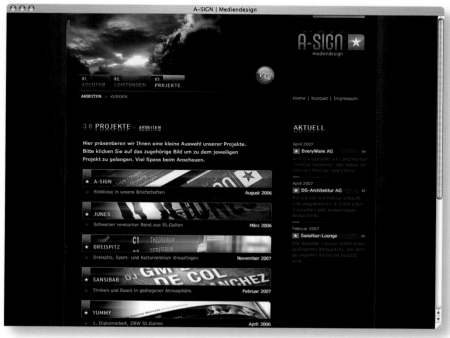

www.a-sign.ch

D: peter keller, roger vögeli **C:** peter keller
A: a-sign | mediendesign **M:** info@a-sign.ch

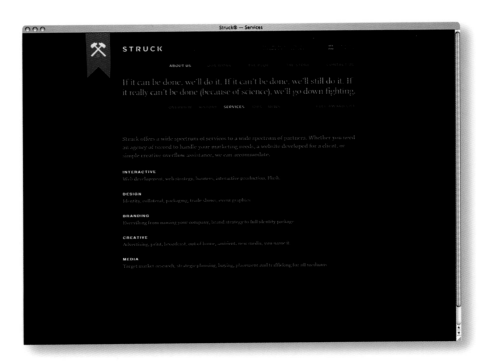

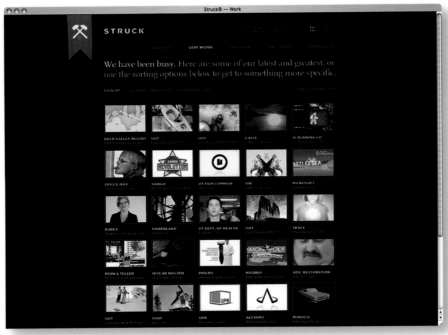

struckcreative.com
D: ryan goodwin C: jeramy morrill, matt wigham, tyler martin P: kyle snarr
A: struck M: info@struckcreative.com

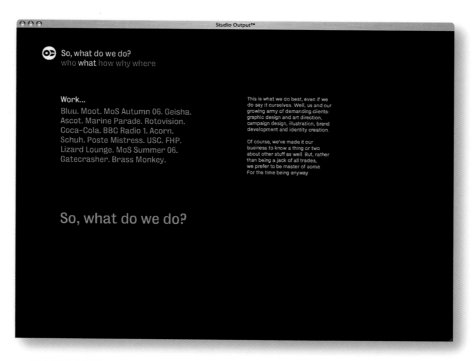

Studio Output™

So, what do we do?
who **what** how why where

Work...
Bluu. Moot. MoS Autumn 06. Geisha.
Ascot. Marine Parade. Rotovision.
Coca-Cola. BBC Radio 1. Acorn.
Schuh. Poste Mistress. USC. FHP.
Lizard Lounge. MoS Summer 06.
Gatecrasher. Brass Monkey.

This is what we do best, even if we
do say it ourselves. Well, us and our
growing army of demanding clients:
graphic design and art direction,
campaign design, illustration, brand
development and identity creation.

Of course, we've made it our
business to know a thing or two
about other stuff as well. But, rather
than being a jack of all trades,
we prefer to be master of some.
For the time being anyway.

So, what do we do?

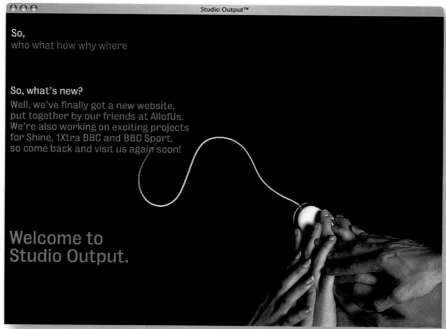

Studio Output™

So,
who what how why where

So, what's new?
Well, we've finally got a new website,
put together by our friends at AllofUs.
We're also working on exciting projects
for Shine, 1Xtra BBC and BBC Sport,
so come back and visit us again soon!

Welcome to
Studio Output.

www.studio-output.com
D: dan moore, rob coke **C:** nic mulvaney **P:** allofus
A: studio output **M:** info@studio-output.com

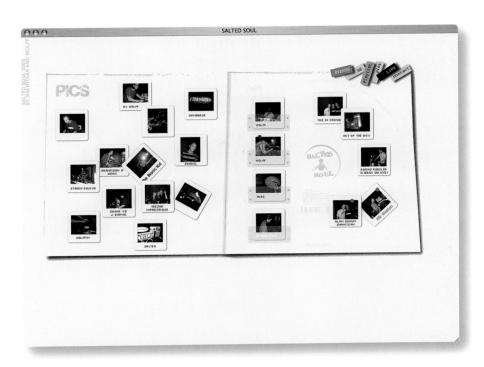

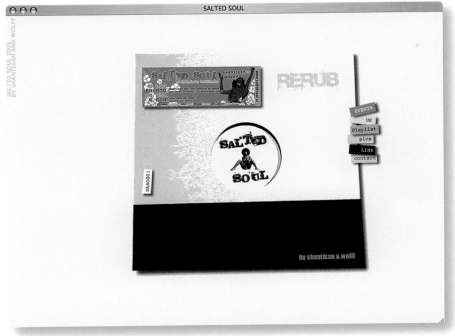

www.saltedsoul.at

D: dietmar halbauer **C:** dietmar halbauer **P:** embers consulting

A: embers consulting **M:** d.halbauer@embers.at

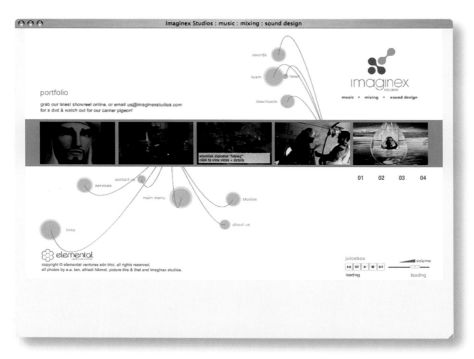

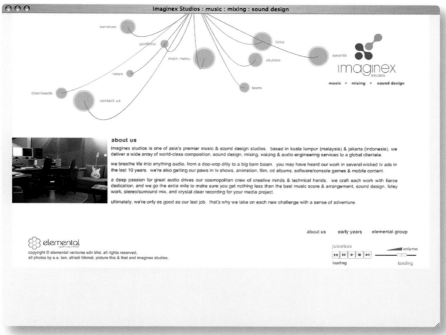

www.imaginexstudios.com
D: eugene low, matthew ng, steven chan C: steven chan P: steven chan
A: bombshelter studios sdn bhd M: s.o.s@bombshelter-studios.com

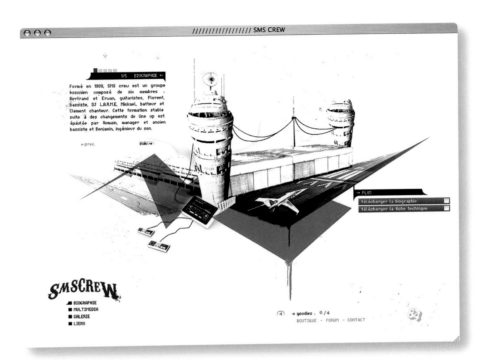

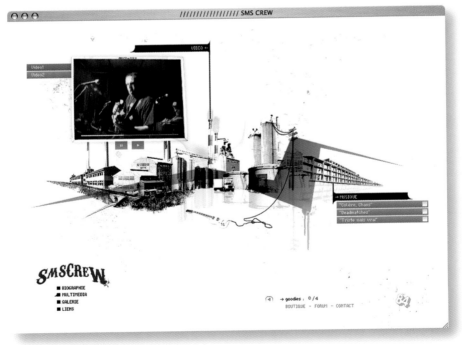

www.smscrew.com

D: drey

M: contact@smscrew.com

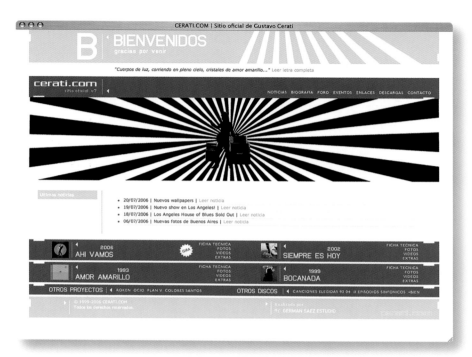

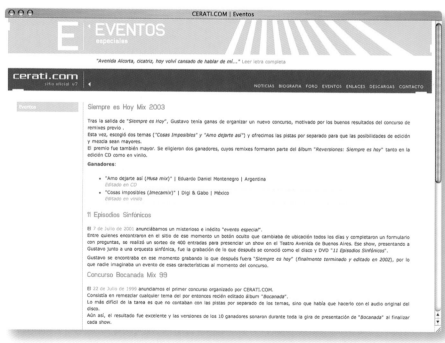

cerati.com

D: germán saez **C:** germán saez **P:** germán saez

A: germán saez estudio **M:** cerati.com

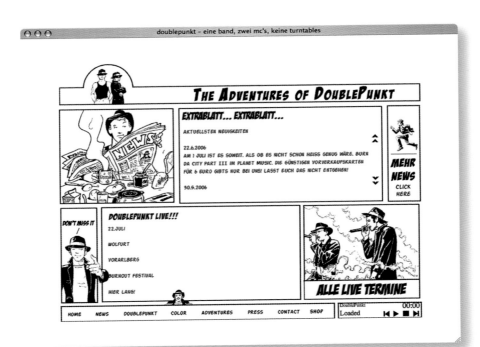

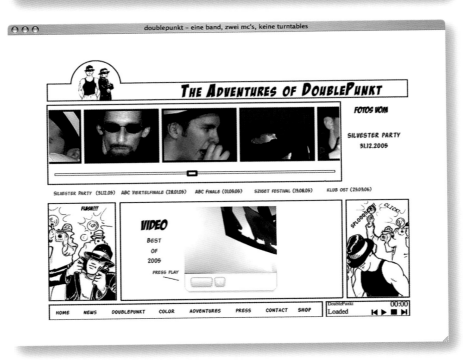

www.doublepunkt.com

D: mario debout, rene debout C: mario debout P: mario debout

A: cz13 M: office@cz13.at

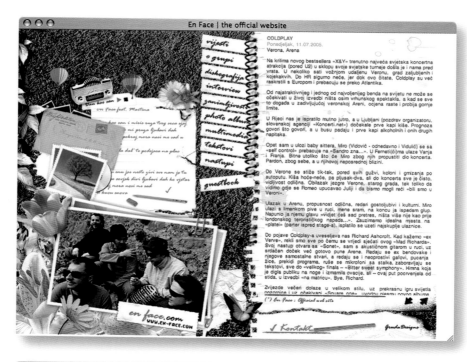

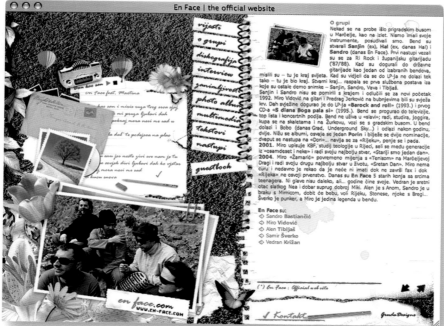

www.en-face.com

D: goran grudic C: goran grudic P: goran grudic
A: gruda designs M: webmaster@en-face.com

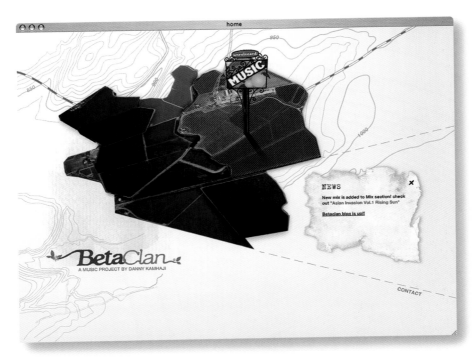

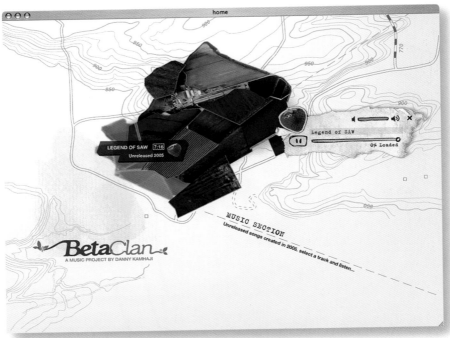

www.betaclan.net
D: futaba hayashi, danny kamhaji
A: zeroevil **M:** dk@betaclan.net

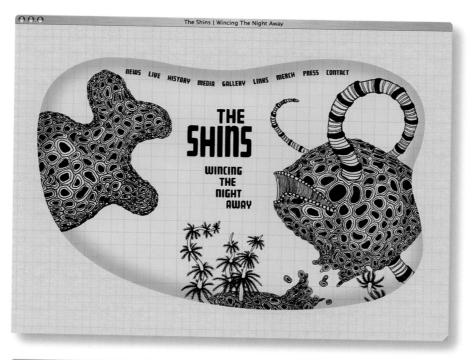

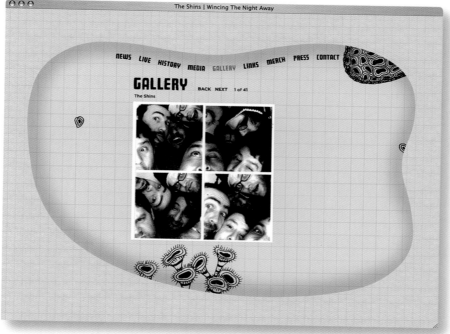

www.theshins.com
D: mike grigg, robert mercer, peter brown C: mike grigg, morgan lavigne P: mike grigg
A: royal magnet design co. M: mike@royalmagnet.com

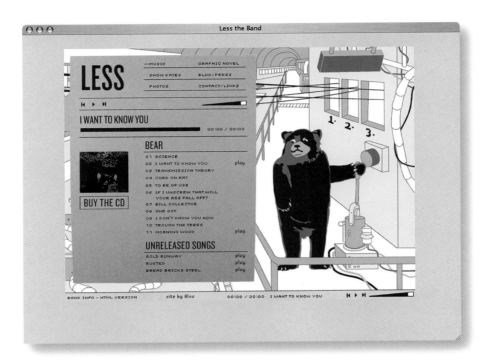

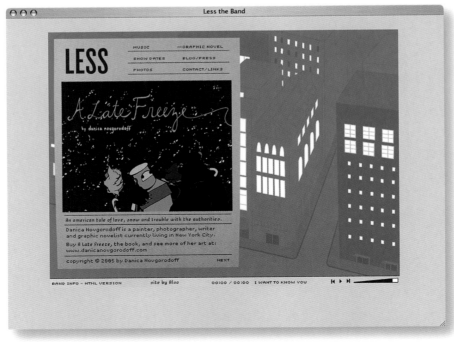

D: also, jenny volvolski, matt lamothe, julia rothman C: also P: less the band

A: less the band M: less@lesstheband.com, info@also-online.com

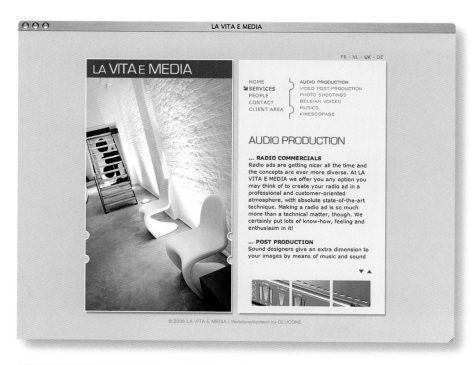

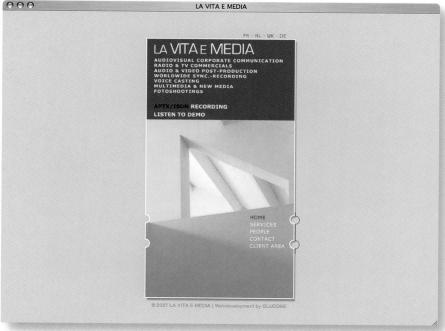

www.lavitaemedia.be
D: micha neroucheff C: patrick videira
A: glucone M: info@glucone.com

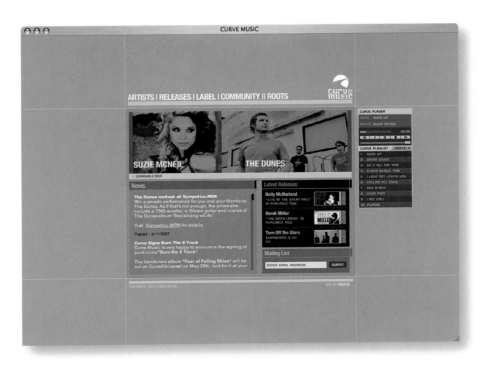

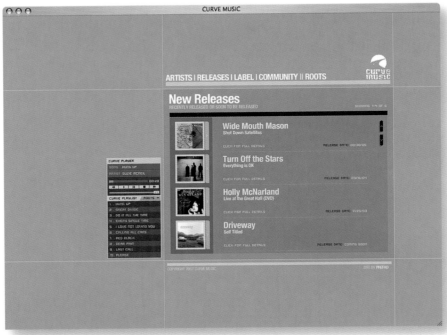

www.curvemusic.ca
D: vince zerdzicki C: vince zerdzicki P: vince zerdzicki
A: prefad M: brian@curvemusic.ca | vince@prefad.com

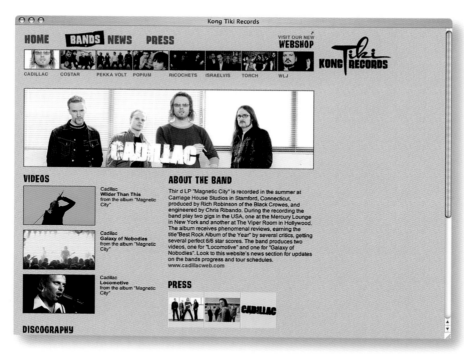

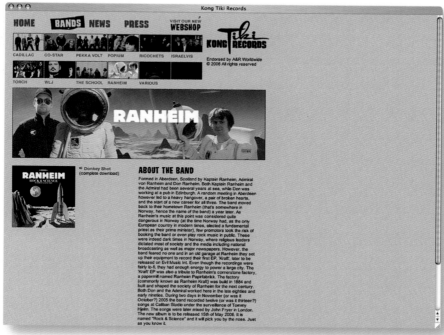

www.kongtiki.com
D: håvard gjelseth, martin kvamme C: håvard gjelseth P: håvard gjelseth
A: this way design M: hgjelseth@thiswaydesign.com

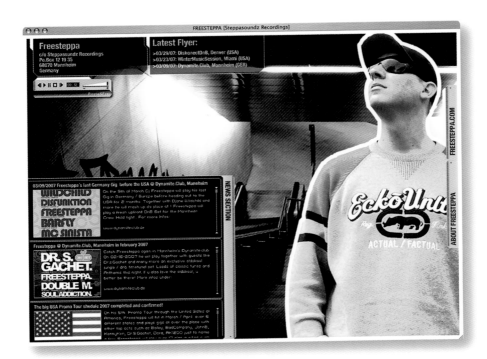

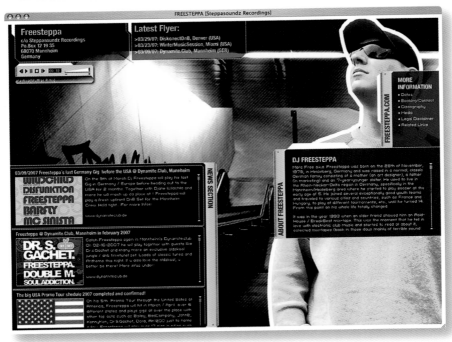

www.freesteppa.com

D: stefan schröder C: stefan schröder P: marco matthäus
A: pixelsinmotion M: info@pixelsinmotion.de

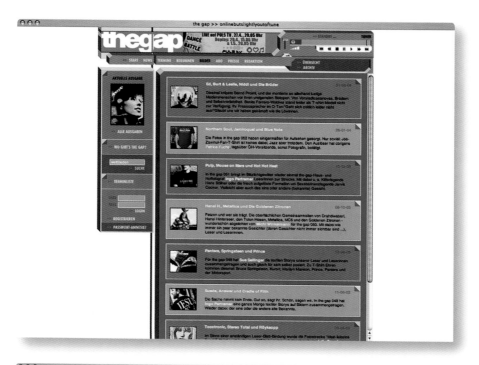

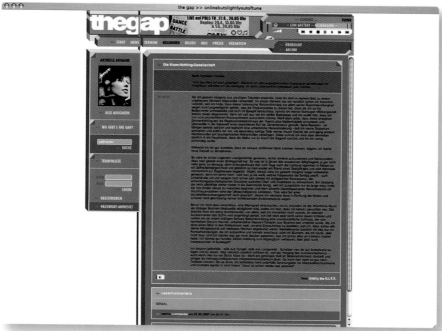

www.thegap.at

D: christoph hofer **C:** christoph hofer

A: super-fi **M:** vienna@super-fi.eu

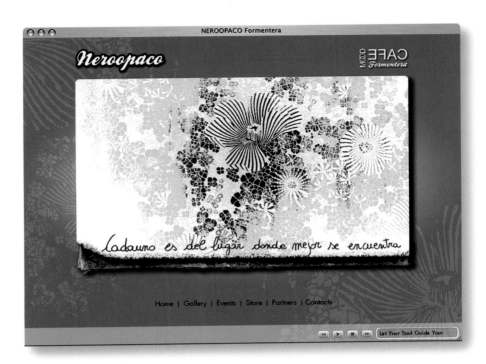

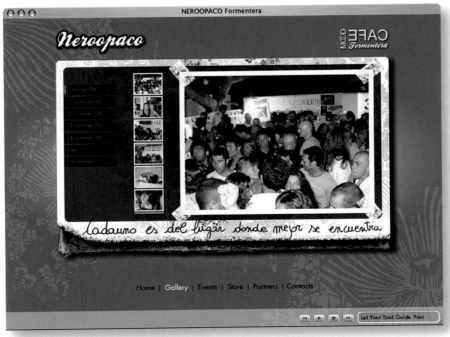

www.neroopaco.com
D: pasini gianluca
M: info@neroopaco.com

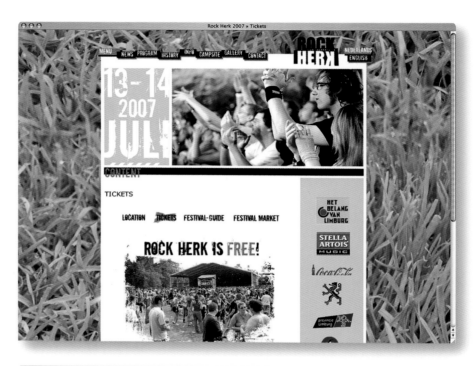

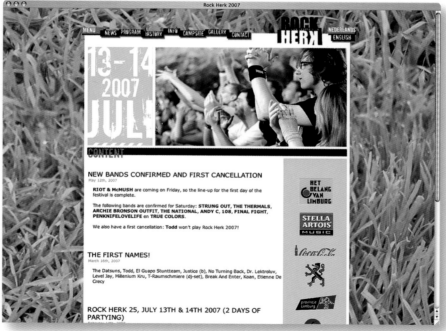

www.rockherk.be
D: davy kestens **C:** davy kestens **P:** davy kestens
A: webber's design **M:** www.webbersdesign.be

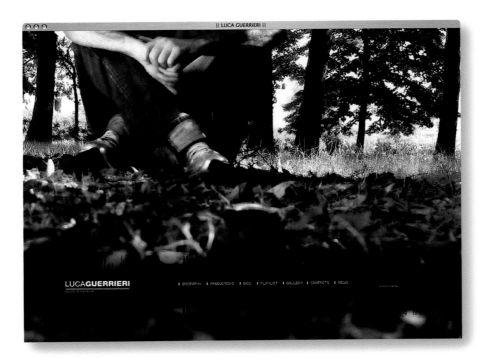

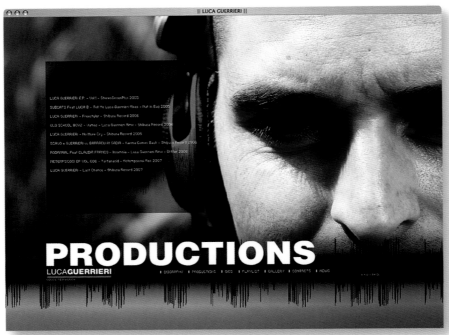

www.lucaguerrieri.com
D: gianluca procaccini C: michele bianchi
A: netfabrica M: info@netfabrica.com

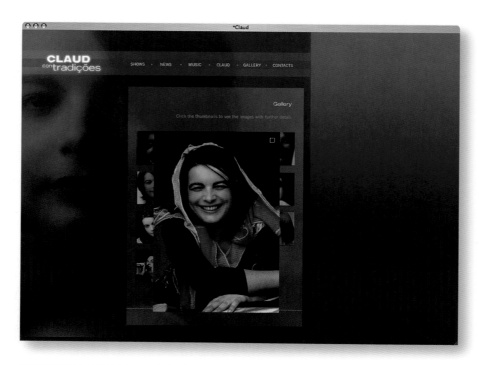

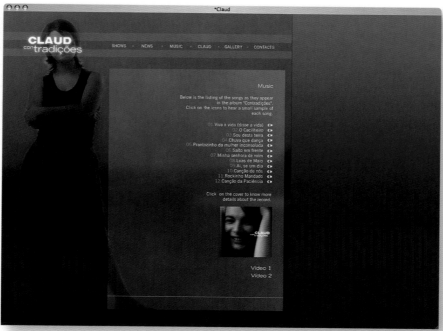

www.claudmusic.com
D: joao pedro canhenha **C:** joao pedro canhenha **P:** claudia antunes
A: claud **M:** geral@joaopedrocanhenha.com

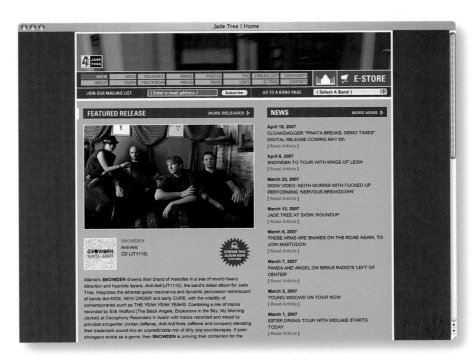

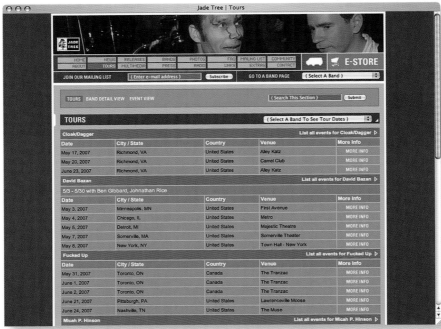

www.jadetree.com
D: bill boulger **C:** bill boulger **P:** bill boulger
A: v.media **M:** bill@vmediacontrol.com

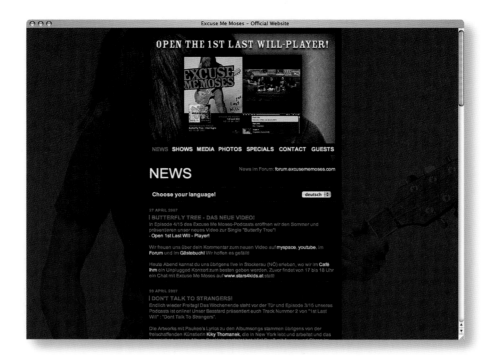

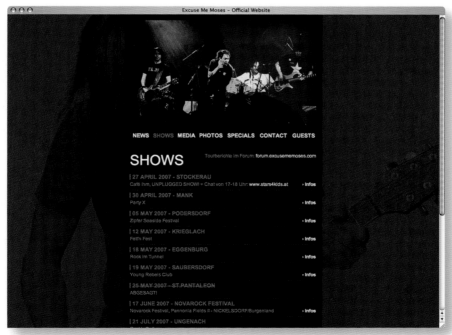

www.excusememoses.com

D: michael paukner **C:** michael paukner **P:** michael paukner
A: substudio*design media **M:** michael.paukner@substudio.com

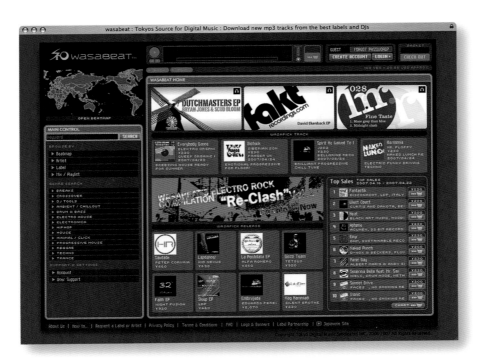

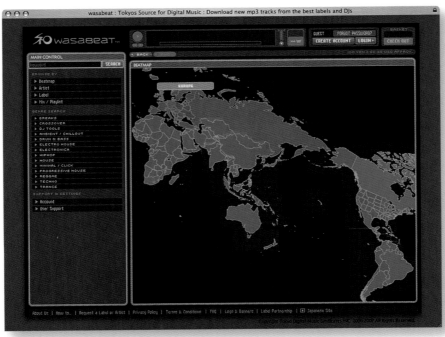

www.wasabeat.com
D: haruma kikuchi C: jun komatsu P: bay yong-bo
A: uniba inc. M: info@uniba.jp

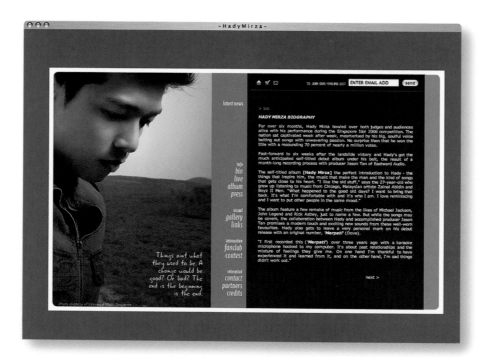

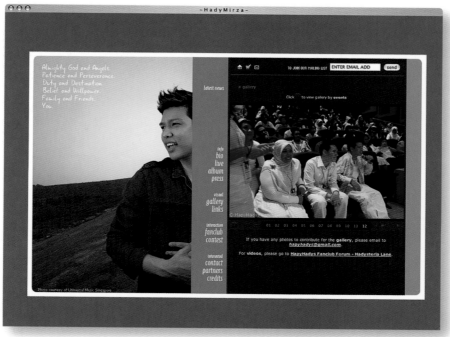

www.hady-mirza.com
D: lee shaari C: lino suárez P: hady mirza official website
A: aspirasi design M: lee@aspirasidesign.com

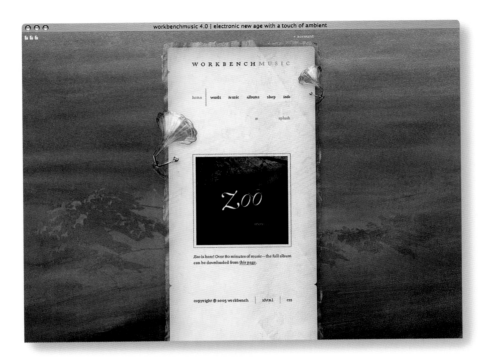

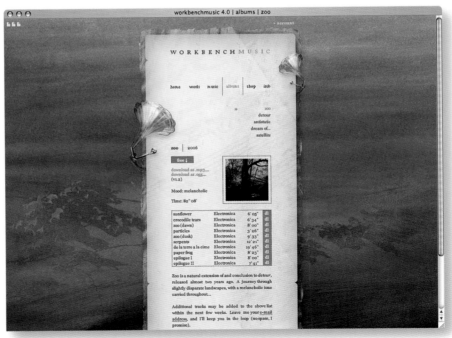

workbench-music.com

D: sébastien marchal C: sébastien marchal
A: workbenchmusic M: sebastien@workbench-music.com

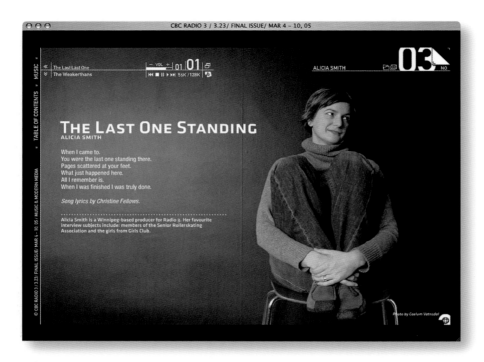

The Last Last One
The Weakerthans

ALICIA SMITH

03
NO

THE LAST ONE STANDING
ALICIA SMITH

When I came to.
You were the last one standing there.
Pages scattered at your feet.
What just happened here.
All I remember is.
When I was finished I was truly done.

Song lyrics by Christine Fellows.

Alicia Smith is a Winnipeg-based producer for Radio 3. Her favourite
interview subjects include: members of the Senior Rollerskating
Association and the girls from Girls Club.

Photo by Caelum Vatnsdal

© CBC RADIO 3 / 3.23, FINAL ISSUE/ MAR 4 – 10, 05 / MUSIC & MODERN MEDIA

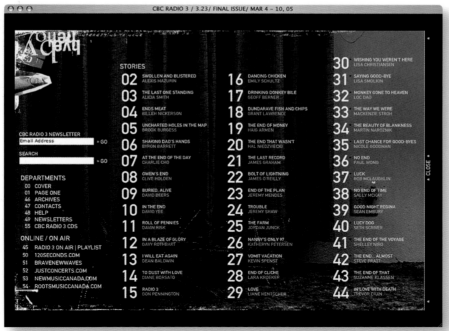

CBC RADIO 3 NEWSLETTER
Email Address » GO

SEARCH
 » GO

« CLOSE »

archive.cbcradio3.com

D: various contributors

A: canadian broadcasting corporation **M:** feedback@cbcradio3.com

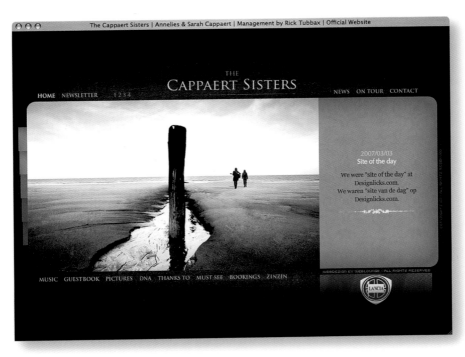

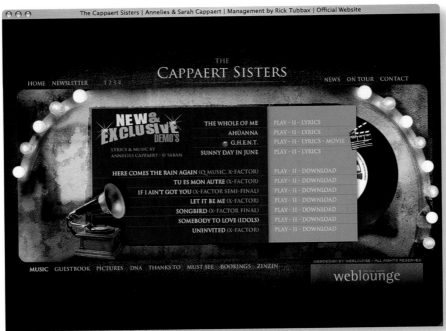

www.cappaertsisters.com

D: kristof van rentergem **C:** maarten bulckaen **P:** kristof van rentergem

A: weblounge **M:** www.weblounge.be

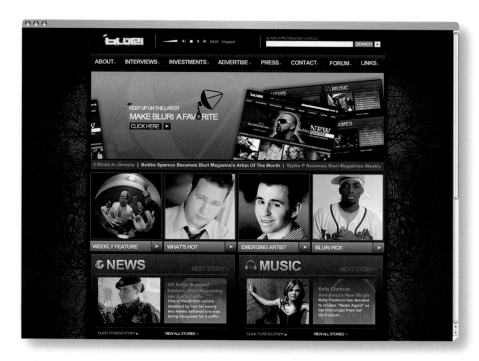

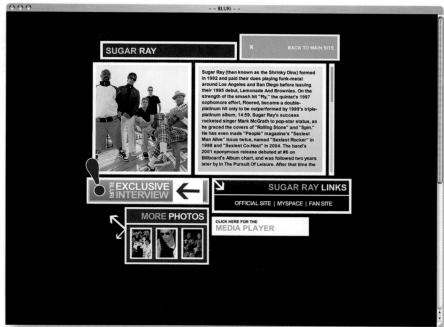

www.bluri.com
D: tom pastotnik P: mikey bo
A: bluri inc M: tom@bluri.com

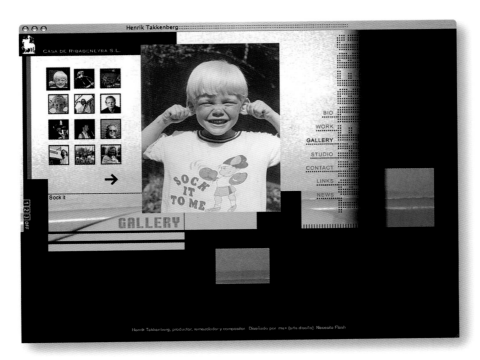

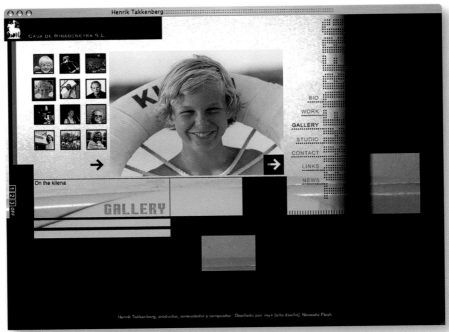

www.henriktakkenberg.com
D: mario gutiérrez cru C: maite camacho pérez P: henrik takkenberg
A: ma+ (arte.diseño) M: www.estudiomamas.com

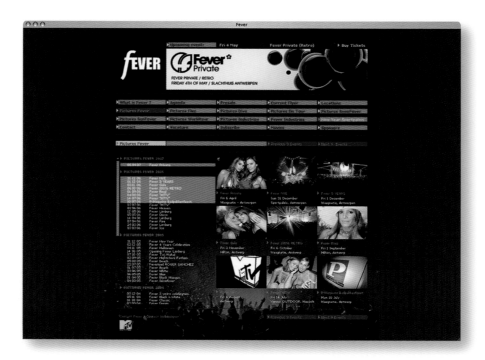

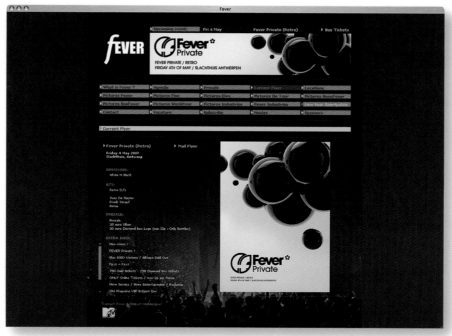

www.fever.be
D: rizon parein C: pc maan, peter decuypere P: rizon parein
A: rizon M: info@rizon.be

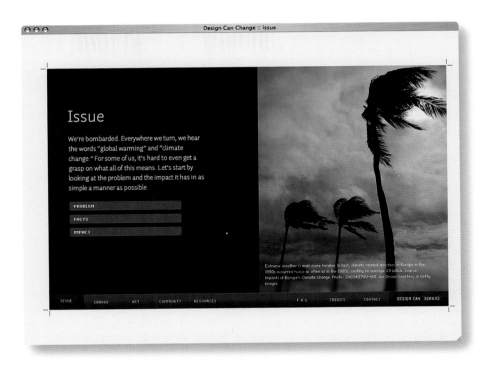

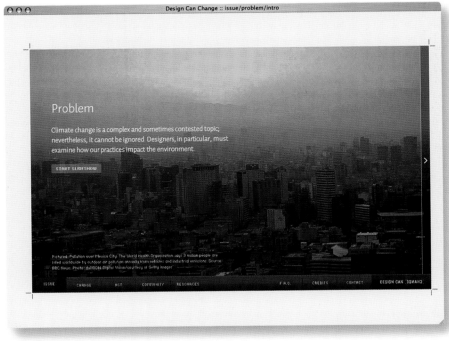

www.designcanchange.org
D: eric karjaluoto, peter pimentel C: eric shelkie
A: smashlab M: hello@smashlab.com

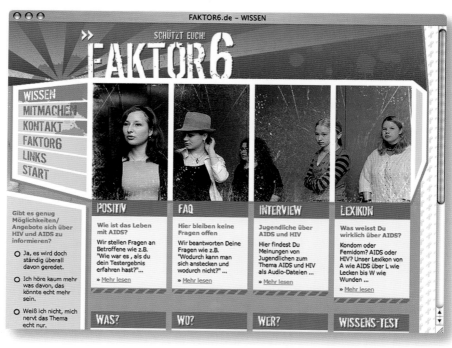

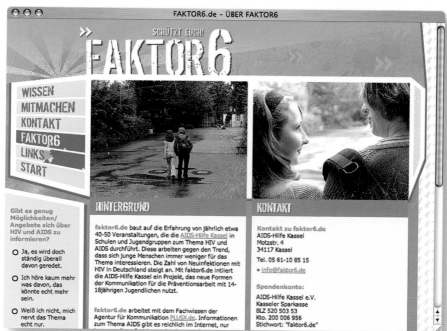

www.faktor6.de

D: sebastian siebert **C:** stefan schleich

A: plusx.de **M:** siebert@plusx.de

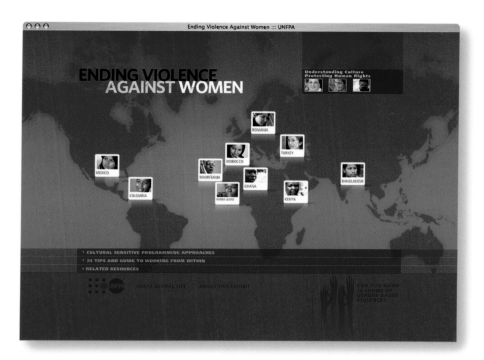

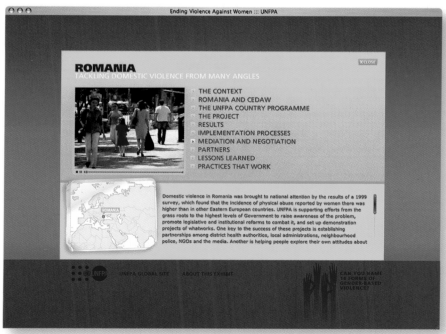

www.unfpa.org/endingviolence
D: allysson lucca P: alvaro serrano
A: unfpa - united nations population fund M: serrano@unfpa.org

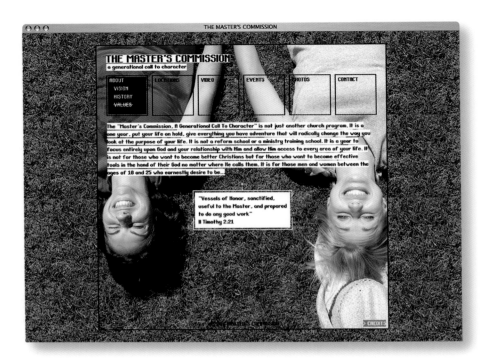

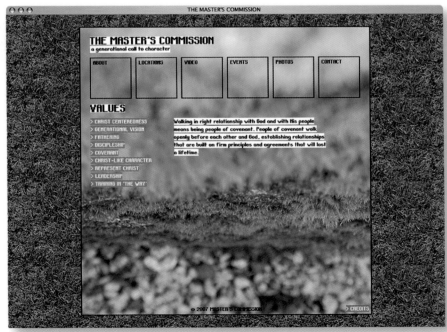

www.masterscommission.com

D: jim greeson **C:** jim greeson **P:** jim greeson
A: jumping jack studio **M:** jim@kmintl.org

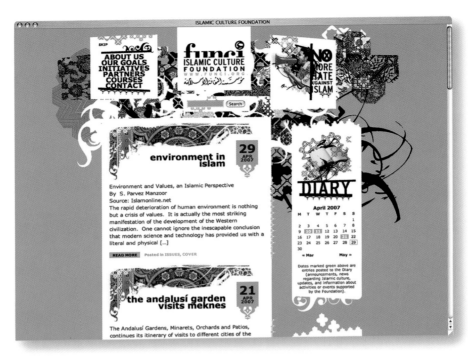

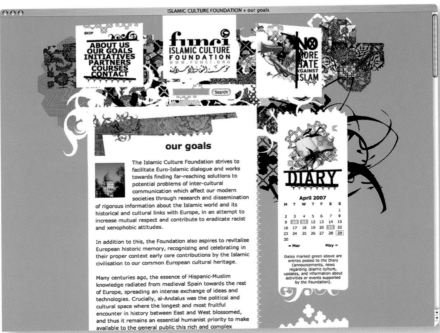

www.funci.org/en/

D: miguel ripoll C: miguel ripoll P: encarna gutiérrez
A: www.miguelripoll.com M: miguel@miguelripoll.com

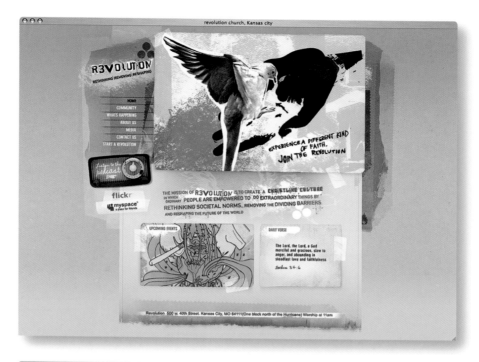

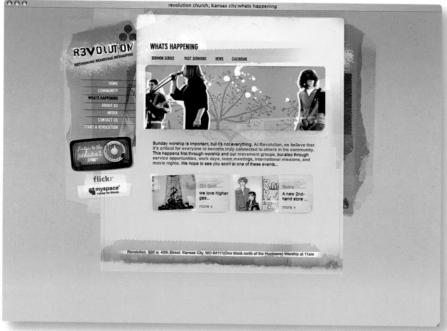

www.kcrevolution.org

D: brandon wilson C: brandon wilson P: kc revolution
A: contrabrand.net M: brandon@contrabrand.net

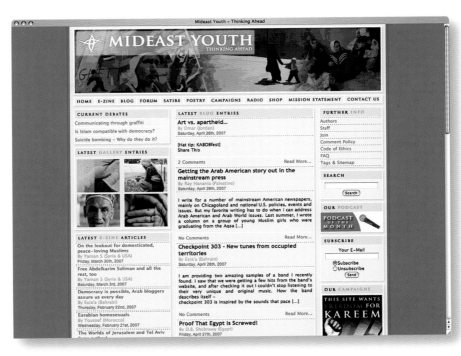

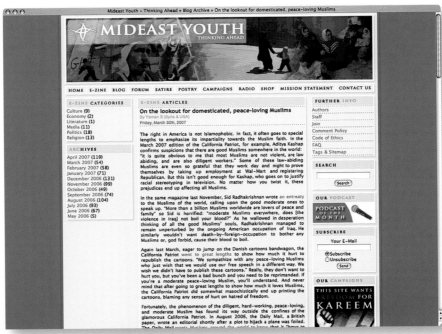

D: lalith sankar sivananthan C: lalith sankar sivananthan P: lalith sankar sivananthan
A: lazy bee lab M: lalithsankar@gmail.com

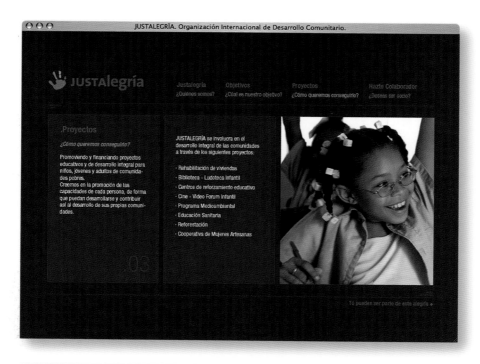

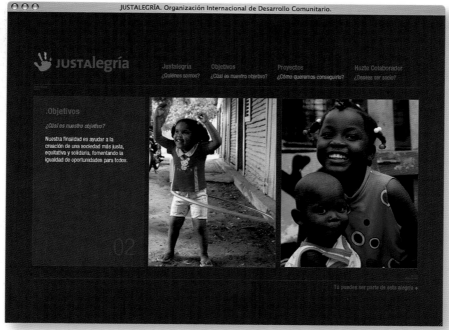

www.justalegria.org
D: takeone dsgn C: takeone dsgn P: lourdes molina
A: takeonedsgn.es M: takeone@takeone.es

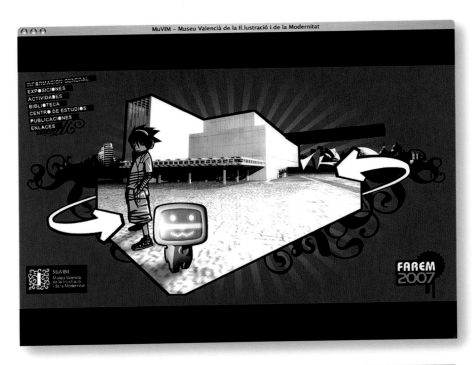

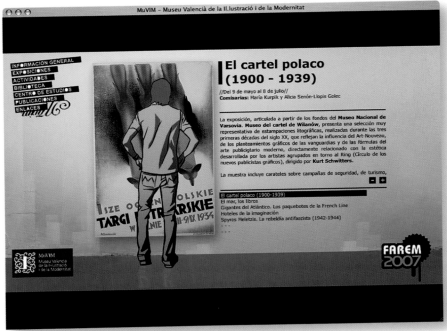

www.muvim.es

D: miguel esteve, leire ferreiro P: muvim
A: kamestudio M: info@kamestudio.com

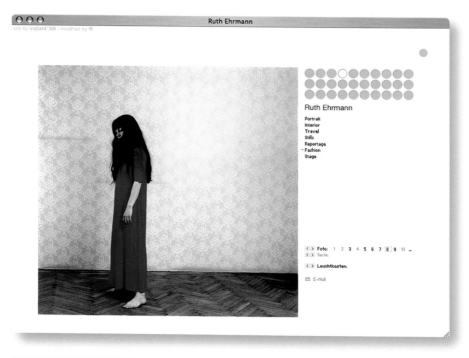

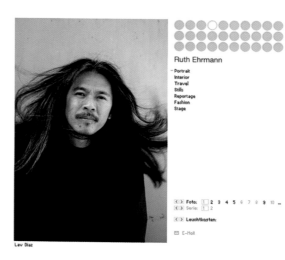

www.ruthehrmann.com
D: mario pizzinini C: mario pizzinini
M: mario.pizzinini@gizmocraft.com

http://www.maudfiori.com/

MAUD FIORI
photographe - Paris

mobile : 0672058308
email : maudfiori@gmail.com

vue lactée
portraits
mode
nudes
doudoux
still life
client order

DOUDOU 07
POUR "UNE JOURNEE PARTICULIERE"

http://www.maudfiori.com/

MAUD FIORI
photographe - Paris

mobile : 0672058308
email : maudfiori@gmail.com

vue lactée
portraits
mode
nudes
doudoux
still life
client order

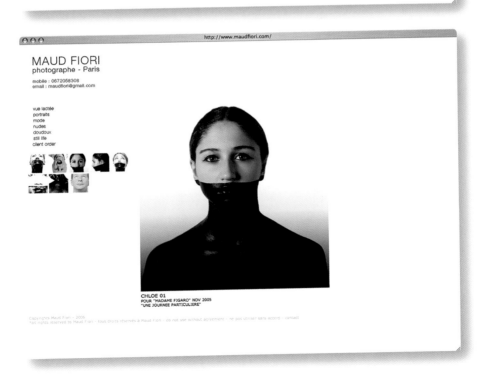

CHLOE 01
POUR "MADAME FIGARO" NOV 2005
"UNE JOURNEE PARTICULIERE"

www.maudfiori.com
D: maud fiori
M: maudfiori@gmail.com

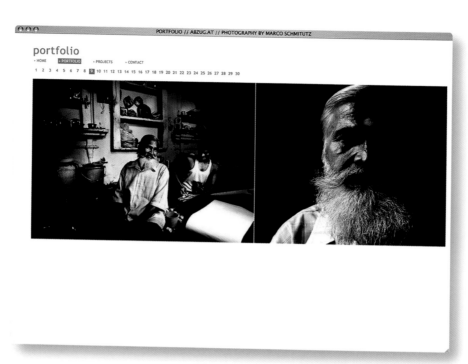

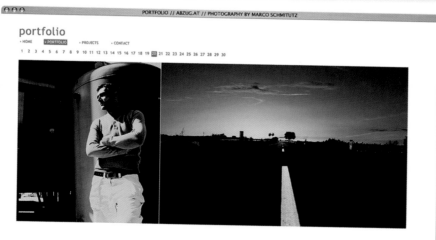

abzug.at

D: marco schmitutz C: thomas fritz P: thomas fritz

M: fritztho@gmail.com

photographer
anders hald

info contact

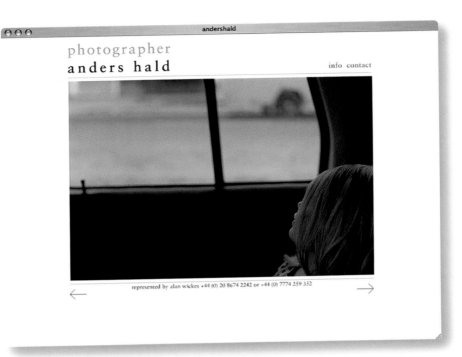

represented by alan wickes +44 (0) 20 8674 2242 or +44 (0) 7774 259 352

photographer
anders hald

info contact

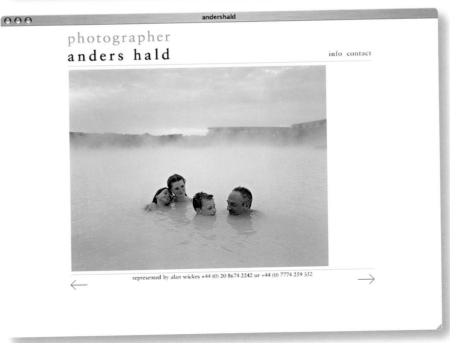

represented by alan wickes +44 (0) 20 8674 2242 or +44 (0) 7774 259 352

www.andershald.com
D: yasuko ikeda C: yasuko ikeda P: anders hald
A: photographer anders hald ltd M: photo@andershald.com

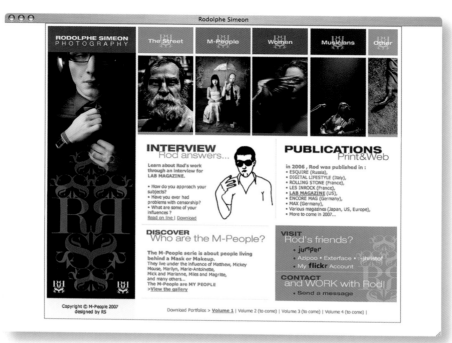

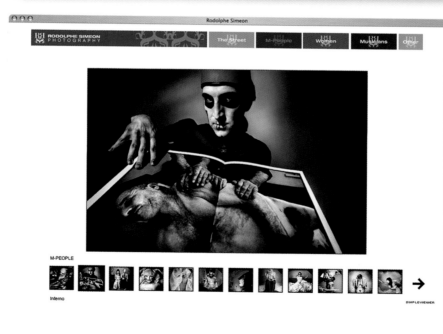

www.m-peoplephotography.com
D: rodolphe simeon **C:** rodolphe simeon
M: rodolphe.simeon@wanadoo.fr

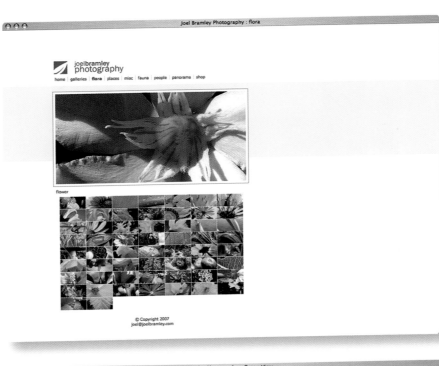

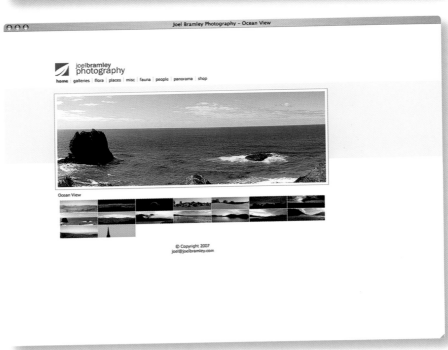

www.joelbramley.com
D: joel bramley
M: joel@joelbramley.com

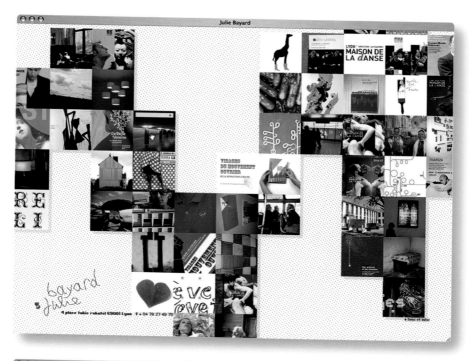

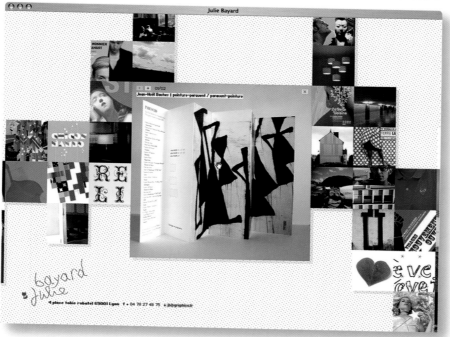

www.juliebayard.fr

D: guillaume bonnecase, grégoire gerardin C: grégoire gerardin P: joão cabral
A: danka studio M: danka@dankastudio.fr

showcase
INTERNATIONAL PORTFOLIO REVIEW

SHOWCASE INTERNATIONAL PORTFOLIO REVIEW
JUNE 14TH – 15TH, 2007 ZURICH, SWITZERLAND

View the best portfolios - Screen new talents - Cultivate your contacts -
Benefit from educational facilities - Expand your industry knowledge -
Practice professional networking - Be part of the international photography
convention

NEWS

SHOWCASE STARLINGS - YOUNG PHOTOGRAPHERS AWARD

EXTENDED REGISTRATION BY MAY 14, 2007
click here for more information

HOME
GENERAL INFORMATION
VISITOR INFORMATION
EXHIBITORS
PAST SHOWS
PARTNERS
NEWSLETTER
PRESS

CONTACT
IMPRINT

Picture by: Harriet Logan (represented by: Bransch)

showcase
INTERNATIONAL PORTFOLIO REVIEW

STARLINGS SHOW (JUNE 14 & 15)

SHOWCASE STARLINGS is a new platform for young photographers.

Every photographer fulfilling the conditions listed below, may
participate.

Please register on the SHOWCASE website by May 14, 2007 at latest.
On May 22, 2007, the SHOWCASE STARLINGS jury will select 24
photographers to be invited to show their portfolios to an international
expert audience at this year's SHOWCASE to take place on June 14
and 15. Every photographer shall be assigned a marked exhibition
surface at the Kaufleuten Lounge in Zurich.

On June 15, 2007, various jury prizes shall be awarded before an
audience and the media. ILFORD (ILFOCHROME DE LUXE) shall
sponsor the production of 24 photographs of the exhibiting
photographers. The sales revenue of these pictures shall be invested
to cover part of the traveling expenses of the SHOWCASE
STARLINGS.

Red Bull gives you wings - but more than that: from June 14 - 17, Red
Bull will also be your host. Red Bull will be welcoming the SHOWCASE

HOME
GENERAL INFORMATION
VISITOR INFORMATION
EXHIBITORS
Industry Show
Agents Show
Starlings Show
Artists
Exhibitor Registration
Starlings Registration
PAST SHOWS
PARTNERS
NEWSLETTER
PRESS

CONTACT
IMPRINT

Picture by: Matthieu Paley (represented by: Corbis Artist Representation)

www.showcase-international.com
D: marc rinderknecht C: marc rinderknecht
A: kobebeef M: mr@kobebeef.ch

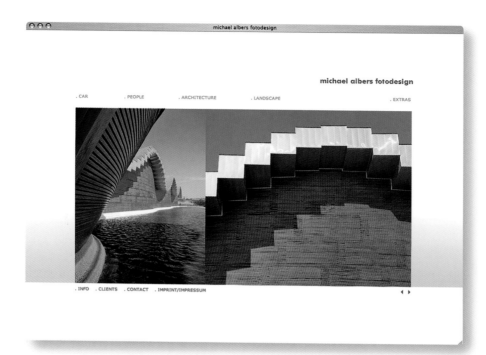

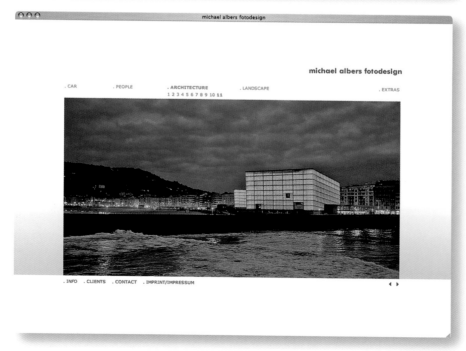

www.michaelalbers.com
D: florian hetmann C: florian hetmann P: michael albers fotodesign, köln
A: virtual köln M: foto@michaelalbers.com

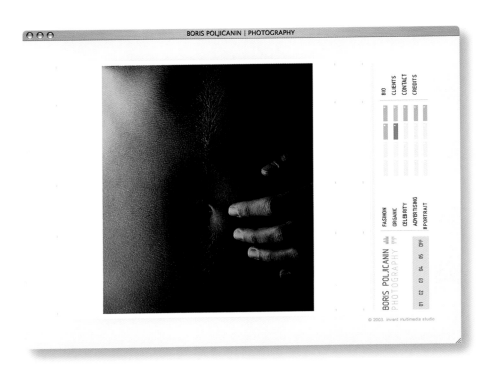

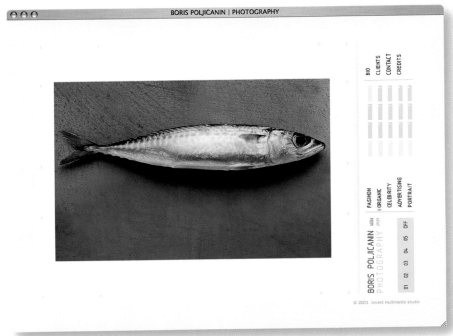

www.borispoljicanin.com

D: igor skunca C: igor skunca P: igor skunca
A: grupa ultima M: info@borispoljicanin.com

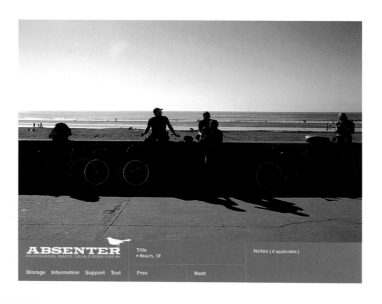

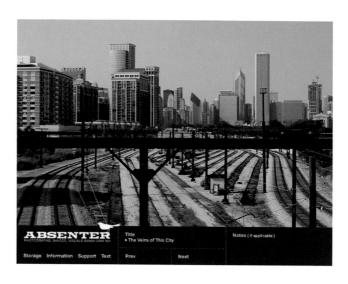

www.absenter.org
D: naz hamid C: naz hamid P: naz hamid
A: weightshift M: work@weightshift.com

home

CONTENTS
GALLERY
PEOPLE
BLOG
NEW YORK TRENDS
HEARTFELT
BIO
CONTACT

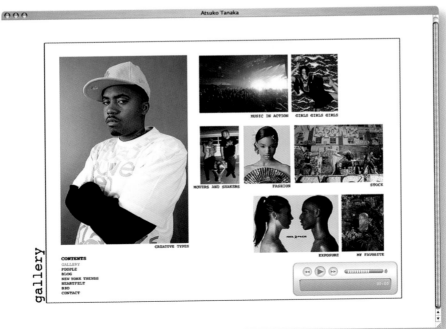

gallery

CREATIVE TYPES

MUSIC IN ACTION GIRLS GIRLS GIRLS

MOVERS AND SHAKERS FASHION STOCK

EXPOSURE MY FAVORITE

CONTENTS
GALLERY
PEOPLE
BLOG
NEW YORK TRENDS
HEARTFELT
BIO
CONTACT

www.atsukotanaka.com

D: yui morishita **C:** yuji takhashi **P:** atsuko tanaka, ryo iwanaga
A: electric space studio **M:** ryo@ess.nu

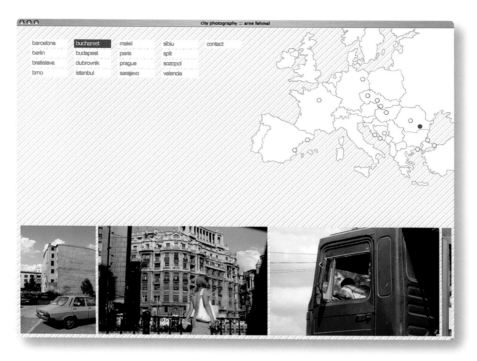

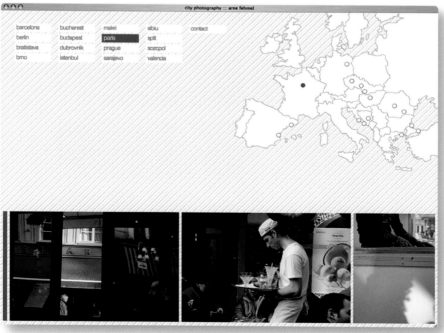

www.cities.arnelefant.de

D: arne fehmel **C:** rasso hilber **P:** korbinian kainz

A: basics09 **M:** arne@basics09.de

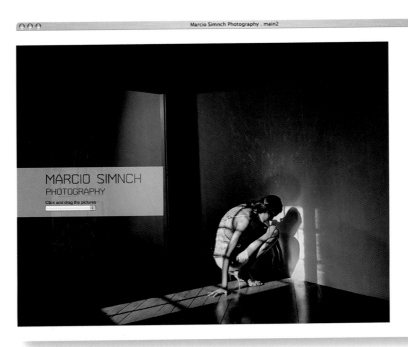

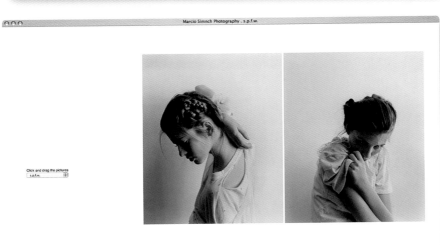

marciosimnch.com
D: dimitre lima C: dimitre lima
A: dmtr.org M: d@dmtr.org, ms@marciosimnch.com

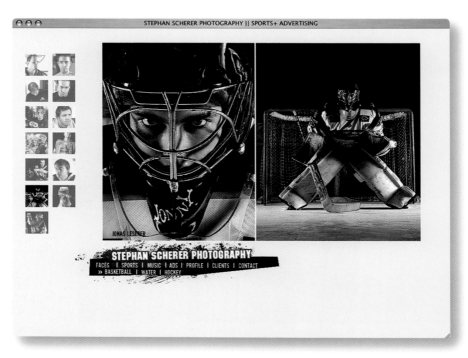

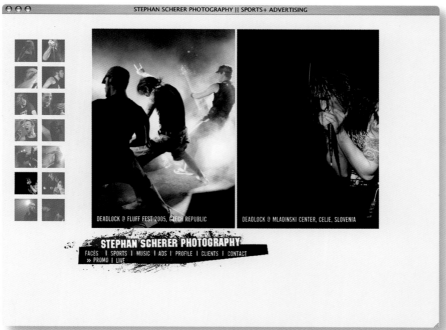

www.stephanscherer.com
D: roland straller, stephan scherer **C:** stephan scherer
A: stephan scherer photography **M:** studio@stephanscherer.com

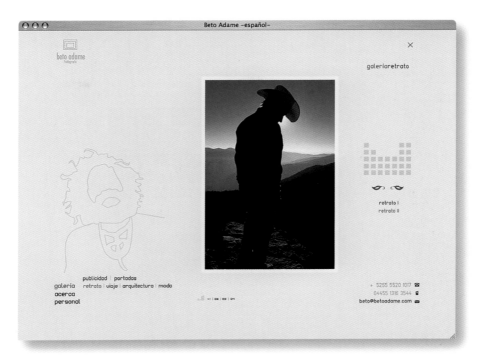

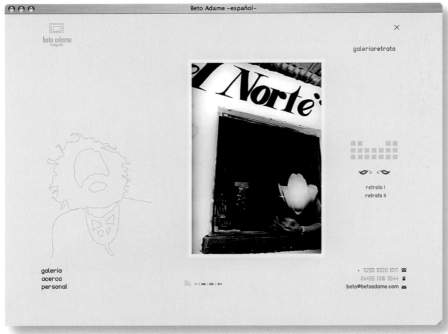

www.betoadame.com

D: beto adame, roommedia C: roommedia, dan chamorro, gerardo gonzález P: peluxe! prod
A: beto adame photographer M: beto@betoadame.com

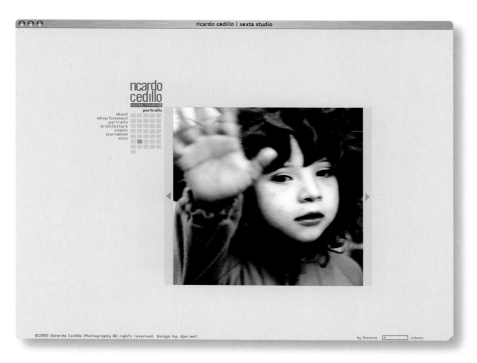

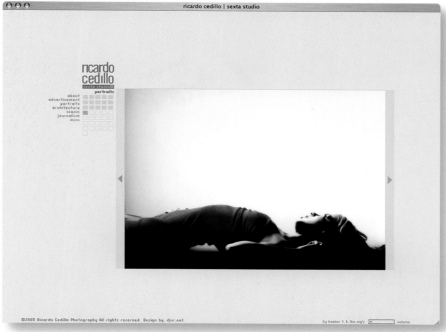

www.ricardocedillo.com
D: jenaro diaz **C:** jenaro diaz **P:** jenaro diaz
A: djnr.net **M:** djnr@djnr.net

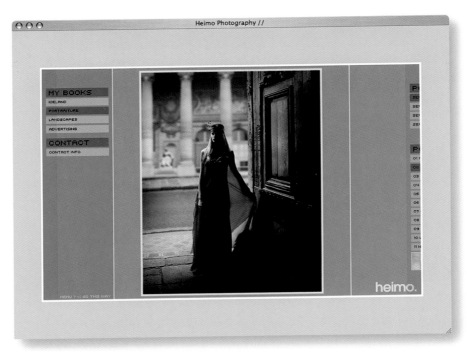

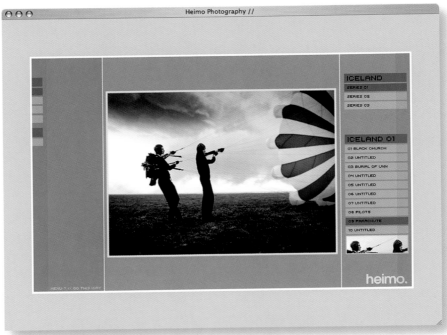

www.heimophotography.com

D: andreas tagger **C:** andreas tagger

A: butler, shine, stern and partners **M:** andreas@brothersbychoice.net

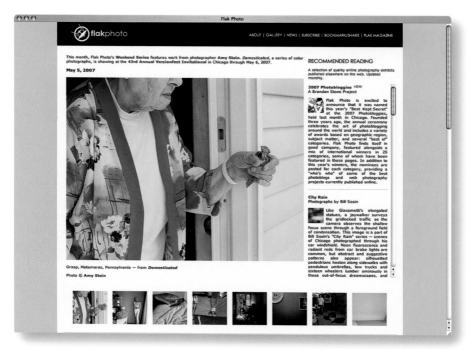

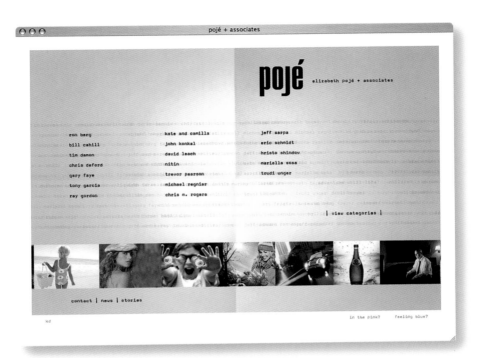

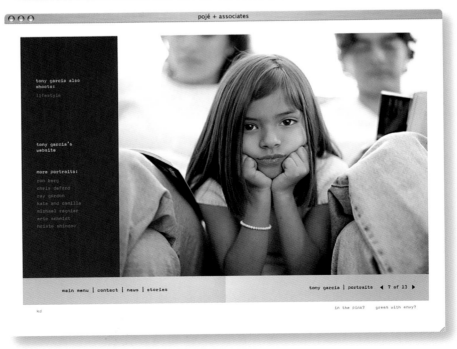

www.elizabethpoje.com
D: sarah rainwater, karen knecht C: sarah rainwater P: karen knecht
A: konnectdesign M: look@konnectdesign.com

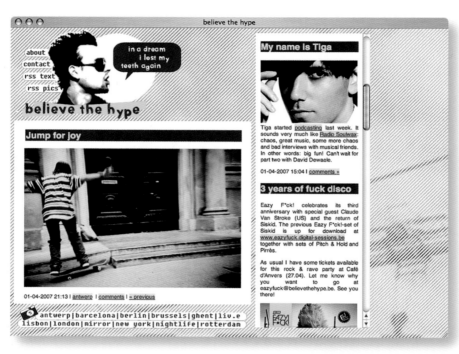

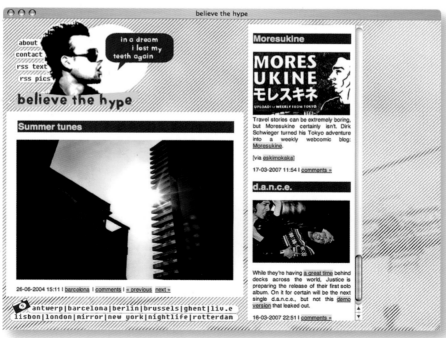

www.believethehype.be
D: stijn van kerkhove
M: info@believethehype.be

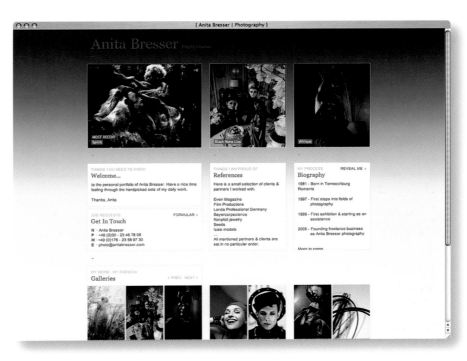

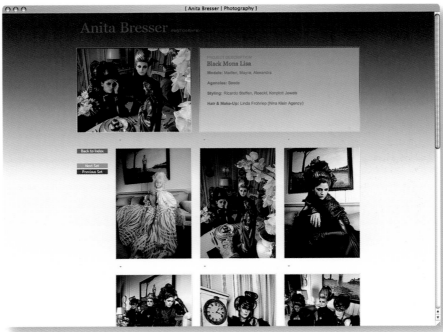

www.anitabresser.com

D: andreas kemerle C: norman rath P: andreas kemerle; anita bresser
A: uponseven . audio visual coder M: www.uponseven.de

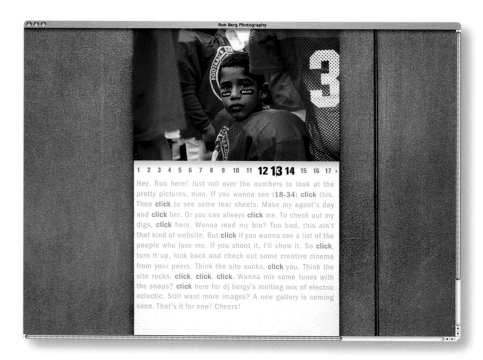

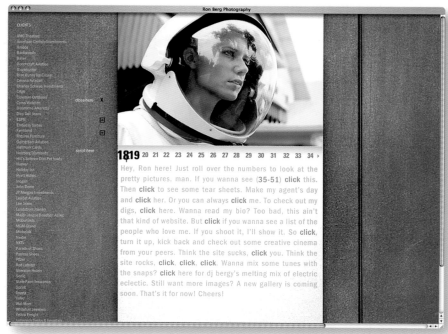

www.ronbergphoto.com

D: karen knecht-konnect design, todd eaton-mojo studios **C:** tod eaton- mojo **P:** ron berg
A: ron berg photo **M:** ron@ronbergphoto.com

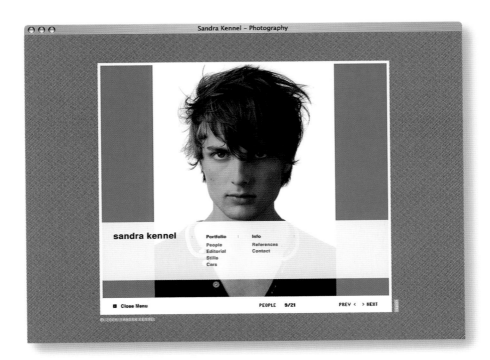

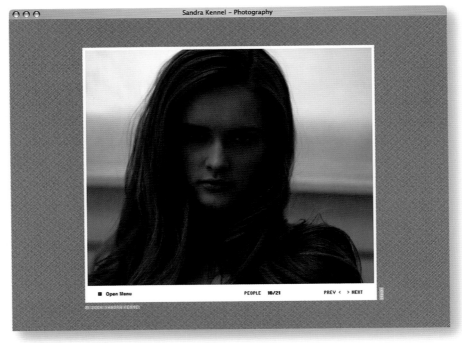

www.sandrakennel.com
D: jan strahlberg C: jan strahlberg P: jan strahlberg
A: c/ko/pro M: www.c-ko.com

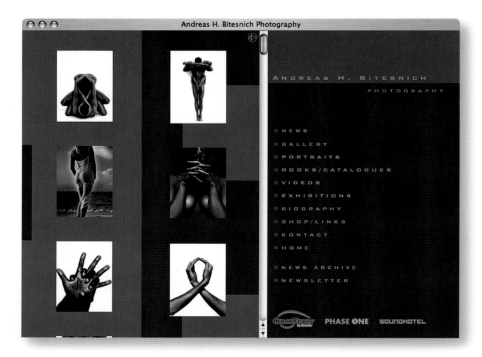

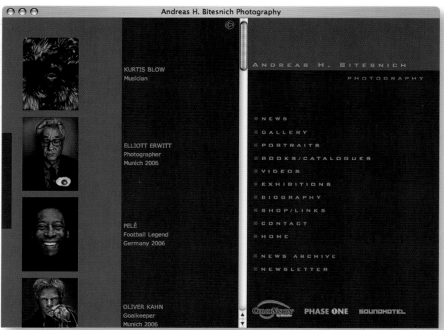

www.bitesnich.com
D: kathi wogrolly
A: spreitzer new media M: studio@bitesnich.at

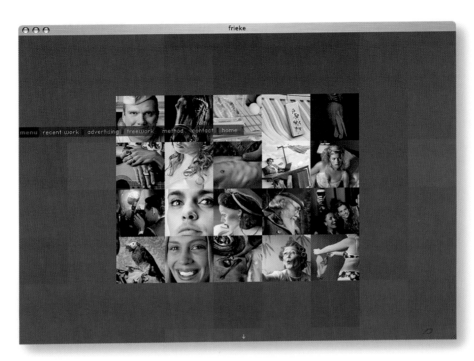

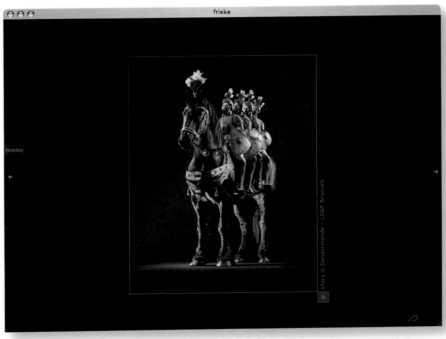

www.friekejanssens.com
D: johan simons, johny styven C: bregt vanbilsen P: pure communication
A: pure communication M: info@pure-communication.be

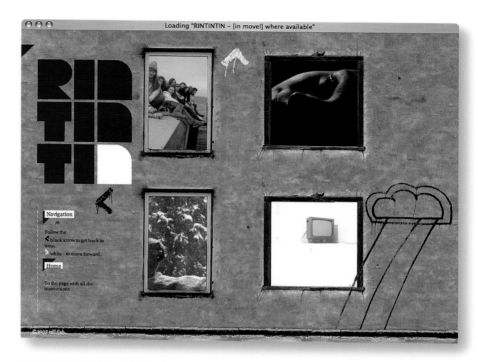

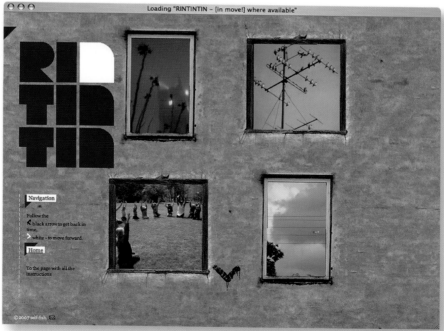

self-fish.com/rintintin
D: gediminas saulis C: esmilis norvaisas
A: loft11 M: lofteleven.lt

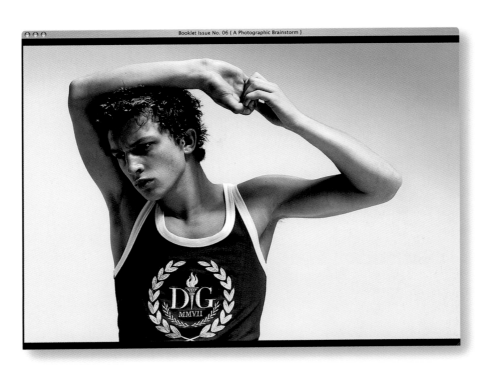

Booklet Issue No. 06 { A Photographic Brainstorm }

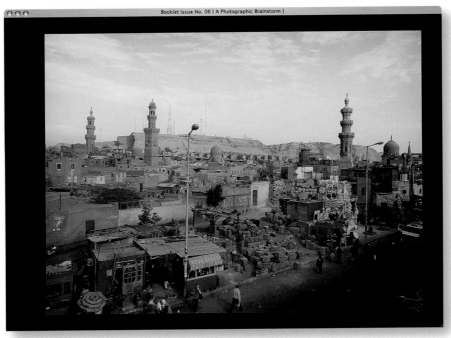

Booklet Issue No. 06 { A Photographic Brainstorm }

www.booklet.ws
D: sonja gutschera C: sonja gutschera
A: home made gmbh M: office@booklet.ws

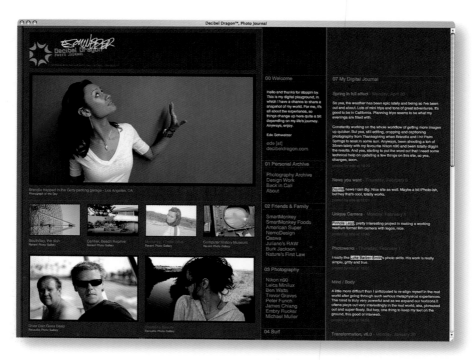

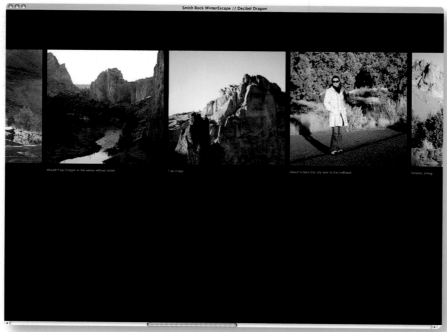

www.decibeldragon.com

D: ede schweizer

A: good design is innovative M: ede@decibeldragon.com

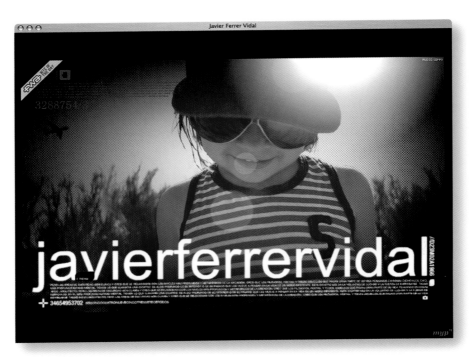

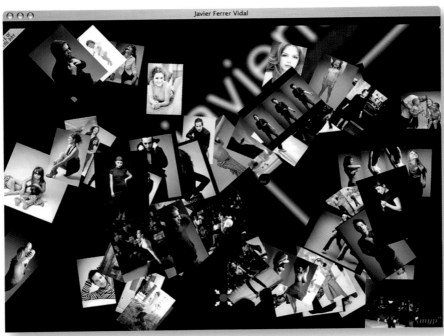

www.javierferrervidal.com
D: hector monerris, jesus pascual C: myp” P: myp”
A: myp” M: www.mediosyproyectos.com

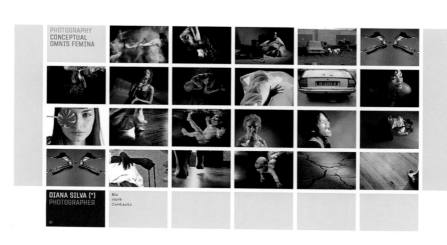

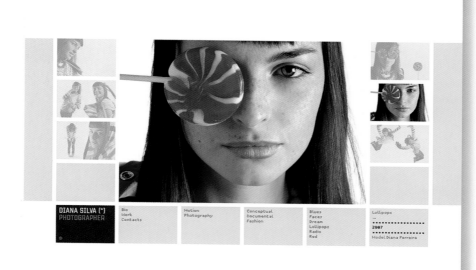

www.dianasilva.pt.vu
D: tiago machado C: tiago machado P: tiago machado
A: weplayout M: www.weplayout.com / info@weplayout.com

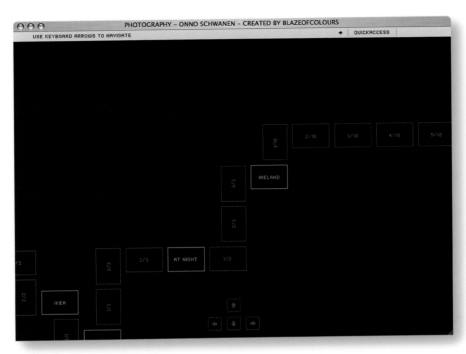

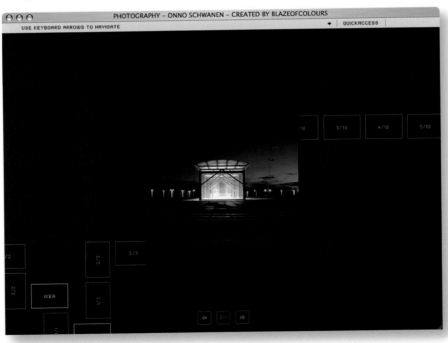

www.blazeofcolours.nl/photography

D: onno schwanen **C:** onno schwanen **P:** onno schwanen
A: blazeofcolours **M:** onno@blazeofcolours.nl

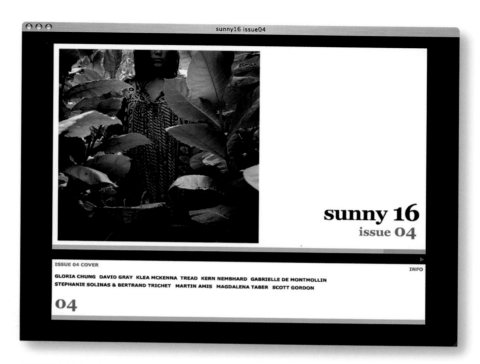

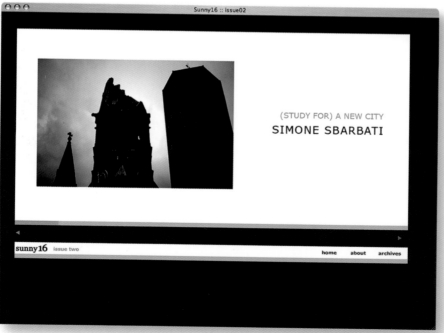

www.sunny16.ca
D: tracy tang
M: tmtang@sunny16.ca

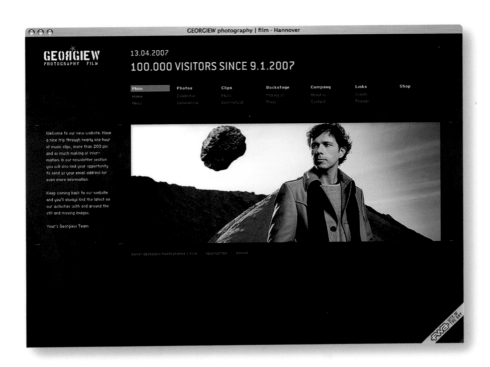

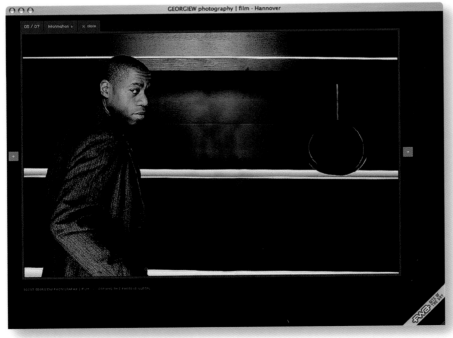

www.georgiew.de
D: ulf germann C: jens franke
M: www.hydiho.com

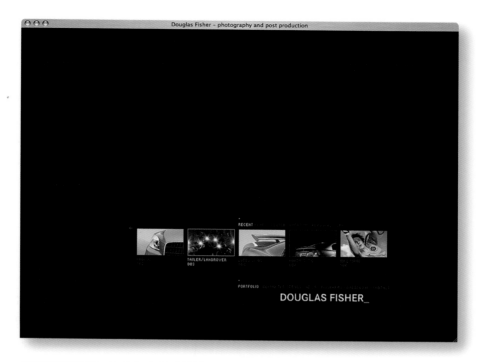

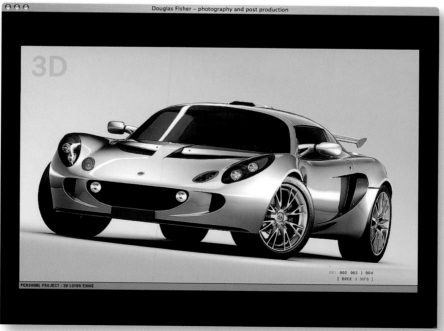

www.douglasfisher.co.uk
D: group94 C: group94 P: douglas fisher
A: douglas fisher photography M: doug@douglasfisher.co.uk

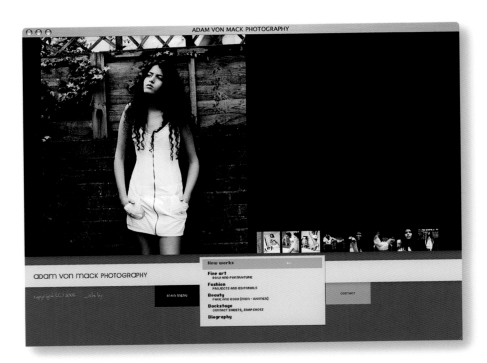

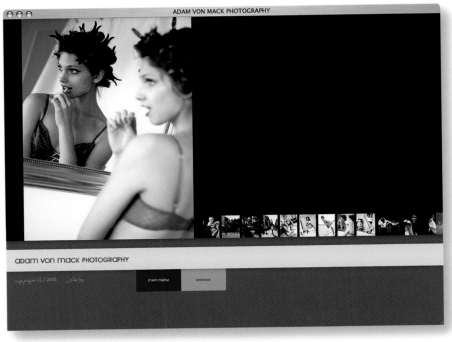

www.adamvonmack.com
D: laszlo tandi
M: tandi.laci@pr.hu

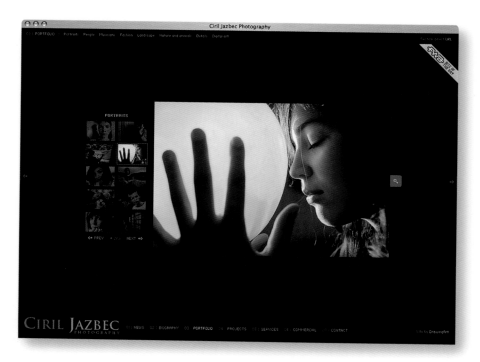

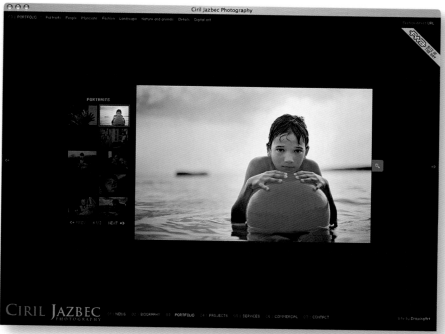

www.ciriljazbec.com
D: miroslav koljanin C: miroslav koljanin P: miroslav koljanin
A: www.drawingart.org M: ciril.jazbec@gmail.com

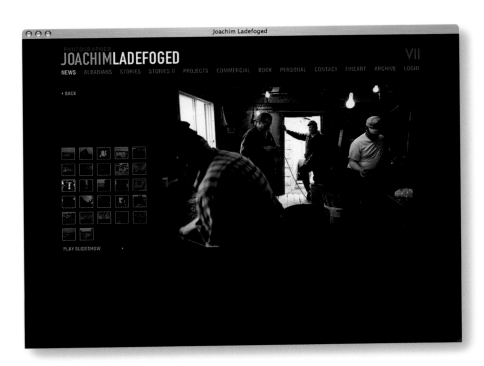

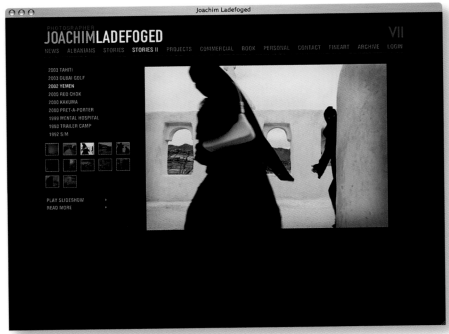

www.joachimladefoged.com
D: nanna bentel
M: www.komputer.nu

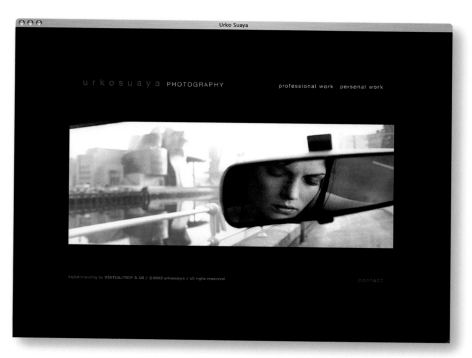

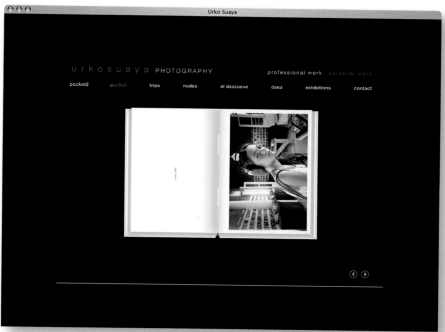

www.urkosuaya.com
D: urko suaya, julian bedel C: julian bedel P: urko suaya
A: virtual trip M: contact@virtualtrip.com

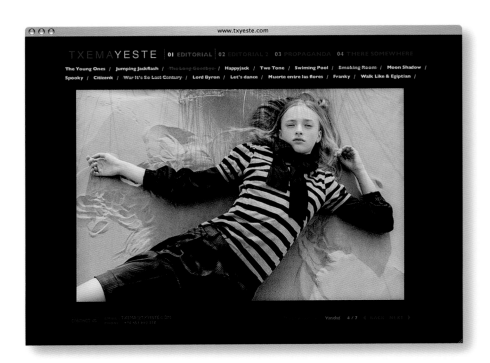

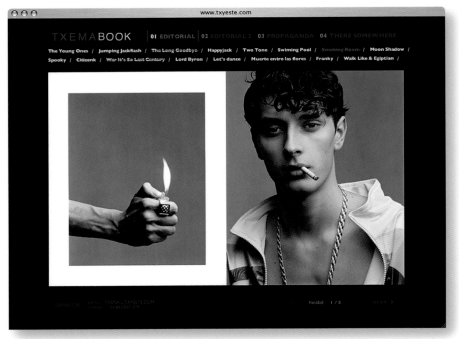

www.txyeste.com
D: mosi mosi design
M: info@mosi-mosi.com

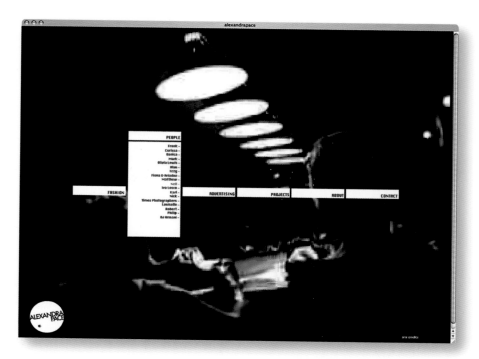

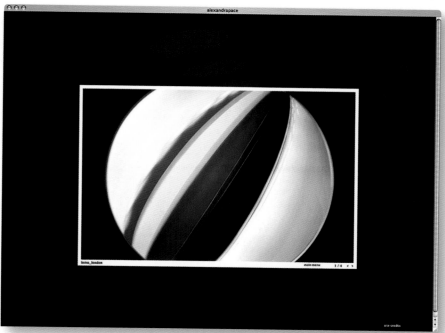

www.alexandrapace.com
D: lab1977.com C: lab1977.com
M: info@lab1977.com

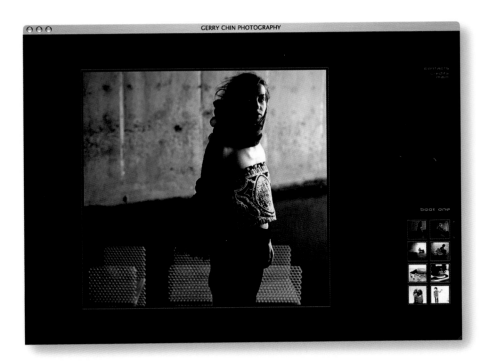

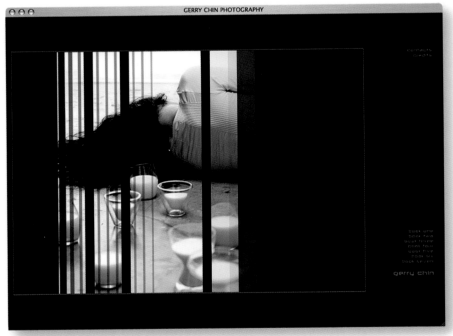

www.gerrychin.com
D: matthew ng C: matthew ng, steven chan P: matthew ng
A: bombshelter studios sdn bhd M: s.o.s@bombshelter-studios.com

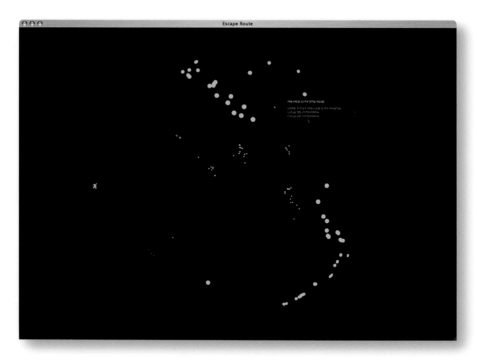

travel.escapelab.com.au
D: henry dawson **C:** henry dawson
A: escape laboratories **M:** henry@escapelab.com.au

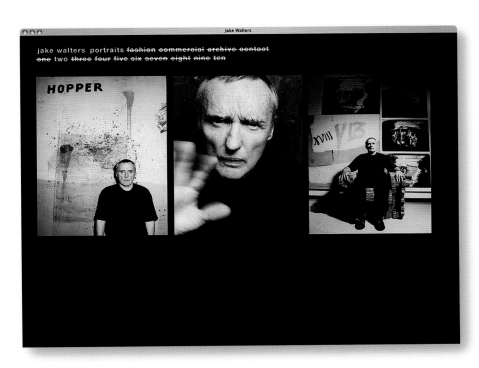

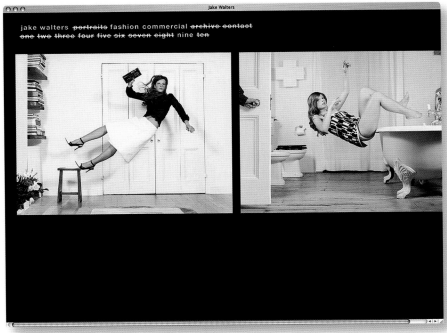

www.jakewalters.com

D: non-format

M: jake.walters@virgin.net

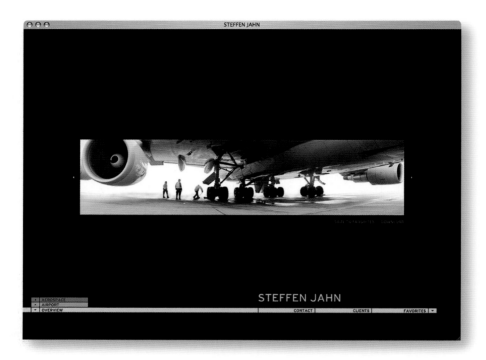

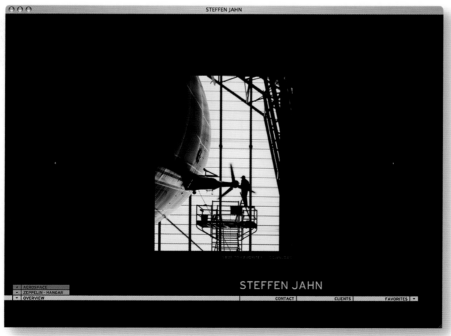

www.steffenjahn.com
D: wolfgang von geramb C: martin schoberer P: wolfgang von geramb
A: robinizer M: robin@robinizer.de

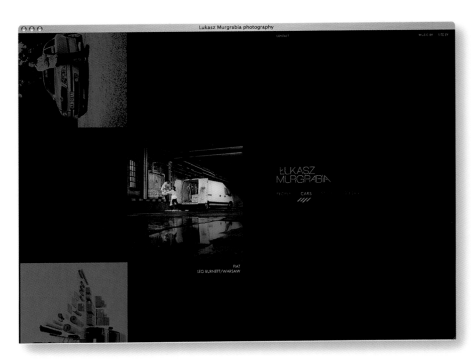

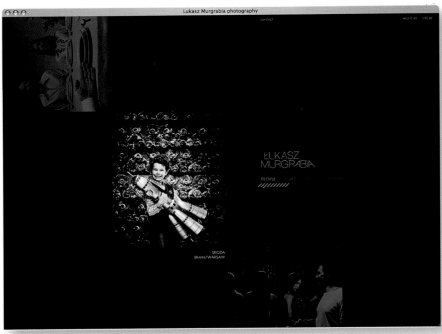

www.murgrabia.com

D: kamil bohdanowicz C: piotr lupinski P: kamil bohdanowicz
A: www.berlincut.com, www.mamastudio.pl M: lukasz@murgrabia.com

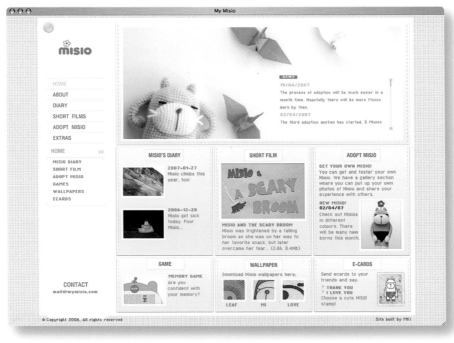

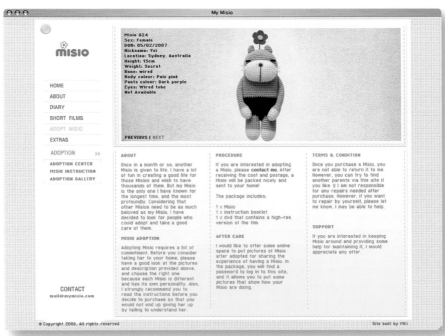

www.mymisio.com
D: madoka muto **C:** martin konrad
A: martin konrad interactive **M:** mail@mymisio.com

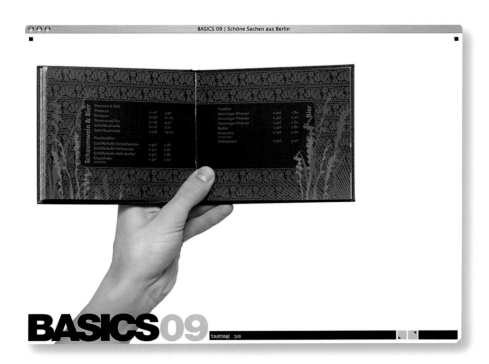

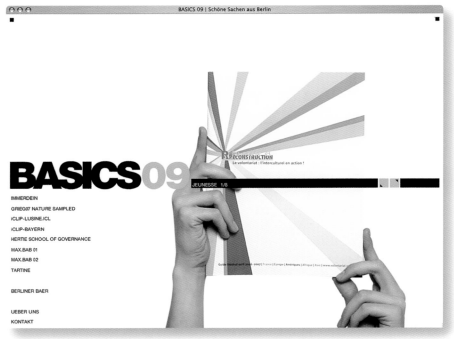

basics09.de

D: arne fehmel, korbinian kainz, rasso hilber

A: basics09 **M:** info@basics09.de

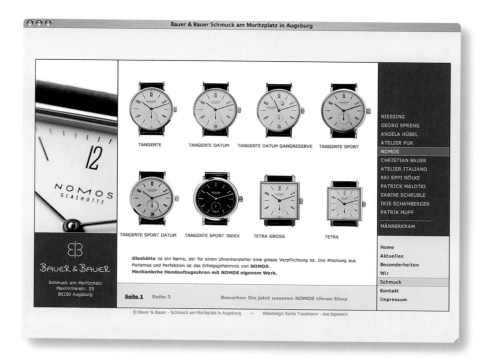

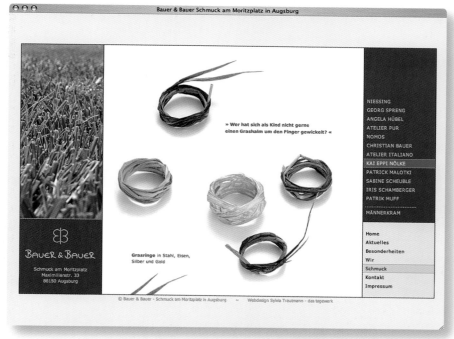

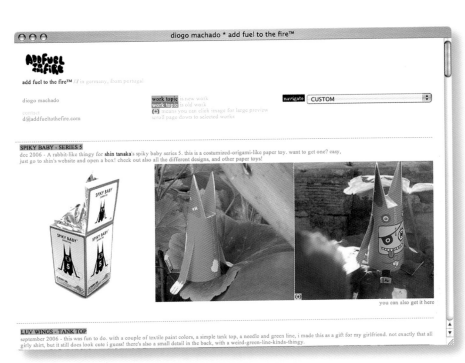

diogo machado * add fuel to the fire™

add fuel to the fire™ // in germany, from portugal

diogo machado

contact
d@addfueltothefire.com

work topic is new work
work topic is old work
(+) means you can click image for large preview
scroll page down to selected works

navigate CUSTOM

SPIKY BABY - SERIES 5
dec 2006 - A rabbit-like thingy for **shin tanaka**'s spiky baby series 5. this is a costumized-origami-like paper toy. want to get one? easy, just go to shin's website and open a box! check out also all the different designs, and other paper toys!

you can also get it here

LUV WINGS - TANK TOP
september 2006 - this was fun to do. with a couple of textile paint colors, a simple tank top, a needle and green line, i made this as a gift for my girlfriend. not exactly that all girly shirt, but it still does look cute i guess! there's also a small detail in the back, with a weird-green-line-kinda-thingy.

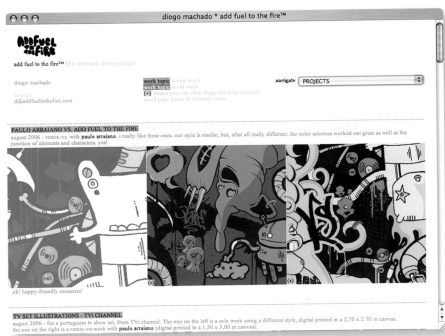

diogo machado * add fuel to the fire™

add fuel to the fire™ // in germany, from portugal

diogo machado

contact
d@addfueltothefire.com

work topic is new work
work topic is old work
(+) means you can click image for large preview
scroll page down to selected works

navigate PROJECTS

PAULO ARRAIANO VS. ADD FUEL TO THE FIRE
august 2006 - remix-vs. with **paulo arraiano**. i really like these ones. our style is similar, but, after all really different. the color schemes worked out great as well as the junction of elements and characters. yes!

oh! happy-friendly monsters!

TV SET ILLUSTRATIONS - TVi CHANNEL
august 2006 - for a portuguese tv show set, from TVi channel. The one on the left is a solo work using a different style, digital printed in a 2,70 x 2,70 m canvas. the one on the right is a remix-vs-work with **paulo arraiano** (digital printed in a 1,50 x 3,00 m canvas).

www.addfueltothefire.com
D: diogo machado **C:** diogo machado **P:** diogo machado
A: add fuel to the fire™ **M:** d@addfueltothefire.com

STEREOTYPE ⑤

HOME

ABOUT

ARTISTS

CONTACT

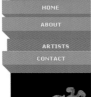

STEREOTYPE ⑤ SERIES04
BE MY GUEST

SERIES04 BE MY GUEST

THE LIMITED BLACK EDITION ⑤

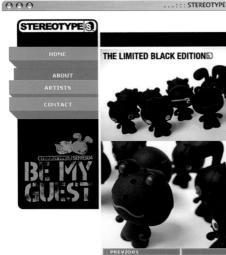

Stereotype history:

The concept behind Stereotype is to create metaphoric creatures in costumes that mimic well known identities we see on our streets and in our imagination. Guided by what surrounds us in our immediate surroundings in mass media, the streets and even in our education, we all have developed a common understanding about certain identities (be it a S&M professional or an alien). Our designs are driven by the irony and humor of taking these identities and applying them to cute figures.

Five series have already been designed by our studio, Superdeux while production is handled by Redmagic: **Be My Slave, Be My Slave black edition, Army Of Death (with a limited edition pack), From Outer Space** and most recently **Be My Guest.** A cross over of a unique 8" Dunny of Kidrobot was also designed.

Stereotype is not only a toy line. In collaboration with Redmagic, Superdeux is currently working on of other collectable goodies including clothing, high quality, super unique accessories and limited series collectable toys.

For this new series, **BE MY GUEST,** we asked designers /artists from all over the world to make custom designs to our giant BOO and ALBAN. The results will amaze you!

We would like give our thanks to the collaborators on this project:
Scien and Kler/123klan, Jeff/Staple Design, Geneviève Gauckler, Melvin/Phunkstudio, Bill McMullen, Justin DEMO, Dan /Acquired, Richard and Charles/Redmagic

Special thanks to: Stephane/Tepat for the website and Jamiru for the translation.

PREVIOUS NEXT

STEREOTYPE ⑤

HOME

ABOUT

ARTISTS

CONTACT

STEREOTYPE ⑤ SERIES04
BE MY GUEST

SERIES04 BE MY GUEST

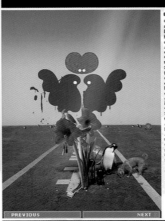

Geneviève Gauckler

Genevieve Gauckler is a Paris based artist who creates numerous lovable characters, blends them into everyday life scenes and turns the fantastical world into reality with her magical power. She has an evident taste for simple, colorful shapes. She's into everything and constantly amazed, handling and creating images and shapes with dexterity and innocence.

Genevieve Gauckler can look back on broad experience in the field of graphic design, illustration and art direction. Starting with French record company F Communications (Laurent Garnier, St Germain) she later worked with directors Kuntzel & Deygas on various music videos, commercials, titles and short movies. In 1999, she was hired by the Internet company boo.com to create their online fashion magazine, then she went to London where she helped to create a new version of the same site. While in London, she worked for the design agency Me Company, developing a number of projects for the web. Since 2001, Genevieve has been focusing on videos with the collective Pleix, websites, illustrations, art (Mandalas) and character design. She also made a comic book, L'Arbre Genialogique: minimalistic black and white images and a good story. In 2004, she held 2 exhibitions with the Colette store in Paris and Colette Meets Comme Des Garçons store in Tokyo. She has managed to develop, renew and juggle a visual language of her own making, resulting in a world that is funny, sparky, cheerful, surprising and full of joy.

www.g2works.com

PREVIOUS NEXT BACK

stereotype.superdeux.com

D: sebastien roux **C:** tepat
A: unchi leisure center **M:** info@superdeux.com

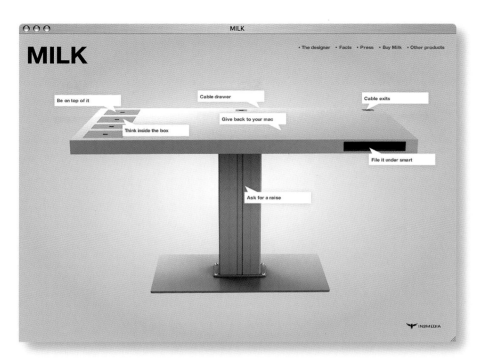

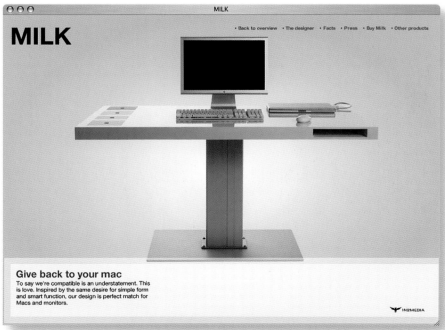

www.milk.dk

D: pelle martin **C:** felix nielsen, jake jensen **P:** soren kjaer

A: in2media **M:** sk@lightbox.dk

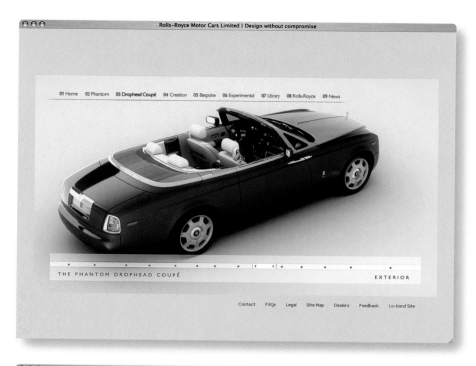

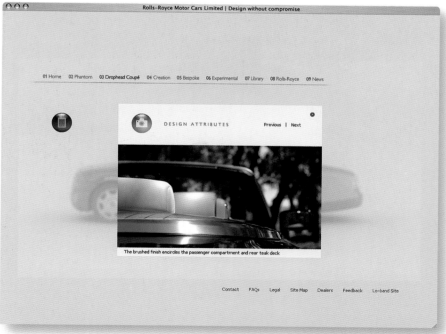

www.rolls-roycemotorcars.com
D: jason loader, andrew rees C: daniel goulding P: francis jago
A: fingal M: francis.jago@fingal.co.uk

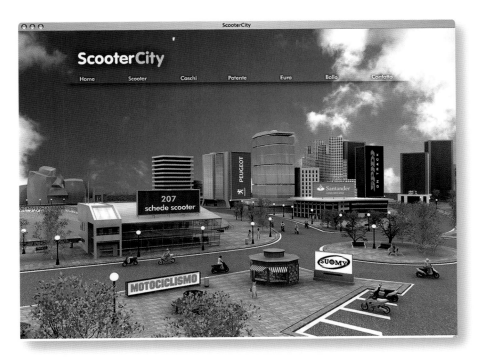

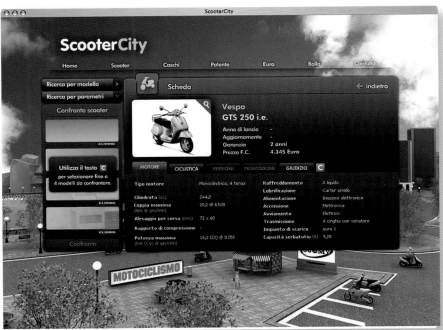

www.scootercity.it

D: marco testoni C: massimo tagliavini P: daniele flecchia
A: mediaexe M: www.mediaexe.it

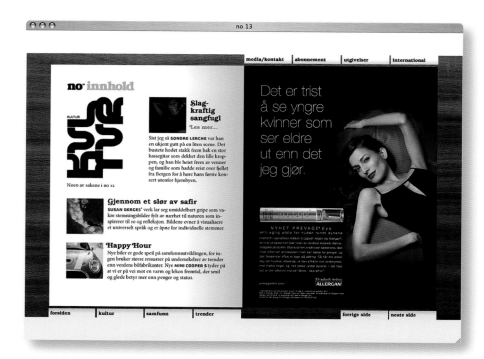

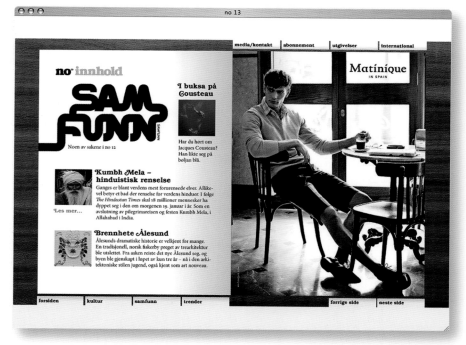

www.nomagazine.no
D: håvard gjelseth **C:** håvard gjelseth **P:** håvard gjelseth
A: this way design **M:** hgjelseth@thiswaydesign.com

index
MAGAZINE INDEX WORLDWIDE

Imagine a dinner party with the most exciting, weirdest people you'd ever meet. For ten years, index magazine, founded by artist Peter Halley in 1996, was that party. From influential stars to off-the-radar voices, index brought together film people, photographers, designers, musicians, artists, fashionistas, and freaks -- and just let them talk.

HOME INTERVIEWS COVERS CELEB PHOTOS PARTY PHOTOS WHO PLAYLIST BOOKS CONTACT

RICH BOY GASKETS mp3 downloads UNAGI THE MAE-SHI indexed
TENNISCOATS **the playlist** ▶ EKKEHARD EHLERS **full archive**

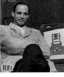

contributers
who's who
The contributors, photographers, editors and writers who came together **to make index more indexy** during its ten-year run.

▶ FEATURED
INTERVIEWS

FASHION

TOM FORD
JERRY HALL
MARC JACOBS
HELMUT LANG
ISAAC MIZRAHI
HEDI SLIMANE

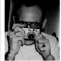

back issues
covers
gallery
A gallery of **index's cover portraits** by photographers such as Leeta Harding, Wolfgang Tillmans, Terry Richardson, and Juergen Teller. Plus, the contents of each issue.

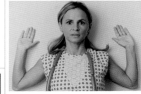

Amy Sedaris
featured interview
INDEX 46, NOVEMBER 2004
We love her exuberance, her zest for self-satire, her grotesque characters. She started at Second City, wrote plays with David, did downtown theater, stormed Comedy Central. Amy's bringing *Strangers With Candy* to a cineplex near you.

MUSIC

ANTONY
BJORK
BRIAN ENO
EVE
WILL OLDHAM
PHOENIX

FILM

WES ANDERSON
KAREN BLACK
XAN CASSAVETES
TERRY GILLIAM
WERNER HERZOG
SCARLETT JOHANSSON

indexed
party
photos
index's legendary parties

publications
index books
Photographer **Ryan McGinley** was rocketed to fame with his photo book of NYC youth.

ART

SYLVIE FLEURY

index**ed**
INDEX MAGAZINE
INDEX WORLDWIDE™

Imagine a dinner party with the most exciting, weirdest people you'd ever meet. For ten years, index magazine, founded by artist Peter Halley in 1996, was that party. From influential stars to off-the-radar voices, index brought together film people, photographers, designers, musicians, artists, fashionistas, and freaks -- and just let them talk.

HOME INTERVIEWS COVERS CELEB PHOTOS PARTY PHOTOS WHO PLAYLIST BOOKS CONTACT

index
who's who

The unexpected mix of people who came to make index such a party

indexed
full archive
Read the full text of over 150 of *index's* interviews

▶ FEATURED
INTERVIEWS

indexmagazine.com
IS EXPANDING!

If you are interested in contributing content, please **contact us**.

celebrity
photos
Scarlett! Bianca! Aiden Shawl Kathleen Hannah! **The stars you want to see**, the way you've always wanted to see 'em.

index
books
Photographer **Ryan McGinley** became known in 1998 with his photo book of NYC youth. More

www.indexmagazine.com
D: teddy blanks C: teddy blanks P: peter halley
A: index worldwide M: office@indexmagazine.com

High Play

Highplay **Performance Development** Center for High Performance Experiential Marketing

Overview HPD Outros Serviços

Rua Damião de Góis 75 Ap 82
4050 -225 Porto
Tel. 22 509 46 46 Fax 22 502 70 12
e-mail info@highplay.pt

HIGH PLAY VOLTA À AMAZÓNIA

HIGH PLAY DESENVOLVE CONSULTORIA EM ANGOLA

CENTER FOR HIGH PERFORMANCE

A High Play, Consultores está a prepara mais um curso de liderança na Amazónia. A Aventura no Mundo dos Negócios vai ...
ler mais 沔

Em parceria com uma consultora multinacional a High Play, Consultores marcará presença em Angola no ...
ler mais 沔

O Center for High Performance iniciou no dia 6 de Março deste ano um terceiro Projecto de Estudo e ...
ler mais 沔

High Play

Highplay Performance Development Center for High Performance Experiential Marketing

HUMAN PERFORMANCE DEVELOPMENT > HPD

Este tipo de projecto, apoia-se num trabalho de consultoria que favorece o estabelecimento de uma relação estreita entre o treino (formação), melhoria do desempenho, necessidades do negócio e ambiente de trabalho. Na implementação destes projectos de consultoria, a High Play integra campeões de mudança internos e indicadores de desempenho, que permitem um foco na realidade da organização através da aplicação de metodologias estruturadas de Desenvolvimento da Performance das Pessoas - HDP, Human Performance Development .

A abordagem - Human Performance Development (HPD), permite-nos que as pessoas trabalhem nas tarefas certas e com processos eficazes, mediante o reconhecimento prévio dos problemas e identificação das melhores soluções com medidas concretas em termos de progresso.

Todo este trabalho é feito com base em pequenos pré diagnósticos que nos permitem fazer a concepção de um mapa de relacionamento de performance, o qual resume a informação recolhida ao analisar as necessidades de negócio, performance, formação e ambiente de trabalho.

Os projectos ficam concluídos com a sua fase de implementação, que consiste na melhoria efectiva da performance e dos resultados operacionais desejados que formam a expectativa do grupo de trabalho (constituído pelos campeões de mudança internos e o consultor de performance). Esta fase de implementação é conduzida pelas acções estruturadas com o objectivo de se atingir o padrão de rendimento desejado, o qual é medido pelos indicadores de desempenho (Key Performance Indicators) seleccionados para o efeito.

voltar 沔

www.highplay.pt
D: paula granja **C:** paula granja **P:** paula granja
A: pcw **M:** paula granja

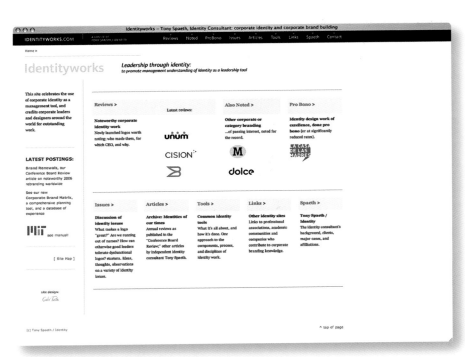

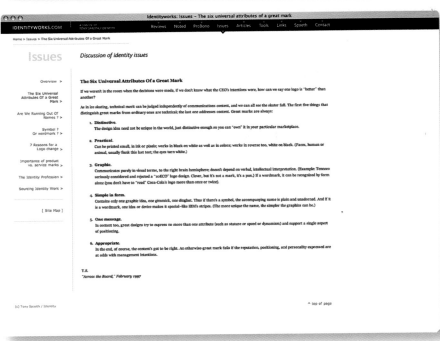

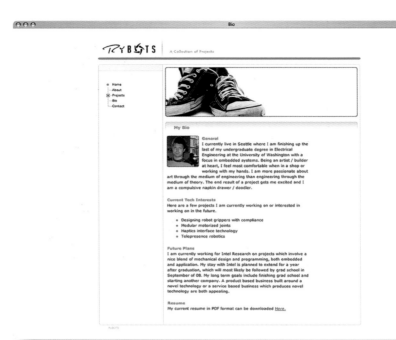

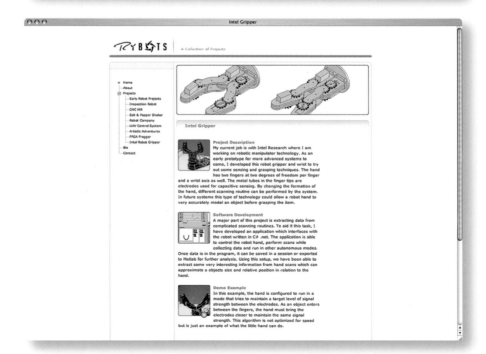

www.rybots.com

D: ryan wistort **C:** ryan wistort **P:** ryan wistort
A: rybots **M:** ryan@rybots.com

 ijzerman & van spréw
landschappers en adviseurs ruimtelijke ordening

FLORA & FAUNA　ARCHEOLOGIE & CULTUURHISTORIE　GIS　LANDSCHAP　　OVER IJVS　NIEUWS　CONTACT

IJzerman & Van Spréw: **adviseurs ruimtelijke ordening en landschap.**
Sinds 2005 bouwt IJzerman & Van Spréw bruggen tussen ontwikkeling, onderzoek, wetgeving en samenleving. Voor zowel particulieren als overheden. Door middel van cultuurhistorisch, ecologisch en ruimtelijk onderzoek, advies en (effect)rapportages geeft IJzerman en Van Spréw sturing aan de ontwikkeling van een gebied en begeleidt trajecten van aanvraag tot en met maatregel. De vraag en het landschap vormen gezamenlijk de basis voor onafhankelijk, objectief advies en ruimtelijke ontwikkeling.

De werkwijze? Logisch naar een gebied kijken en op een creatieve en effectieve manier invulling geven aan nieuwe ruimtelijke ontwikkelingen. Steeds op de hoogte zijn van de laatste regelgevingen en ontwikkelingen en interpretaties daarvan.
Het gezonde verstand gebruiken de juiste vertaalslag maken tussen aanwezige, landschappelijke elementen en de toekomstige invulling van een gebied. Bruggen bouwen tussen beleid en inhoud door informatie toegankelijk en begrijpelijk raadpleegbaar te maken voor gebruikers en belissers.

 Aftrap MonumentenPlan Veldhoven (MPV)
Op dinsdag 6 maart is in Museum 't Oude Slot de aftrap gegeven voor het MonumentPlan Veldhoven ...

 IJVS artikel in GIS magazine
IJVS geeft zijn visie op cultuurhistorie en GIS in het GIS-Magazine van maart/arpil 2007. Klik hier ...

 JOMY (Just Outside My Yard)
Brandgangen, achterpaden, opritten, binnenpleinen. De haarvaten en longen van stad en dorp: ...

© 2007 IJzerman & Van Spréw　|　home　|　website door freshheads

ijzerman & van spréw
landschappers en adviseurs ruimtelijke ordening

FLORA & FAUNA　ARCHEOLOGIE & CULTUURHISTORIE　GIS　LANDSCHAP　　OVER IJVS　NIEUWS　CONTACT

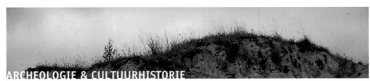

ARCHEOLOGIE & CULTUURHISTORIE

Het Europese Verdrag van Valletta uit 1992, ook wel het Verdrag van Malta genoemd, regelt de bescherming van ons (archeologisch) erfgoed en de inpassing ervan in de ruimtelijke ontwikkeling. Nederland heeft dit verdrag ondertekend en zijn eigen Monumentenwet hierop aangepast. De specialisatie Archeologie & Cultuurhistorie van IJzerman & Van Spréw stelt zich ten doel om in zijn advies het erfgoed zo efficiënt mogelijk in te passen in het ruimtelijk ordeningsproces en de kansen voor kwaliteitsverbetering in dat proces zo goed mogelijk te benutten.

Eén van de uitgangspunten van IJzerman & Van Spréw is om onnodig onderzoek te vermijden. De focus ligt vooral op het traject zelf én de koppeling tussen beoogde plannen en wet- en regelgevingen. Met deze werkwijze ondersteunt IJzerman & Van Spréw zijn opdrachtgevers tijdens het ruimtelijk ontwikkelingsproces. Er is daarnaast altijd oog voor het waarborgen en benadrukken van de identiteit van een streek. En streven dat in de archeologische quick scans, cultuurhistorische onderzoeken, cultuurhistorische waardenkaarten en projectleiding steeds terugkomt. IJzerman & Van Spréw is lid van de Vereniging Ondernemers In Archeologie (VOIA).

Producten
- Archeologische Quick Scan
- Cultuurhistorisch onderzoek - Inventarisaties - Waardering - Historische geografie
- Cultuurhistorische producties - Cultuurhistorische waardenkaarten - Cultuurhistorische atlassen - Monumentenplannen
- Projectleiding & advies - Directievoering - Coördinatie - Opstellen programma van eisen - Begeleiding

→ Projecten Archeologie en cultuurhistorie
→ Alle projecten

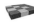 **Aftrap MonumentenPlan Veldhoven (MPV)**
Op dinsdag 6 maart is in Museum 't Oude Slot de aftrap gegeven voor het MonumentPlan ...

JOMY (Just Outside My Yard)
Brandgangen, achterpaden, opritten, binnenpleinen. De haarvaten en longen van stad en ...

IJVS onderzoekt cultuurhistorische waarden stadskern Tilburg
De gemeente Tilburg heeft IJzerman & Van Spréw opdracht gegeven om onderzoek te doen ...

© 2007 IJzerman & Van Spréw　|　home　|　website door freshheads

www.ijzermanvansprew.nl
D: sjoerd eikenaar **C:** joost gielen **P:** joost gielen
A: freshheads **M:** info@freshheads.com

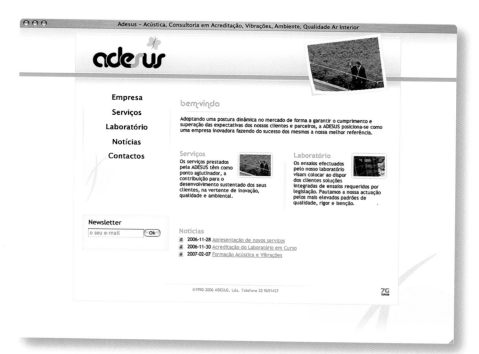

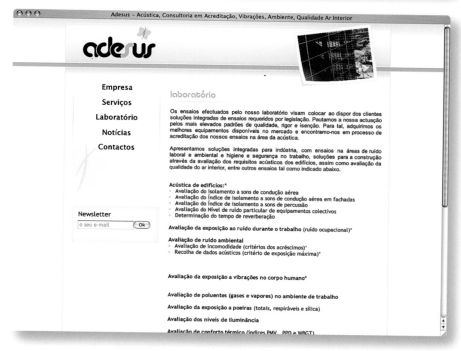

www.adesus.pt

D: 7graus

M: www.7graus.com

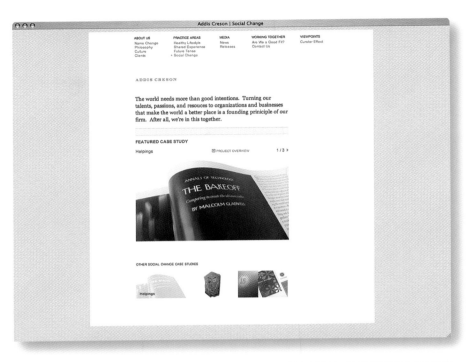

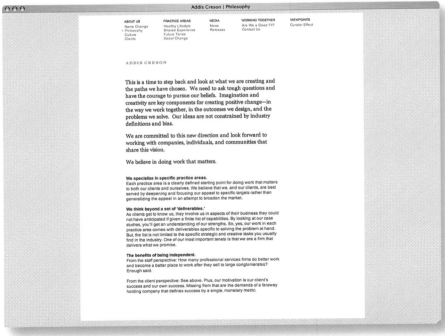

addiscreson.com

D: john creson **C:** susan mullaney

A: addis creson **M:** john.creson@addiscreson.com

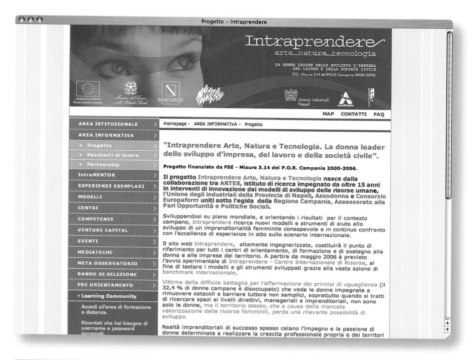

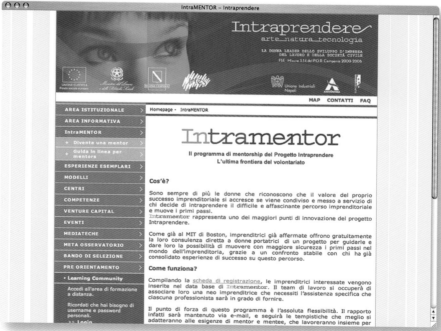

www.intra-prendere.com

D: francesco e. guida, carla de luca, jaana zammer **C:** time & mind **P:** artes
A: studioguida **M:** feguida@studioguida.net

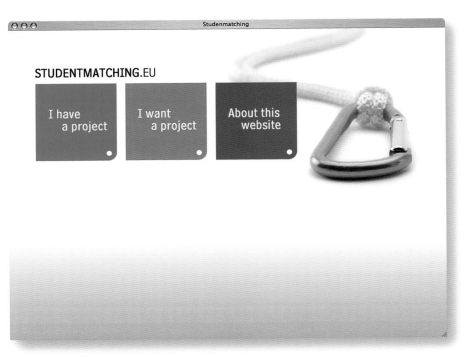

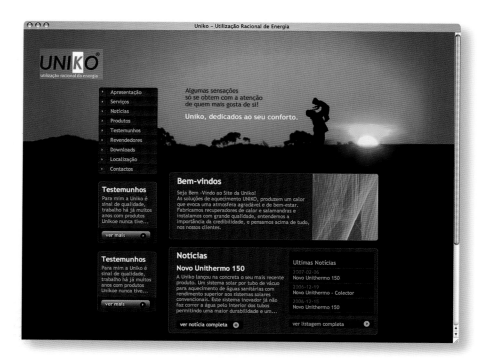

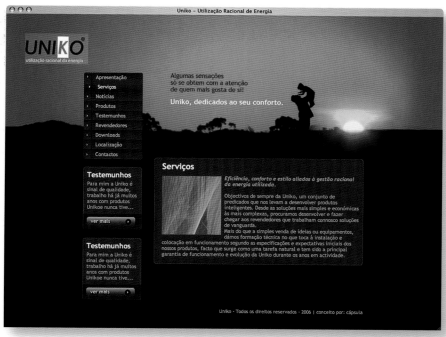

www.uniko.pt
D: luis daniel cunha **C:** romeu ribeiro **P:** eurico lages
A: cápsula - soluções multimédia **M:** geral@capsula.com.pt

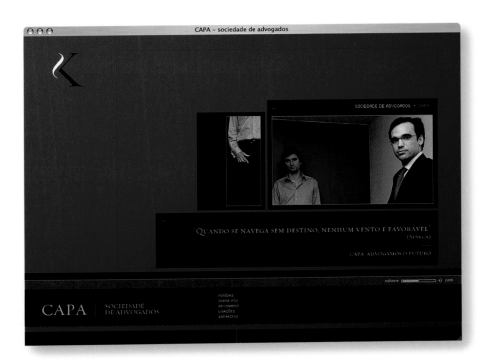

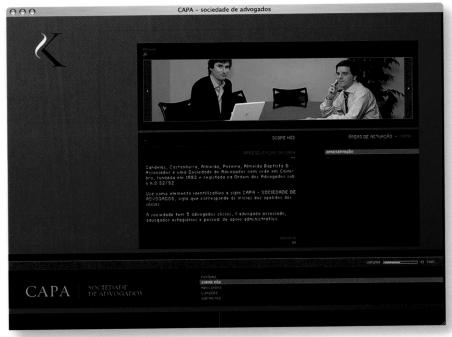

www.capa-advogados.com

D: filipe cavaco, alexandre r. gomes **C:** alexandre r. gomes **P:** bürocratik

A: bürocratik **M:** info@burocratik.com

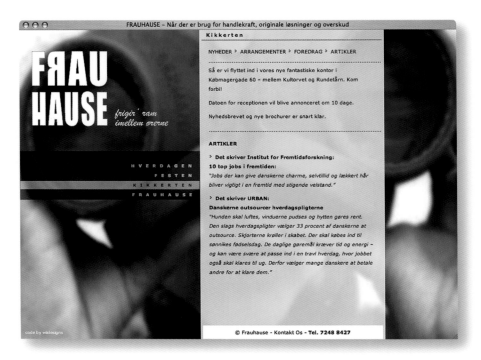

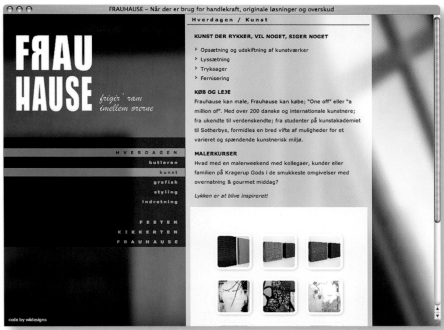

www.frauhause.com
D: willy nielsen C: willy nielsen P: willy nielsen
A: wiidesigns.com M: www.wiidesigns.com

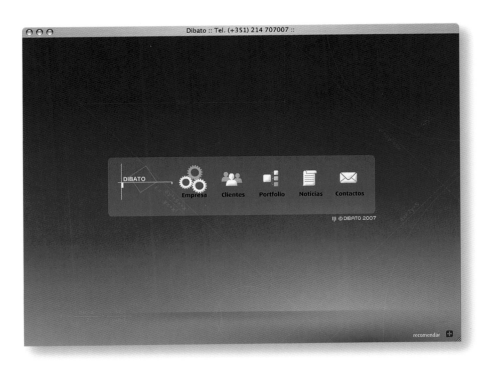

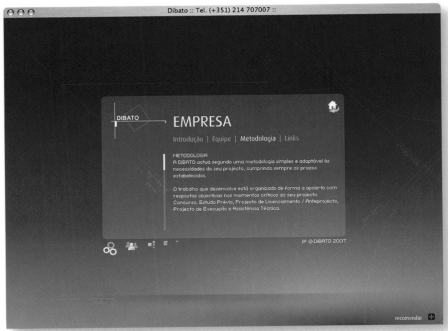

www.dibato.pt

D: paulo afonso C: paulo afonso P: paulo afonso

A: semmais.com M: www.semmais.com

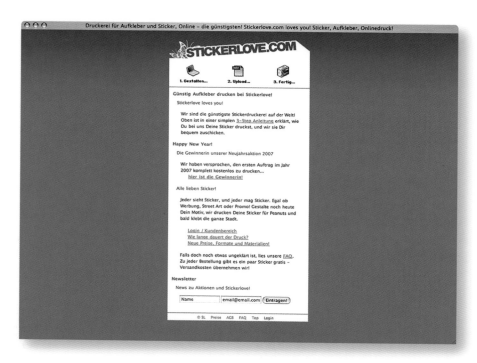

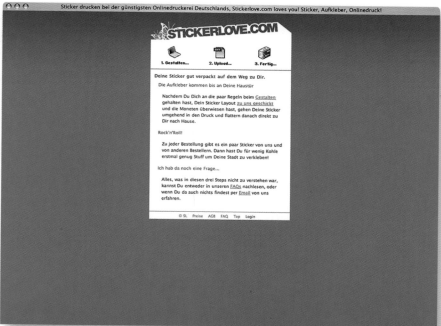

www.stickerlove.com

D: roman basilius brämer, simon-alexander buchhagen

M: hello@stickerlove.com

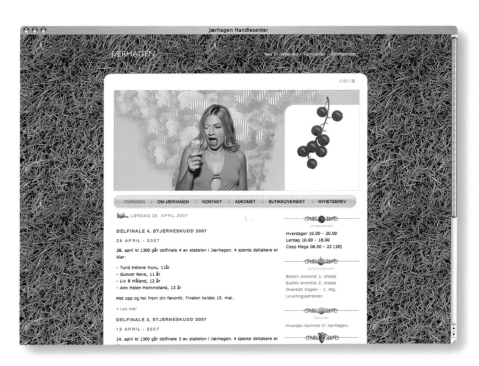

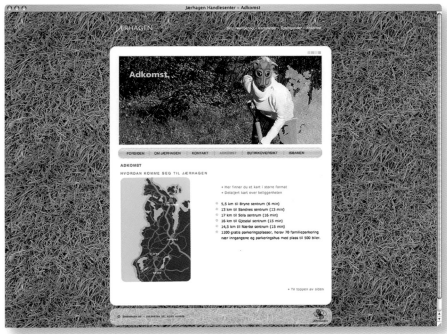

www.jaerhagen.no
D: petter sømme
M: tommy.hoyland@jaerhagen.no

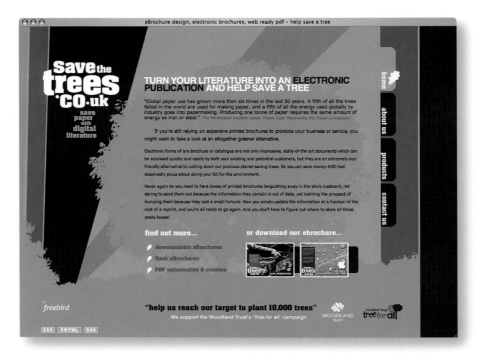

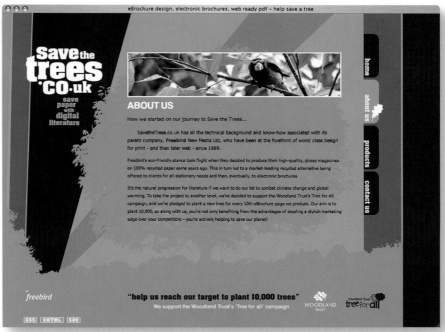

www.savethetrees.co.uk

D: john stirzaker **C:** john stirzaker **P:** nigel burton
A: freebird.co.uk **M:** enquiries@savethetrees.co.uk

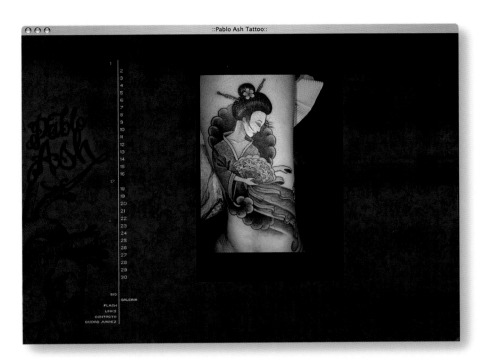

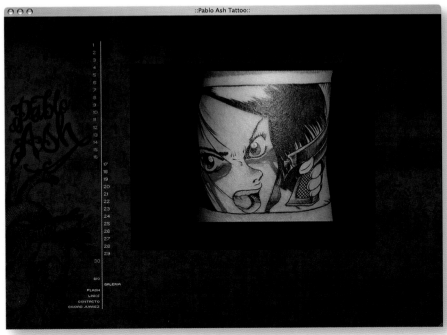

www.pabloash.com
D: domot antistudio
M: www.pabloash.com

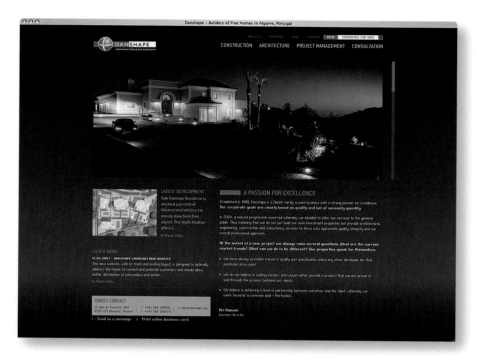

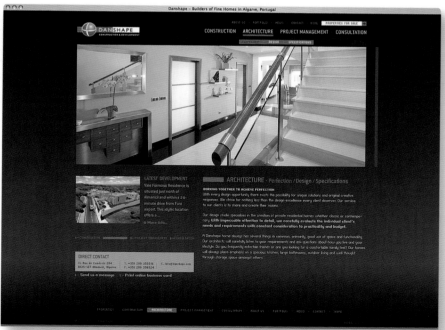

www.danshape.com
D: bruno silva C: sidney veiga P: arta design
A: arta design M: bua@arta-design.com

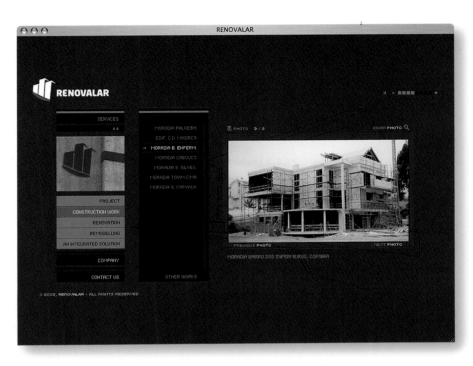

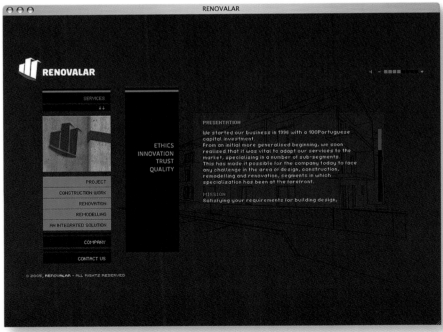

www.renovalar.pt

D: f. cavaco, a. esteves, a. r. gomes C: alexandre. r. gomes, r. simão P: bürocratik

A: bürocratik M: info@burocratik.com

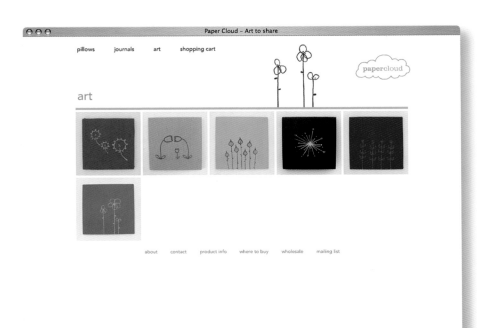

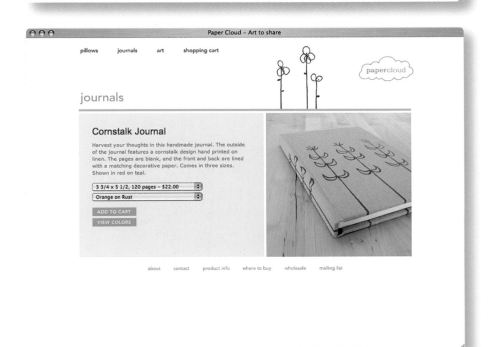

www.paper-cloud.com
D: matthew broerman, ariana broerman **C:** matthew broerman
A: paper cloud **M:** contact@paper-cloud.com

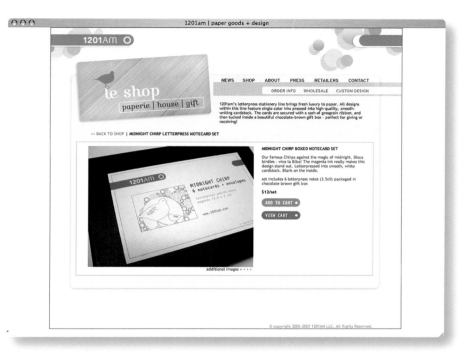

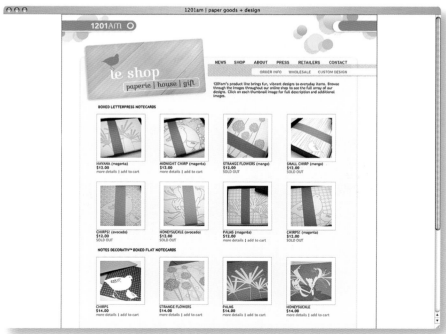

www.1201am.com
D: laurie forehand C: laurie forehand P: laurie forehand
A: 1201am llc M: mail@1201am.com

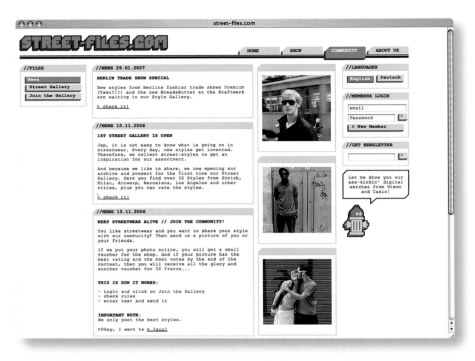

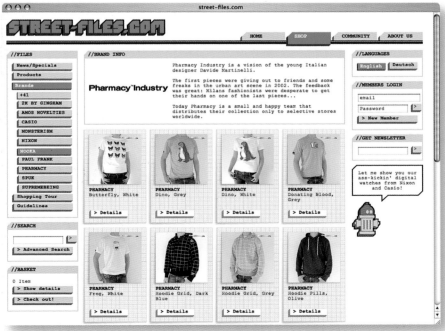

www.street-files.com
D: dominik buser **C:** rafael beck
A: 19m2 atelierkollektiv **M:** dominik@19m2.ch

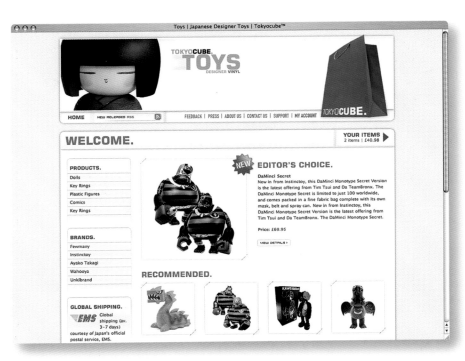

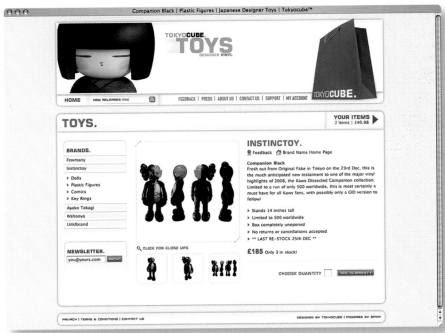

shop.tokyocube.com

D: tom vining

A: tokyocube **M:** info@tokyocube.com

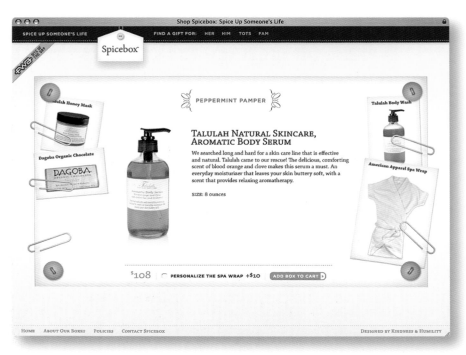

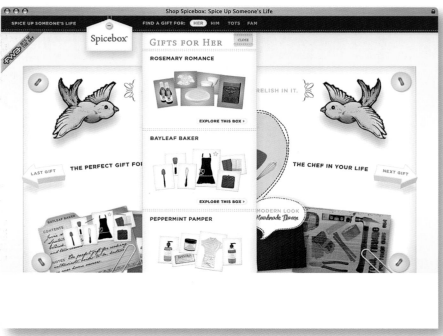

www.shopspicebox.com
D: chris erickson **C:** chris erickson
A: kindness and humility **M:** chris@kindnessandhumility.com

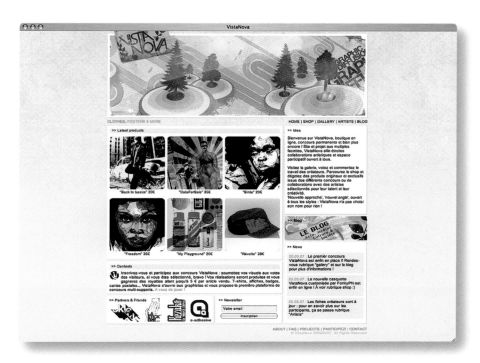

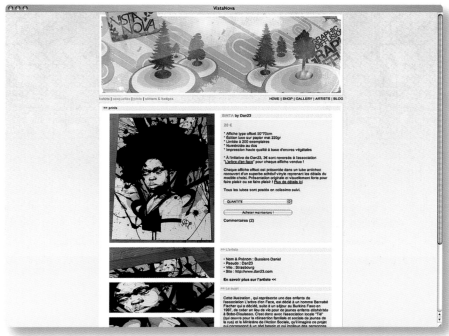

www.vistanova.fr
D: french community **P:** joaquim massabo
A: vistanova **M:** contact@vistanova.fr

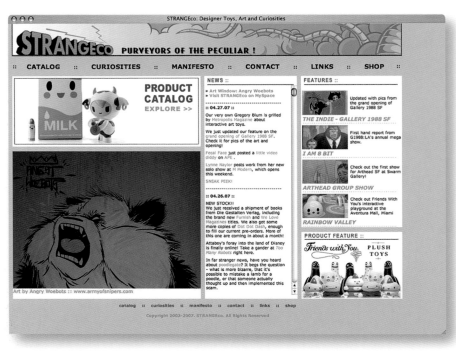

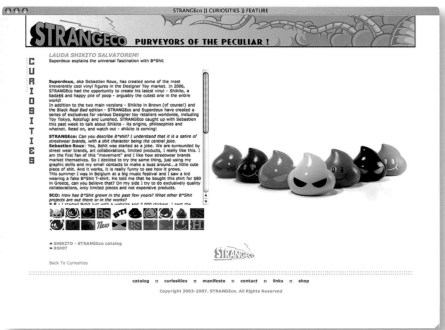

www.strangeco.com

D: reuben rude, g. blum, j. crawford, a. celes **C:** new media design **P:** strangeco
A: strangeco **M:** info@strangeco.com

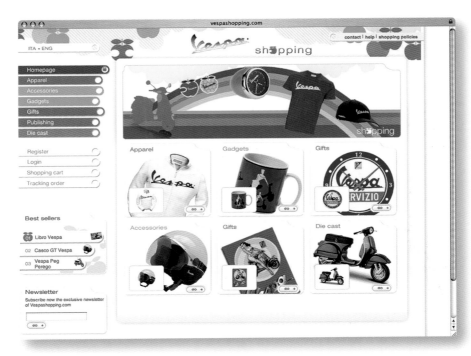

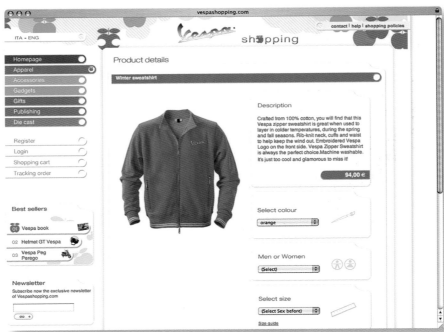

www.vespashopping.com

D: daniele scola **C:** dario castiglioni **P:** antonio tranchida
A: vox2web s.p.a. **M:** www.vox2web.com

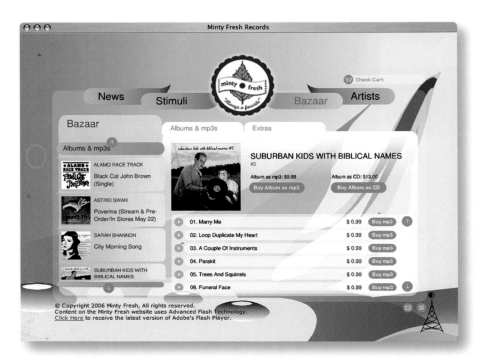

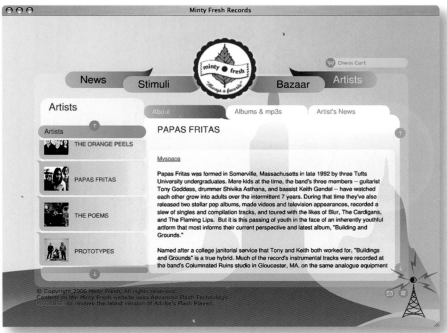

www.mintyfresh.com
D: jon montenegro, jef lacson
A: minty fresh **M:** info@mintyfresh.com

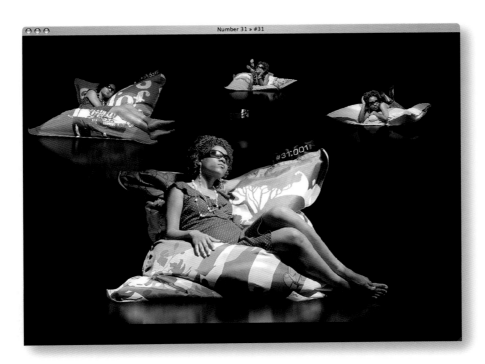

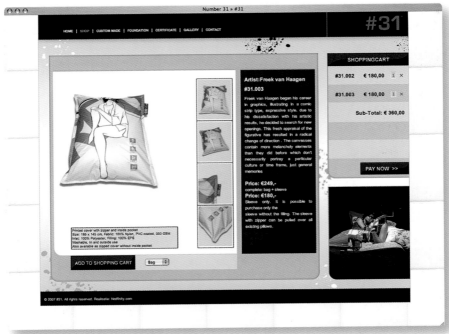

www.number31.nl
D: nedfinity C: renzo P: #31 (number31)
A: #31 (number31) M: info@number31.nl

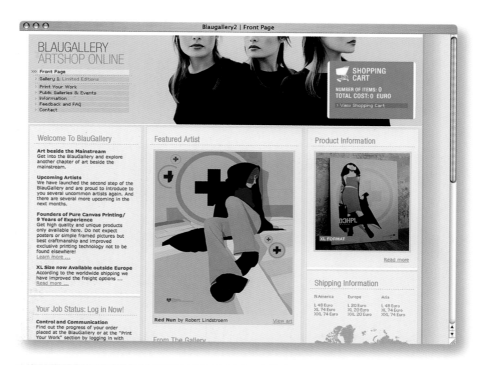

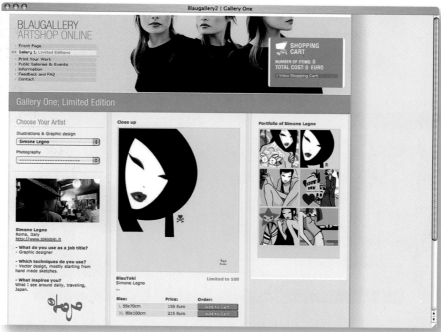

www.blaugallery.com

D: robert lindstroem

A: designchapel M: info@blaugallery.com

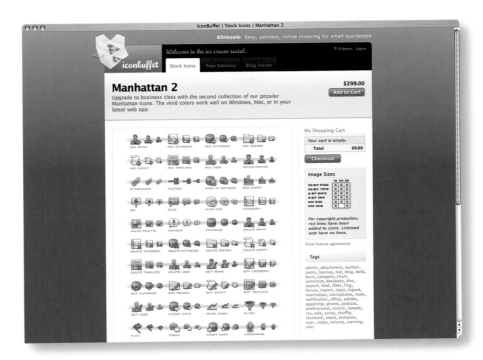

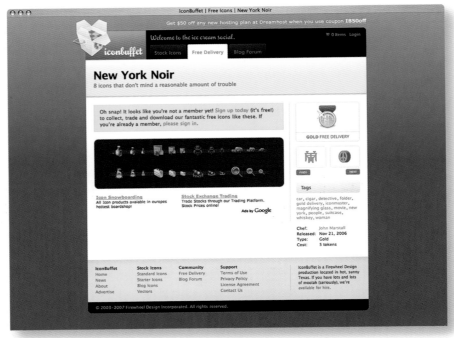

www.iconbuffet.com

D: brian brasher, keegan jones, john marstall C: john critz, sco P: josh williams
A: firewheel design M: design@firewheeldesign.com

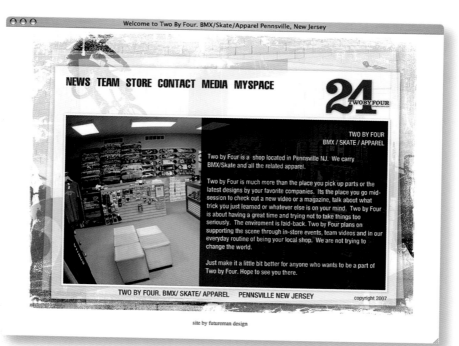

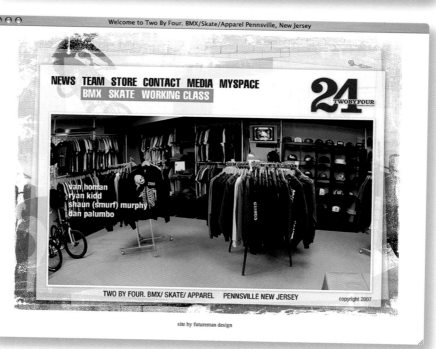

www.twobyfourstore.com
D: jon yucis
A: futureman design M: info@futuremandesign.com

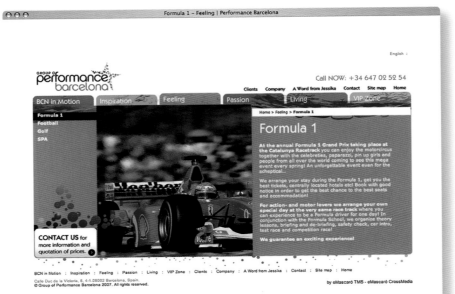

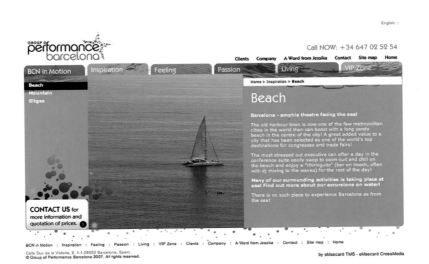

www.performancebarcelona.com
D: emascaró crossmedia
M: www.emascaro.com

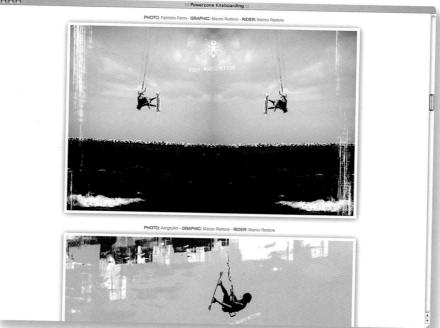

www.powerzone.org

D: marco rettore

M: kite@powerzone.org

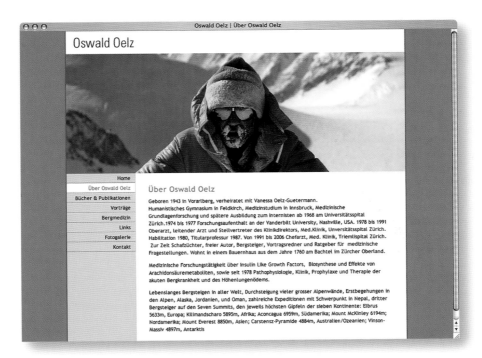

Über Oswald Oelz

Geboren 1943 in Vorarlberg, verheiratet mit Vanessa Oelz-Guetermann.
Humanistisches Gymnasium in Feldkirch, Medizinstudium in Innsbruck, Medizinische
Grundlagenforschung und spätere Ausbildung zum Internisten ab 1968 am Universitätsspital
Zürich. 1974 bis 1977 Forschungsaufenthalt an der Vanderbilt University, Nashville, USA. 1978 bis 1991
Oberarzt, leitender Arzt und Stellvertreter des Klinikdirektors, Med.Klinik, Unversitätsspital Zürich.
Habilitation 1980, Titularprofessur 1987. Von 1991 bis 2006 Chefarzt, Med. Klinik, Triemlispital Zürich.
Zur Zeit Schafzüchter, freier Autor, Bergsteiger, Vortragsredner und Ratgeber für medizinische
Fragestellungen. Wohnt in einem Bauernhaus aus dem Jahre 1760 am Bachtel im Zürcher Oberland.

Medizinische Forschungstätigkeit über Insulin Like Growth Factors, Biosynthese und Effekte von
Arachidonsäuremetaboliten, sowie seit 1978 Pathophysiologie, Klinik, Prophylaxe und Therapie der
akuten Bergkrankheit und des Höhenlungenödems.

Lebenslanges Bergsteigen in aller Welt, Durchsteigung vieler grosser Alpenwände, Erstbegehungen in
den Alpen, Alaska, Jordanien, und Oman, zahlreiche Expeditionen mit Schwerpunkt in Nepal, dritter
Bergsteiger auf den Seven Summits, den jeweils höchsten Gipfeln der sieben Kontinente: Elbrus
5633m, Europa; Kilimandscharo 5895m, Afrika; Aconcagua 6959m, Südamerika; Mount McKinley 6194m;
Nordamerika; Mount Everest 8850m, Asien; Carstensz-Pyramide 4884m, Australien/Ozeanien; Vinson-
Massiv 4897m, Antarktis

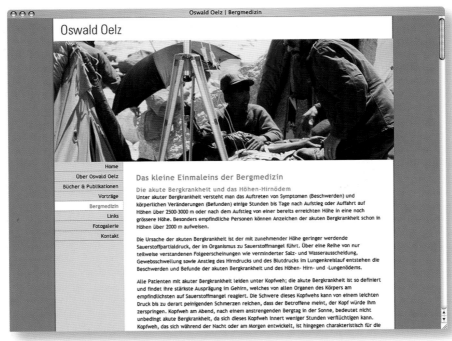

Das kleine Einmaleins der Bergmedizin

Die akute Bergkrankheit und das Höhen-Hirnödem
Unter akuter Bergkrankheit versteht man das Auftreten von Symptomen (Beschwerden) und
körperlichen Veränderungen (Befunden) einige Stunden bis Tage nach Aufstieg oder Auffahrt auf
Höhen über 2500-3000 m oder nach dem Aufstieg von einer bereits erreichten Höhe in eine noch
grössere Höhe. Besonders empfindliche Personen können Anzeichen der akuten Bergkrankheit schon in
Höhen über 2000 m aufweisen.

Die Ursache der akuten Bergkrankheit ist der mit zunehmender Höhe geringer werdende
Sauerstoffpartialdruck, der im Organismus zu Sauerstoffmangel führt. Über eine Reihe von nur
teilweise verstandenen Folgeerscheinungen wie verminderter Salz- und Wasserausscheidung,
Gewebsschwellung sowie Anstieg des Hirndrucks und des Blutdrucks im Lungenkreislauf entstehen die
Beschwerden und Befunde der akuten Bergkrankheit und des Höhen- Hirn- und -Lungenödems.

Alle Patienten mit akuter Bergkrankheit leiden unter Kopfweh; die akute Bergkrankheit ist so definiert
und findet ihre stärkste Ausprägung im Gehirn, welches von allen Organen des Körpers am
empfindlichsten auf Sauerstoffmangel reagiert. Die Schwere dieses Kopfwehs kann von einem leichten
Druck bis zu derart peinigenden Schmerzen reichen, dass der Betroffene meint, der Kopf würde ihm
zerspringen. Kopfweh am Abend, nach einem anstrengenden Bergtag in der Sonne, bedeutet nicht
unbedingt akute Bergkrankheit, da sich dieses Kopfweh innert weniger Stunden verflüchtigen kann.
Kopfweh, das sich während der Nacht oder am Morgen entwickelt, ist hingegen charakteristisch für die

www.oswald-oelz.ch
D: marc rinderknecht **C:** marc rinderknecht
A: kobebeef **M:** mr@kobebeef.ch

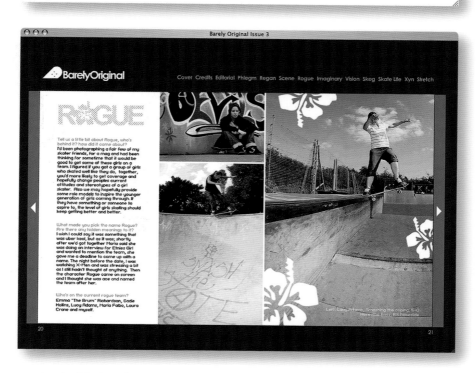

www.barelyoriginal.co.uk

D: chris robinson **C:** chris robinson **P:** chris robinson
A: crobbo **M:** info@crobbo.com

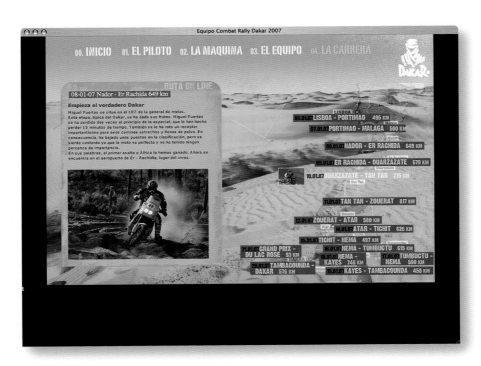

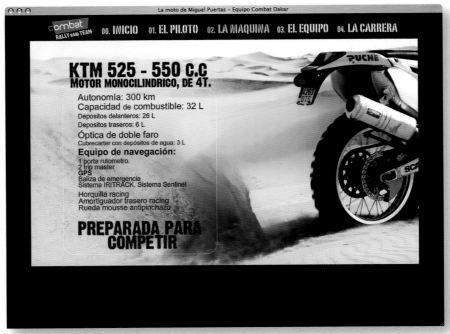

www.equipocombat.com

D: daniel tomas C: daniel tomas P: daniel tomas, cecilio puertas
A: 4000 flores M: dani@4000flores.com

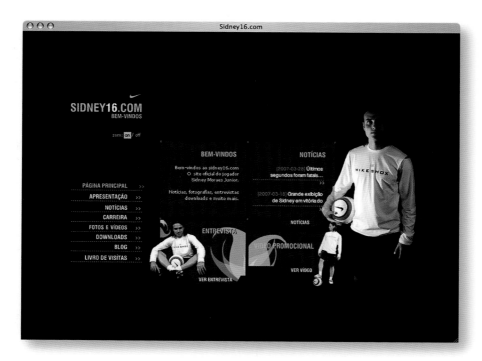

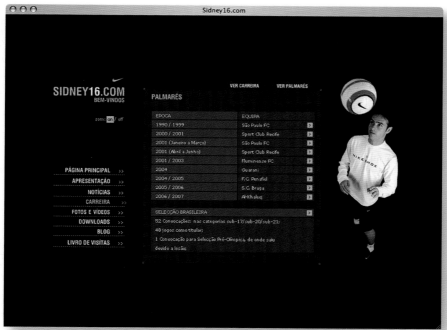

www.sidney16.com

D: luís daniel cunha **C:** romeu ribeiro **P:** eurico lages
A: cápsula - soluções multimédia **M:** geral@capsula.com.pt

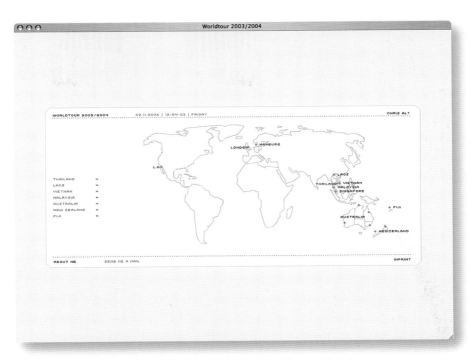

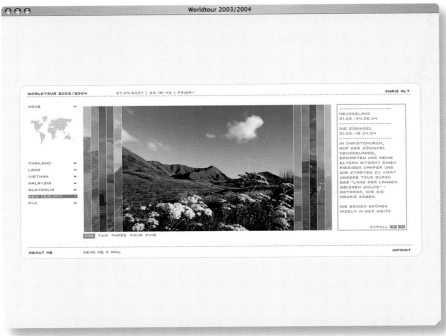

www.chrisalt.com/worldtour
D: chris alt C: uli müller P: chris alt
A: chris alt design M: design@chrisalt.com

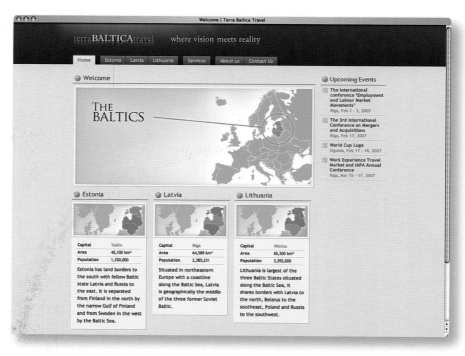

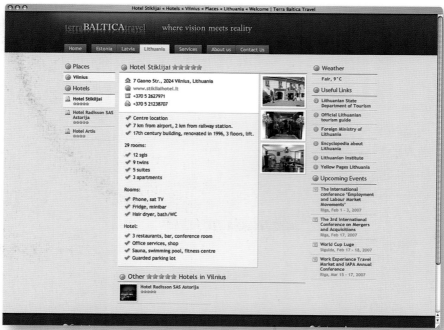

www.terrabaltica.lv

D: edgars beigarts C: edgars beigarts

M: edgars@wb4.lv

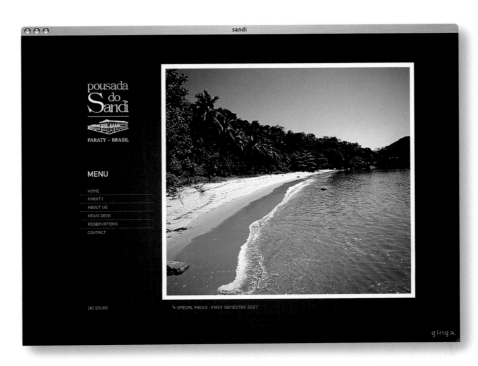

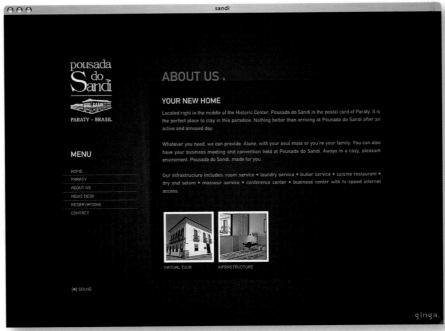

www.pousadadosandi.com.br
D: felipe bachian
A: ginga M: www.agenciaginga.com.br